Unruly
VISIONS

PERVERSE MODERNITIES

A Series Edited by Jack Halberstam and Lisa Lowe

GAYATRI GOPINATH

Unruly
VISIONS

The
Aesthetic
Practices of
Queer
Diaspora

DUKE UNIVERSITY PRESS DURHAM AND LONDON 2018

Designed by Heather Hensley
Typeset in Garamond Premier Pro by Graphic Composition, Inc., Bogart, GA

Library of Congress Cataloging-in-Publication Data
Names: Gopinath, Gayatri, [date] author.
Title: Unruly visions : the aesthetic practices of queer diaspora / Gayatri Gopinath.
Other titles: Perverse modernities.
Description: Durham : Duke University Press, 2018. | Series: Perverse modernities |
Includes bibliographical references and index.
Identifiers: LCCN 2018008226
ISBN 9781478002161 (ebook)
ISBN 9781478000280 (hardcover : alk. paper)
ISBN 9781478000358 (pbk. : alk. paper)
Subjects: LCSH: Homosexuality and art. | Aesthetics. | Queer theory.
Classification: LCC N72.H64 G67 2018 | DDC 700/.453—dc23
LC record available at https://lccn.loc.gov/2018008226

Cover art: Akram Zaatari, *Ahmad al-Abed, early 1950s*, from Zaatari's ongoing
project *Hashem El Madani: Studio Practices* (2006), courtesy of Akram Zaatari
and Arab Image Foundation.

Duke University Press gratefully acknowledges the support of NYU–Abu Dhabi,
which provided funds toward the production of this book.

IN LOVING MEMORY OF APRIL COTTE
(1968–2018)

Contents

Acknowledgments

This book has been long in the making, and I am deeply grateful to the many friends and colleagues who got me across the finish line. Ann Cvetkovich and Nayan Shah were my ideal readers: they saw the connective threads and the larger stakes of the project better than I could, and their clear-eyed critiques helped me immeasurably. A manuscript workshop funded by NYU's Department of Social and Cultural Analysis provided me with invaluable feedback from Cristina Beltrán, Macarena Gómez-Barris, Kris Manjapra, and Dean Saranillio. I am happily indebted to my dear friends and series editors Jack Halberstam and Lisa Lowe for reading, listening to, and commenting on many iterations of this project over the years, and for their unwavering support of my work. It's been a true joy to write and think alongside Martin Manalansan and Karen Shimakawa; they have been dream interlocutors, and made the writing process feel much less daunting and a whole lot more fun. Kandice Chuh read the manuscript from start to finish and offered critical insights that transformed its entire framing. Juana María Rodríguez commented on very early versions of chapters 1 and 4 with her singular high femme brilliance. My compatriots in SCA, particularly Awam Amkpa, Carolyn Dinshaw, Lisa Duggan, the late Juan Flores, Jennifer Morgan, Crystal Parikh, Ann Pellegrini, Mary Louise Pratt, Renato Rosaldo, Josie Saldaña, Fran White, and Deborah Willis provided daily motivation with the rigor

of their thinking and their intellectual generosity. I thank the NYU Humanities Initiative and the participants of the "Sense Matters, Matters of Sense" Research Cluster, particularly Tavia Nyong'o, for creating a rich and invigorating cohort of queer scholars. Bryan Waterman and Robert Young graciously created space for me at NYU Abu Dhabi, and I am thankful for the remarkable community that carried me through my days there: Fawzia Afzal-Khan, May Al-Dabbagh, Swethaa Ballakrishnnen, Bill Bragin, Una Chaudhuri, Maya Kesrouany, Marc Michael, Sana Odeh, Lisa Philp, Ella Shohat, and Bob Stam. I am also grateful for the support I received through the NYU Abu Dhabi Faculty Research Grant and the NYU Center for the Humanities.

Friends and colleagues in New York City and beyond who have provided invaluable support, feedback, inspiration, a sense of community, and all-round delight include Jaishri Abichandani, Bob Alotta, Jacqui Alexander, Paul Amar, Paola Bacchetta, Herman Bennett, Emma Bianchi, Arnaldo Cruz Malavé, Tina Campt, Alexis De Veaux, David Eng, Esther Figueroa, Licia Fiol-Matta, Nicole Fleetwood, Steve Friedman, Randy Gernaat, Faye Ginsburg, Carl Haacke, Shaheen Haq, Grace Hong, David Kazanjian, Aamir Khandwala, Rosamond King, Eng-Beng Lim, Rekha Malhotra, Bakirathi Mani, Susette Min, Yong Soon Min, Ann Morning, Angelique Nixon, Sandy Onamura, Pratibha Parmar, Toshi Reagon, Svati Shah, Michael Simonsen, Javid Syed, Atif Toor, Damon Wadsworth, and Rinaldo Walcott. Thanks to Chandra Mohanty for quiet writing time in her magical home in Ithaca, New York, and to Zillah Eisenstein for the long walks, delicious meals, and warm welcome. Rod Ferguson, Chandan Reddy, and Stephanie Smallwood are my heart: our retreats of water and woods are more precious than I can say. I miss long runs through the Berkeley hills with Karl Britto; I'm grateful to have benefited from his unparalleled skill in close reading and careful listening, and in knowing just how to make me giggle uncontrollably. I miss dinners at Angelica with Sonia Katyal; I thank her for long-lasting friendship that has withstood several cross-country moves. Jackie Brown and Lisa Baltazar are family, pure and simple, and give me a reason to love NYC every day.

My West Coast family continues to make the Bay Area feel like home, even many years after having left: Anna Berg, April Cotte, Karen Elliott, Cici Kinsman, Ana Perez, and Jade Williams gave me the gift of their friendship, and the calm oasis of their beautiful homes as a place to write and renew.

I have worked with wonderful graduate students at NYU—especially Leticia Alvarado, Karen Jaime, Ronak Kapadia, Summer Kim Lee, Rajiv Menon, Manijeh Moradian, and Elliot Powell—who are now valued colleagues. Spe-

cial thanks to Summer, who acted as my research assistant during the final stages of manuscript preparation, for the care and efficiency she brought to the project.

The feedback I received upon presenting this work to audiences in various venues never failed to reenergize me. I am indebted to the many colleagues who gave their time and labor to organize talks for me at their institutions. I can't name them all here, but in the past two years those I thank in particular include Sadia Abbas at Rutgers University, Newark; Alberto Fernández Carvajal at the University of Leicester; Lisa Lowe, Jyoti Puri, and Kimberly Juanita Brown at the Graduate Consortium for Women's Studies; Alex Lubin at the American University of Beirut; Sara Mourad at the American University of Beirut; Chandan Reddy and Amanda Swarr at the University of Washington, Seattle; Nandita Sharma at the University of Hawaii, Manoa; Janice Stewart at the University of British Columbia; Deborah Willis at NYU Florence.

I am especially grateful to the artists I write about in these pages, without whom this book would not exist. I especially thank Allan deSouza, Chitra Ganesh, Aurora Guerrero, David Kalal, Seher Shah, and Akram Zaatari for ongoing conversations and critical feedback.

Ken Wissoker first took an interest in my work some twenty years ago, and I feel supremely lucky for his enthusiasm and belief in its value. His calm and steady presence has meant the world to me. Thanks to him and to Elizabeth Ault for so ably seeing the book through its final stages.

In the midst of the writing of this book, two cherished comrades passed away within two months of one other: Rosemary George (1961–2013) and José Muñoz (1967–2013). Rosie mentored me with an easy generosity early on in my graduate career, and became a beloved friend and colleague. Coteaching with José over the course of six years brought me tremendous joy, and was truly my definition of "the good life." Their luminous work represents the two touchstones of my intellectual investments: an engagement with questions of postcolonial, diasporic (un)belonging on the one hand, and with the productive, imaginative possibilities of queerness on the other. The lessons I've learned from them imprint this book in ways both subtle and obvious. I would like to think of *Unruly Visions* as a tribute to what their work has taught me and continues to teach me.

Finally, my deepest thanks go to Tei Okamoto, for never doubting that this book would be completed, for making space for the writing, for nourishing me in ways large and small, for pushing me to think through and beyond,

for his adventurous spirit, and for his own unruly and brilliant vision. This book is for him.

Portions of chapters 1 and 4 appeared in a different form in the following essays: "Queer Regions: Locating Lesbians in *Sancharram*," in *The Black-well Companion to LGBT Studies*, ed. Molly McGarry and George Haggerty (Malden, MA: Blackwell, 2008): 341–355; "Archive, Affect, and the Every-day: Queer Diasporic Re-Visions," in *Political Emotions*, ed. Ann Cvetkovich et al. (New York: Routledge, 2010); "Who's Your Daddy? Queer Diasporic Reframings of the Region," in *The Sun Never Sets: South Asian Migrants in an Age of US Power*, ed. Vivek Bald et al. (New York: NYU Press, 2013): 274–300; and "Queer Visual Excavations: Akram Zaatari, Hashem El Madani, and the Reframing of History in Lebanon," *Journal of Middle East Women's Studies* 13, no. 2 (2017): 326–336. I thank Vivek Bald, Miabi Chatterjee, Ann Cvetkovich, Banu Gokariksel, Frances Hasso, Molly McGarry, and Manu Vimalassery, for their astute editing of my work; I have incorporated many of their comments and suggestions into these pages.

Archive, Region, Affect, Aesthetics

The image stopped me in my tracks. "I know you," I thought as I gazed at the black-and-white photograph from the early 1950s. Identified in the caption simply as "Abed, a tailor," the subject in the photograph looks directly into the camera as he leans on his elbows with his hands folded gracefully under his chin. There was something in Abed's gaze — forthright, uncompromising, fierce — and the precise and delicate gesture of his hands framing his face, that evoked the femme aesthetic of the young queers of color I remember seeing on the Hudson River piers during my young adulthood in New York City in the early 1990s. With his finely chiseled face, perfectly arched eyebrows, and elaborately coiffed hair, Abed was to my contemporary gaze immediately recognizable as a gender-queer figure.

I first encountered this image while leafing through the 2004 coedited book *Hashem El Madani: Studio Practices*, by the Beirut-based Lebanese artist Akram Zaatari. El Madani is a studio photographer from Saida (Sidon), Zaatari's coastal hometown in southern Lebanon, and the book was created to coincide with the first exhibition of El Madani's work in the United Kingdom, cocurated by Zaatari at the Photographer's Gallery in London in 2004. El Madani opened his Studio Shehrazade in Saida in 1953, and over more than fifty years created hundreds of thousands of portraits of Saida's residents:

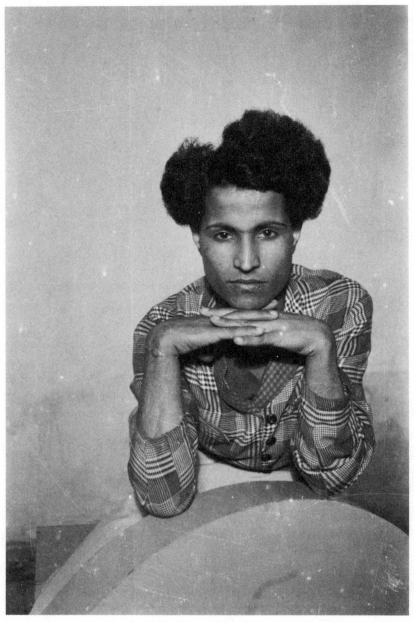

FIGURE INTRO.1 "Abed, a tailor. Madani's parents' home, the studio, 1948–53," from *Hashem El Madani: Studio Practices*, courtesy of Akram Zaatari and Arab Image Foundation.

brides and grooms, wrestlers and babies, resistance fighters and refugees. The portraits in *Hashem El Madani: Studio Practices* date from the early 1950s to the mid-1970s, and tell of everyday life and the self-representational practices in the mid-twentieth-century city. Zaatari's fascination with El Madani's work stems from his general interest in the making of modernity in Lebanon, and specifically in the role of image-making practices such as studio photography. But of special interest to Zaatari is El Madani as a chronicler of everyday life in south Lebanon per se, a region rendered "other" in relation to the larger Lebanese nation by successive waves of war and Israeli occupation between 1978 and 2000.[1]

In *Hashem El Madani: Studio Practices*, Zaatari in his dual role as artist and curator reproduces and organizes specific images from El Madani's vast collection that he finds especially significant and moving. Of the thousands of negatives in El Madani's collection, a striking number of the images reprinted by Zaatari suggest some version of gender nonconformity or same-sex eroticism. This includes the photograph of "Abed, a tailor" that I found so arresting, and whom El Madani matter-of-factly notes was "effeminate."[2] Despite my initial, visceral sense of familiarity upon encountering this image in El Madani's reconstituted archive, the longer I gazed at it the further it receded. Given that a photograph can never act as a transparent or unmediated visual record of the past, the image of "Abed, a tailor" cannot tell me who Abed "really" was, who or how he desired, or what his gender embodiment definitively meant to him or those around him. Rather, as my own initial shock of (mis)recognition suggests, Zaatari's re-presentation of El Madani's images activates transtemporal relays of affective relationality between the subjects in the photographs, Zaatari, and other contemporary viewers (such as myself) that produce new meanings for these images as they circulate in the present.

I discuss Zaatari's work at length in chapter 4, but I open with this image, and my initial response to it, because it exemplifies the interrelation of archive, region, affect, and aesthetics that is my central concern in *Unruly Visions*.[3] Zaatari's reading of El Madani's archive, and the reordering and reframing of the images he finds there, stand as a model for the queer curatorial practice I offer here; indeed there are multiple layers of queer curation at play in this book. Zaatari curates El Madani's images to do a specific kind of work: in Zaatari's hands, El Madani's images "perform new histories," as he himself puts it.[4] He uses them to tell an alternative history of the Lebanese nation in a minor key, so to speak, through foregrounding the queer desires and embodiments that suffused everyday life in mid-twentieth-century Saida.

In turn, I situate Zaatari's images alongside the work of other artists to do a different kind of work, and in this sense *Unruly Visions* stands as my own act of queer curation. As scholars/curators Erica Lehrer and Cynthia E. Milton point out, the root meaning of the word "curate" is "caring for": this connection between "curation" and "caring for," they contend, demands that we think of curation "not only as selection, design, and interpretation, but as care-taking—as a kind of intimate, intersubjective, interrelational obligation," an obligation to "*deal with* the past" in particular.[5] The notion of curation not only as "repositioning" and "re-arrangement,"[6] but also as a mode of "intersubjective, interrelational obligation" to engaging the past, resonates deeply with my own sense of *Unruly Visions* as a queer curatorial project.[7] I want to suggest that the "caring for" the past that is at the root of curation can take the form of carefully attending to aesthetic practices through writing: the critical analysis of art objects/aesthetic practices by placing them in relation to one another can function as a mode of queer curation. To "care for" is also to "care about"; thus the project of queer curation, as I understand it, is the obligation to impart that "caring about" to others. Queer scholars have powerfully demonstrated the ways in which queer art, scholarship, and activism have always evinced a sense of obligation to document, analyze, archive, and value the small, the inconsequential, and the ephemeral, so much of which make up the messy beauty and drama of queer life-worlds.[8] My own project of queer curation in these pages is similarly engaged with valuing that which has been deemed without value, but, even more importantly, it deliberately stages "collisions and encounters" between aesthetic practices that may seem discontinuous or unrelated.[9] My queer curatorial practice entails an obligation to "care for" and "care about" the connections between these texts and, crucially, to make apparent why these connections matter and what they tell us about our imbricated pasts and futures. As such, *Unruly Visions* is an act of queer curation that seeks to reveal not coevalness or sameness but rather the co-implication and radical relationality of seemingly disparate racial formations, geographies, temporalities, and colonial and postcolonial histories of displacement and dwelling.

My process of selection is driven both by my personal friendship and political networks, as well as by happenstance: some of the artists I write about are known to me through the queer and/or progressive South Asian activist circles we share, while others are established figures who circulate widely in global art markets, and whose work I came across in galleries, exhibitions, museums, and film festivals. My own access to these works speaks to the un-

even circuits of production, distribution, exhibition, and reception through which they travel. I seek to call attention to the relatively obscure work and defamiliarize the more established work by placing them in relation to one another, in juxtapositions that may seem surprising given their apparently dissimilar formal and thematic concerns. My goal is to arrange and reposition these works so as to identify a shared queer visual aesthetic that mobilizes new ways of seeing both regions and archives, and that puts into play, through an affective register, an intimate relation between the two.

As I hope will become evident in the pages that follow, queer visual aesthetic practices function simultaneously as archival practices that suggest alternative understandings of time, space, and relationality that are obscured within dominant history. But, as Zaatari's reanimation of El Madani's portraits makes clear, queer visual aesthetic practices also transform regional archives into queer archives: they bring into the field of vision the memory of quotidian forms of queerness and gender nonconformity that mark the space of the region, as defined both supranationally and subnationally. Such practices thereby conjure forth what I term "a queer regional imaginary," which I discuss in chapter 1, that stands in contradistinction to a dominant national imaginary that effaces nonconforming bodies, desires, and affiliations. My turn to the region in *Unruly Visions* as a fruitful concept for both queer and diaspora studies stems from my dissatisfaction with standard formulations of diaspora that inevitably foreground the nation as the primary point of reference, as well as with standard formulations of queerness that fail to grasp the texture of regionally inflected gender and sexual formations.[10] In the aesthetic practices that I consider in this book, the evocation of a queer regional imaginary suggests the possibility of tracing lines of connection and commonality, a kind of South-South relationality, between seemingly discrete regional spaces that in fact bypass the nation.[11] Thus, to foreground the category of the region in queer diaspora studies, as I do here, is to produce a new mapping of space and sexuality; this alternative cartography rejects dominant cartographies that either privilege the nation-state or cast into shadow all those spaces, and gender and sexual formations, deemed without value within the map of global capital.

While much of the work under discussion in *Unruly Visions* explores the contours of a queer regional imaginary that mobilizes the concept of the region in its subnational sense, other work in these pages simultaneously explores supranational framings of the region. For instance, Zaatari's experimental documentary *This Day* (2003) referenced in chapter 4 calls into ques-

tion the production of the "Middle East" as a knowable and mappable entity. Similarly, Delhi-based artist Sheba Chhachhi's installation *Winged Pilgrims* (2007), which I analyze in chapter 1, disrupts area studies framings of "Asia" as a region by mapping older histories of encounter and exchange that predate European colonialism and entirely provincialize the global North.[12] As such, much of the work I consider in *Unruly Visions* represents a queer incursion into area studies, where a queer regional imaginary in its supranational sense instantiates alternative cartographies and spatial logics that allow for other histories of global affiliation and affinity to emerge.[13] In this sense, my book is aligned with the rich body of scholarship that maps lines of interregional and transnational influence and confluence between and among colonized peoples that transcend a colonial cartographic imagination.[14] The queer visual aesthetic practices that are the focus of *Unruly Visions* both enable and deploy a queer cartographic imagination, which brings into the field of vision precisely those bodies, desires, and modes of affiliation that are elided within dominant colonial—or, indeed, postcolonial nationalist—cartographies.

I understand these queer visual aesthetic practices, through which a queer regional imaginary takes shape, more precisely, as "the aesthetic practices of queer diaspora." These practices negotiate diasporic movement in multiple geographic locations, and suggest other ways of being in and moving through these spaces that deviate from the straight lines of hetero- and homonormative scripts that typically determine one's life trajectory.[15] My conceptualization of "queer diaspora," which is the formation out of which these aesthetic practices emerge, draws on my previous work in *Impossible Desires: Queer Diasporas and South Asian Public Cultures*. There, I theorize queer diaspora as both a spatial and a temporal category: spatial in that it challenges the heteronormative and patrilineal underpinnings of conventional articulations of diaspora and nation, and temporal in that it reorients the traditionally backward glance of conventional articulations of diaspora, often predicated on a desire for a return to lost origins.[16] One of my central arguments in *Impossible Desires* was that queer diaspora provides us with an alternative model of visuality, in that it allows us to see those forms of sexual subjectivity, desire, and relationality rendered invisible and unintelligible within conventional mappings of diaspora and nation, as well as within dominant Euro-American articulations of queerness.[17]

Unruly Visions elaborates upon this alternative model of visuality, which a queer and feminist reformulation of diaspora brings into being, by turning our attention to "minor" sites and locations of queer possibility (such as the

region). My focus is specifically on aesthetic practices that engage the visual register, and that constitute, and are constituted by, the historical and epistemic formation of queer diaspora. While the aesthetic practices of queer diaspora may take any number of forms—literature, performance, music—in this book I specifically emphasize visuality because of its centrality to the workings of colonial modernity and its afterlives.[18] Imperial, settler colonial, and racial regimes of power work through spatial practices that order bodies and landscapes in precise ways; these regimes of power also instantiate regimes of vision that determine what we see, how we see, and how we are seen.[19] The legitimacy and authority to rule and regulate particular populations has been inextricably linked to the concomitant power to visually survey these populations and the landscapes they inhabit. The targets of this surveilling gaze are consigned simultaneously to both hypervisibility and invisibility.[20] An abiding legacy of colonial modernity is its institution of a way of seeing, and hence knowing, that obscures the interrelation of imperial, racial, and settler colonial projects as they produce racial, gendered, and sexual subjectivities.

Thus, as part of a first generation of scholars working on queer diaspora,[21] *Unruly Visions* is my attempt to foreground new directions in the field. Tracing the interrelation between region, archive, and affect through the aesthetic allows queer diaspora studies to engage with bodies of knowledge that have only tangentially entered its purview, and to bridge divides between disciplinary and area studies. A careful tending to (and attention to) the aesthetic—and to queer visual aesthetic practices in particular—enables and demands that connections be made between fields of thought, geographic areas, and temporalities that would otherwise not be grasped readily through standard disciplinary approaches. *Unruly Visions* argues that it is in the realm of the aesthetic that we can excavate these submerged, comingled histories and become attuned to their continuing resonance in the present as they echo across both bodies and landscapes. Through a sustained engagement with queer visual aesthetic practices, we can identify alternative ways of seeing and knowing capable of challenging the scopic and sensorial regimes of colonial modernity in their current forms. The aesthetic practices of queer diaspora, in other words, disrupt the normative ways of seeing and knowing that have been so central to the production, containment, and disciplining of sexual, racial, and gendered bodies; they do so, crucially, through a particular deployment of queer desire and identification that renders apparent the promiscuous intimacies of our past histories as they continue to structure our everyday present, and determine our futures.

These aesthetic practices enact an excavation of the past through a queer optic, which allows us to apprehend bodies, desires, and affiliations rendered lost or unthinkable within normative history. This queer excavation of the past does not seek to identify or mourn lost origins; nor do queer visual aesthetic practices necessarily aim at visibility or coherence. Instead, the queer optic instantiated by these practices brings into focus and into the realm of the present the energy of those nonnormative desires, practices, bodies, and affiliations concealed within dominant historical narratives. The aesthetic practices of queer diaspora evoke history without a capital H, one that is ingrained in small acts and everyday gestures that play out not on the stage of the nation but in the space of the region. These minor histories can be carefully extracted from informal archives made up of discarded or devalued objects, and in haptic journeys through dust, dirt, and detritus. The aesthetic practices of queer diaspora conjure these minor histories into being and make them apparent. Their value lies in their ability to demand that we look beyond the main event and instead become attuned to submerged and forgotten modes of longing, desire, affiliation, and embodiment that may in fact allow us to envision an alternative present and future. As such, these aesthetic practices enact a queer mode of critique that demands a retraining of our vision and a reattunement of our senses, and in so doing point to the limits of the entire apparatus of vision that is the inheritance of colonial modernity.

The aesthetic practices of queer diaspora are clearly the product of the "intimacies of four continents," as Lisa Lowe phrases it, in the sense that they emerge out of, and respond to, the legacies of the colonial labor relations that tie Europe, Africa, Asia, and the Americas to each other; such legacies include the dispossession of indigenous peoples, postcolonial nationalisms, and the diasporas of racialized, migrant labor.[22] I argue that these aesthetic practices transform "the scales and timetables of intimacy"[23] that were enjoined under colonial or imperial regimes, and that are often resuscitated in contemporary nationalist, postcolonial, or diasporic contexts. For instance, as I discuss in the chapters that follow, the reconstituted family photographs of artists Chitra Ganesh and Allan deSouza, or Tracey Moffatt's collages and photographs of the sites of her childhood, lay bare the ways in which "home" spaces—whether the South Asian immigrant household or the Australian Aboriginal "settlement"—function as dense zones of sexual/gender/racial regulation under contemporary iterations of empire and colonialism. I understand "intimacy," then, to reference the micropolitical spaces of the body, the family, and the domestic as key spaces where power under successive colonial and

nationalist regimes is consolidated, as well as the spaces where the colonial (or postcolonial) "order of things" may be disrupted and fractured.[24] But I also use the term "intimacy" more broadly, to reference the forms of affiliation and affinity, encounter and crossing, not only between bodies but also between histories, spaces, and temporalities. The aesthetic practices of queer diaspora, in other words, both make apparent and instantiate the intimacy of fields of thought, historical formations, geographic areas, and temporal frames conventionally viewed as discrete and distinct.[25]

Queer desire, identification, and affiliation are central to apprehending this indiscreteness of multiple histories, spaces, and temporalities. If these aesthetic practices bring to the fore those shadow histories, subjectivities, and desires that are occluded in dominant history, queerness is the conduit through which to access the shadow spaces of the past and bring them into the frame of the present. It is through the backward glances of Akram Zaatari's queer curation of El Madani's portraits (chapter 4), or David Kalal's queering of the late nineteenth-century oil paintings of the South Indian painter Raja Ravi Varma (chapter 1), or the queer genealogies traced by Chitra Ganesh (chapter 2) and Allan deSouza (chapter 4) via their family photographs, or through Tracey Moffatt's reframing of the scenes and sites of her childhood (chapter 3), that we can glean the queer modes of affiliation, desire, and embodiment that suggest alternative possibilities of organizing social relations in the present.[26] The queerness of the archive in these works rests not only in the fact that it acts as a record of queer desires, embodiments, and affiliations that connect different temporal moments, but that it revalues that which is seen as without value: the regional, the personal, the affective, the everyday. From Chitra Ganesh and Mariam Ghani's creation of a "warm database" that collects information on post-9/11 South Asian and Arab Muslim male detainees that has meaning to the detainees themselves rather than to the U.S. surveillance state, to Allan deSouza's use of the dead matter of his own body in his queer reframing of postcolonial Kenyan nationalism, to Sheba Chhachhi's repurposing of cheap Chinese-made "plasma TV toys" to tell the history of precolonial Asian cosmopolitanisms, the artists I discuss in *Unruly Visions* amass and curate queer archives out of precisely those objects that are deemed insignificant, marginal, minor, tangential.[27] In so doing, they reveal, interrogate, and transform the ways in which hierarchies of value determine archival production in the first place.

The rubric offered by "the aesthetic practices of queer diaspora" allows me to group together seemingly unrelated objects of analysis not typically placed

in conversation. These works are heterogeneous in form as well as in the var-iegated histories and geographic locations they reference, and out of which they emerge. As I noted earlier, some are by well-established artists, and have garnered significant critical attention, while others are relatively "minor" texts, in that they have limited circulation and fall outside of traditional art-historical frames; still others are considered "minor" or anomalous works in a recognized artist's oeuvre. The rubric of "the aesthetic practices of queer diaspora" illuminates the unexpected convergences between these wide-ranging texts through several key interrelated concepts: the region, as both subnational and supranational space, and the production of alternative car-tographies; the personal and the autobiographical, and the impossibility of originary narratives of individual and collective selves; queer counterarchives and the reframing of history; the role of the ordinary and the everyday, the affective and the sensorial, in producing these alternative archives and car-tographies; the interrogation of the visual field and the limits of a politics of visibility and representation; queerness as an optic and reading practice that brings alternative modes of affiliation and relationality into focus. As this brief sketch of concepts central to *Unruly Visions* makes clear, I am very much in conversation with the important queer scholarship that has emerged in the past decade or so to powerfully rethink questions of time, space, affect, and ar-chive through a queer lens. Such work has been tremendously useful in under-scoring how queer spaces are more often than not marked by queer time, and the temporal and affective markings of all spatial categories.[28] Specifically, this work has made clear how the spatial categories of region, diaspora, and nation function simultaneously as temporal and affective categories.[29] For instance, as Valerie Rohy has argued, the region as subnational location is closely tied to notions of backwardness, anachronism, and abjection in relation to the larger nation-state.[30] As I discuss in chapter 1, contemporary artists such as David Kalal are able to exploit this temporal lag of the region in order to envision new logics of desire and affiliation across multiple times and spaces. *Unruly Visions* contributes to these collective, ongoing queer reformulations of time, space, affect, and archive by considering how the aesthetic practices of queer diaspora extend and transform our understandings of these concepts.

As I argue in the following chapter, a turn to the regional is quite often a turn to the personal and the autobiographical. Evocations of the region often take the form of deeply affective, personal explorations of regional be-longing or alienation. Both the regional and the personal/autobiographical, which emerge as central categories in the work of many of the artists I discuss

throughout this book, occupy a kind of minor, degraded status and are seen as mere "digressions" that detract from a focus on more legitimate objects of study (such as the nation or the global) or aesthetic forms (such as the novel).[31] The aesthetic practices of queer diaspora are archival practices that excavate and memorialize the minor histories (personal, familial, collective, regional) that stand outside of official nation-centered narratives. The connection between region, affect, archive, and autobiography is particularly apparent in much of the photography-based work I discuss in this book. Photography, of course, has always been a profoundly affective medium, and one cannot afford to deny the centrality of affect in producing the meaning of a photograph.[32] Photography's mobilization of affect is particularly clear in Zaatari's work (chapter 4), as well as that of visual artists Chitra Ganesh (chapter 2), Allan deSouza (chapter 4), and, to a certain extent, Tracey Moffatt (chapter 3), all of whom work with and through the genre of the family photograph and its foregrounding of the personal and the everyday to create deeply affective counter-archives of regional (un)belonging. These alternative archives produce forms of queer desire and identification across multiple temporalities, and narrate the construction of queer selfhood and queer genealogies in nonteleological terms; indeed, the modes of queer memoir and memorialization that emerge in the work of these artists soundly reject notions of origin and authenticity. Significantly, in a number of the most clearly autobiographical texts I consider in this book, such as Saidiya Hartman's memoir *Lose Your Mother* (chapter 4), Allan deSouza's *The Lost Pictures* (chapter 4), and Chitra Ganesh's *13 Photos* (chapter 2), the figure of the mother—typically connoting the origins of a self in racial, national, gendered, and sexual terms—is both foregrounded and irretrievably lost. This loss of origins is coterminous with the limits and failures of the visual field and its strategies of self-representation and reclamation. Thus the turn to the autobiographical and the personal on the part of the artists I discuss here does not function to enshrine a model of autonomous selfhood in liberal humanist terms. In the work of Hartman, deSouza, and Ganesh, this lost or receding figure of the mother becomes an occasion not for the recuperation of a narrative of an authentic self, but rather for the creation of alternative, queer forms of memoir and memorialization. The work of these artists evinces an imaginative reconstruction of personal and collective genealogies that rejects both origin stories and the truth claims of the visual, and that instead animates a multisensorial and affective relation to visuality.

My own queer reading and curatorial practice deliberately places in the same frame very disparate aesthetic genres, from photography (the work of Allan

deSouza, Chitra Ganesh, David Kalal, Tracey Moffatt, Seher Shah, Akram Zaatari); to narrative feature film (Aurora Guerrero's *Mosquita y Mari* and Ligy Pullappally's *The Journey*); to installation and web-based work (Sheba Chhachhi, Chitra Ganesh and Mariam Ghani); to watercolor painting (Chitra Ganesh, Tracey Moffatt); and to poetry and literary non-fiction (Agha Shahid Ali and Saidiya Hartman). These formally distinct works are united by their attention to the limits and possibilities of the visual: while most of the work I write about functions within a visual medium, visuality itself and the practice of looking are insistently interrogated (even in the literary texts I consider) and their inevitable failures are foregrounded so as to point to alternative sensorial regimes—touch, smell, sound, taste—through which historical memory is evoked. The aesthetic practices of queer diaspora are finely attuned to the violences of the visual field and its centrality to the workings of colonial modernity. They therefore work within the visual field in order to point to that which exceeds the visual, and which the visual field cannot accommodate. They gesture to realms outside and beyond it, suggesting instead the sensorial and the affective as alternative modes and conduits for apprehending the intertwined nature of seemingly discrete historical formations. They allow us not only to see, but also to sense, the proximity of these histories and their contemporary instantiations. In other words, the aesthetic practices of queer diaspora enact an intimate relation between the visual, the affective, and the sensorial: the visual serves as a portal to other senses and affects, and the alternative modes of knowing and accessing the past they make available. The aesthetic practices of queer diaspora thereby open the way to a different apprehension of time and space, history and memory, that counters those instantiated by colonial modernity and its legacies.

Moreover, while many of the artists I write about can be understood as having some relation to South Asia and/or the South Asian diaspora, I consciously place their work alongside and in conversation with that of artists who engage other diasporic histories so as to map the lines of convergence between them. In chapter 2, for example, I juxtapose the photography of South Asian American artist Chitra Ganesh with Aurora Guerrero's independent feature film *Mosquita y Mari*, a queer Latina coming-of-age story. I do so in order to trace the ways in which each work mobilizes notions of the region through a queer diasporic lens, and, in the process, reshuffles the temporality of conventional narratives of success and upward mobility so central to both South Asian and Latinx immigrant formations. Similarly, in chapter 3, by setting the work of South Asian diasporic artists Seher Shah and Allan deSouza in rela-

tion to that of Tracey Moffatt, which deeply engages the history of Aboriginal dispossession in Australia, I work against fixed notions of both diaspora and indigeneity that would situate these two categories in implacable opposition to one another. And my final chapter spans African, Middle Eastern, and South Asian diasporic histories as it situates Saidiya Hartman's memoir, *Lose Your Mother*, next to the visual art and installations of Allan deSouza, Akram Zaatari, and a collaborative project by Chitra Ganesh and Mariam Ghani.

The concept of diaspora has typically been deployed to connote the dispersal of populations from one particular national or geographic location to multiple other sites in such a way that produces a transnational web of affiliation and affect. Therefore, understanding the work of artists such as Tracey Moffatt or Akram Zaatari (both of whom have been primarily based in their so-called countries of origin) as diasporic demands that we rethink the parameters of the term to account for the movements and dispersals that happen within, rather than simply across, dominant nation-state boundaries, and how their work engages with and interrogates those movements. Moffatt's work, for instance, as I argue in chapter 3, requires us to see diaspora and indigeneity as co-constitutive categories, rather than as antithetical, as these categories are often understood. For Moffatt, what it means to be diasporic is inextricable from indigeneity and the experience of settler colonial dispossession; likewise, what it means to be indigenous is, for her, inextricable from the experience of diasporic displacement. Similarly, in my reading of Zaatari's work, I find the concept of diaspora useful to signal the displacements and dispersals that occur within the space of the dominant nation-state itself, when subject to the vagaries of war and occupation that precipitate the constant shifting of borders — displacements and dispersals that are both material and metaphoric. Zaatari, for instance, chose to return to Lebanon after spending periods of time in the U.S. and Europe. Hence his connection to the region is marked by a paradoxical sense of distance and alienation; his diasporic sensibility is predicated not so much on geographic remoteness as it is on psychic and temporal remove. Situating the art of Moffatt and Zaatari as diasporic, therefore, does the important work of reframing the nation-state itself as "diaspora space":[33] a zone constituted by ongoing histories of settler colonial violence, war, and occupation, and shot through with the migrant trajectories, socialities, and affiliations that these histories engender. This more capacious understanding of diaspora places in tandem the displacements wrought by settler colonial occupation with those wrought by military occupation, even as the displaced ostensibly remain within the boundaries of the dominant nation-state.

Just as I stretch the category of diaspora to encompass movements and formations that may not seem to reside comfortably within its rubric, so, too, do I stretch the notion of "queer" in perhaps unexpected directions. In the work of all the artists I discuss in these pages, queerness functions as an optic through which to engage past histories and be attuned to the way these histories continue to imprint the present. This queer optic reanimates the nonnormative desires, practices, embodiments, and affiliations that can be gleaned from the past; it brings them into the present in order to envision other possibilities of social life. Indeed the queerness of the work under discussion in *Unruly Visions* resides in multiple sources. First, the work itself produces a certain way of seeing that I am calling queer: this alternative vision brings to the fore the unruly embodiments and desires buried within dominant historical narratives, and also makes apparent the intimacies and afterlives of apparently discrete historical processes. Second, the queerness of the work derives from a specific spectatorial dynamic between the artist and the historical archive. For example, as I discuss in chapter 4, it is Zaatari's own erotic relation to El Madani's images that brings their queer valences to the fore. And, finally, the work's queerness is predicated on the particular affective investments of each of us as viewers; as my initial response to the image of "Abed, a tailor" demonstrates, we each come to the work with our own situated spectatorial gaze.

In short, queerness functions throughout *Unruly Visions* as a mode of reading through which we can apprehend the intimacy of multiple historical formations (racialization, diaspora, indigeneity, colonialism); bodies of knowledge (diaspora studies, indigenous studies, queer studies, area studies); geographical locations (regions, nations, diasporas); and temporalities (past, present, future). But I also deploy queerness in the book in a more straightforward sense, to foreground the workings of nonheteronormative desires, sexual practices, identifications, and embodiments, and to name two interrelated processes: first, the modes of gendered and sexual subjectification through which racialized and colonized populations are produced as nonnormative, perverse, and deviant; and, second, the imaginative, creative, and vibrant ways in which gender and sexual nonnormativity is expressed, inhabited, and embodied so as to challenge and contest the very terms upon which these subjectifications are produced.

Significantly, much of the artwork I consider here pictures seemingly depopulated landscapes or built environments devoid of living beings, whether these are the deceptively innocuous housing structures of an indigenous Australian "settlement" or the eerie nightscapes of the Australian outback in

Tracey Moffatt's photographic series *Spirit Landscapes*; Seher Shah's photographs of the U.S. Southwest, where empty stretches of sky and highway are interrupted only by what she terms "hinterland structures" such as trailers or surveillance towers; or Chitra Ganesh's reconstituted family photographs in *13 Photos*, which documents her parents' honeymoon in the early 1970s, and where the tiny blurred figure of her mother is dwarfed by the vast mountainous landscape of what may or may not be Kashmir. The status of the body in these works ranges from the barely discernible (Ganesh's *13 Photos*) to its complete disappearance (Shah's *Hinterland Structures*), to its reappearance in the realm of the immaterial and the haptic (Moffatt's *Spirit Landscapes*). These representations of apparently empty, disembodied landscapes may at first appear to be far removed from the questions of nonnormative desire and embodiment that typically concern queer studies. Furthermore, such representations may initially appear to reproduce the logic and aesthetic of "emptied space."[34] This logic is central to the racial, gendered, and sexualized mechanisms of American empire, but it also undergirds other nation-building projects, such as settler colonialism in Australia and, to a certain extent, India's claim to the region of Kashmir.[35] However, the aesthetic practices of queer diaspora demand that we read these seemingly disembodied landscapes through a queer optic that brings into focus the bodies of the disappeared and the dispossessed.[36] This optic makes clear not only that these landscapes are in fact inescapably embodied, but also that these apparently disparate spaces are linked through distinct yet complementary projects of empire and occupation. Moreover, given that figurative representations of the body for minoritarian and colonized subjects have been the site of profound violence in the realm of the visual, the disappearance of the body, and the imprint of its absence on the landscape, may be one strategy of contesting this long and ongoing history of representational violence.

Zaatari has commented that he "considers Earth to be the ultimate archive, the ultimate recording,"[37] and certainly landscapes, as envisioned by the artists I discuss in this book, are hardly "neutral representations of nature,"[38] as one tradition of art historical criticism would have it. Rather, they tell the story of how colonial and racial power is violently consolidated through the gendered and sexual regulation of bodies in space (through spatial practices of containment, segregation, and dislocation), and how the dispossessed powerfully contest these forms of regulation through alternative imaginings of emplacement, dwelling, and housing. The aesthetic practices of queer diaspora make apparent how all spaces of "home" and dwelling are shot through

with contradictions and fissures, that there is no going back, no return to an unsullied past, no secure space of safety. In light of this knowledge, these aesthetic practices reveal how those who are subjected to the violent legacies of colonial modernity contest this violence by finding imaginative and pleasurable ways to dwell in the wake of forced containment and forced mobility. They thus act as a resonant, alternative archive that records everyday forms of dwelling in the context of containment, displacement, and dispossession, and thereby offer a nuanced sense of the relation between staying and leaving, immobility and mobility, home and exile, dwelling and removal, indigeneity and diaspora, that refuses to privilege one of these terms over the other, but always attends to their co-constitutive nature.

The aesthetic practices of queer diaspora, then, allow us to see and sense the intertwined nature of various bodies of knowledge, racial formations, and historical experiences of displacement and dispossession, as well as of housing and dwelling, that are otherwise obscured. As I suggested at the outset of this chapter, it is in the realm of the aesthetic that new forms of relationality and affiliation can be apprehended. But I also emphasize that the aesthetic *enacts*, *produces*, and *performs* these affinities and affiliations rather than simply rendering them apparent.[39] Throughout *Unruly Visions* I stress that these are aesthetic *practices*, not just aesthetic forms, because they do things in the world: they shift our field of vision so that alternative possibilities, landscapes, and geographies come into view.[40] First, as I have been suggesting, they enact a practice of reading, one that both produces and renders apparent new modes of affiliation, relationality, and connection between bodies, times, spaces, objects of study, and fields of thought that have heretofore been kept distinct and discrete. This practice teaches us how to read dominant archives through the minor, and for their gaps, slippages, and erasures; to do so is to engage in the practice of emplacing ourselves and others in those narratives of the past that are occluded within dominant nationalist or even diasporic ideologies. Second, the aesthetic practices of queer diaspora produce alternative archives by demanding we pay close attention to the regional, the everyday, the personal, and the discarded that typically fall outside the purview of official archives. They thereby rearrange the hierarchies of value so central to canonical notions of both the archive and the aesthetic. Third, these aesthetic practices disorient and reorient us; they unsettle normative temporalities by pointing to alternative pathways and routes through the past and to the future that bypass the familiar touchstones of hetero- and homonormative life histories. In so doing, they emplace us in a state of productive suspension, as

I argue in my reading of Aurora Guerrero's feature film *Mosquita y Mari* in chapter 2.

Given that the aesthetic practices of queer diaspora negotiate the ongoing, often traumatic histories of forced mobility and immobility, dislocation and relocation, it is no surprise that an artist such as Akram Zaatari utilizes the metaphor of suspension to name the state of being situated, as he puts it, "somewhere between a violent present and a desired for life of peace and prosperity—seemingly impossible given the continuing injustices of this world, particularly in the Middle East."[41] Clearly, being relegated to a state of suspension or disorientation can very well be the effect of dominant regimes of power. One need only think of the testimonies of undocumented youth in the U.S. that I mention in chapter 2, who use the language of stuckness and "being in limbo" to describe their experience of living without papers, or the example of a stateless Bedouin man whom Zaatari encounters in his experimental documentary *This Day*, which I write about in chapter 4, suspended as he is between two states and claimed by neither. But the aesthetic practices of queer diaspora transform the states of disorientation and suspension that are the by-product of dominant constructions of national and communal (un)belonging into forms of disorientation and suspension that are potentially disruptive and productive. Being suspended need not be the same as being trapped or in perpetual stasis; rather, it may be a temporary temporal and spatial respite from the relentless forward momentum of "conventional good life fantasies," to cite Lauren Berlant's apt phrase, or from demands to stay put or to relocate.[42] Suspension as both a spatial and temporal category, in other words, may allow for a momentary vantage point from which to envision an alternative to the here and now.

Finally, the aesthetic practices of queer diaspora descale and rescale geographies through their attention to both the personal and the regional. Questions of region as subnational and/or supranational space animate the work of Ligy Pullappally, David Kalal, Aurora Guerrero, Seher Shah, Chitra Ganesh, Sheba Chhachhi, Tracey Moffatt, Agha Shahid Ali, and Akram Zaatari. In their work, it is through the personal and the autobiographical that we grasp the contours of regional geographies that disturb and disrupt the inherited colonial and neocolonial cartographies keeping differently racialized bodies, as well as histories of displacement and dispossession, segregated and discrete. The personal and the autobiographical serve here not to prop up forms of bourgeois intimacy, with their insistent delineation of public and private spaces, but rather to reveal the violent effacements upon which

this delineation depends. As such, the aesthetic practices of queer diaspora create new cartographies that produce South-South, region-to-region, and diaspora-to-region connectivities that critique, subordinate, and at times bypass the nation-state.[43] These new multiscalar cartographies demand that we place in the same frame analyses of histories of settler colonialism, empire, military occupation, racialization, and diasporic dislocation, as they indelibly mark both bodies and landscapes. Ultimately, the aesthetic practices of queer diaspora are modes of emplacement: just as Akram Zaatari rearranges El Madani's photographs so that they "perform new histories," and just as my own act of queer curation seeks to juxtapose incommensurate texts in order to enable new ways of seeing the relation between archives, regions, and affect, the aesthetic practices of queer diaspora rearrange and emplace us, as viewers and readers, in a different relation to space and time, history and memory. They allow us to see, sense, and feel the promiscuous intimacies of multiple times and spaces. They bring into the realm of a "violent present" glimpses of past desires, longings, and articulations of alternative social and political worlds that provide the occasion for a different sense of possibility and horizon.

Queer Regions

Imagining Kerala from the Diaspora

I write these words from Saadiyat Island in Abu Dhabi,[1] the site of abiding controversy surrounding the labor conditions that went into the construction of several high-profile cultural institutions on the island, including the university where I work.[2] Thanks to the advocacy of activist organizations such as Human Rights Watch and the Gulf Labor Coalition, a fair amount of attention has been given to the often deplorable living and working conditions of the primarily South Asian male construction workers in Abu Dhabi who build the global outposts of elite cultural institutions in the area.[3] Less remarked upon are the messy, heterogeneous queer socialities that are created by working-class migrants in the shadow of the luxury buildings that dominate the Abu Dhabi skyline—the museums and college campuses, the high-end hotels and shopping malls—and constructed, maintained, and serviced with their labor.[4] Despite (or perhaps because of) the fact that homosexuality remains illegal in the United Arab Emirates, mundane locales in Abu Dhabi—its waterfront promenade and vegetable markets, its taxis and buses—also function for those in the know as sites of gay male cruising and queer sociality.[5] The largest percentage of the UAE's South Asian migrant population is Malayalam-speaking,[6] from the state of Kerala that runs along the southwest border of India; South Asian diasporic socialities in the

UAE and elsewhere are often structured precisely around such subnational regional/linguistic affiliations rather than simply around national affiliations.

I open with this evocation of the particular and peculiar landscape of Abu Dhabi—and, more specifically, of the modalities through which both queerness and Kerala take shape in Abu Dhabi—because it provides an especially striking instance of how queerness emerges in the space where conventional indices of spatial scale, such as region, nation, and diaspora, collide, collapse, and coalesce.[7] This chapter homes in on one of these indices, the region, and contends that it provides a valuable vantage point from which to view queerness differently, just as queerness provides a particularly valuable vantage point from which to view the region differently. By "region" here, I mean subnational spaces such as Kerala and Abu Dhabi, but also supranational regional spaces such as the Indian Ocean and its flows of traffic and travel which, over the course of centuries, have rendered proximate these and other apparently disparate geographic sites.[8] Indeed I find it useful to mine the plasticity of the term, which can reference both subnational and supranational formations simultaneously. And by "queerness" here, I reference not only nonnormative sexual practices, desires, affiliations, and gender embodiments, but also the alternative ways of seeing (and sensing) space, scale, and temporality made available by this collision of the regional and the diasporic. As such, my project is aligned with recent work that calls on queer studies to engage more deeply with the geopolitical, particularly with the spatial and epistemological concepts of the region and the area, along with the more frequently engaged concepts of diaspora and nation.[9] Thinking queerness through the region, and the region through queerness, demands that we understand a site such as Abu Dhabi as one of *intersecting queer regional diasporas*: here, migrants laboring under various conditions of duress create vibrant queer socialities—often structured around regional affiliations—that navigate the exigencies imposed upon them by multiple nation-states.[10] These social worlds may very well be contingent, temporary, and transitory, but they may also provide moments of queer intimacy, pleasure, and respite.[11] As I discuss further in the following chapter, such instances of queer world-making can easily be obscured if our critical lens is trained solely on the most obvious and recognizable forms through which political agency takes shape, such as labor actions and protests. Much of the popular and academic literature on migrant labor in the Gulf focuses on South Asian male "bachelor builders" and invariably presumes the existence of a heteropatriarchal family unit that these men are a part of and that they leave behind. While this may indeed be the case for many migrant

subjects, it nevertheless does not preclude the possibility that they may also be a part of queer social worlds, both regional and diasporic. In other words, I want to suggest that the "Gulf dreams" of many migrants may extend beyond limited heteronormative framings.[12] If working-class migrants are viewed as heterogeneous, desiring subjects rather than reductively defined simply through their labor, what other longings and forms of relationality come into view in the homosocial, regional, and diasporic spaces they inhabit?[13]

We can approach these questions by turning to the aesthetic practices of queer diaspora, for it is in the space of the aesthetic that we can apprehend the "warm data" of migrant sociality. "Warm data," as I discuss in chapter 4, is a term used by artists Chitra Ganesh and Mariam Ghani to refer to the realms of the sensorial and the affective that are effaced by the U.S. state's attempt to discursively and materially "fix" and locate the thousands of South Asian and Middle Eastern men detained after 9/11 as potential terrorist threats. In restoring to these detainees the "warm data" denied them by the state, Ganesh and Ghani turn the surveilling, scrutinizing gaze of the state back on itself. Ironically, some of the popular and scholarly accounts of low-wage migrant labor in the Gulf tend to replicate this homogenizing gaze, to the extent that they efface precisely the "warm data" of those they purportedly centralize.[14] Turning to the aesthetic counters the investment in normative, institutional modes of data collection, categorization, and classification that are apparent on the part of dominant state mechanisms as well as even some progressive scholarly and activist endeavors.

The aesthetic practices of queer diaspora are one site where the categories of queer, diaspora, and region collide, and where they are thereby transformed, undone, and remade. These aesthetic practices bypass the nation as they enact *a queer restaging of the region from the vantage point of diaspora*. In so doing, they disorganize not only conventional spatial scales, but also the temporal valences associated with these scales. The dominant temporal framings of the region in its subnational sense—as anachronistic, atavistic, and timeless—are both referenced and revised by the aesthetic practices of queer diaspora.[15] Both of the texts I consider in this chapter—Ligy Pullappally's 2004 film *Sancharram*, and the visual art of David Dasharat Kalal—situate the subnational region of Kerala as the locus and point of departure from which to imagine alternative logics of gender and sexuality, time and space. Both texts engage in a project of queer archiving, in that they memorialize these alternative logics; as such, they encapsulate the interplay of archive, region, affect, and aesthetics that concern me throughout this book.

Kerala serves as a particularly interesting case study through which to explore the nexus of queerness, region, nation, and diaspora, given both its complicated relation to the Indian nation writ large, and its long-standing imbrication within the global economy. While it is outside the scope of this chapter to give a thorough accounting of these histories of Kerala—in relation to Indian nationalism on the one hand, and to global influences on the other—it is necessary to at least acknowledge them here. The region has the potential to simultaneously disrupt and reinforce hegemonic state nationalist discourses; this becomes particularly clear when we look at how Kerala, at different historical moments, has been made representative of the Indian nation even as it was fixed as marginal and excentric to a nationalist project. The very framing of Kerala as a region replicates the logic of the Nehruvian nationalist project: modern-day Kerala came into existence in 1956, when the three different political units of Malabar, Kochi, and Tiruvitamkoor were merged into a single, linguistically defined state by the central government. The Kerala example makes very clear the ways in which the region is a temporally and spatially defined category, one that shifts meaning across both space and time.

In terms of its insertion within a global system of exchange of bodies, commodities, capital, and culture, modern-day Kerala bears the traces of extensive premodern trade routes with the Middle East, China, and Europe, and sits at the crossroads of Islamic, Jewish, Hindu, Buddhist, and Christian cultural influences. In the latter half of the twentieth century, Kerala rose to international prominence with the institution of a democratically elected communist government in 1957. One of the latest phases of Kerala's engagement with the global economy began during the oil boom in the 1970s, as thousands of skilled and semiskilled laborers sought employment in the Persian Gulf. Malayali migrants' remittances from the Gulf have dramatically shifted the local landscape of Kerala over the past four decades,[16] even as the influx of Malayali migrants has in turn transformed the landscape of Gulf cities.[17] Interestingly, the work of Pullappally and Kalal evokes not a thoroughly globalized present-day Kerala but rather an earlier, imagined history of the region (which, at least in Pullappally's case, wipes out this long history of immersion within a global economy); this imagined history provides the fodder for queer diasporic reimaginings of the region in the present. While the work of Pullappally and Kalal undoubtedly traffics in what we can term a regional nostalgia, it nevertheless allows us to parse out both the uses and the limits of viewing queerness from the vantage point of the region, and of viewing the region from the vantage point of queerness.

In this chapter, my focus on Kerala in particular as (imagined) region is also driven by more personal investments. My own family is from Kerala, and I spent the early years of my childhood in Ottapalam, a then-small town in central Kerala, and the site of my family home, Palat House. The house was built by my great-grandmother at the time of her marriage, in 1920; she deliberately designed it in a way that drew from traditional Kerala architectural styles but constituted a "modern" break from the structure of the *taravad* in which she herself had grown up.[18] For close to a century, Palat House has been the place where members of my family, far-flung throughout the diaspora, reconvene. The house remains standing today, albeit in a radically transformed state: much of the front yard is now replaced by a major road, while the house itself is half its former size. I still have a deep visceral connection to this place, and to Kerala in general, although it has never been "home" in any easy sense: my ability to speak Malayalam has slipped away from me, and I never spent a significant amount of time in Kerala as an adult. Nevertheless, my connection to India (the place of my birth) is made not primarily through a national identification, but through this regional connection to Kerala, however attenuated and fragile this connection may be. The centrality of the region as a deeply affective site within a queer diasporic imaginary remained unaddressed in my first book, *Impossible Desires*, which was for the most part focused on disrupting a nation-diaspora hierarchy; indeed, the region was not an operative category in the book. The genesis of this chapter—and *Unruly Visions* as a whole—lies in my desire to address this lacuna within *Impossible Desires*, and the field of queer diaspora studies more generally, as it has emerged in the past decade or so.

The question of regional nostalgia and my own fraught relation to Kerala was (quite literally) brought home to me when I attended at San Francisco's Castro Theatre a sold-out screening of *Sancharram*, the lesbian-themed independent feature film directed by the Chicago-based, South Asian diasporic filmmaker Ligy Pullappally. *Sancharram* first premiered in 2005 in both mainstream and queer film festivals in the U.S., and the screening I attended at the Castro was part of the San Francisco International LGBTQ Film Festival.[19] I had heard that *Sancharram* (translated as *The Journey* in English) depicted a burgeoning love affair between two schoolgirls growing up in a small town in rural Kerala. Not since Deepa Mehta's *Fire* (1996), released close to a decade earlier, had a feature film set within India dealt so explicitly with the theme of lesbian desire, and I was curious why *Sancharram*'s release in India hadn't garnered any of the controversy that *Fire*'s had; I was unconvinced that

the markedly different responses to each film—heated debate surrounding the latter, acclaim or benign indifference toward the former—could be explained solely by the different political climates of their respective historical moments.[20] Filmed entirely in Malayalam, *Sancharram* was (and, at the time of this writing, still is) the only queer Indian film not in English or Hindi, but in a regional language, to circulate transnationally in the international film festival circuit. As the lights dimmed, I felt a jolt of recognition: one of the first scenes opened with a montage of shots of an old Nair *taravad*. The distinctive architecture of the house's sloped tiled roofs, the solid teak pillars, hanging brass lamps, and walls replete with old family portraits brought to mind my own family home of Palat House, to which I would return during periodic trips to Kerala. As the camera lingered on these prototypical signifiers of "Kerala culture," I was fully conscious of how the film's framing of a "typical" Nair *taravad* was fixing "Kerala tradition" as timeless and unchanging, as well as rendering it synonymous with a particular elite (Hindu/Nair) caste and class status. Nevertheless, I could not deny that, as a diasporic viewer, these images also powerfully hailed me: there was something richly seductive about the reassuring if uncanny familiarity of this nostalgic representation of the region. As the camera panned across a landscape of lush forests and waterfalls, I became convinced that the film was set in Ottapalam, where Palat House is located; the final credits confirmed my suspicion. Yet while I instantly recognized *Sancharram*'s cinematic landscape, it also, curiously, disoriented me. Despite the fact that the film is meant to take place in the present, the Ottapalam I saw onscreen was nothing like the noisy, bustling, dusty town that exists today; rather, it depicted the far more tranquil, rural space I remember from my childhood. For me, the disjuncture of time and space enacted by the film both evoked and defamiliarized an intimate, familial landscape, particularly as I watched the lesbian narrative unfold in the Castro Theatre, surrounded by a, cheering, mostly white, queer San Francisco film festival audience. This viewing experience made me wonder about the ways in which diasporic representations of the region (in this case, Kerala), and its particular logics of gender and sexuality, are rendered pleasurable and intelligible within national and transnational circuits of reception and consumption, for diasporic and nondiasporic viewers alike.

Around the same time, an old friend and activist colleague, David Dasharath Kalal, shared with me a series of recently completed images that formed part of a larger digital art project entitled *Kalalabad*. Much like the work of contemporary U.S. artist Kehinde Wiley, which reappropriates and resignifies the

genre of Old Master portraiture by replacing its traditional subjects with heroic, homoerotic images of contemporary Black youth, Kalal's *Kalalabad* reimagines iconic Orientalist art historical landscapes by repopulating them with his own image and those of other contemporary queer diasporic South Asians in his hometown of New York City. One set of images in *Kalalabad*, entitled *RV RV: Ravi Varma Recreational Vehicle*, was particularly striking to me: here, Kalal digitally remakes the canonized oil paintings of the artist Raja Ravi Varma (1848–1906), who was born in present-day Kerala and is commonly termed the "father of modern Indian art" and of Indian portraiture in particular. Varma's work still circulates widely as mass-market lithographs and prints throughout India; cheap reproductions of his portraits of Indian women—many of which are of Kerala Nair women in particular—can be found in middle-class Indian homes in India and in the diaspora, and have come to serve as signifiers of iconic "Kerala culture." (The opening scenes of *Sancharram*, for instance, reveal the walls of the *taravad*'s dark interior to be adorned with several of Varma's paintings, or reproductions thereof.) Kalal's restaging of Varma's work transposes the late-nineteenth-century elite Nair women who are the usual subjects of Varma's portraits with images of contemporary queer diasporic South Asian women of specifically Nair descent. Kalal himself describes *RV RV* as "a series of iconic ironic objects and images that merge the relentlessly duplicated Ravi Varma paintings, prints and oleographs with contemporary diasporic portraiture."[21] One such image restages a typical Varma portrait from the late nineteenth century, entitled *Malabar Girl*, which depicts an elaborately dressed and coiffed Nair woman holding a veena as she sits in a plush, high-Victorian-era-style interior.[22] Kalal's remake transposes my own face onto the body of Varma's female figure; the background is transformed from a Victorian domestic interior to the red brick exterior of the building in New York City where I grew up. The image is meant to be humorous, and indeed it made me laugh out loud the first time I saw it; through its humor and parody, it raised for me important questions about this turn to a specific regional, caste- and class-inflected historical formation in the past in order to recast, as it were, contemporary queer diasporic identity in the present.[23]

THE PERSONAL AND THE REGIONAL

I reference my visceral responses to these queer diasporic representations of the region and my own (quite literal) location within their frames to underscore the fact that a turn to the region is, quite often, a turn to the personal

and autobiographical.[24] Engagements with the region, scholarly and otherwise, are often inextricably linked to the project of narrating the self, even as these engagements attempt to deconstruct an essentialist logic of identity, place, and belonging.[25]

Indeed, the cultural texts that concern me here bring to the fore the centrality of the personal and the autobiographical in a queer diasporic redeployment of the region. As I noted in the introduction, both the personal and the regional are generally seen as "digressions" from objects of study, narratives, or spatial categories deemed truly consequential. The aesthetic practices of queer diaspora dwell precisely in the digressions offered by mining both personal and regional histories, identifications, and affiliations: they constitute alternative byways that veer away from developmental and assimilationist narratives of both gay and national formation and instead lead us toward what we can term *a queer regional imaginary*. We can understand both the personal and the regional as minor forms of knowledge, and as sites that are marginal to larger historical narratives; they can thus serve as conduits for a different way of conceptualizing both space and time.[26] They function as alternative archives that allow us to apprehend the historical formations that have been cast into shadow by conventional historiography, as well as the imprints they leave on our bodies, desires, and psyches in the present.

Juxtaposing Pullappally's feature film to Kalal's multimedia, semiautobiographical work—two texts quite unlike one another in terms of form and genre, circulation and reception—makes apparent the uses and limits of queer diasporic evocations of the region in producing new temporal and spatial models of sexuality. While both Pullappally and Kalal evoke the region (Kerala specifically) as a fictive site of queer possibility, they do so to very different effects. Pullappally, unlike Kalal, has familial ties to the region—she was born in Kerala and left as a child—and her film to a large extent traffics in the production of authenticity and "local color." However, the fact that she had only a tenuous grasp of everyday life in contemporary Kerala at the time the filming commenced meant that she would rely deeply on the experience and aesthetic sensibility of her regionally based film crew to produce a vision of an "authentic" Kerala for a transnational film audience.[27] The film's diasporic imprimatur, in other words, is apparent precisely in its attempt to erase its tracks. In contrast, Kalal's evocation of Kerala, in his irreverent, collage-like works, eschews any claims to verisimilitude or regional authenticity; raised in the U.S. by an Irish mother and a Gujarati-Indian father, Kalal displays an affective relation to a region that is not "his own" in any traditional sense;

rather, this relation was nurtured through a specifically queer South Asian art/activist network in New York City, where he lived and worked for much of his life. As such, Kalal's "counter-hegemonic claims on regional space"[28] do not rely on blood-based genealogical ties but on an imagined, constructed, but nevertheless deeply felt affiliation to place that is forged in the diaspora. His work frames the region not as an originary locus of identity, but as a site of digression, where both personal and collective aesthetic and political genealogies productively cross-cut and disrupt the straight lines of dominant gay and nationalist formation. Taken together, Pullappally's *Sancharram* and Kalal's *Kalalabad* allow us to consider the diverse and contradictory effects and implications of a queer diasporic restaging of the region.

As my own personal narrative demonstrates, the region is clearly an affect-laden category, and the intimate connection between the personal and the regional can have both productive and reactionary effects. Claims to regional belonging, particularly when they originate from the diaspora, are often bound up in nostalgia for lost origins and class/caste privilege, a deeply felt sense of rootedness, a fierce identification with (or, conversely, a rejection of) place. Whether longed for or repudiated, desired or disavowed, diasporic evocations of the region may serve to buttress or undermine dominant narratives of national cohesion. As such, regional imaginings can easily be the basis for the most virulent forms of chauvinism, where regional identification serves as a kind of complement or counterpart to the diasporic nationalisms that in turn undergird religious, sectarian, or state nationalist ideologies.[29] For instance, within Indian diasporic communities in the U.S., one of the central ways in which diasporic Indian nationalism—and its attendant gender and sexual normativities—is expressed is by organizing around regional/linguistic/caste affiliations: dozens of organizations proudly claiming a regional identity are a major presence at New York City's India Day Parade, the annual celebration of Indian independence, and many of these diasporic organizations have significant material and political links to the region. Similarly, in the UAE, many community-based organizations serving the Indian diaspora are structured around regional affiliations that also appear heavily invested in upholding caste and class hierarchies, as well as gender and sexual normativity.[30] Claiming a regional identity can be completely in line, in other words, with both dominant diasporic and state nationalist discourses; at the same time, this claim can work against the nationalist project of the nation-state.[31]

Thus, while there is nothing *inherently* oppositional or reactionary about claims to the region, I want to explore the extent to which queer evocations

of the region from the place of diaspora—as is apparent in the work of Pullappally and Kalal— reiterate or transform conventional regional identifications with their invariable insistence on origins, purity, and authenticity, and their adherence to dominant sexual and gender ideologies. For many diasporic queers, the region as the "place where you're from" is an ambivalent site, where one's queerness is both formed and nurtured but also disciplined and repudiated. For queer people, the relation to the region can be a fraught one, where nostalgia for a place "left behind" is invariably tempered by a recognition of why it was left in the first place, and vice versa. The aesthetic practices of queer diaspora become the site where these ambivalent relations to the region are expressed and reworked; through these practices, we can identify an imaginative reframing of the region from the vantage point of diaspora, and the potentially oppositional, transformative uses to which the region can be put. The works of Pullappally and Kalal, as aesthetic practices of queer diaspora, evoke the specificities of Kerala's regional history to articulate new modes of sexual, racial, and gendered subjectivity in the diaspora; they compel us to decouple the diaspora from its usual referent, the nation, and to think instead in terms of diaspora-region, or region-to-region connectivities. This chapter attempts to think through the uses of the region in producing new forms of queer scholarship, and asks what a diaspora-region or region-to-region axis might offer queer studies. As such, it is broadly concerned with the relation between queer studies, diaspora studies, and area studies, and suggests the possibilities for a queer studies project that is rooted and routed in and through each of these fields. The notion of the region may be a way of troubling the boundaries and presumptions of these bodies of knowledge, and can offer us a particularly productive spatial metaphor to map sexual topographies in this transnational moment. This understanding of region is a heuristic device that allows us to see the "queer" of queer studies, the "diaspora" of diaspora studies, and the "area" of area studies in novel and unexpected ways.[32]

QUEERING THE REGION

Before exploring the contours of each visual text more closely, a brief gloss on the concept of the region may be helpful in order to ascertain to what extent it might serve as a useful category for queer purposes. The use of the region in both its sub- and supranational senses has gone in and out of favor at various moments in different disciplines, from economics to geography, political

science, literature, anthropology, and history.[33] Conventional models of area studies, of course, have from their inception been reliant on a notion of the region, and have tended to take supranational entities such as "South Asia" or subnational entities such as the "American South" as preconstituted, stable referents that are bounded, geographically circumscribed, and naturalized.[34] However, South Asian studies scholars in recent years have reanimated the concept of the region by understanding it as a relational category, shifting and mobile, rather than fixed or static.[35] These new articulations of the region push against nation-centered models of area studies by insisting on the contingent nature of the region and its interplay with different spatial scales: the local, the national, the transnational, and the global.[36]

The question of the region has also animated some of the most interesting work in recent U.S. area studies scholarship; indeed, reframings of the region in American studies resonate with similar reframings in South Asian studies, in that both projects stress not only the spatial but also the temporal valences of the term. This work points to the ways in which the region as a *spatial* category simultaneously animates notions of linear *temporality* and modernity, where the region is often figured as premodern and atavistic in relation to the modern nation. This temporal slippage is explored in a growing body of work that brings a queer lens to the study of the region;[37] such scholarship points to the instrumentality of the region for the nation, where the projection of sexual aberrance and deviance onto the former cements the region in both an anterior and exterior (or at least marginal) relation to the latter. As Valerie Rohy argues, the region is necessary for the nation to narrate itself in terms of a forward-looking futurity, even as it situates the region as behind nation time and outside of nation space.[38]

This queer scholarship extends the reconceptualization of the region that we see in recent work in area studies by foregrounding both regional sexualities and the queerness of the region itself.[39] Queer scholarship on the region emerging from both American studies and South Asian studies uses the space of the region as a way of decentering and destabilizing dominant nationalist narratives, and of foregrounding "other" narratives that tell entirely different stories of gender, sexuality, and nationalist subjectivity.[40] The alternative narratives that emerge from a regional rather than national frame are not static and self-enclosed, but rather are produced by the collision of the local, the national, and the transnational. As noted by the editors of a special issue of *GLQ* on "race, region and a queer Midwest," thinking with, through, and against the idea of the region means denaturalizing normative notions of space and

scale.[41] I use the term "queer regions" in its subnational sense, then, to name the particularities of gender and sexual logics in spaces that exist in a tangential relation to the nation, but are simultaneously and irreducibly marked by complex national and global processes. Framing queerness through the region, and the region through queerness, provides us with an alternative mapping of sexual geographies that links disparate transnational locations and allows new models of sexual subjectivity to come into focus.[42] Clearly, this kind of multisited project is a risky proposition which can easily fall into ahistoricity and a flattening out of the specificities of each location. Despite its dangers, however, these cross-regional analyses—focusing on diaspora-region, South-South, and region-to-region connectivities—are well worth taking on, in that they challenge us to think ambitiously about the future directions of both area studies and queer studies. In fact, I would suggest that this model of queer regional studies offers an important critique of conventional area studies and the balkanized forms of knowledge production that it encourages, even as it pushes queer studies outside of a Euro-American frame and towards a deep engagement with questions of globalization and diaspora.[43]

IMAGINING KERALA: LIGY PULLAPPALLY'S *SANCHARRAM*

Let us return, then, to Pullappally's 2004 film *Sancharram*, as it offers a telling illustration of both the limits and uses of thinking queerness and region together. The film's plot centers on the studious, writerly Kiran and the outgoing, flirtatious Delilah, two young women in a small rural town whose friendship begins in childhood, when Kiran's Hindu, Nair family moves next door to Delilah's Christian one. Kiran eventually realizes that she is in fact sexually attracted to Delilah, and is initially so disturbed by this realization that she agrees to help a neighboring male friend, Rajan, win Delilah's affections by writing love poems to Delilah that Rajan passes off as his own. This triangulated relation of passing and substitution comes to an abrupt end when Delilah discovers the charade, and, to Kiran's astonishment and joy, reciprocates Kiran's affections. Once both families find out about their romance, however, they push Delilah into an arranged marriage and Kiran to the brink of suicide. The film's ending shows Kiran standing precipitously on the edge of a waterfall, dressed in a plain white kurtha, the clothes of renunciation and mourning. Ultimately, she chooses not to kill herself, but instead to embark on her own "sancharram" or journey, presumably away from home and its oppressive gender and sexual ideologies.

FIGURE 1.1 Still from *The Journey* (*Sancharram*) (2004), courtesy of Wolfe Video, copyright Ligy Pullappally.

We can situate this film within multiple cinematic and ideological gene-alogies. On the one hand, *Sancharram* can be placed within the tradition of Malayalam cinema, a major regional film industry in India, with its own rep-resentational regimes of gender and sexuality that are at times at odds with those of popular Hindi cinema.[44] On the other hand, the film clearly follows a trajectory charted by South Asian feminist directors such as Mira Nair and Deepa Mehta, both of whom are based in the diaspora but whose films are set in India.[45] Pullappally's film parts ways with these other feminist diasporic in-vocations, in that her imagined India is neither urban nor North Indian (both Nair and Mehta set their films in metropolitan Delhi) but resolutely rural and South Indian. Juxtaposing *Sancharram* to these earlier films suggests the need to "provincialize" their urban, Hindi-speaking, North Indian contexts;[46] it underscores precisely the regional and particular nature of the diasporic rep-resentations of "India" that circulate transnationally and that ostensibly stand in for the nation writ large. Viewing the metropolitan context of *Fire* and *Monsoon Wedding* as, in fact, just as regionally inflected as *Sancharram* dis-lodges the universalizing tendency within Indian nationalist discourse that presumes the representative status of urban, Hindi-speaking North India.

More importantly for my purposes here is the way in which the film's rep-resentation of queer female desire and subjectivity functions quite clearly within a global human-rights-based framework; to that extent, it mirrors both the uses and limits of such a framework. Pullappally has stated that she created the film very much as an activist tool, to raise national and interna-tional awareness about the rash of double suicides of young women in Kerala

that garnered some Indian media attention in the 1990s and early 2000s.[47] This coverage was due in no small part to local queer activist organizations such as the Kerala-based sexual minority rights group Sahayatrika. Deepa V. N., the founder of the organization, documented over the course of eight years in Kerala at least twenty-four deaths of young women, all of whom appear to have taken their lives after being forced into marriages or to separate from their female lovers. Interestingly, at least some of these double suicides involved a gender-nonconforming partner, but neither Deepa V. N., in her appraisal of Sahayatrika's mission, nor Pullappally's film, as I will discuss, fully explores the gendered dimensions of these deaths.[48] While Deepa notes that many of those who contact Sahayatrika are in fact transgender, she still tends to privilege the rubric of "women-loving-women" to frame both the suicides as well as the work that Sahayatrika does more generally.[49] This subsumption of gender nonconformity under the generalized sign of "lesbian" on the part of an activist organization such as Sahayatrika is echoed in the film's fictionalized meditation on the suicides, and may be due to the way in which both Sayahatrika and *Sancharram* ultimately adhere to a global "LGBT" and feminist-rights-based discourse that fails to sufficiently trouble the category of "woman."

The various genealogies that converge in a text like *Sancharram* can only be traced through a queer diasporic frame, one that would allow us to read the multiple registers within which the film gains meaning: the local, the regional, the national, the diasporic, and the transnational.[50] What becomes apparent when considering the interrelation between these various registers is that the film is marked by transnational feminist and gay rights discourses even as it is rooted intensely in the regional. The film in effect supersedes a national frame; instead it interpellates a transnational lesbian and gay viewership in its framing of its heroines' struggle within these transnational discourses. *Sancharram* therefore allows us to consider the formation of a transnational lesbian/feminist subject through the use of a regional linguistic and aesthetic idiom. My purpose here is not to criticize either the film or activist organizations for their invocation of a Euro-American human-rights-based framing of queer sexuality; indisputably, bringing into national and international visibility the unmarked deaths of numerous young people due to the violence of heteronormativity is a necessary and laudable project. But, as Anna Tsing argues, the aspiration to the universal on the part of subaltern populations is a double-edged sword: "Universalism is implicated in *both* imperial schemes to control the world and liberatory mobilizations for justice and empower-

ment Universals beckon to elite and excluded alike."[51] In the same vein, Deepa V. N., founder of Sahayatrika, is herself well aware of the double-sided nature of rights discourse, but nevertheless argues that it is an effective strategy in the context of Kerala, "simply because it draws attention to notions of 'humanness' and personhood that are popularly, politically and legally denied to lesbians and other minorities."[52] Yet at the same time, as Tsing crucially reminds us, "teaching a language of universal rights can foreclose other trajectories."[53] It is precisely those trajectories both opened up and foreclosed by aspirations to the universal, as articulated in *Sancharram* in the form of a transnational feminist and gay rights discourse, that I seek to examine and interrogate here.

As is evident from the brief synopsis I provided earlier, the film quite seamlessly slots into a familiar telos of "global gayness," albeit with a lesbian rather than gay male subject at its center. Over the past two decades, many scholars working at the intersection of queer, postcolonial, and transnational feminist studies have critiqued rights-based discourses of a "global gay" subject as hinging on an identifiable "lesbian" or "gay" subject who leaves behind a space of gender/sexual oppression in order to emerge into a space of liberation and freedom; this emergence into an out, visible, public, gay or lesbian identity marks the subject's entry into modernity.[54] In the case of *Sancharram*, the film's ending implies that Kiran leaves behind the rural, the regional, the provincial, and the nonmetropolitan in order to enter not so much a modern *nationalist* subjectivity as a modern *transnational* lesbian subjectivity. Significantly, one of the film's final scenes shows Kiran holding clumps of the waist-length hair that she has just cut off, and letting the strands catch in the wind and flow into the water. We then see her as she walks away from the camera, her shoulder-length hair now stylishly coiffed. This scene brings together a global gay discourse with a liberal feminist discourse, in that it quite clearly signals Kiran's rebirth and renewal as a transnational *feminist* subject, as well as a lesbian one. In fact, the poem that Kiran writes to express her growing attraction for Delilah is entitled "The Awakening," an apparent reference to Kate Chopin's classic 1899 novel of feminist individuation which, of course, also ends in suicide. While Kiran becomes increasingly more masculine as the film progresses, particularly in relation to Delilah's sensuous femininity, this last scene pulls back from any hint of gender nonconformity and instead positions Kiran as a modern, metropolitan lesbian/feminist subject rather than as genderqueer. Here she emerges as the film's "authentic" lesbian/feminist subject, while Delilah, we can only presume, remains mired in the

deadening strictures of rurality, normative femininity, and heterosexuality. This ending makes clear why *Sancharram* is so readily intelligible to an international audience. The overwhelmingly queer, non-South Asian audience at the Castro Theatre, where I initially saw the film, was clearly enthralled by it, despite, or perhaps because of, the particularities of its rural Kerala setting and its evocations of Kerala "tradition" and custom. The film translates its regionalism for an international audience through its adherence to a standard metronormative narrative,[55] one that presupposes the freedom of the urban, the metropolitan, and the "West" as opposed to the backwardness of the rural, the nonmetropolitan, and the "non-West."[56] To an extent, then, the film allows itself to be read as depicting the tragic fates of protolesbians in the global South who have no recourse to liberatory discourses of "lesbian" identity in the global North.

The film's implicitly developmentalist narrative of sexuality dovetails in interesting ways with the more general developmentalist discourse within which Kerala has gained international prominence and recognition.[57] The so-called "Kerala model" of development, which has been central to a larger discourse of the state's exceptionalism, has been exhaustively cited and studied by economists and political scientists since the mid-1970s.[58] Scholars have lauded its unusually low birth rates, and high female literacy and life expectancy rates, as a paradigm of an alternative model of development, one that does not follow along the lines of neoclassical economic doctrine.[59] While scholars have productively used the "Kerala model" to critique the notion that states in the global South must follow a similar developmental trajectory as Europe and North America, this championing of Kerala as a model of gender equality and social justice has also had the inadvertent effect of effacing the ongoing struggles of women, sexual and gender minorities, and tribal communities who contend with systematic forms of dispossession and violence.[60] While *Sancharram*'s representation of the opprobrium faced by the two girls repudiates the notion of Kerala as a haven of sexual and gender egalitarianism, it does so, ironically, only through upholding a developmentalist and metronormative narrative of sexuality that reinscribes the hierarchical binaries of rural/urban, and global North/global South.

Both the film as well as adherents of the "Kerala model" collude to a certain extent with the current marketing of Kerala as an idyllic locale and prime tourist destination for North American and European travelers. The film's evocation of Kerala—through images of an idyllic, lush, impossibly rural landscape, complete with curious religious rituals and intact *taravads*—must

be situated within this current moment of globalization and Kerala's relatively new status as tourist haven. One outcome of India's embrace of free-market liberalization policies starting in the early 1990s has been the aggressive marketing of a romanticized vision of Kerala as "god's own country," as the slogan of the Kerala tourist board puts it—a land of banana palms, leisurely backwater cruises, Ayurvedic spas, and yoga retreats. *Sancharram* in a sense traffics in this latest incarnation of Kerala within a global consumer imagination, through its depiction of a space seemingly untouched by outside influences and in an anachronistic relation to the nation. As previously mentioned, the film opens with the arrival of Kiran and her parents to the small Kerala town; we are told that her parents have left behind a cosmopolitan life in New Delhi in order to take possession of the mother's *taravad*. While the film jumps forward to the present day, with Kiran as a young woman, the film's portrayal of Kerala remains curiously dehistoricized and decontextualized. There is no sense of the rapid industrialization and global processes that have impacted even the most remote areas of Kerala, let alone a medium-sized town such as Ottapalam in central Kerala, where the film is set.[61] Given the long history of Kerala's imbrication within a global economy, what are we to make of the strategic effacement of this history by a diasporic text like *Sancharram*? Within the diasporic imaginary of the film, the regional emerges as a pure, reified, inviolate space; this nostalgic evocation of Kerala easily slots into the narrative of Kerala exceptionalism that is central to the current selling of "Kerala" as a product for the global marketplace, and is a key element of the larger "Brand India" promulgated by the Indian state.

Thus far I have argued that the film is marked by and reiterates various discourses of globalization, even as it produces the region as a site completely untouched by these discourses. However, if we move away from the film's narrative resolution, where Kiran emerges as a prototypical lesbian feminist subject, we find that the dominant, developmentalist narrative of region, gender, and sexuality evident in *Sancharram* is not the only one at work in the film; a queer diasporic lens can resituate the film outside of the hegemonic interpretive frames of global rights discourse in order for other frameworks to come into focus. One scene in particular encapsulates both the developmentalist logic of the film and its resistance to and repudiation of this logic. Here, Kiran and Delilah meet for the first time after Kiran has divulged her love to Delilah. The scene takes place in the water tank where the two girls habitually bathe, and is the film's only "sex" scene. As Kiran and Delilah sit on the steps leading down to the water, Delilah tentatively reaches out to touch Kiran's face. The

camera is in continuous motion, panning from left to right and back again, accompanied by an evocative syncopated soundtrack of flutes and drums. The scene fades to black at key moments, selectively revealing images of striking visual beauty akin to still photographs: the reflection of water and the play of light on skin, strands of wet hair, eyes closing, a hand caressing a leg.

On the one hand, the scene encapsulates the film's problematic collapsing of various temporalities as it nostalgically evokes Kerala as a space outside of history, and thereby highlights the film's own "inauthentic" diasporic origins: middle-class girls at this particular moment in Kerala would be unlikely to bathe regularly in a water tank, as the characters in the film do.[62] On the other hand, the scene also suggests that regional sexualities may in fact elude the discourses of visibility and modernity that mark dominant nationalist narratives, as well as transnational narratives of global gay or feminist subjectivities. The scene does not in fact "show" us much: the camera gives us glimpses — fragmented shots of a hand on a waist, a foot hitting the water. The blankness between these syncopated images in part speaks to the demands placed on Pullappally by the Indian film censor board: she has stated that she was particularly cognizant of the need to evade the scrutiny of the board, and was careful to avoid showing lips ever meeting in this scene or others.[63] But the scene's refusal to "show" lesbian sex in this scene, and its privileging of the soundtrack over the image track, also gestures to the alternative desires and subjectivities that exist beneath and beyond the threshold of the visible. These desires evade the scrutinizing gaze of the state, and cannot be contained within developmentalist nationalist, gay, or feminist narratives.

This scene, and others in the film that reference the ways in which gender-segregated spaces allow for forms of homosocial intimacy that tip quite seamlessly into homoeroticism, speak to what T. Muraleedharan has called the "pleasurable intimacies" of the socially sanctioned homosocial spaces that exist in rural India, and in Kerala in particular. Furthermore, these scenes speak to the sexual and gendered organization of the Nair community in Kerala, which maintained social dominance in Kerala throughout the nineteenth century. In a series of laws enacted between 1887 and 1976, the colonial and then-postcolonial Indian state legislated matriliny out of existence in Kerala. The rationale given by the elite Nair male reformers who championed these changes in the late nineteenth century was that it was only by dismantling its "barbarous" system of female-centered households and through the establishment of monogamous, patrilineal conjugality that Kerala could integrate itself into the "modern" time of the nation. The Malabar Marriage

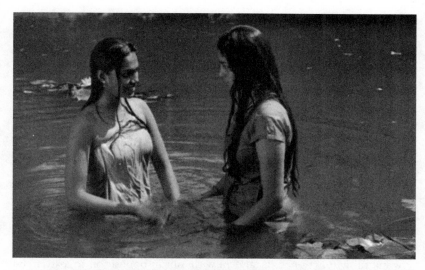

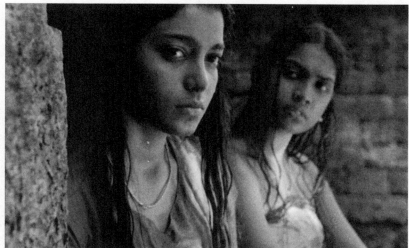

FIGURES 1.2 AND 1.3 Stills from *The Journey* (*Sancharram*) (2004), courtesy of Wolfe Video, copyright Ligy Pullappally.

Bill of 1887 sought the legalization of Nair marriages, so that they would have the same status as Hindu marriages. Prior to the bill, a Nair woman would enter into an "alliance" (or "sambandham") with a man of her choosing. The bill, as well as the subsequent Malabar Marriage Act of 1896, represented "an attack on the extant, mother-centered family form."[64] The Madras Marrumakkathayam Act of 1933 further dismantled the Nair matrilineal system, which was finally formally abolished in 1976.

I reference this history here not to romanticize Kerala's matrilineal past as an idyllic protofeminist or queer site, or to suggest that the end of a matrilineal system marked a neat shift from female empowerment and freedom to the strictures of patriarchal oppression. Feminist scholars of Kerala have carefully detailed the complexities and contradictions of this kinship system, and the fact that there certainly can be no direct or transparent relation between matriliny and female agency;[65] crucially, historian G. Anurima has shown how matriliny functioned in tandem with, not in opposition to, patriarchy and caste and class hierarchies.[66] Nevertheless, it is worth asking to what extent and in what forms this particular past continues to shadow contemporary sexual and gendered logics in Kerala. For instance, recent queer scholarship on Kerala has suggested that, despite its destruction at the hands of the colonial and postcolonial legal apparatus, traces of Kerala's alternative organization of gender and the various sexual practices to which it gave rise continue to be apparent in various forms in rural Kerala.[67] *Sancharram* obliquely references this complex history of gender and sexuality in Kerala, not only in its depiction of the homosocial/homoerotic intimacies between the two girls, but also in the sidelining of the men in the film: both Kiran and Delilah have complicated relationships with their mothers and grandmothers, while the men in the family remain somewhat peripheral and removed. But the film also cautions against recuperating this matrilineal past as an idyllic or utopian protolesbian space, as is particularly apparent in the interactions between Kiran and her mother, who presses upon her the family jewelry that has been passed on from one generation of women to the next. These are attempts on the part of the mother to impart not only a matrilineal inheritance to Kiran but also a normative femininity and an adherence to a reproductive imperative; indeed the film makes clear how matriliny, normative femininity, and a reproductive logic are inextricably intertwined. Kiran's refusal to abide by the standards of normative gender and sexual logics, and her mother's subsequent violent rejection of her when her affair with Delilah comes to light, underscores the limits and boundaries of this matrilineal inheritance.

Still, *Sancharram* points to the ways in which the normalizing power of nationalist and transnational discourses of gender and sexuality do not necessarily shut down all possible spaces for gender and sexual alterity. The film's suturing of queerness to the region disrupts the binary relation between diaspora and nation. I have elsewhere characterized this inevitable pairing of diaspora and nation as one that is marked by a hierarchical relation between the two terms. Within dominant nationalist discourse, the nation is equated with authenticity, purity, and originality while the diaspora can only be read as impure, inauthentic, and sexually and morally perverse.[68] *Sancharram* intervenes into the diaspora/nation nexus by inserting into this equation the third term of the region, which in fact dislodges the nation from its primacy as diaspora's invariable locus of origin and return. By making the region the locus of queer female desire, the film queers the space of home and origin in much the same way that *Fire* does in its urban North Indian context. But by transforming the equation of diaspora/nation to diaspora/region, the film is able to circumvent the nationalist ire that a film like *Fire*—set in the nation's capital with protagonists that speak in both Hindi and English—provoked from the Hindu Right. The fact that Kerala exists as a tangential, "other" space in relation to the Indian nation means that representations of a "queer Kerala" never bear the burden, for better or for worse, of representing the nation as a whole. The film therefore suggests the productive potential of suturing queerness to a regional idiom, in that it allows for the circumvention of the strictures and exigencies of nationalist discourses of gender and sexuality. Thus a queer diasporic reading of the film would allow us to hold in balance its seemingly contradictory and opposing elements: its adherence to a developmentalist, rights-based model of gender and sexuality, and its critique of this model; its strategic use of the marginality of Kerala within a national imaginary in order to suggest an "Other India,"[69] and the appeal of this "Other India" to a transnational viewership; its nostalgic evocation of a mythic Kerala that never was, and its detailing of the violences of caste hierarchies and heteronormativity that simultaneously mark this space.

BETWEEN THE REGION AND THE NATION: THE ART OF RAJA RAVI VARMA

Sancharram, then, makes apparent the contradictory effects of a queer mobilization of a region-diaspora or region-region axis; we can further explore these effects through David Dasharath Kalal's queer diasporic re-visions of the

work of the iconic early twentieth-century Indian painter Raja Ravi Varma. But in order to fully appreciate Kalal's intervention, it is necessary to first situate Varma's work in the context of early Indian nationalism in the late nineteenth century. Varma was born into an aristocratic family in 1848, in what is now Kerala. Significantly, he rose to prominence as an oil painter, despite the fact that he did not travel through the system of British art schools set up in India in the mid-nineteenth century as a way of shaping the tastes and sensibilities of a newly emergent Indian bourgeoisie. Instead, Varma was largely homeschooled in the art of oil painting, by a resident British oil painter at work in the Travancore palace in the 1860s—a fact that would endear Varma to Indian nationalists, who saw him, as art historian Saloni Mathur puts it, as "stealing the fire [i.e., Western techniques of representation such as oil and easel] for his own people."[70] Mathur locates Varma as part of the first generation of Indian artists who were seen as "gentleman painters," rather than as "native craftsmen," in the eyes of both the British colonizers and the Indian elite, who were the subjects of his work. Elevating the profession of the artist to one that was deemed respectable and refined, Varma towards the end of his life paradoxically opened a printing press, producing mass-market lithographs of Hindu mythological themes. These reproductions circulated widely and acted as the precursor of modern visual forms such as the cinema and photography that would come to dominate the visual field in India in the ensuing decades.

Varma is a contradictory figure, variously lauded and denigrated by Indian nationalists at different historical moments. On the one hand, his mastery of a "foreign" mode of representation, and the recognition he attained both within India and abroad, was seen as a victory for a fledgling nationalist movement. On the other, his adherence to the conventions of Western academic realism and his subsumption of an indigenous aesthetic tradition were derided by subsequent nationalists—particularly after his death in 1906—as wholly derivative of British art. These charges of inauthenticity and mimeticism continue to haunt his reputation to the present day: over the years his work has been dismissed as debased, mass-market kitsch by art critics who nevertheless concede to his enduring influence on visual culture in contemporary India. Recently, however, there has been a reassessment of his work by postcolonial art historians, who read Varma and his artwork as hybrid and syncretic. As art critic Geeta Kapur notes, Varma's reception underscores multiple tensions in early Indian modernity: between the regional and the national, the indigenous and the foreign, the aristocratic and the bourgeois, "high" art and "low" art. Varma was "as much as an imperialist as he was a

nationalist," in that his work spoke to a burgeoning nationalist sentiment as much as it confirmed a colonial, orientalist view of the so-called East, particularly in its depiction of Indian women.[71]

Valerie Rohy identifies the trope of synecdoche (where the part stands in for the whole) as the central logic that governs the relation of the region to the nation. "The trope of synecdoche," she writes, "implies a certain aggrandizement or assimilation—a capacity to incorporate the other at the same time that it recognizes difference.... Regionalism [thus] has a double attitude: it celebrates regional particularities even while it feeds national fantasy."[72] Varma's paintings demonstrate very clearly how this synecdochal logic governs the place and time of the region within Indian national discourse, as well as the ways in which both temporal and sexual backwardness are neatly mapped onto regional difference. The subjects of many of Varma's oil paintings were drawn from his own social milieu: these are portraits of the regional elite of Kerala, many of them belonging to the Nair community. A vast majority are of women, and a significant number of these are specifically of idealized Nair women; Saloni Mathur notes that the "European-like grace, neo-classical features and ivory skin" of these figures are conjoined with their regionally inflected clothing, hairstyles and jewelry.[73] Varma's mapping of regional difference onto the bodies of women is particularly apparent in the consignment of artwork that he sent to the 1893 World's Fair in Chicago. Here, he showed a series of ten paintings, which he named *Native Peoples of India*, all of them portraits of Indian women from various regions and of different religious affiliations. His work was extremely well received at the World's Fair, and the prize that he won subsequently was heralded in India as both a regional and national victory. Significantly, Varma's work was displayed not in the fine arts section of the fair but in the ethnographic section, and the prize was for the work's "ethnological value" rather than its artistic merit. Mathur argues that Varma's experience at the World's Fair makes clear how he was trapped by and yet challenged the terms of orientalist discourse even as he attempted to produce a nationalist visual iconography. His 1889 painting *A Galaxy of Musicians*, for instance, depicts a band of female musicians representing the different regions of India.

As a number of critics have noted, *A Galaxy of Musicians* provides the visual equivalent of the nationalist slogan of "unity in diversity." This motto, as art critic Chaitanya Sambrani notes, is "one of the foundational myths of the modern secular democracy ... mobilized to support the creation of a sovereign state out of the disparate remnants of British colonialism."[74] The

FIGURE 1.4 Ravi Varma, *A Galaxy of Musicians* (1889).

region, embodied in the portrait's idealized and orientalized figures of women, is evoked only to be contained in the service of the larger Indian nation. The painting is symptomatic of how Varma's work in general simultaneously celebrated and disavowed regional, linguistic, and religious difference. Furthermore, the "India" that emerges in his paintings is based on a Hindu ideal, once again embodied in his images of feminine respectability and devotion, that effectively wipes out Islamic, Christian, and Buddhist histories in the making of an Indian past and present.[75]

Varma continuously indexes and resolves the region/nation tension by subsuming the former to the latter. This is particularly clear in his 1893 portrait *There Comes Papa*, one of the ten paintings exhibited at the Chicago World's Fair. Crucially, the transformation of the region into an entity that buttresses rather than challenges a nationalist project hinges on the simultaneous transformation of gender and sexual ideologies. The portrait depicts an upper-class Nair woman holding her infant son and gesturing to the arrival of the father, who is out of the frame, but around whom the entire scene is organized. We can read this image as speaking quite directly to the rapidly

FIGURE 1.5 Ravi Varma, *There Comes Papa* (1893).

changing gender and sexual norms of turn-of-the-century Kerala, as the system of matriliny that governed the Nairs and other communities in Kerala up to the mid-nineteenth century gave way to a patriarchal, patrilineal nuclear family structure. There is a remarkable consonance and continuity in the language and logic deployed by Indian reformers and British authorities during the colonial period, and by post-Independence Indian lawmakers, in their zeal to transform existing gender and sexual norms in Kerala. For all of these state actors, matriliny and the system of female-centered households it organized around were deemed barbarous, primitive, and immoral—archaic social forms that had to be abolished in order for Kerala to enter into the temporality of the modern nation. In other words, Kerala's modernity and its admission into the national imaginary was purchased quite explicitly through excising its matrilineal past, and establishing the primacy of the "ideal monogamous conjugal patrifocal unit" in its stead.[76] The critique of matriliny was part of a broader critique of class and caste hierarchies on the part of social reformers;[77] the disparate interests of various social groups coalesced around

a vision of modernity that entailed the production of conjugal domesticity and the nuclear family as the norm, and that strategically deployed Victorian notions of sexual and gender respectability.[78]

There Comes Papa, then, must be read within this contested history. The painting marks the precise moment when the particular sexual and gendered logics of the region were being translated into the more intelligible, patriarchal logic of the nation; indeed the painting itself performatively enacts and colludes in this transformation. As G. Anurima writes in her reading of the portrait, "The absent yet approaching Papa signifies the crisis in Nayar matriliny in the late nineteenth century. The fact that Ravi Varma chose to celebrate conjugal domesticity and the nuclear family at a time when these were comparatively unknown among large sections of the matrilineal population reveals his growing patrilineal sensibilities. *There Comes Papa* becomes akin to a clarion call for the end of matriliny."[79] Again, in marking this shift from matriliny to conjugal domesticity, which the painting thematizes, I do not mean to imply that there existed, prior to the establishment of colonial and postcolonial gender and sexual norms, a kind of "golden age" of sexual and gender freedom in Kerala. However, I do want to suggest that the particular sexual and gendered logic of matriliny may have opened up spaces for nonnormative sexual practices and same-sex intimacies in the past that counter hegemonic narratives of gender and sexual normativity enshrined within nationalist modernity in the present. As I will discuss, it is the evocation of this past that is forcefully conjured into the present by the aesthetic practices of queer diaspora. In this sense, these aesthetic practices serve as archiving practices that gesture to repudiated and forgotten forms of queer sociality that may once have marked the space of the region.

ROUTING THROUGH THE REGION: QUEER DIASPORIC GENEALOGIES

I have spent time situating the work of Ravi Varma in the complex history of Indian modernity because, by recognizing how his work colluded in a nationalist project that shut down regional differences even as it seemed to celebrate them, we can now understand the wry interventions being made by a queer diasporic artist such as David Dasharath Kalal.

The Ravi Varma painting *Malabar Girl*, which I mentioned earlier, is one of five Varma oil paintings that Kalal digitally remakes; Kalal rescales the original portraits into five three-dimensional wood block art pieces that mimic

the look and dimensions of leather-bound books and are meant to be displayed as such, spine out. In his artist's statement, Kalal writes that "the individual 'volumes' in the series are classified and recorded in the Colon classification (CC) system of library classification developed by S. R. Ranganathan." Ranganathan, an Indian mathematician and a famed innovator of library science, introduced his "Colon Classification" scheme in 1933, as an alternative to the Dewey Decimal and Library of Congress systems. As one critic notes, Ranganathan felt that these existing systems "contained flaws because they were developed in order to organize existing collections. He felt there was a need to create a scheme that would be able to reflect forthcoming titles with different subject matter than had been seen in the libraries and to expand to new areas of knowledge over time. His Colon Classification scheme was developed to fill this need."[80] Ranganathan's system was thus inherently forward looking, meant not only to classify existing knowledge but to accommodate as yet unthought and unimagined forms of future knowledge. The Colon Classification scheme was adopted to a limited extent in Indian libraries during Ranganathan's lifetime but never fully caught on, as it was deemed too complicated for the layperson. In Kalal's explicit reanimation of Ranganathan's apparently failed and anachronistic system of classification as a mode of ordering his Varma remakes, Kalal implies that his own backward glance to Varma may in fact hold the possibility of new forms of knowledge that in turn require new logics and structures of ordering and classification.

Indeed, all of Kalal's reworkings of Varma's most celebrated paintings of Nair women dismantle Varma's region/nation equation. In Kalal's witty remake of Varma's *There Comes Papa*, for instance, the entire gravitational pull of the painting has shifted away from the father's impending entrance into the scene. The woman's eyes are no longer demurely gazing downward at her son, schooling him in the locus of patriarchal authority; in Kalal's image, the woman looks directly at the viewer, as does the collie which has been transformed into a pit bull held by a chain. Neither of them is waiting for the inevitable entry of the father—only the child remains static. The upper-middle-class interior of the Nair household in Varma's painting is utterly disaggregated here: only a piece of the original background remains visible to the right. The rest of the background is in shards, connoting exterior landscapes in motion; triangular fragments of what may be the borders of an Islamic miniature appear above and to the left of the figures. It would be a mistake, however, to read Kalal's composite image as decontextualized postmodern pastiche. Instead, we can read the painting's title, *Not Gonna*, as a refusal to celebrate the advent

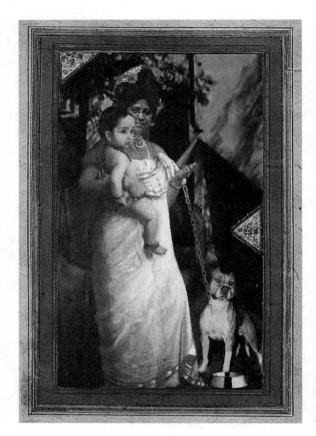

FIGURE 1.6 David Dasharath Kalal, *Not Gonna* (2005), courtesy of the artist.

of a caste- and class-based, patrilineal conjugal domesticity as the hallmark of a new nationalist subjectivity. It is also a refusal of a nationalist narrative of progress and integration that wipes out regional logics of gender and sexual alterity in its inexorable march towards "national unity." And, finally, it is a refusal of the reproductive imperative that bears down on women's bodies, as they are enjoined to (re)produce male nationalist subjects.

In its critique of the nationalist paradigm of "unity in diversity," Kalal's work must also be situated alongside contemporary feminist and queer Indian visual artists such as Nalini Malani, Pushpamala N., and Tejal Shah, who have specifically taken on the legacy of Ravi Varma. Malani is a multimedia artist whose work has long been concerned with the gendering of Indian national identity, history, and religious identity. Her initial, explicit engagement with Ravi Varma took the form of a 1989 watercolor entitled *Re-thinking Raja*

Ravi Varma, where, as Chaitanya Sambrani writes, "quoted figures from [Varma's *Galaxy of Musicians*] were presented as being pushed into the margin by the massively articulate form of a female nude that represents an animated conversation with normative notions of Indian womanhood."[81] Malani returned to Varma's *Galaxy of Musicians* in her 2003 video installation *Unity in Diversity*—a direct response to the horrific 2002 Gujarat massacre, in which Muslims were slaughtered by Hindu extremists, with the complicity of the Hindu nationalist state government led by Chief Minister Narendra Modi, who went on to be elected prime minister of India in 2014. The ghostly outlines of the orientalized female figures in Varma's painting, along with quotations from Varma himself, overlie the images of contemporary political violence, accompanied by the spoken testimony of eyewitnesses describing the atrocities. Here, as Sambrani puts it, "the fragile fabric of the national ideal [of "unity in diversity"] is quite literally stretched, torn apart."[82] In both the earlier watercolor and the video installation, Malani uses Varma's work to underscore the contradictions of a secular, modern nationalist project, and the ways in which women and religious minorities pay the deadly cost of its failure. Similarly, in a series of photographs entitled *Native Women of South India: Manners and Customs*, the photographer and multimedia artist Pushpamala N. elaborately restages Varma's *Native Peoples of India* paintings by substituting her own body inside the frame. As in Malani's work, Pushpamala's photographs ironically comment on the gendered logic of the "unity in diversity" model of the modern Indian nation, but they also respond to the legacies of the orientalizing and classificatory gaze of the colonial state, particularly in terms of an ethnographic project that seeks to document and "know" the natives. As such, Pushpamala's restaging of Varma's work points to the complicity of a modern nationalist project with an earlier colonial project that disciplines minoritized bodies under the surveilling gaze of the state.[83]

Pushpamala's reframings of Varma have influenced a new generation of queer/feminist artists in India such as Tejal Shah, who restages one of Varma's most iconic mythological oil paintings, entitled *Krishna with Yashoda*, which depicts a jewel-bedecked baby Krishna playing happily on his doting mother Yashoda's lap. In her 2006 *Hijra Fantasy Series*, Shah radically revises Varma's painting in a photograph entitled *You too can touch the moon—Yashoda with Krishna*. Here, Shah places at the center of the frame a transgender protagonist named Malini, who is also featured in one of Shah's earlier video installations; Malini takes the place of Yashoda as she gestures to the full moon, the baby Krishna sitting beside her. Shah describes her image as follows:

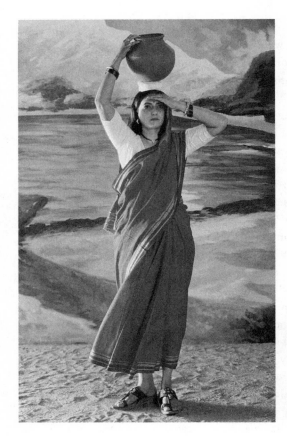

FIGURE 1.7 Pushpamala N., in collaboration with Clare Arni, "The Native Types/Returning from the Tank (after oil painting by Raja Ravi Varma)," from *Native Women of South India: Manners and Customs* (2014), courtesy of the artist.

This is a portrait of Malini. She expressed the desire to be a mother. "I want to point to the moon and tell my child that s/he too can reach out and touch the moon".... This photo-fantasy of Malini is ... meant to function as a perverse "queering" of Ravi Varma's mythological pictures, and of the colonial history that produced them. I paid a lot of attention to art direction, casting, lighting and detailing in general for this series. The opulence of the chosen reference also helps to transcend the class hierarchies that prevent hijras from moving into any positions of power or privilege.[84]

By replacing Varma's idealized female figure with a transgender subject who lays claim to motherhood, and by displacing the centrality of Krishna altogether—the photograph is no longer a portrait of Krishna but rather a portrait of Malini—Shah directly challenges the gender normativity, as well as the class

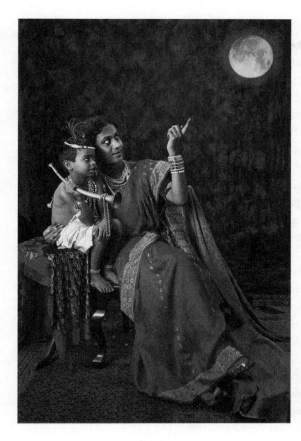

FIGURE 1.8 Tejal Shah, *You too can touch the moon — Yashoda with Krishna, Hijra Fantasy Series* (2006), courtesy of the artist and Project 88, Mumbai.

and caste hierarchies, that lie at the heart of Varma's (implicitly Hindu) national fantasy.

Kalal's project clearly shares with Malani, Pushpamala, and Shah an interest in pointing to the fissures and violences of a nationalist project through an engagement with Varma's legacy. Although a critique of the nation remains the primary focus of these feminist and queer citations of Varma, Kalal parts ways with Malani and Pushpamala in that, in his work, the nation is not only critiqued but radically disaggregated. The axis that Kalal's reworkings of Varma mobilize is not nation/region as much as it is diaspora/region: the nation is worked in and through the images, but is not the singular or primary frame of reference at work. Instead they offer us, in a sense, a queer diasporic countervision of the region: they dis-integrate the region from its subsumption into the nation. In this dis-aggregation of the nationalist logic of gen-

der and sexuality that Varma's paintings so clearly thematize, Kalal's images obliquely reference Kerala's matrilineal history and the particular sexual and gendered logics to which it gave rise. But Kalal does not fix or fetishize this history within a nostalgic narrative of regional exceptionalism. Rather, Kalal's evocation of a fantasied matrilineal past—one that reanimates the complex gendered and sexual arrangements that mark Kerala's history prior to the reformist movements of the nineteenth and twentieth centuries—provides the raw material that forms the present for the queer diasporic female subject at the center of the frame. As such, Kalal's images suggest a queer feminist genealogy that resituates the region as the locus of queer desire, practices, and subjectivity within a diasporic imaginary. Clearly, Kalal is not interested in bringing to light a heretofore-buried history of Kerala "as it really was": his project is not so much recuperative as it is reflective upon the ways in which, within queer diasporic memory, the region suggests alternative formations of desire and relationality deemed impossible within the dominant nationalist and diasporic discourses that structure the present moment. This intimation of other, more capacious landscapes is particularly apparent in Kalal's re-creation of Varma's 1890 portrait *Lady with Garland*. Here, the original background—the domestic interior of a Nair household—is transformed into the interior of an aircraft: the painting's original flower tray becomes the tray of an airline seat, and the face of Varma's female figure, dressed in traditional Nair garb, is substituted with that of a contemporary queer diasporic academic/activist. The image thus literalizes the region-diaspora axis I have been referencing throughout this chapter; the (Indian) nation ceases to exert quite as strong a gravitational pull on the female subject, suspended as she is between diaspora and region, suggesting alternative horizons of possibility.

The queer diasporic re-visioning of nationalist iconography that we see in Kalal's images emerges specifically from a very particular moment of South Asian queer organizing in New York City in the 1990s, in which Kalal was involved: the subjects of all three images (myself included) are in fact fellow activists and academics who were part of the progressive South Asian social and political landscape of the time. Kalal's reworking of Varma demands a reckoning with the caste/class hierarchies that mark even these progressive diasporic spaces. The queer temporality of these images—where a heteronormative nationalist past butts up against a queer diasporic present—disorganizes the inexorable linearity of developmental narratives of modernity. In their apparently anachronistic quality, Kalal's images provide us with an optic that allows us to see the past queerly; indeed, this optic allows the queerness of the past to

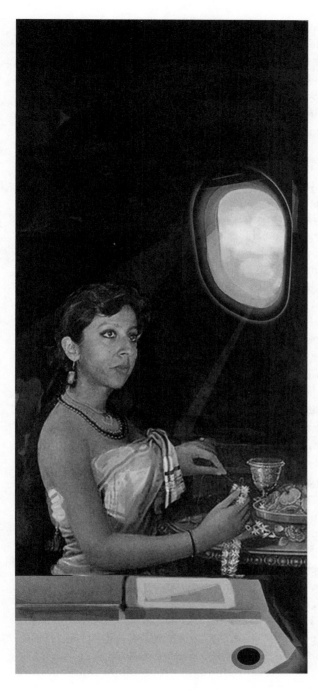

FIGURE 1.9 David
Dasharath Kalal, *Lady
with Garland* (2005),
courtesy of the artist.

come into focus. Situated as it is in the particularities of regional logics of gender and sexuality, this past is one that the heteronormative logic of both the nation and diaspora seeks to obliterate. Kalal's queer diasporic framing of the region, then, allows for the intimate touching of multiple times and spaces. His work speaks to what Carolyn Dinshaw terms "the possibility of touching across time, collapsing time through affective contact between marginalized people now and then"; Dinshaw suggests that these "queer historical touches" enable the formation of "communities across time."[85] Kalal's work produces precisely a kind of affective genealogy and transtemporal sense of community that links contemporary queer diasporic subjects to the queer(ed) past of the region. In so doing, his work allows us to approach those alternative sexual and gendered logics that exist in the interstices of hegemonic nationalist, diasporic, and transnational formations. It is also from the vantage point of a queer diasporic present that we can place multiple geographic locations within a shared conceptual space. The category of "queer" in Kalal's work names a way of reading the past so that the perverse and the antinormative come into view, of resignifying histories, practices, and desires systematically effaced by both heteronormative nationalist and diasporic narratives. In other words, Kalal's work reaches back to an occluded past (which may never have really been) in order to imagine a queer diasporic present and future.

I want to circle back to the centrality of the personal and the autobiographical in the project of queering the region. Just as Pushpamala inserts her own body into the frame of Varma's images, so too does Kalal's queer diasporic re-visioning of Varma mobilize the autobiographical in crucial ways. In one of his remakes of Varma's popular lithographs of Hindu mythology, for instance, Kalal substitutes his own face for that of the god Krishna: the original Varma image, entitled *Gorgeous Krishna*, is now rebaptized as *Who's Your Daddy*? Kalal disrupts Varma's idealization of the Indian nation as implicitly Hindu with the insertion of a Jesus figure at the bottom of the image, as well as with his evocation of Islamic miniature art in the image's framing. The title can be read as referencing Kalal's own search for an alternative personal, aesthetic, and artistic genealogy. As a queer diasporic artist, Kalal grapples with the legacy of Ravi Varma as the "daddy" of modern Indian art and as a central figure in the production of nationalist iconography. We can see Kalal's act of placing himself in the center of the frame as his rejection of a patrilineal nationalist genealogy and a suggestion of an alternative that foregrounds the non-Hindu, the perverse, the non-reproductive, the female, the diasporic.

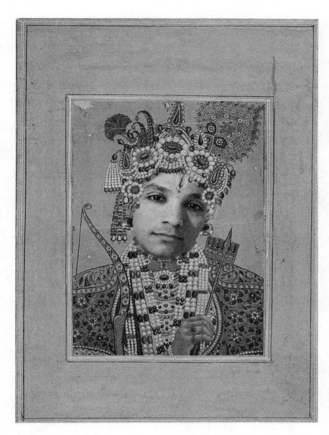

FIGURE 1.10 David
Dasharath Kalal,
Who's Your Daddy?
(2005), courtesy of
the artist.

And, finally, I cannot escape my own positionality in this project of queer-
ing the region. As I was researching this chapter, I was startled to come across
Ravi Varma's very first oil painting, *The Kazhikke Palat Krishna Menon Fam-
ily*, a portrait commissioned in 1870 by a prominent Nair family. The im-
age portrays the family of Krishna Menon, a subjudge in the Tiruvitamkoor
district of Kerala and a member of a wealthy landowning family from north
Kerala. Aesthetically, Varma has not yet developed his distinctive style, which
combines Western academic realism with "indigenous" subject matter. The
perspective here is flat, more in keeping with the art forms that preceded
the establishment of colonial art education in India. Yet, like the later *There
Comes Papa*, the painting is performative and aspirational, in that it grants an
ontological certainty to a patrilineal conjugal household that was in reality

FIGURE I.II Ravi Varma, *The Kazhikke Palat Krishna Menon Family* (1870).

only just coming into existence in Kerala in 1870. As G. Anurima writes in her reading of the painting,

> How strange . . . that this portrait was painted in matrilineal Kerala at a time when most of the Nayars, Krishna Menon's caste, would have been unused to living in patrilocal nuclear families, let alone anything that remotely resembled the western bourgeois family. The gravity given to this form of the family by Ravi Varma, himself a matrilineal man, points . . . to a changing sensibility within Kerala regarding matriliny.[86]

I was taken aback to realize that the Krishna Menon portrayed in the image is in fact my own great-great-great-grandfather. My great-great-grandmother is the little girl in the image. She went on to marry one C. Sankaran Nair, my great-great-grandfather who, I found out, was the architect of the Malabar Marriage bill that some twenty years later sought to legislate matriliny out of existence in Kerala. It was their youngest daughter, my great-grandmother, who built Palat House, the house in central Kerala to which I still return. Like Krishna Menon, both Sankaran Nair and his son, R. M. Palat, were civil

servants in the British colonial administration. Palat, my great-grand-uncle, went on to become the architect of the 1933 bill that further dismantled the matrilineal system. In a sense, this chapter is my response to and negotiation with this past from the vantage point of a diasporic present. Kalal's images force me to grapple with my own particular caste- and class-marked patrilineal, and matrilineal, genealogies; they allow me to make sense of this past and reframe it in terms of a queer diasporic genealogy. The aesthetic practices of queer diaspora thus demand that we map the connections between the personal, the regional, and the diasporic as they take shape over various bodily, psychic, and geographic landscapes.

BIRD'S-EYE VIEW: SHEBA CHHACHHI'S SUPRANATIONAL FRAMINGS OF THE REGION

Thus far I have primarily referenced how the region in its subnational sense—as it emerges in the work of Pullappally and Kalal—disorients conventional framings of both queerness and region. I end this chapter by turning to the art of Sheba Chhachhi—a photographer and multimedia installation artist born in Harare, Ethiopia, and based in Delhi, India—to suggest the ways in which the aesthetic practices of queer diaspora also deploy the region in its supranational sense to disorient a Eurocentric vision writ large, on a global scale. This vision is predicated on a teleological developmental logic that situates the global South in an anterior and hierarchical relation to Europe and North America. Chhachhi's 2007 installation *Winged Pilgrims: A Chronicle from Asia*, which involves sculpture, video, and a soundtrack, was first shown in New York City at the Bose Pacia Gallery, in a show entitled *Migration: Another View of Globalization*. As the title suggests, Chhachhi gives us an alternative genealogy of globalization that envisions the premodern, cosmopolitan histories of migration between South Asia, China, and the Middle East. As such, *Winged Pilgrims* is a powerful instantiation of precisely the kind of queer framing of the region that I called for at the beginning of this chapter: one that allows us to see and to sense the intimacies of multiple times and spaces as it foregrounds region-to-region connectivities. This alternative view of the region is particularly apparent in the most striking part of the installation: a series of lightboxes that remake "Plasma Action Electronic TV toys." As Chhachhi explains in her artist's statement, these Chinese-made toys, found in many small Indian markets, are cheap imitations of electronic plasma television screens:

This low-cost facsimile of a plasma screen monitor uses an ingenious system of an electronically operated roller to create the illusion of a moving image which repeats itself in an endless loop. The images in the box are most often idealized views of nature, utopian landscapes both urban and pastoral. The objects in the screen move with a sort of hypnotic, slow repetition. Images can move in one or two layers with a slight time lag between each layer so that viewers feel as though they were watching a mobile landscape.[87]

Chhachhi's reconstituted TV toys screen another kind of utopian landscape, a fantastical palimpsest of multiple times and spaces. Recurring tropes of migrating birds, the robes of Buddhist pilgrims, and stringed instruments float above and against this landscape, speaking to the dense networks of travel, traffic, and influence between the Middle East, South Asia, and China within which, as I mentioned earlier, Kerala played a central part. The layering and looping of classical Islamic, Buddhist, and Hindu architecture, aesthetics, and mythology in this landscape brings into the present the memory of older circuits of production, exchange, and consumption within the Indian Ocean arena, tracing a prehistory to the current forms of neoliberal globalization emblematized by the plasma TV toy (plate 1).

At first glance, *Winged Pilgrims* may seem easily intelligible within an orientalist framework that would read Chhachhi's citations of the natural world and of religious and cultural emblems as evocations of the timeless, essential elements of a generic and homogenized "Asian" culture; this reading dovetails with conventional area studies framings of the region as a fixed, knowable, geographically circumscribed entity. However, a more careful look at the images reveals that Chhachhi chronicles a very different story of the past and present of "Asia." In one lightbox, nineteenth-century-style galleon ships bearing tiny U.S. flags traverse roiling seas, speaking to the ways in which older histories of European colonization shadow contemporary forms of U.S. empire. In another image, Chhachhi's mythological winged creatures fly over landscapes ravaged by environmental degradation, replete with urban sprawl and oceans littered with glaciers or industrial detritus. And, in yet another image, a row of menacing figures dressed in white contamination-safety suits carry bags of dead birds while spectral Buddhist robes and geese float behind them. Chhachhi has stated that the entire installation was initially inspired by the global panic around avian flu and the killing of millions of birds that ensued; thus, Chhachhi's bird's-eye view of "Asia" and globalization chronicles

multiple histories of violence to both the human and nonhuman worlds from the vantage point of the besieged. These violences are engendered by European colonial encounters, the contemporary imperial ambitions of the U.S., and unfettered global capitalism in the region, as well as by everyday attempts to contain and quarantine bodies, both human and nonhuman, as they travel across borders. *Winged Pilgrims* makes evident the "disasters that are slow moving and long in the making," as Rob Nixon phrases it, exacted by these myriad colonial and neocolonial histories upon bodies and landscapes.[88] As such, it also makes clear how the aesthetic practices of queer diaspora allow us to critique the fixity of area studies and produce alternative mappings of space and time.[89] These aesthetic practices place seemingly incommensurate texts, geographic locations, and temporal moments in relation to one another, not to empty out their historical and temporal specificity, but to map the continuities and dissonances between different regimes of power as they discipline and "disappear" bodies in particular ways. Chhaccchi's bird's-eye view constitutes what I have been calling a "queer optic." This queer optic allows us to bring into the same, multisighted field of vision both the female homosocial/ homoerotic intimacies of the queer Kerala that emerges from Pullappally's and Kalal's U.S.-based diasporic imaginations, and the male homosocial/ homoerotic laboring intimacies of the queer Kerala—which exists amid the storefronts and vegetable stalls of Gulf cities in the UAE—that I alluded to at the beginning of this chapter (plate 2).

Hence, Chhachhi's work perfectly encapsulates a queer regional incursion into area studies: it disorients orientalist and area studies modes of knowing "Asia" as a region, and in so doing queers our understanding of the "region" itself. In other words, *Winged Pilgrims* shows us how to read the map of "Asia" differently, enacting a queer critique of area studies knowledge through what I have been calling a "queer regional imaginary." *Winged Pilgrims* offers a bird's-eye view of the intra- and transregional mappings of Asia that radically decenter Europe and the U.S., thereby disorienting the linear temporality and discrete geographic boundaries of normative forms of knowledge production. Instead, it brings into the present field of vision the past and continuing histories of South-South relationality and affiliation. The stretched-out temporality that marks the bird's-eye vision of Chhachhi's "winged pilgrims" not only renders apparent the killing effects of colonial and neocolonial histories; it also brings into focus the long counterhistories and alternatives to those violences that involve the convergences of both human and nonhuman actors. Ultimately, the aesthetic practices of queer diaspora—as seen in the work of

Chhachhi, Pullappally, and Kalal—offer us different routes through the regional and the personal that enable alternative genealogies and modes of apprehending the "warm data" of migrant, queer socialities to come to the fore. These queer articulations of the region force us to see beyond the limited vista of conventional knowledge production, as well as dominant articulations of both nation and diaspora, that depend on heteronormative framings of family and community.

CHAPTER 2

Queer Disorientations, States of Suspension

Some years ago, a friend took me to "La bota loca" at the gay nightclub Bench and Bar in Oakland, California, which since 2003 has billed itself as "the West Coast's biggest and hottest Noche de Vaquero/Latin Gay Cowboy Night."[1] As I walked through the door, I was greeted by the exhilarating sight and sound of hundreds of predominantly Mexican and Latino men dancing the *quebradita* together. What I remember most about that night was how the MC hailed these men through their specific regional affiliations, calling out the names of states, regions, and small towns in Mexico, to which the audience responded with shouts of recognition and raucous applause. It was particularly significant that these men were performing a queer Mexican regional identity in this off-center space in Oakland, in the East Bay, rather than in the "gay mecca" of San Francisco. It was also significant that the men were dancing the quebradita: a dance form with a complicated history as a transnational yet regionally based working-class aesthetic practice. The quebradita was central to the emergence of a transnational Mexican American youth culture in the 1990s in Los Angeles and the U.S. Southwest, and was deeply rooted in the specificities of particular regional identities in Mexico.[2] Thus this scene at "La bota loca" was an enactment of precisely the quotidian forms of diaspora-to-region and region-to-region connectivities that I explored in

the previous chapter, and underscores the necessity of theorizing queerness through the region. Just as the homosocial/homoerotic migrant intimacies in Abu Dhabi that I alluded to earlier speak to the interplay of queerness, region, and diaspora, so too does this scene in Oakland, California, speak to the centrality of regional identifications to queer migrant sociality in the diaspora. In this context, I take "queer regions" to refer to those subnational spaces that exist at the margins of dominant national *and* gay imaginaries, where different logics of sexuality operate that may not be intelligible within a metronormative or nationalist grid of sexual subjectivity.[3] I would suggest that, for the men I encountered at "La bota loca" in Oakland, claiming a Mexican regional/provincial identity becomes a means of challenging one's unbelonging not only within the U.S. nation-state but also within white, gay, metronormative spaces. Similarly, the regionally inflected intimacies among migrant men in Abu Dhabi that I referenced in chapter 1 can be understood as speaking to their sense of unbelonging from the national spaces of both the UAE and India, and are utterly unintelligible within a metronormative "global gay" imaginary.[4] Such instances allow us to consider how transnational queer migrants negotiate their relation to multiple national formations, as well as their relation to dominant gay formations both in the U.S. and globally, through an evocation of a regional rather than national idiom.

We can understand both the scene at the Bench and Bar that Oakland night, as well as the migrant socialities I evoked in chapter 1, as queer world-making practices that draw on the embodied memory of regional identifications to articulate a nonmetronormative queer migrant collectivity. The aesthetic practices of queer diaspora that concern me in this book translate such evocations of the region—which I have been calling "queer regional imaginaries"—into the realm of visual representation, where they have both powerfully disorienting and reorienting effects. First, they disorient conventional narratives of success and uplift that are directed towards assimilation into a metronormative gay and national imaginary, and that congeal into a normative vision of "the good life." Within the logic of neoliberal capitalism, "the good life" is that which possesses value according to familiar hetero- and homonormative measurements of success, including marriage, reproduction, and property ownership. The queer regional imaginaries evoked by the aesthetic practices of queer diaspora disrupt such "conventional good life fantasies," in Lauren Berlant's words.[5] Second, they simultaneously reorient us toward other spaces and temporalities that promise alternative pathways through the world. As such, they imply that "the good life" for some migrants may

mean not so much the lure of hetero- and homonormativity and its rewards; instead it may signify pleasurable forms of queer relationality, intimacy, desire, and affiliation, between and among bodies, spaces, and temporalities.[6]

This chapter thus extends the concerns of the previous chapter by exploring the productively disorienting and reorienting effects of queer diasporic evocations of the region enacted by queer visual aesthetic practices. When I speak of "region" in this context, I refer to subnational spaces in multiple national locations, but I also want to keep in play the supranational valences of the term. As we saw in Sheba Chhachhi's *Winged Pilgrims* in chapter 1, queer articulations of the region in its supranational sense evoke intra- and transregional imaginations that also powerfully challenge Euro-American metronormativities, queer and otherwise.[7] Extending our horizons in this way, by mapping both subnational and supranational evocations of the region from the vantage point of queer diaspora, is to truly displace metronormativity in both its local and global registers. This does not entail doing away with the nation as a category of analysis; rather, it involves seeing how the region in both its subnational and supranational senses is deployed to negotiate the constraints of metronormative nationalisms in multiple locations. Such a project may necessitate losing our bearings and getting lost, as familiar touchstones and markers recede from our field of vision; it demands a simultaneous disorientation and reorientation of a U.S.-centric, metronormative vision so that other spaces and temporalities come into view. This project, then, is very much in conversation with other queer scholarship that sees queerness itself as a form of disorientation, of getting and staying lost, that diverges from the straight and narrow paths prescribed by heteronormativity.[8] "Queerness" here names a state of being out of place and disoriented in the landscape of heteronormativity. We might ask what emerges when we see queerness not as homecoming, or as finding our true selves or our proper paths, but as a process of both dwelling in those off-center spaces and of staying lost, and thereby perhaps even stumbling into new worlds of possibility.

The aesthetic practices of queer diaspora—queer visual aesthetic practices that negotiate the intersection of race, sexuality, and migration in multiple geographic and national locations—open the vista to these alternative horizons of pleasure and possibility. It is in these practices that we can locate different imaginings of queer, racialized, migrant desire and sociality that refuse and refute the lures of recognition, inclusion, and legitimacy that frame conventional articulations of success and "making it." These practices enact a particular mode of reading: through the mobilization of a queer regional

imaginary, in both its subnational and supranational senses, they teach us how to read in a way that profoundly disrupts a metronormative queer and nationalist vision. This mode of reading is necessarily disorienting in that it surfaces the connections between seemingly disparate geographic locations, temporalities, and sites of power. It makes evident the intimacies between different racial formations and various historical moments with their particular structures of subordination—intimacies typically obscured within dominant forms of knowledge production. While the aesthetic practices of queer diaspora reorient us away from the straight and narrow, they do not instead offer recourse in the fictions of stable identity, narratives of linear progress, or the security of homecoming. Rather, they demand that we dwell, perhaps uncomfortably, in the space of disorientation that they open up.

FRAMING THE FAMILY

The aesthetic practices of queer diaspora powerfully challenge the way in which the concept of "the family" is fetishized within both mainstream liberal gay and immigrant rights contexts in the U.S., in the service of a politics of incorporation and respectability. The deployment of a sentimentalized, naturalized notion of the family is made abundantly clear when considering the liberal gay rights movement's aggressively desexualized emphasis on gay marriage and parenting, as well as some strands of the mainstream immigrant rights movement in the U.S. which argues (quite rightly) that draconian deportation policies tear families apart. While queer critiques of mainstream gay marriage politics and its assimilative goals are now fairly widespread,[9] less remarked upon and worth underscoring is how a homonormative emphasis on the family maps quite neatly onto heteronormative discourses of the family articulated by a mainstream liberal immigrant rights platform; indeed, liberal gay and immigrant rights discourses both adhere to normative notions of the family, the home, and the child. The aesthetic practices of queer diaspora suggest a very different understanding of these formations than that which is enshrined within liberal affirmations of both gay and immigrant rights.

U.S.-based queer of color critique has been indispensable in denaturalizing heteronormative framings of the racialized immigrant family in the U.S. Such scholarship demonstrates the ways in which the state demands heteronormativity, and an adherence to sexual respectability, as a precondition of citizenship, even as it renders normative kinship arrangements outside the reach of many impoverished racialized communities.[10] The assertion, performance,

and enactment of heteronormative familial relations have been the primary means by which racialized immigrant subjects gain access to the material privileges of citizenship. The state's demand that racialized migrant communities cleave to heteropatriarchy, and the subsequent internalization of heteropatriarchy by these communities themselves, is particularly apparent in the way the mainstream immigrant rights movement deploys a rhetoric of the family that naturalizes heteronormativity.[11] This is not to say that all sectors of the movement are equally invested in asserting hegemonic family structures. In fact, as various scholars have pointed out, more radical immigrant rights activists powerfully challenge these naturalized notions.[12] For instance, political theorist Cristina Beltrán examines how many DREAM activists—undocumented youth advocating for the passage of the DREAM Act—engage in forms of protest and resistance that sharply diverge from the traditional immigrant rights movement's rhetoric of "patriotism, legality and loyalty."[13] Beltrán instead looks to the ways in which Dreamers—and particularly queer undocumented youth activists, some of whom dub themselves "UndocuQueer"—draw from the rhetoric of LGBT politics to "come out" as both queer and undocumented; in so doing they embrace what she calls "more aggressive forms of nonconformist visibility, voice, and protest" through social media as well as more conventional forms of resistance such as sit-ins, marches, and rallies.[14] Beltrán also notes that the ideological leanings of DREAM activists are variegated and heterogeneous, with some articulating a patriotic politics of inclusion and loyalty, while others articulate a much more radical, multi-issue politics of social justice that critiques the very terms of inclusion and exclusion, legality and illegality. Beltrán thus argues that the tactics and visions of democracy of DREAM activists "queer the politics of immigration" and the immigrant rights movement itself.[15]

While the forms of queer undocumented youth activism Beltrán and others document may diverge from the demands and tactics of the traditional immigrant rights movement, they adhere more to the liberal humanist language of individual choice, freedom, and autonomy so central to mainstream LGBT rights politics than to the anti-identitarian, subjectless stance of queer critique. This becomes particularly clear if we consider the posters created by UndocuQueer artist Julio Salgado as one articulation of the (admittedly multifaceted) UndocuQueer project. In 2012, Salgado, a self-described Mexican American "artivist" based in Long Beach, California, created a series of online posters entitled "I am Undocu-Queer!" based on photographs that he solicited online from other undocumented queer youth. The resulting agitprop

portraits each bear the heading "I am Undocu-Queer," and is accompanied by a short written statement from the individual profiled, describing their sense of themselves as both queer and undocumented. One image depicts a young brown man with glasses named Felipe, wearing a white T-shirt with stickers that read "Undocumented and Unafraid" and "Queer and Unashamed"; the text accompanying the image reads, "Equality for some isn't equality for everybody and that's why I can no longer hide! I can no longer wait! We can no longer afford to be in the closet either as queer or undocumented. We can no longer let others who haven't been in our shoes decide and tell us how to act and how to feel!" Another poster in the series depicts a young woman, also wearing the same stickers, and states simply, "Undocuqueer. Taking control of my own destiny. I exist!" Clearly such assertions of selfhood are a necessary and forceful rejection of the injunction to secrecy, shame, and invisibility that bears down on those who are undocumented and/or queer. At the same time, the reliance on a politics of visibility, authenticity, and autonomous selfhood that is evident in this particular iteration of queer immigrant youth activism runs the risk of replicating the very terms upon which liberal citizenship is based.[16] Given their strong emphasis on liberal selfhood, the extent to which the tactics and modes of representation at work in UndocuQueer "artivist" practices "queer the politics of immigration" is unclear.

I want to turn our attention instead to those aesthetic practices articulating forms of queer critique that do not traffic within the logic of "visibility, voice, and protest" that mark even oppositional immigrant rights activism. The aesthetic practices of queer diaspora offer a powerful repudiation of state-mandated heteronormativity (and, increasingly, homonormativity), and its subsequent embrace within racialized immigrant communities, without recourse to a liberal humanist model of subjectivity. As I suggested in the previous chapter in relation to working-class queer migrant socialities in the UAE, these modes of resistance may be inaudible or unintelligible because they do not announce themselves as resistance as such. Indeed a valorization solely of those "out, loud, and proud" forms of collective action may obscure the more subtle forms through which resistance and refusal take shape. Unlike, say, the UndocuQueers' in-your-face strategies of voice and visibility, the aesthetic practices of queer diaspora that interest me here instead illuminate modes of queer critique and noncompliance that are unspectacular and banal, woven into the fabric of everyday life. These practices traffic not so much in bold assertions of identity—"coming out" as immigrant, as undocumented, as queer—but rather in those forms of queer world-making that allow us to

apprehend new modes of being oriented in the world. The injunction that one's life be directed in a particular way, towards a recognized "social good," as Sara Ahmed puts it, is powerfully contested by the aesthetic practices of queer diaspora.[17] Such practices disarrange the temporal and spatial logic of conventional articulations of aspirational success, home, and family evident within a mainstream gay *and* immigrant imagination. This is a logic that is predicated on the straight line forward, away from a closeted and/or impoverished past and toward a future that promises normative kinship structures and property ownership; economic and social uplift; and recognition, intelligibility, and inclusion within the public sphere. In contrast, the aesthetic practices of queer diaspora point the way to alternative modes of inhabiting time and space, of relationality and affiliation, of success and "making it," that are, in fact, unintelligible within this developmental logic. Queer desire, relationality, and identification function as a kind of propulsive force that throws one off a normative life course and into a different trajectory that is in fact open-ended, with no fixed itinerary or ending.

If, in spatial terms, queerness names a state of being out of place, of disorientation in the landscape of heteronormativity, in temporal terms queerness has the potential to suspend the linear temporal rhythms of hetero- and homonormative life courses.[18] The aesthetic practices of queer diaspora allow us to apprehend queerness in both these spatial and temporal dimensions, as a form of disorientation and suspension that opens up new orientations and directionalities in the world. We can clearly see how the familiar familial equations of diasporic immigrant kinship and generationality are disorganized and made anew if we turn to the work of South Asian American artist Chitra Ganesh, and the 2012 independent feature film *Mosquita y Mari* by queer Latina filmmaker Aurora Guerrero. Echoing the interplay of the personal and regional that I traced in chapter 1, I read these works by Ganesh and Guerrero as forms of queer memoir and memorialization: they trace the formation of queer selves through alternative, regionally inflected genealogies that work against the standard logic of liberal subjecthood, descent, and filiation proscribed within hetero- and homonormative notions of family and kinship. Queer critique enables us to place these two seemingly incommensurate texts in relation to one another, and gives us a frame through which to view the commonalities and divergences between distinct and overlapping racial formations and diasporic histories. While much of the national conversation on immigrant rights has focused on Latinx communities, I want to foreground the possibility of coalition and alliance between differentially

racialized immigrant communities—South Asian and Latinx—that are similarly disciplined through a politics of respectability that demands hetero- and homonormative framings of family and kinship.[19] The ongoing vilification of both Latinx and South Asian/Middle Eastern migrants in national debates about immigration, and the resultant violence directed at these populations, underscores the urgency of such coalitional framings.

CHITRA GANESH'S DISORIENTING LANDSCAPES

The work of Chitra Ganesh allows us to consider how the normative discourses of the "immigrant family" are undone through queer diasporic evocations of the region. Ganesh is a New York City-based artist born in Brooklyn whose parents emigrated from Calcutta, India, to the U.S. in the early 1970s as part of the wave of middle-class professionals who were naturalized with the passage of the Hart Cellar Immigration Act of 1965. In her 2009 work *13 Photos*, Ganesh reinvents the genre of the family photograph album by selecting and recontextualizing those discarded photographs that never made it into an "official" family album. Ganesh's reconstituted album consists of thirteen image-texts, bound together in book form, that she creates by reproducing, enlarging, and transforming the original photos of her parents' honeymoon in India a few years prior to their emigration to the U.S. The reconstructed album ends with two paired images: one of Ganesh as a five-year-old child in Brooklyn, and, finally, an image of her mother as a young girl in India. Interspersed throughout the album are lines of cursive text, seemingly nonsensical, that either stand alone or that frame the reproduced photographs. The images and text appear on a background of uneven, mottled yellow and white that evokes the faded, decaying quality of old albums (plates 3 through 7).

We can understand Ganesh's autobiographical turn in *13 Photos* less as an attempt to recover the past than as a queer archival practice, a way of producing a counterhegemonic historiography. I would suggest that the work of autobiography in *13 Photos* is to narrate alternative logics and modes of sensing, feeling, and knowing the past as it haunts the present; these sensorial and felt knowledges escape standard historical or sociological accounts. Ganesh's critical detours through the past, her mining of the invented and reimagined terrain of her own familial history, allow her to trace the production of racialized subjectivity within the most intimate of landscapes—namely, familial and domestic space. *13 Photos* demands that we frame queer selfhood not with

the familiar metronormative narrative of staying vs. leaving, third world oppression vs. first world liberation, the closet vs. coming out; it suggests instead an alternative spatialization and temporality of queerness that insists on the simultaneity, rather than the discreteness, of legacies of British colonialism, postcolonial Indian nationalism, and U.S. racialization in the formation of contemporary queer subjectivity.

We can enter into a reading of Ganesh's work by reflecting on her evocation and transformation of the generic conventions of the family photograph and the family album in particular. Theorists of family photography and cultural memory, such as Annette Kuhn and Marianne Hirsch, stress the intimate relation between photography and "the ideology of the modern family."[20] For Hirsch, "photographs locate themselves precisely in the space of contradiction between the myth of the ideal family and the lived reality of family life."[21] The work of reading the family photograph, then, is to see it as a form of evidence, not of things "as they really were," but rather, as Annette Kuhn puts it, as "material for interpretation . . . to be solved, like a riddle; read and decoded, like clues left behind at the scene of a crime."[22] If we understand Ganesh's photographs as "evidence" in Kuhn's sense of the term, we can read them as constituting an alternative archive—one that tells quite a different story about the formation of family, nation, and diaspora than that which is enshrined within an assimilationist nationalist or heteronormative narrative. Furthermore, the structure of the conventional family album, as Hirsch points out, stresses "chronology, continuity, and repetition," and relies on linearity and predictability in order to produce and reproduce the family as cohesive across time and generations.[23] Ganesh's photo album, conversely, attends to the disjunctures and discontinuities, the gaps and fissures, that haunt the imagined plenitude of familial and national forms. In this sense, Ganesh's album functions not as a project of recovery, a return to familial and national origins, but lays bare the dense and sedimented histories of colonialism, postcolonial nationalism, and racialization that determine the contours of "the family" itself. Ganesh's work enacts a queer critique of the family, and the couple form in particular, in the context of both postcolonial Indian nationalism and diasporic dwelling in the U.S., and, in so doing, excavates the genealogical traces of a queer self that is produced in the interstices of these various historical processes.

What is most striking to me about these "honeymoon" photos is their utter desolation. In almost all thirteen of them, the female figure, Ganesh's mother, appears stranded; she is unpaired and alone in the center of the frame,

dwarfed by the landscape, and it is impossible to make out her features or expression as she stands in front of the generic images of mountains and meadows. We can therefore locate Ganesh's images in that very space of contradiction that Hirsch points to, where the idealized vision of the couple form—emblematized in the honeymoon photograph—is disaggregated and placed under erasure. The isolation and singularity of the female figure signal the ways in which Ganesh remakes the family album and the honeymoon photo into radically and staunchly antinostalgic genres that refuse and refute romance in all its guises: of the family, of the postcolonial nation, of a postracial U.S. democracy. The lone figure of the newly married Indian wife—and the South Asian immigrant mother in the U.S. she will become—is shadowed by the absent presences of those who remain outside the frame: the photographer, presumably Ganesh's father, and Ganesh herself, who engages in a transtemporal dialogue with her mother's ghostly image through both her framing of the images and the written text that accompanies them. These phrases do not function to explicate the images in any simple sense; instead, in their fragmentary and disjointed quality, they underscore the deep sense of loss, loneliness, and longing that saturate the images. These are irrevocably melancholic landscapes.

However, as scholarship on the political uses of affect has shown us,[24] the forms of negative affect that saturate this landscape and forge the ties that bind husband to wife, mother to daughter, also have the capacity to be productive: they open the way to alternative histories and modes of knowing the past that triumphalist, temporally linear, "happy" stories of familial and national formation violently occlude and render ghostly. But if we understand the family photograph album as the official archive of familial formation, cohesion, and continuity, as well as a performance of national belonging, we can understand *13 Photos* as more than an act of creating an alternative archive. It also enacts for us, the viewers of these images, a mode of reading dominant archives "along the archival grain," as anthropologist Ann Stoler puts it.[25] *13 Photos* reveals precisely the anxieties, ambivalences, and failures of this project of familial and national coherence, as well as that which is relegated to its margins and shadows.

The album ends with two paired images that act as a kind of coda to the honeymoon series. The first is of Ganesh herself as a five-year-old girl, sitting on the floor of her family home in Brooklyn, a clown mask covering her face. The image is rendered from a slide imprinted with both the time and place of its creation (the words "Dec '77" and "made in USA" are faintly visible on

the original slide beneath the cursive text). We can read Ganesh's image as speaking to the ways in which, for racialized immigrant subjects, the domestic space serves as the site where the injunction towards both racial assimilation and the institution of heteropatriarchy come down most forcefully. *13 Photos* thus points to the investment on the part of both national sites (India and the U.S.) in the production of a heteronormative national subject. Ganesh's response to such a demand is to trace an alternative queer genealogy for the child she once was and the adult she has become; this genealogy detaches the female figure from the heteronormative couple form and rejects the move from child to adult, as Kathryn Bond Stockton phrases it, as "relentlessly figured as vertical movement upward . . . toward full stature, marriage, work, reproduction and the loss of childishness." Stockton coins the notion of "growing sideways" rather than growing up to connote "something that locates energy, pleasure, vitality and emotion in the back-and-forth connections and extensions that are not reproductive."[26] I find Stockton's notion of sideways growth an apt metaphor for understanding Ganesh's own sideways motion through multiple times and spaces. This is particularly evident in the album's final image, where the picture of five-year-old Chitra is followed by the repainted photograph of her mother as a young girl, just as indelibly marked by time and place as the preceding image. The practice of overpainting photographs in India dates back to the mid-nineteenth century and was especially popular in provincial studios throughout the country, particularly in post-Independence India.[27] The layering of paint on photography is itself an anachronistic act that disturbs a teleological move from an older technology of representation (paint) to another, more modern one (photography); the anachronistic quality of this final image underscores the various slippages of both time and place that characterize *13 Photos* as a whole. If we take *13 Photos* to be a genealogical project in Foucault's sense of the term—where genealogy implies a sense of history marked not by linearity and origins but rather by digressions, ruptures, and ellipses—we can understand the figure of the wife, the mother she is to become, and the young girl she once was, as the queer precursors that ghost the present tense of the queer diasporic subject. In Ganesh's act of retrospective queering, the lines of descent, influence, and inheritance between adult and child, mother and daughter, India and the U.S., are shuffled and remade into a different kind of familial and diasporic logic. Ganesh, then, transforms the genre of the family photograph album to create a queer genealogy through the discarded remains of the official archive of familial and national formation (plate 7).

Particularly striking in Ganesh's project of tracing queer diasporic genealogies is the way in which the region is evoked. In *13 Photos* it is the very unlocatability and undecidability of space that opens the door to queer possibility; I find it especially significant that we have no way of knowing quite where these images are set. At various points in the writing of this chapter, I asked Ganesh herself if she knew their location, and her response at the time was inconclusive: she herself didn't know, her father was not forthcoming with a definitive answer, her mother was dead. However, if I were to hazard a guess, the fields and valleys devoid of living figures, the well-tended gardens and lakes surrounded by mountains, the open meadows with snowcapped peaks in the background: all these seem to be stock images that fit squarely into conventional representations of Kashmir, the bitterly contested border territory at the geographic limits of India, Pakistan, and China.[28] In the 1960s and early 1970s, when the original photographs were taken, Kashmir was a popular honeymoon destination for middle-class Indians; as Ananya Jayanara Kabir notes, Kashmir in the Indian nationalist imagination was "the exemplary landscape of erotic desire for modern India . . . a postcolonial playground for metropolitan youth."[29] The pastoral landscape of Kashmir functioned to instantiate a modern, cosmopolitan, heterosexual, national subject, even as it existed within the metronormative Indian nationalist imagination as a space of arrested modernity or as outside of modernity altogether, the "un-modern other for the modern Indian self."[30] Since the 1990s, as the Indian military turned this border area into one of the world's most militarized zones in its fight against both Pakistani forces and those calling for an independent Kashmir, representations of Kashmir within this Indian nationalist imagination shifted from "paradise on earth" to that of a tragic, lost, idyllic utopia always longed for but just out of reach, forever unassimilable and unincorporable within the boundaries of the nation.

Obviously my brief gloss on the tortured relation of the region of Kashmir to the Indian nation does not do justice to its tremendous complexity. My intent here is simply to gesture to the discursive uses to which Kashmir has been put historically within an Indian nationalist imagination, and the ways in which Ganesh is referencing, negotiating, and engaging that history in her own work. *13 Photos* asks us to consider the uses of this "othered" regional space that may or may not be Kashmir—at once so central and marginal to the modern (Indian) nation—within a queer diasporic imagination. In a sense, *13 Photos* demands and schools us as viewers in a reading practice that requires a kind of disorientation, an embrace of the recognition of one's own

always partial knowledge. As I mentioned earlier, as viewers we have no way of knowing if the setting for the photos is or isn't "really" Kashmir. Perhaps they were not taken at the destination at all—whether or not this destination was Kashmir—but rather en route, neither here nor there. I want to interrogate here my own desire as a reader of these images to truly "know" their location, to fix them in both time and space, when they themselves resist any such locatability. The queerness of *13 Photos* lies precisely in the various layers of indeterminacy that it evokes: the figure of the wife/mother is marooned in an alien and alienating landscape; we can never be certain whether this landscape is or is not Kashmir; Kashmir itself remains unfixed and elusive within a nationalist imaginary despite all attempts (discursive, military, and political) to fix it in place, to constitute it as a known and knowable entity and stable geographic territory.

In foregrounding the undecidability of this landscape, I do not mean to suggest that what *13 Photos* gives us is in any way an accurate or authentic representation of Kashmir—that Kashmir is "really" an empty landscape devoid of people or history. I am fully conscious of the materiality and historical specificity of the region that these images clearly obscure. Rather, there may be something useful in Ganesh's evocation of Kashmir through these generic, stereotyped representations as picturesque, empty, natural space. If queerness is a form of disorientation, of being displaced and unplaceable in the alienating landscape of heteronormativity, these images pull us as viewers into that space of disorientation, unknowing, and unlocatability, and demand that we remain there. This is the very valuable reading lesson that *13 Photos* gives us: it shows us how to read "along the grain" of the official archive while it also produces an alternative archive of queer diasporic formation. Even more importantly, it disorients a queer metronormative vision that would locate queerness only in particular places, bodies, or objects. In so doing, *13 Photos* suggests alternative routes to queer desire, subjectivity, and relationality.

OUT OF FOCUS: AGHA SHAHID ALI'S "MYTHIC TERRAIN"

At the same time, I want to affirm that for a viewer of *13 Photos* who is in fact familiar with the actual, lived contours of Kashmir's landscape, these images may not initially occasion disorientation but rather a shock of recognition, where the sight of a particular river, or road, or mountain jars the memory and brings into the present names, places, faces, and dates, along with, perhaps, the memories of horrific violence, oppression, displacement, and dis-

location. Decades of military conflict in Kashmir, after all, have left untold thousands dead and created a disparate Kashmiri diaspora in South Asia and beyond. Thus an exilic viewer of these images may well have a very particular relation to them. This was brought home to me forcefully when I presented an earlier version of this chapter at a conference, and a Kashmiri diasporic scholar approached me with some urgency and emphatically contested my naming of these landscapes as disorienting. She pointed out that someone from Kashmir might know the name and the location of every one of those lakes and mountains and roads in *13 Photos*, and that this landscape takes on added resonance when one is exiled from it.

I want to detour briefly here through work of Kashmiri American poet Agha Shahid Ali, as he beautifully theorizes queerness and region, and the queerness of region, in the context of diasporic dwelling and displacement. Ali's poetry allows us to further explore a queer diasporic relation to a region from which one is forcibly removed, and how this displacement occasions a disorientation of a metronormative vision. Ali was compelled to leave Kashmir first for New Delhi, and then for the U.S., where his peripatetic existence took him to Pennsylvania, Utah, Arizona, and New York, before he died of brain cancer at the age of fifty-two in Northampton, Massachusetts, in October 2001. The point of departure in much of Ali's poetry is his forced exile from Kashmir, a region that was and continues to be a casualty of both successive waves of colonialism and the dueling postcolonial nationalisms of Pakistan and India. Significantly, it is the region of Kashmir—not the nation-states of India or Pakistan—that provides the anchor for Ali's diasporic vision and sensibility.[31] Similarly, his sense of "Americanness" is exquisitely attuned to the contours of region: much of his work evokes the landscapes and layered histories of the U.S. Southwest or Midwest alongside those of Kashmir.

When I was beginning to contemplate writing about Ali's poetry, I was struck by the ways in which questions of sexuality and queer desire both appeared and disappeared in the critical scholarship about his work. A few critics have commented in passing on its homoerotic undertones, as well as on his close, decades-long friendship with his mentor, the gay poet James Merrill. But for the most part, Ali's homosexuality is seen as tangential or irrelevant to the themes of exile, loss, nostalgia, and trauma that echo so powerfully throughout his work.[32] In a departure from this non-engagement with the question of sexuality in relation to Ali's poetry, I want to take queerness seriously as a mode of reading it. I understand Ali's work as exemplary of the

aesthetic practices of queer diaspora not simply because of the orientation of his own desire, but also because of the way in which it demands a disorientation of normative ways of seeing, and of seeing the "region" in particular. His 1987 collection of poetry, *The Half Inch Himalayas*, opens with the poem "A Postcard from Kashmir":

Kashmir shrinks into my mailbox,
my home a neat four by six inches.

I always loved neatness. Now I hold
the half-inch Himalayas in my hand.

This is home. And this the closest
I'll ever be to home. When I return,
the colors won't be so brilliant,
the Jhelum's waters so clean,
so ultramarine. My love
so overexposed.

And my memory will be a little
out of focus, in it
a giant negative, black
and white, still undeveloped.

For the speaker, "Kashmir" as home is multiply mediated, relayed through various technologies of representation. Even actual return will not return home to him; the landscape will never be as perfect as it is in his memory. The postcard, this mundane representation of Kashmir as picturesque landscape, is for the speaker the closest he'll ever get to home; actual return only accentuates the disjuncture between the "giant negative" of home installed in his memory and the lived, messy reality of the place itself. The poem is a recognition of the impossibility of return even if and when physical, geographic return happens. Therefore, if the queerness of *13 Photos* lies in the way it forces us to dwell in a space of indeterminacy, in a space of being lost and disoriented, so too does the queerness of Ali's poem lie in its recognition that our vision is in fact always partial, subjective, limited, fallible.[33] "Postcard from Kashmir" leaves us with a vision of home that is out of focus, a lost and longed-for region where multiple temporalities (present, future, past) collapse onto each other. In this sense, Ali's poem is a gentle riposte to the Kashmiri diasporic scholar who pointed out to me the very particular

knowledge formations that Kashmiri diasporic subjects may bring to such representations of Kashmir. Ali suggests the ways in which, for *all* viewers, perhaps in particular for those with an exilic or diasporic vision, this space of home is multiply mediated and ungraspable in its "true" or authentic form. Ultimately, we, the readers, like the speaker himself, are left to dwell within a disorienting landscape, caught between multiple times and spaces—and this may very well be where queerness lies.

The queerness of Ali's poetry lies not only in how it disorients our vision of "home-as-region," but also in the ways in which this disorientation of vision is occasioned by queer forms of intimacy. At one point while writing this chapter, I contacted the writer Amitav Ghosh, a close friend of Ali, who was "commissioned" by the poet in the months before his death to write what was in effect his eulogy. Upon Ali's death in 2001, Ghosh published his remembrance of Ali in a lyrical essay, "The Ghat of the Only World: Agha Shahid Ali in Brooklyn." I asked Ghosh about what was, to me, the curious silence regarding sexuality in relation to Ali's work. Here is how he responded:

As you will know from the piece ["The Ghat of the Only World"], I wrote it pretty much at Shahid's command. But I did speak to him at some length about it, and he made it clear that there were certain things he did not want to talk about. Since the piece was intended as a testament of friendship, as well as an expression of my admiration for his work, I felt I had to respect his wishes. But even if that were not the case I would not have had much to add. Shahid was not the kind of person who talked about his private life much (at least to me). I really do think that the relationships he cared about most were his professional connections (i.e. with students, teachers, mentors, other poets etc.) and his friendships—these were, in a way, also a part of his life's work and mission.[34]

To me, Ghosh's comment eloquently references the way queerness emerges in Ali's work, as it may have in his life, neither as an overt declaration of homosexuality nor as that which is ensconced safely within the realm of the private. He was not a closeted homosexual or an explicitly out gay poet; indeed the dichotomy of closet vs. outness, public vs. private, are relatively meaningless categories in relation to both his life and work. Rather, the queerness of Ali's poetry lies in the modes of relationality it evinces and occasions: those forms of intimacy between friends, lovers, fellow artists, mentors, and students that, as Ghosh writes, were also "part of his life's work and mission," and constituted his version and vision of "the good life."

The centrality of queer forms of intimacy to re-visioning both time and space is particularly apparent in Ali's 1991 collection *A Nostalgist's Map of America*. One of Ali's most beautiful poems, an elegy entitled "In Search of Evanescence," was written at the height of the AIDS epidemic in the late 1980s and addressed to a friend (perhaps lover) who has died of the disease. "In Search of Evanescence" is made up of eleven loosely connected poems that evoke what Ali terms a "mythic terrain," traversing the Superstition Mountains of Arizona and the flat expanses of the U.S. Midwest, along with the Karakoram and the Hindu Kush mountain ranges of the Himalayas. In an interview a few years before he died, Ali noted how the death of his friend provided the connective tissue that linked poems that "originally had nothing to do with him." Here is an excerpt from one of them:

When on Route 80 in Ohio
I came across an exit
to Calcutta

The temptation to write a poem
led me past the exit
so I could say

India always exists
off the turnpikes
of America...

The signs to Route 80
All have disappeared

And now the road is a river
polished silver by cars

The cars are urns
carrying ashes to the sea

Route 80, queer scholar Scott Herring reminds us, is that straight line of super-highway that connects the metronormative centers of New York City to San Francisco and precludes any detours along the way.[35] If compulsory heterosexuality is one kind of straightening device, as Sara Ahmed notes,[36] we can understand metronormativity as another, one that disciplines bodies and desires into a singular, intelligible, homonormative mode of being gay. Ali's poem takes us off this metronormative grid: we journey through the byways and

backroads off Route 80 that lead us into a different kind of queer territory, where the Ganges and Calcutta exist in the same temporal and geographic frame as the small towns of the U.S. Midwest and the desert landscapes of Arizona. As Ali himself comments on the poem, "It is not just the death of a friend, a simple elegy, but the death of tribes, the death of landscapes, and the death of language. All these things happen simultaneously to create a density."[37] "In Search of Evanescence" speaks precisely to this dense layering of multiple erasures and displacements, occasioned by various forms of historical violence: the AIDS epidemic, the colonial histories of South Asia, the displacement and attempted genocide of Native peoples in the U.S. Southwest.[38] Crucially, it is the queer body and queer relationality—the death of his friend from AIDS—that conjure this palimpsestic landscape into existence; queerness is thus a conduit for seeing and sensing the intimacies of these disparate histories.

STATES OF SUSPENSION: AURORA GUERRERO'S
MOSQUITA Y MARI

For both Ganesh and Ali, the region is a space of both indeterminacy and possibility. Their queered evocations of the region in South Asia and the U.S. produce disorienting and palimpsestic landscapes that reject both a gay and immigrant politics of respectability, and it is here that new possibilities of relationality emerge. I turn now to another example of the aesthetic practices of queer diaspora, Aurora Guerrero's 2012 film *Mosquita y Mari*, which similarly frames the subnational space of the region—in this case, Southern California's immigrant landscape—as the site for a radical repudiation of the developmental logic of gay and immigrant "good life" narratives. As such, the film echoes Ganesh's framing of the family as a densely impacted site where ongoing historical violences are paradoxically both obscured and made apparent. But *Mosquita y Mari* also powerfully resonates with Ligy Pullappally's *Sancharram*, discussed in chapter 1, in that both films capture the lush, dreamy quality of adolescent female homosociality as it slides seamlessly into homoeroticism. In both films, queerness is inextricable from the subnational regional spaces from which it emerges and which are, within a metronormative imagination, presumed to be inhospitable to its flourishing. We can contextualize both Pullappally and Guerrero within what Patricia White describes as a new generation of women feature-filmmakers who produce "world cinema," which she defines as "the aggregate of feature films made ev-

erywhere at least in part for festival and what is called specialty exhibition elsewhere." White argues that this iteration of women's/world cinema is specifically geared towards the "festival and art house ecosystem," which functions "as a privileged one for the cinema of women directors."[39] She notes that these women directors, born for the most part after 1960, have benefited from the financing, distribution, and exhibition opportunities that have expanded in the last twenty years, and are helping "to define the twenty-first-century art house aesthetic," one that "projects a transnational feminist social vision."[40] I find White's framing of "women's cinema, world cinema" useful in situating Pullappally and Guerrero as part of this broader movement within contemporary feminist film culture, rather than as singular or anomalous instances of queer/feminist filmmaking. By placing queer female desire and relationality within the context of the subnational space of the region, both filmmakers project not only a "transnational feminist social vision," as White puts it, but also what we can call a "queer regional" social vision.

The film's website describes *Mosquita y Mari* as a coming-of-age story of two young Chicanas (Mari and Yolanda, whom Mari nicknames "Mosquita") set in the working-class, Latinx enclave of Huntington Park in Los Angeles. Guerrero traces in exquisite detail the feeling—both the sense of possibility and the deadening strictures—of being located in this particular minor, tangential, off-center location.[41] That Guerrero chose to situate her story in Huntington Park rather than in the more recognizable and frequently represented Latinx areas of Los Angeles is significant: in response to an interviewer's query as to why she chose this particular setting, she comments: "East L.A. has been played out so much on films. It's gotten to the point where people across the nation, and even the world, think East L.A. to be the only Latino community in California. Nothing against East L.A., but I wanted to capture a community just west of East L.A. that had its own unique history and vibe. I want to bring Huntington Park out of the shadows."[42] Unlike the geographically indeterminate quality of Ganesh's images, the film immediately situates the viewer in the specificity of this terrain "just west of East L.A." If Ganesh's *13 Photos* demands that we theorize queerness as placelessness, Guerrero's film, like Pullappally's, demands that we consider queerness in place. Against a backdrop of a poisoned landscape replete with endless highways and electrical lines, factories and toxic sunsets, *Mosquita y Mari* beautifully captures the drama and intensity of adolescent female friendship: a moment when the lines between homosociality and homoeroticism are porous and labile, and when desire has not yet congealed into categories of identity. Guerrero has said in interviews

that she wanted to make the film to document her own experience of first love: a way of marking the genealogical beginnings of her own formation as a queer Latina. She comments, "Mosquita and Mari's story is meant to capture the moments that maybe down the line, maybe in college, they will come to discover were their first moments of queerness."[43] One could perceive Guerrero's remark as invoking a straightforward gay developmental narrative, in which one's nascent identity is revealed and discovered through a backward glance from the vantage point of fully formed gay adulthood. Her statement that she seeks to "bring Huntington Park out of the shadows" echoes the language of DREAM activist initiatives such as National Coming Out of the Shadows Day events, which consciously borrow their rhetoric and slogans from the early days of the gay liberation movement and later gay pride events; Guerrero's language implies that her film is similarly committed to a politics of visibility within the public sphere for queer and undocumented youth. While this is clearly part of the political impetus behind the film—it is, like Pullappally's *Sancharram*, an "artivist" project, to use the language of the Undocuqueer movement—the film also exceeds a straightforward politics of visibility and the attendant stability of queer selfhood implied by the language of coming out. Guerrero's young protagonists, like Ganesh's queer child, grow not up but sideways;[44] the film, like Ganesh's *13 Photos*, eschews a linear narrative arc. Instead, *Mosquita y Mari* is finely attuned to the subtle, circular, quotidian rhythms and patterns of existence as "minor" (both as a minor and in a minor space) but also as undocumented, as poor, as female, as racialized, as migrant. Indeed not much happens in the film: it begins and ends in the unremarkable middle, of adolescence (itself a temporary temporal space), of the small and antimonumental pleasures and struggles that give texture and meaning to the everyday. Capturing the scrambled temporality and shifting sense of scale of both queerness and adolescence, the camera lingers in slow motion on seemingly inconsequential details: dust particles hitting the light, a hand silhouetted against the sun, strands of Mari's hair floating in the wind.

Belying the apparent modesty and intimate scale of their concerns, the lives of the protagonists are indelibly marked by multiple histories of U.S. empire, racialization, and neoliberal globalization. It is significant that Huntington Park was initially an aggressively all-white neighborhood that, due to successive waves of deindustrialization, had transformed by the mid-1990s into a predominantly working-class Latinx neighborhood made up of two different demographics: Chicano families from East L.A. in search of upward mobility, and new migrants increasingly displaced and impoverished by neoliberal eco-

FIGURE 2.1 "Estoy cansada," still from *Mosquita y Mari* (2012), courtesy of Aurora Guerrero.

nomic policies in Mexico. The circumstances that created Huntington Park as a working-class Latinx community are mirrored in the circumstances of the protagonists themselves: Mari is undocumented, and her truck-driver father is dead, so she helps to support her younger sister and single mother, a factory laborer, by attempting to insert herself into the informal exchange economy of the street. She is shown constantly looking for work, and one of her jobs is to pass out flyers for a photography studio specializing in family portraits that produce and consolidate the normative nuclear family structure within which Mosquita is firmly embedded, but is emphatically outside of Mari's own reach. Recalling Ganesh's *13 Photos*, one of the very first shots of the film is of Mosquita and her parents posing in the studio for a family portrait; the studio portrait and family photographs are in fact recurring tropes throughout the film, and they speak precisely to an aspirational vision of middle-class success within the racialized migrant imagination embodied by this figuration of the nuclear family.

Mosquita is a straight-A student and the sole daughter of first-generation Mexican immigrants who constantly impress upon her the importance of "making it," through hard work and education, as a way to beat back the poverty that lies just beyond the doors of their neat and orderly home. At one point, when Mosquita's grades start slipping as her friendship with Mari

FIGURE 2.2 Toxic landscapes, still from *Mosquita y Mari* (2012), courtesy of Aurora Guerrero.

deepens, the family silently drives by homeless vendors by the side of the road, prompting Mosquita's father to gravely tell her, "We don't have to go to Mexico to be reminded of what poverty looks like. It's just a few blocks away from us. Your mother and I work very hard to make sure your future is far from this." For Mosquita's parents, the family is seen as a kind of bulwark, indeed the sole protection, against the forces of economic precarity that threaten to engulf them. For them, the only possible motion is forwards and upwards, away from Mexico, from poverty and the perils of what Martin Manalansan calls a perpetually "unsecured life."[45] Lauren Berlant notes that exhaustion is one of the primary affects of neoliberalism, and, in *Mosquita y Mari*, exhaustion saturates the texture of the everyday. Mosquita's parents are shown passed out in front of the television after a long day's work, while the fifteen-year-old Mari is repeatedly exhausted by the daily business of survival: "*Estoy cansada*," she quietly tells her mother, after engaging in an incipient form of sex work to help pay the rent. Early on in the film, the two girls stand on a rooftop and gaze out over the toxic landscape as Mosquita tells Mari, a newcomer to Huntington Park: "I hope you like Huntington Park. Sometimes it smells like pan dulce. Sometimes it smells like chemicals." Mosquita's comment is an astute observation of how working-class communities of color such as Huntington Park often bear the brunt of environmental degradation, even as they create rich social worlds of immigrant life and culture. This is a landscape replete with what Rob Nixon terms "slow violence," a violence that "occurs gradually and out of sight, a violence of delayed destruction that is dispersed across time

and space, an attritional violence that is typically not viewed as violence at all."[46] While Nixon predominantly uses the term to name the delayed temporality of environmental destruction in particular, he also uses "slow violence" to describe various other forms of violence that are "neither spectacular nor instantaneous but rather incremental and accretive, its calamitous repercussions playing out across a range of temporal scales."[47] It is precisely the forms of "slow moving violence," the unspectacular, accretive, and quotidian brutalities visited upon bodies, psyches, and landscapes within neoliberalism, that the film captures through its stretched-out present.

While the girls exist in a landscape characterized by various forms of stasis, punctuated by the ever-present threat of downward mobility, they create their own circuits of sideways movement through the exchange of various objects that both enable and mediate an erotic, bodily intimacy between the two: Mosquita licks an ice cream cone and passes it to Mari, Mari inhales from a joint and exhales the smoke in Mosquita's face, Mari removes the earphones of her CD player (her most prized possession) from her own ears and bequeaths them to Mosquita. The anachronistic quality of the CD player (Mari proudly calls it "classic") signals the scrambled temporality and alternative life-worlds that queer relationality enables. For instance, in one key scene, Mosquita dances in front of the mirror in her parents' bedroom, utterly entranced by her own image as she dons her father's hat and listens to ranchera music on Mari's CD player. The music transports her into the queer world that she shares with Mari, but it also hearkens back to another time and place, a "there and then" of an imagined Mexico prior to her parents' migration, rather than the "here and now" of Huntington Park.[48] Mosquita's reverie is rudely interrupted by her mother, who walks into the room and demands that Mosquita hand over the CD player. As the mother places the earphones in her own ears, she too is momentarily drawn into a queer circuit of exchange as she begins to move to the music and invites Mosquita to dance with her (she leads, no less). This is a lovely moment in the film, a brief intimation of queer couplehood between mother and daughter within the space of the immigrant home itself, but it is abruptly cut short when the mother catches a glimpse of herself in the mirror and calls a halt to the scene. She brusquely brushes off Mosquita's plea that she relate what life was like with Mosquita's father before they migrated, sternly stating that the only thing Mosquita needs to concern herself with is her schoolwork. The scene speaks to the mother's insistence on the here and now, a repudiation of the past and of her former self that is also, obliquely, a repudiation of the queer desire and alternate relationality that she

glimpses in the mirror. The queerness of this scene is not simply in the momentary coming together of mother and daughter into a queer couple form that shadows the "real" queer couple of Mosquita and Mari; it also resides in its evocation of another time and place, through both sound and bodily movement. Faced with the sensorial evocation of this other temporality—not here, not now—and its juxtaposition with the grimness of the present, Mosquita's mother can only respond by attempting to forestall it.[49]

As Mosquita's parents demonstrate, one response to the everyday trauma and deadening strictures of an unsecured life is to shore up the family structure and compulsively adhere to normative notions of success that espouse only forward and upward momentum, but this is not a response available to Mari even if she desired it. Significantly, the shot that follows the scene in the bedroom between Mosquita and her mother is that of Mari on the street as she passes out flyers, gazing at Mosquita's family portrait displayed in the window of the photography studio. Being undocumented means that Mari necessarily inhabits a different temporality than that which is seemingly available to Mosquita. When Mari's mother admonishes her for not caring about her education, Mari responds that she's already figured out that "it's having a green card that gets you an education." Later in the film, when Mari is threatened with suspension after being caught smoking pot in the school bathroom, Mosquita asks her plaintively, "But what about college?" "A waste of time," Mari retorts. Being undocumented in fact situates Mari in a perpetual state of suspension, another temporality within which she has no recourse to the pathways to normative success, and which resonates with the testimonies of several of the UndocuQueer youth activists, who speak of existing in a state of perpetual waiting, of being stuck in limbo, of feeling like their lives are on pause.[50]

Queerness allows for an alternative form of suspension that resists the forward and upward directionality of normative visions of aspirational success. Unlike the stuck or stalled temporality that marks the state of being undocumented, queerness offers another pathway through precarity, one that may be contingent, momentary and tentative, but that nevertheless opens up a different vista of what constitutes success and "making it." In *Mosquita y Mari*, queer desire and relationality take place in those in-between, dead-end, wasted, or anachronistic spaces produced by the merciless logic of a neocapitalist order, that are seemingly without mobility or use-value within this logic: on Mari's bicycle that they ride in circles, in a stationary car they can't drive, on the roof of a broken-down car, along disused train tracks they desultorily

FIGURE 2.3 Forward?, still from *Mosquita y Mari* (2012), courtesy of Aurora Guerrero.

follow on the way home from school, in an abandoned garage that is their primary site of escape and fantasy. Here, Mosquita helps Mari master the art of geometry, tutoring her on the theorems and equations that provide a sense of order, stability, and predictability to Mosquita's world. But the incursion of queer desire and attachment between the two girls provides another kind of geometry to their lives, negating the equation that renders the attainment of the good life synonymous with the privileges of heteronormativity. Here, in the burnt-out garage, Mari narrates to Mosquita her memory of another time and place, her moments with her grandmother in Mexico when she was five years old, prior to her migration to the U.S. "Ten years from now," she tells Mosquita, I'm gonna save up and visit my grandma in Xalapa, Mexico. By then who cares if I can't make it back. Ten years from now, you'll be a doctor or a lawyer, or maybe a truck-driver. You can take me to my grandma's. You can stay if you want." In Mari's fantasy of queer domesticity, the triangulated geometry of the prototypical immigrant family of mother, father, and child (established in the opening shot of the film with the family portrait of Mosquita flanked by her parents) is restructured into a queer geometry of affiliation of Mari's grandmother, Mosquita, and Mari. As in Ganesh's queer reframing of her mother, this then is Mari's queer genealogy, one that instantiates the region-to-region mapping I alluded to at the beginning of this

FIGURE 2.4 States of suspension, still from *Mosquita y Mari* (2012), courtesy of Aurora Guerrero.

chapter. In this case, Mari's queer genealogy is routed in and through Xalapa, Mexico, and the indeterminate minor site "just west of East L.A." that is Huntington Park. The garage — that space of disuse and detritus — becomes a site of what José Muñoz terms "queer utopian memory"; Mari's backward glance "enacts a future vision" of queer relationality that rewrites the standard immigrant narrative structured around a forward momentum away from the past, away from Mexico, and into the locked-down present of kinship normativity.

Thus Ganesh, Ali, and Guerrero each offer us routes to and through queerness that veer off-course from the hetero- and homonormative paths to upward mobility and "making it" that are enshrined in conventional visions of immigrant success. These visions are enjoined both by the U.S. state as it structures the racialized immigrant family, as well as by the postcolonial Indian state as it produces properly gendered, modern, heteronormative, nationalist subjects. The aesthetic practices of queer diaspora suggest other geometries of descent and affiliation that rupture and transform these visions of both gay and immigrant respectability. The sideways genealogies, moments of suspension, and circular, meandering trajectories that these practices engender are rooted and routed in and through the region. The aesthetic practices of queer diaspora thereby allow us to consider what queerness looks and feels like in place (in the specificity of minor nonmetronormative regional locations such as Xalapa, Mexico, or that area "just west of East L.A.") as well

as what queerness looks and feels like out of place, in a space of radical indeterminacy (for instance, in a location that may or may not be Kashmir). In both instances, the alternative cartographies suggested by Ganesh's, Ali's, and Guerrero's remappings of the region are profoundly disorienting: they palimpsestically layer multiple times and spaces atop one another and, in so doing, suggest different forms of relationality that may in fact reorient our vision toward more capacious and hospitable futures.

Diaspora, Indigeneity, Queer Critique

INTIMATE GEOGRAPHIES OF DWELLING AND DISPLACEMENT

Queer relationality, as we saw in the previous chapter, becomes the pathway to disorienting and palimpsestic landscapes; these landscapes in turn speak to the proximity of apparently disparate histories and geographic locations. This chapter further explores how the aesthetic practices of queer diaspora make these proximities apparent. More specifically, it makes a preliminary attempt to contribute to an emergent conversation between diaspora studies and indigenous studies through a queer studies lens. The concepts of diaspora and indigeneity are, more often than not, situated in a binary or oppositional relation to one another: by its very definition, diaspora seems to privilege mobility, hybridity, and uprootedness, while indigeneity seems to privilege belonging, authenticity, and rootedness. The two concepts may also appear to be temporally mismatched: diaspora is often seen as the product and effect of postcolonial migration, whereas indigeneity is often framed in the context of ongoing colonial dispossession. Placing in tandem the work of three artists— the Australian indigenous photographer and video artist Tracey Moffatt, the Pakistani-born mixed media artist Seher Shah, and the Kenyan-Indian/ British photographer and mixed media artist Allan deSouza—as I do in this chapter, may initially appear disjunctive, given that their work appears

to be thematically and formally worlds apart. Nevertheless, this unexpected juxtaposition of cultural forms is in fact the point: it necessitates a critical framework that simultaneously spans both colonial and postcolonial pasts and presents, as well as disparate national and regional spaces (extending from South Asia, to the U.S., to Europe, to Australia). This framework encompasses histories of British colonialism in South Asia, white settler colonialism in the U.S. and Australia, and the racialization of communities of color in the U.S. and in France. The aesthetic practices of queer diaspora thus provide us with a critical model of engaging with difference: a model that does not see past difference, but opens the possibility of forging alliances in and through it. Such a model evinces a deep understanding of conjoined pasts, presents, and futures, and envisions (indeed, insists upon) the possibility of affiliation among nonequivalent and at times even oppositional formations.

In particular, the aesthetic practices of queer diaspora allow us to apprehend the intimacies of the modes of dispossession and displacement that attend to the historical formations of diaspora and indigeneity, in a manner attuned to their singularities and convergences. In other words, these practices gesture to the intertwined nature of various modes of domination that bind non-native racialized migrant and indigenous populations to one another. In so doing, they reveal the interconnected forms of violence and dispossession that characterize U.S., Australian, and European projects of modernity and empire. Just as importantly, the aesthetic practices of queer diaspora also allow us to apprehend the ways in which viable modes of dwelling and rootedness are created in the wake of dispossession and displacement. These processes of displacement, dispossession, and dwelling may very well be obscured within conventional historical archives, and inaccessible through conventional disciplinary approaches. It is in the realm of the aesthetic that we can most clearly see and feel the imprint of these histories that often elude disciplinary or canonical knowledge, that cannot be measured, quantified, or categorized through conventional methodologies, but that nevertheless powerfully shape the contours of our material lives in the present.[1] The aesthetic practices of queer diaspora constitute an alternative archive of what remains submerged within dominant epistemologies, and also demand and enact a reading practice of dominant archives that renders visible their gaps, fissures, and inconsistencies.

The dissonances and points of commonality between formations and framings of diaspora and indigeneity have been the focus of increased attention on the part of both diaspora studies and indigenous studies scholars in recent

years. These scholars point to the ways in which diasporic formations and diaspora studies can be at odds with the concerns of indigenous communities and indigenous studies, in that diaspora studies scholars may not be sufficiently attentive to the collusion of non-Native formations with the project of settler colonialism. As some critics have noted, diaspora studies scholars are not always attentive to alternative, indigenous articulations of nationhood and sovereignty that are irreducible to hegemonic articulations of the nation-state.[2] Clearly, as these critics suggest, a deep engagement with settler colonialism by diaspora studies scholars, and a genuine reckoning with the role played by diasporic formations within this settler colonial project, is necessary for a substantive dialogue between diaspora studies and indigenous studies. In contradistinction to the apparent incommensurability of these two projects, a burgeoning body of indigenous studies scholarship documents the "everyday practices of mobility and dwelling" of indigenous people.[3] These scholars have coined a plethora of terms—such as "indigenous diasporas," "diasporic indigeneity," "Native diasporas," and "Native diasporic consciousness"[4]—to refer to the ways in which indigenous subjectivity is transformed, rearticulated, and extended (rather than lost) in the process of movement and migration away from a traditional land base.[5]

Thus, while the concepts of diaspora and indigeneity may initially appear inherently oppositional, many scholars have rendered in rich historical and ethnographic detail the lived experiences of indigeneity that evince the fluid exchanges between the indigenous and the diasporic.[6] However, if indigenous studies scholars have crucially identified how these exchanges reframe the contours of "indigeneity" itself, diaspora studies scholars have been less adept at engaging deeply with these insights to explore how they might in turn transform an understanding of diaspora.[7] This chapter intends to do just that. If we take diaspora to name the movement of indigenous populations not only across nation-state borders but also across and between different sovereign indigenous nations or tribal land bases, rural and urban spaces, island and mainland, new mappings of diaspora emerge that utterly displace the primacy of dominant nation-state formations as the inevitable loci of diasporic movement. These new mappings point instead to the salience of the diaspora-region, and region-to-region, connectivities that I gesture to throughout this book. I want to emphasize, though, that to identify the shared terrain between the indigenous and the diasporic, as I intend to do here, is not to efface the ways in which non-Native diasporic populations have been conscripted into, and participate in, the project of settler colonial-

ism. A truly effective theorization of settler colonialism demands a complex analysis of the intertwined nature of various historical structures of power and domination.[8] Such an analysis calls for a critical framework nuanced and capacious enough to attend to the imbrication of multiple histories of colonial dispossession and enslavement, indentureship and labor migration, that link disparate geographic regions—Europe, the Americas, Asia, Africa, and the Pacific—to each other.[9]

Queer diaspora studies, and a consideration of the aesthetic practices of queer diaspora in particular, provides just such a framework, and is especially well poised to intervene in the seemingly conflicting investments of diaspora and indigeneity. One of the most useful contributions of queer diaspora studies, as I understand it, lies in its contestation of the heteropatriarchal moorings of the modern nation-state. In pointing to alternative articulations of kinship, community, and affiliation that exceed and are illegible within heteronormative and homonormative nationalist logics, queer diaspora studies offers us an excavation of the dominant, but also, crucially, illuminates the alternatives that have always existed in its interstices. How, then, can queer diaspora's destabilization of the modern nation-state and its heteropatriarchal underpinnings be useful in contesting settler colonialism? Furthermore, how must we rethink the meanings of "diaspora" and "nation," as well as "indigeneity," if we place queer indigenous and queer diaspora studies in conversation?[10] We can begin to answer these questions by looking to the critiques of queer diaspora and queer of color scholarship that have emerged in recent years from indigenous studies scholars. Andrea Smith, for instance, takes such scholarship to task for its a priori presumption of the U.S. settler colonial state, and its complicity with what she terms "the normalizing logics of settler colonialism."[11] More specifically, Smith points to instances in queer diaspora scholarship, including my own work, where queer diaspora's critique of the "nation" precludes a recognition of "alternative forms of nationalism that are not structured by nation-states."[12] Such an erasure of indigenous nations and nationalisms sets up, for Smith, "a problematic juxtaposition of a simple national identity with a complex diasporic identity," a juxtaposition that "reinstates a white supremacist settler colonialism by appropriating Indigenous peoples as foils for the emergence of postcolonial, postmodern, diasporic, and queer subjects."[13] Similarly, Jodi Byrd identifies and cautions against a pervasive tendency within both postcolonial and American studies scholarship wherein indigenous peoples serve merely as "signposts and gravemarkers along the roads of empire."[14] I take these critiques as necessary openings and

challenges to truly engage indigenous studies analyses of settler colonialism from the vantage point of queer diaspora studies.

Clearly, as both Smith and Byrd imply, and as I suggested earlier, rethinking "nation" and "diaspora" in terms of both indigenous nationalisms and indigenous mobilities importantly shifts the frame of queer diaspora studies, and diaspora studies in general. But I also contend that queer diaspora studies and queer of color critique give us an indispensable analysis of the violences that subtend what Chandan Reddy terms "the liberal egalitarian nation-state," and that such a reading of the state is crucial to contesting settler colonialism.[15] In Reddy's analysis of "freedom with violence," the legal inclusion and enfranchisement of sexual and racial others through civil rights protections is the primary mode of domination that characterizes U.S. state power in the twentieth and early twenty-first centuries.[16] An important complement to Reddy's argument can be found in historian Nayan Shah's work, which details the dense thicket of judicial and extrajudicial mechanisms that kept working-class South Asian male migrants to the U.S. in the first half of the twentieth century from settling in the various communities where they labored.[17] The enforced mobility of South Asian migrants that Shah details cannot be equated with a privileged diasporic cosmopolitanism constructed over and against the enforced fixity of Native populations. Indeed, taking Reddy's and Shah's analyses of the mechanisms of state power as our starting point disallows any attempt to valorize a "complex," mobile, diasporic identity over and against a "simple," static, indigenous national identity. Rather, the critique of state power offered by queer diaspora and queer of color scholarship demands that we see both inclusion *and* exclusion, enforced fixity *and* enforced mobility, as mutually dependent parts of the liberal egalitarian nation-state's variegated arsenal for normalizing, containing, and eradicating social formations deemed both out of place and out of time.

This is not, however, to render equivalent these disparate histories.[18] Indigenous studies scholars have long highlighted the dangers of simply folding Native struggles into those of racialized minorities in the U.S.[19] It seems crucial to place the ongoing colonization of Native populations in relation to processes of racialization of communities of color and diasporic communities in the U.S. and elsewhere, but to do so in a way that always attends to the contradictions, points of opposition, and contingent alliances of this relationship.[20] Such a framing may ultimately allow us to more fully grasp the workings of the liberal egalitarian nation-state and its ongoing colonial project, as well as the possibilities for contesting and transforming its killing logic.

It is precisely the intertwining of nonequivalent histories of dispossession and segregation, displacement and dwelling, that are suggested by the aesthetic practices of queer diaspora. These practices allow us to place in the same frame, as it were, the interconnected histories of colonialism and racialization, without rendering them equivalent. Instead, the aesthetic practices of queer diaspora bring into sharp focus a powerful critique of the liberal egalitarian nation-state that is fundamental to both queer diasporic *and* queer indigenous studies projects. The realm of the aesthetic may be a particularly fruitful site for such an inquiry, in that it situates us in the productive state of suspension I referenced in the previous chapter. The aesthetic practices of queer diaspora demand a pause in thinking of the relation of indigeneity to diaspora in terms of either opposition or equivalence, and to think of it instead in terms of affinities, encounters, and conversations that avoid congealing into fixed political positions.[21] I understand the work of Moffatt, Shah, and deSouza as queer and diasporic not only because of the specific identity markers and life histories of the artists themselves, nor simply due to the transnational/translocal circuits within which the works themselves travel. Indeed, none of their work is explicitly homoerotic or references same-sex desire, practices, or subjectivities in any obvious sense. Rather, as we saw in the work of Ganesh, Ali, and Chhachhi in the previous chapters, these art practices teach us how to read: they school us as viewers in a queer mode and method of reading that is as attuned to the ongoing processes of racialization and colonial dispossession in Europe, Australia, and the U.S., as it is to the legacies of colonialism in South Asia. In the work of Moffatt, Shah, and deSouza, I understand queerness to reference both the production and regulation of nonheteronormative bodies, desires, and practices, as well as alternative modes of seeing and sensing these braided histories and their imprint on bodily, psychic, and geographic landscapes. Queerness, in other words, is an optic through which we can glean the unexpected congruences that these histories engender.[22] As I discussed in chapter 1, queerness affords us the "bird's-eye vision" that Sheba Chhachhi so beautifully evokes in her work — a field of vision capacious enough to encompass diasporic mobilities as well as past and present processes of settler colonial violence. The aesthetic practices of queer diaspora, then, constitute a crucial site for alternative renderings of racialization and colonialism, diaspora and indigeneity, that refuse to situate these formations in a hierarchical, equivalent, or binary relation to each other. Instead, these practices allow us to glimpse the shifting grounds of diaspora and indigeneity, and enable a more supple and subtle theorizing of the shared terrain between the two.

PLATE 1 Sheba Chhachhi, "Kaha—Bird," animated lightbox from the installation *Winged Pilgrims: A Chronicle from Asia* (2006/2008), courtesy of the artist.

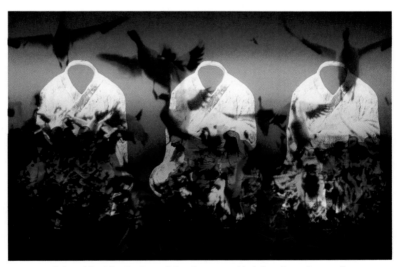

PLATE 2 Sheba Chhachhi, "Robes II," detail, animated lightbox from the installation *Winged Pilgrims: A Chronicle from Asia* (2006/2008), courtesy of the artist.

Bleeding nostalgia—,

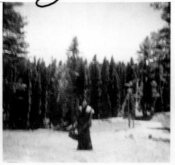

the frayed rose rope

PLATES 3–5 Chitra Ganesh, *13 Photos* (2009), courtesy of the artist, copyright Chitra Ganesh.

PLATE 6 Chitra Ganesh, *13 Photos* (2009), courtesy of the artist, copyright Chitra Ganesh.

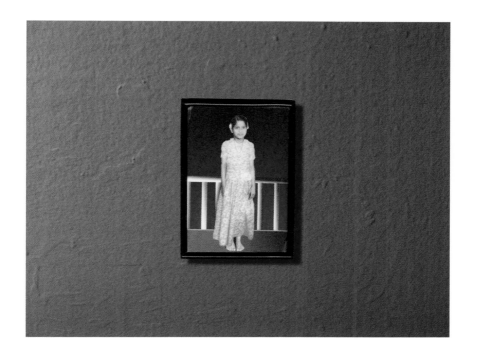

PLATE 7 Chitra Ganesh, *13 Photos* (2009), courtesy of the artist, copyright Chitra Ganesh.

PLATE 8 Tracey Moffatt, from *Suburban Landscapes* (2013), courtesy of the artist and Tyler Rollins
Fine Art.

PLATE 9 Tracey Moffatt, from *Picturesque Cherbourg* (2013), courtesy of the artist and Tyler Rollins Fine Art.

PLATE 10 Tracey Moffatt, from *Picturesque Cherbourg* (2013), courtesy of the artist and Tyler Rollins Fine Art.

PLATE 11 Tracey Moffatt, from *As I Lay Back on My Ancestral Land* (2013), courtesy of the artist and Tyler Rollins Fine Art.

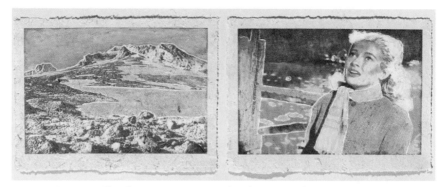

PLATE 12 Tracey Moffatt, from *Pioneer Dreaming* (2013), courtesy of the artist and Tyler Rollins Fine Art.

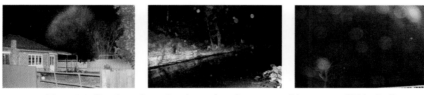

PLATE 13 Tracey Moffatt, from *Spirit Landscapes* (2013), courtesy of the artist and Tyler Rollins Fine Art.

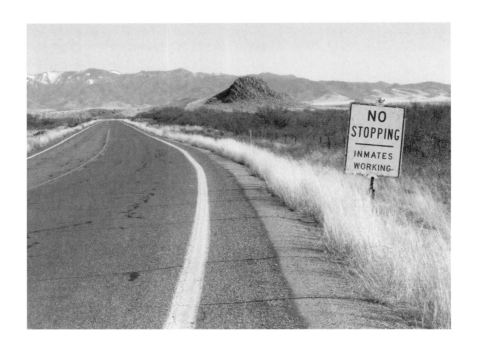

PLATE 14 Allan deSouza, "No Stopping," from *World Series* (2012), courtesy of the artist.

PLATE 15 Allan deSouza, "Blossom," from *The Lost Pictures* (2004), courtesy of the artist.

PLATE 16 Allan deSouza, "Fountain," from *The Lost Pictures* (2004), courtesy of the artist.

PLATE 17 Allan deSouza, "Harambee!," from *The Lost Pictures* (2004), courtesy of the artist.

PLATE 18 Allan deSouza, "Tomorrow," from *The Lost Pictures* (2004), courtesy of the artist.

this is all you may find: your finger on the vanishing point
where public secrets swallow
private lives
behind the bars &
in between the lines
& the question
and before the answer
the unspeakable truth of

(another instance of ... the hardest working kid i've ever seen ...)

Ansar Mahmood for taking a photograph

how many forms will he take?

PLATES 19–20 *Seeing the Disappeared* (2005), courtesy of *Index of the Disappeared* (Chitra Ganesh+Mariam Ghani), copyright Chitra Ganesh and Mariam Ghani.

PLATE 21 Allan deSouza, *UFO 1* (2007).

PLATE 22 Allan deSouza, *Divine 1881* (2007).

PLATE 23 Allan deSouza, "Navigation Chart," from *Through the Black Country* (2017), courtesy of the artist.

DIASPORIC ROOTEDNESS: THE QUEER-SIGHTED
VISION OF TRACEY MOFFATT

Let us begin, then, with the work of celebrated Australian photographer and filmmaker Tracey Moffatt, whose rich and varied body of work has, since the 1980s, powerfully engaged with the gendered and sexual dimensions of colonialism and Aboriginal dispossession in Australia. Moffatt is one of Australia's best-known contemporary artists, and her work regularly circulates in exhibition spaces throughout Europe and the U.S.; I first came across her exhibition *Spirit Landscapes* at the Tyler Rollins Fine Art Gallery in Chelsea, New York City, in 2013. Moffatt's visibility within the global art market means that critics tend to readily position her as representative of any number of minoritarian categories (such as "feminist" or "indigenous"), a positioning that she herself continuously resists.[23] In my engagement with Moffatt's work, I hope to avoid replicating such tokenizing gestures; while I am mindful of not making her bear the conceptual weight of "the" indigenous artist in this chapter, I do want to suggest that her work speaks precisely to the necessity of bringing the insights of indigenous studies to bear on diaspora studies. It therefore provides a critical opening within both fields that underscores the ways in which diaspora and indigeneity are always already co-implicated. Viewed solely through a diaspora studies lens, one risks misreading as essentialist Moffatt's complex articulation of an embodied subjectivity formed through a deep connection to place and land. Viewing the work instead through a queer optic reveals how this deeply rooted connection to place and land is forged precisely through diaspora and displacement. In other words, the sense and feeling of indigeneity in Moffatt's work is apparent in her attachment to home, land, and landscape, even as she approaches these sites and concepts from the vantage point of displacement, migration, and diaspora. Thus, queer visual aesthetic practices such as Moffatt's require and indeed demand a mode of reading that reveals the imbrication between the diasporic and the indigenous. Queerness is an optic through which to read this co-implication of the diasporic and the indigenous; it allows us to see and to sense occluded histories—specifically of settler colonial violence—and how they continue to imprint the present. But queerness also names the ways in which "the normalizing logic of settler colonialism"[24] produces sexually and gender nonnormative bodies that are then subject to discipline, containment, and regulation. Moffatt's work makes apparent how indigenous bodies are "queered" by settler colonialism, in the sense of being positioned as aberrant,

perverse, and deviant. In other words, queerness in Moffatt's work is both a critical hermeneutic and a positioning outside of white settler normativity.[25] And, finally, Moffatt's queer-sighted vision enables a glimpse of what José Muñoz terms a "forward-dawning futurity," a vision of an alternative landscape that counters the deadening strictures of the here and now.[26]

Moffatt, the daughter of an Australian Aboriginal mother and a white Irish father, was raised along with her three siblings by a white foster mother in a working-class suburb of Brisbane, Australia. I focus here on *Spirit Landscapes*, one of her most autobiographical works, where she returns to the site of her childhood after twelve years of living in New York City. Moffatt has eschewed directly biographical readings of her work, and has also been reluctant to be labeled as an "Aboriginal" or even "Australian" artist.[27] Such a stance has led some critics to argue that she represents an urban indigeneity that embraces diasporic cosmopolitanism at the expense of, and at odds with, her indigenous roots. These critical engagements with her work reproduce precisely the commonplace understanding of the relation between diaspora and indigeneity as inherently oppositional. For instance, art historian Ian McLean notes that "Gordon Bennett and Tracey Moffatt, the best known of . . . urban art practitioners, discount their Aboriginality and make art that follows, in an almost classic sense, the post-colonial paradigms of migration—of exiles, diasporas and strangers. . . . However, these paradigms privilege a particular set of experiences that do not match those Aborigines who still walk with their ancestors."[28] In fact, if we read Moffatt's work as queer in the different senses I suggest above, it evinces a complex interrelation between the diasporic and the indigenous that, far from "discounting" her Aboriginality, clearly draws on personal and collective histories and symbolic repertoires. The vexed psychic and material legacies of Australia's Aboriginal child removal policies—where Aboriginal children were systematically taken from their birth families and placed in missionary or government boarding schools, or with white families—as well as the ongoing history of Aboriginal dispossession more generally, provide the emotional undercurrent for much of Moffatt's work.

This is particularly clear in *Spirit Landscapes*, made up of five distinct photographic series of digital prints, which unabashedly engages with the artist's own fraught familial history and ancestral past. When shown at the Tyler Rollins Fine Art gallery in 2013, *Spirit Landscapes* opened with the series *Suburban Landscapes*: six black-and-white photographs of unremarkable suburban streets overlaid with brightly colored water-crayon text that, as the gallery statement puts it, "acts like a semi-transparent veil of memory over the streets

of [Moffatt's] youth" (plate 8).[29] The stenciled phrases—"bullied here," "stole a Mars Bar," "tea at the Reverends," "tossed flower petals," "crossed the creek," "to guitar lessons"—are rendered in capital letters that stretch to cover the entire surface of the print. The images memorialize the quotidian acts and ordinary affects, the minor moments of trauma, pleasure, excitement, and boredom, that saturate the experience of childhood and adolescence. Reminiscent of Chitra Ganesh's *13 Photos*, the interplay between text and image in *Suburban Landscapes* both indexes and collapses the temporal and geographic distance between the adult Moffatt recently returned from New York, and her childhood self in Brisbane of the 1960s and 1970s; indeed, the images keep these multiple temporal and geographic frames in play. In interviews Moffatt has spoken of the Brisbane of her youth as "a holiday paradise—the heat, the joy, but also the terrible mood of fear and racism."[30] Moffatt's ambivalent relation to this space of "home" ("the heat and the racism and the redneck attitudes," as she puts it[31]) is evident in the disjuncture between the meaning of the text itself and the images of apparently innocuous suburban streets overlaid with cheery crayon colors: the stark phrase "bullied here," for instance, is an assertion of and testament to the quotidian violences that are just as much a part of the fabric of everyday life as is the heat and boredom of "those endless Brisbane summers."[32]

Moffatt's relation to home as a site of both belonging and unbelonging is even more apparent when we view *Suburban Landscapes* alongside *Picturesque Cherbourg*, a series of six digital print collages that was exhibited adjacent to it at Tyler Rollins (plates 9 and 10). Initially, the *Cherbourg* images appear to be picture-postcard-pretty, color-saturated landscapes of white picket fences and neat clapboard houses set against lush foliage and a bright blue sky filled with cottony clouds. A closer look, however, reveals the images to be in fact composed of photographs torn apart and then imperfectly sutured together to make apparent the breaks, shards, and ruptures in this vision of the picturesque. Cherbourg itself is an Aboriginal "settlement" founded in the late nineteenth century through the forced segregation, containment, and removal of disparate Aboriginal communities from all over Queensland, in Northern Australia. Moffatt's own family members were relocated to Cherbourg in the 1920s, and their descendants continue to reside there.

In order to appreciate the full import of Moffatt's images, it is helpful to consider the specific meaning of the "picturesque" in relation to Australia. As an aesthetic ideal, the picturesque emerged in late eighteenth-century Britain

as a way of mediating between the sublime and the beautiful; landscape paint-
ers turned their attention to creating "picturesque" images of Scotland, Wales,
and the Lake District, for instance, in order to render these unfamiliar land-
scapes as "unthreatening, 'safe,' and accessible."[33] As social geographer Allaine
Cerwonka notes, "Landscape painting [in Britain] in particular de-politicized
the effects of the displacement of the peasants from the countryside by creat-
ing beautiful melancholy landscapes . . . absent of beggars and gypsies who in-
creasingly populated such landscapes in the nineteenth century. Picturesque
landscape painting converted poverty and industrialization into art and thus
kept it at a manageable distance from the bourgeois and the upper class."[34]
Cerwonka details how this British ideal of the picturesque was deployed in
the white settler colony of Australia not only through visual technologies
such as painting and photography but also through the actual reshaping of
the land itself—for instance, the imposition of English-style gardens onto
the Australian landscape: "The aesthetic production of the landscape was a
useful method for mystifying the colonial appropriation of land underway
in Australia. Turning the Australian continent into an English countryside
and farmland helped erase the physical evidence of Aboriginal presence and
influence on the land."[35] The production of the picturesque was a key aes-
thetic strategy which rendered an unfamiliar and threatening landscape both
knowable and familiar. It enabled white settlers to imagine an organic tie to
the land, naturalizing Aboriginal dispossession and laying claim to Aboriginal
lands under the legal doctrine of *terra nullius*: empty land belonging to no
one, and therefore available for white settlement.

It is precisely this mystification of colonial domination, and the erasure of
colonial violence in the framing of the picturesque, that Moffatt's *Picturesque
Cherbourg* both references and dismantles. Moffatt's disquieting collages
of ruptured landscapes and visions of "home" directly reference the spatial
practices of settler colonial domination in Australia. The apparent "pictur-
esqueness" of Cherbourg belies its history as a key site of containment, seg-
regation, and disciplining of Aboriginal peoples; "inmates" (as its Aboriginal
inhabitants were called) needed permission from settlement authorities to
enter or leave Cherbourg until well into the 1970s. Various historians and
first-person accounts have detailed the intense forms of "bodily and sensory
regimes"[36] that governed every aspect of inmates' lives. These forms of disci-
pline, surveillance, and regulation were spatialized in the built environment
of Cherbourg itself, which was split into two distinct areas: the "camp do-
main," where the majority of Aboriginal inmates lived, and the "administra-

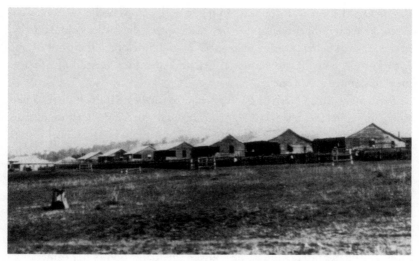

FIGURE 3.1 Inmates' cottages on Barambah Aboriginal Settlement (renamed Cherbourg), circa 1925.

tive domain," reserved for the white supervisors, along with a number of favored Aboriginal inmates.[37]

These inmates lived in small timber cottages that they built themselves and that were meant to foster a European heteropatriarchal domestic ideal, even as this ideal was impossible to achieve, given the system of child removal and labor exploitation in place. Family units were routinely disaggregated, with adults forced into gendered forms of labor (domestic labor for the women, manual labor for the men), while children were housed in sex-segregated dormitories away from their biologically related kin. Historian Thom Blake describes as follows the housing spaces of inmates: "These cottages were identical in form and located on small blocks and enclosed by timber fences. The cottages were provided for 'better' inmates who demonstrated they could adopt white norms of behavior and family life."[38] In light of this history, Moffatt's photographs of seemingly innocuous, even banal images of flowers and sky, tidy houses and white picket fences, take on a far more chilling valence: this is the built environment of settler colonial power, where the houses and fences, lawns and gardens, are not simply markers of suburban domesticity. Rather, as Moffatt's fractured images indicate, this architecture indexes the transformation of bodies and landscapes deemed threatening and antithetical to white settler norms of racial, gendered, and sexual order. *Picturesque*

Cherbourg, then, reveals the ways in which indigenous bodies—seen as co-extensive with indigenous land—are "made queer" by settler colonial logic, in the sense of being positioned as aberrant and developmentally out of step with European civilizational modernity, and therefore in need of management and transformation.

Settlements like Cherbourg were meant to inculcate in its inmates a personal and collective historical amnesia through the criminalization and attempted eradication of indigenous languages, spiritual belief systems, kinship, and entire ways of life. Consequently, what does it mean for Moffatt to claim this space, which attests to the ongoing violence of the settler colonial project, as home? At Tyler Rollins, directly facing *Picturesque Cherbourg* on an opposing wall, were displayed the most visually striking photograph series in the exhibition, entitled *As I Lay Back on my Ancestral Land*. In six large-scale (49 × 72 in.) images, each of which is shot through a differently colored monochromatic filter, Moffatt lies on the earth and points her camera upward, capturing trees and sky; the outlines of nude female figures are faintly discernible among the clouds and tree branches (plate 11). As art critic Kathryn Weir comments on the images, "The view from the ground of sky and trees is radical; photographic conventions favor the heroic tree portrait or the sweep of forest captured from above or yonder."[39] Moffatt's claiming of "her" "ancestral land" is not a repossession, in the sense of the ownership, control, and mastery that characterize a settler colonial relation to land. What emerge instead are landscape photographs that reject the generic conventions of landscape photography; given their vantage point from the ground, looking up, away from the earth, in Moffatt's photographs the earth itself is felt and sensed rather than seen, manipulated, or controlled.

Yet *As I Lay Back on My Ancestral Land* could also be read as reinscribing essentialist notions of an inherent connection between the female body and nature, and the indigenous subject and land/geography; certainly Moffatt's title makes the work available to such an interpretation. If read solely through what I would call a "narrowly diasporic" lens, Moffatt's apparent conflation of female bodies, indigeneity, and landscape appears indicative of what Stuart Hall terms "a backward looking conception of diaspora," marked by "the endless desire to return to 'lost origins', to be one again with the mother, to go back to the beginning."[40] Moving through the gallery space from *Suburban Landscapes* to *Picturing Cherbourg* to *As I Lay Back on My Ancestral Land*, one could read *Spirit Landscapes* as tracking a movement backwards, from the place of displacement to the place of origin: from Brisbane,

to Cherbourg, to the female body, and to the land itself. But such a critique of Moffatt's work would in fact misread the far more complex relation she maps out between her own embodied subjectivity and the space of "home" in all its valences.[41] As both *Suburban Landscapes* and *Picturesque Cherbourg* make clear, Moffatt's claiming of "ancestral land" is a complicated, hard-won negotiation of various home spaces, all of which are simultaneously spaces of comfort and intense discomfort, multiply displaced, rent, and dislocated. Her images speak to what I would term a "diasporic rootedness": her sense of being indigenous to the land is in fact rooted and routed in and through diaspora and the myriad dislocations and historical violences that both Cherbourg and the working-class suburban streets of Brisbane represent.[42] Moffatt's framing of "ancestral land" thus holds important lessons for queer diaspora studies, a field which has long sought to disrupt narratives of origin and return. In Moffatt's work, "ancestral land" is simultaneously a space of displacement; to "lay back" on it is to lay claim to it, and to inescapably reckon with traumatic histories of dispossession and the ambivalent modes of affective connection to and alienation from "home" they engender. Her understanding of "ancestral land" precludes any simple claiming of such space as home, origin, or site of return.

In Moffatt's work, there is no generalizable category of "the land" or "the female body."[43] Her transposition of nude female figures onto the sky and trees must be read within the specific history of white settler appropriation of indigenous lands and the gendered and sexual regulation of indigenous bodies. In light of this history, *As I Lay Back on My Ancestral Land* may in fact envision an alternative cosmology, a utopian landscape of possibility which José Muñoz would name "queerness": a "forward-dawning futurity" that "is visible only in the horizon."[44] Countering the multiple histories of violent dispossession and forced containment that continue to exact a brutal price on indigenous bodies and lands, Moffatt's imaginary landscape—or, rather, dreamscape—dares to imagine other ways of being in the world that are not beholden to settler colonialism's normalizing logic. It does so by envisioning a way of dwelling in displacement that wrests and lays claim to home spaces long the site of the violent imposition of settler colonial norms and regulations.

This white settler logic is directly referenced in *Pioneer Dreaming*, a series of six smaller, rather unassuming hand-painted photographic diptychs which were exhibited at Tyler Rollins as a kind of bridge between *Suburban Landscapes* and *Picturesque Cherbourg*. The right frame of each diptych depicts a white female heroine from classical Hollywood or Australian western cinema gazing out across the Australian outback, while the left frame of each diptych

evokes the expansive landscape in subtle gradations of black, yellow, and red (the colors of the Australian Aboriginal flag) (plate 12). Historian Margaret Jacobs has detailed the crucial role that white women played in U.S. and Australian settler colonial projects in their effort to regulate indigenous bodies and minds.[45] In Moffatt's foregrounding of the white heroine of popular U.S. and Australian cinema, we can understand *Pioneer Dreaming* to reference this gendering of settler colonial power and the centrality of maternalist discourses to indigenous dispossession in both national contexts. Moffatt has shied away from claiming that her work draws on "traditional" mythologies and belief systems, preferring to speak of it as articulating a highly "personal mythology."[46] Nevertheless, both the landscapes of *Pioneer Dreaming* and *As I Lay Back on My Ancestral Land* can be read as specifically evoking the continued salience of Aboriginal notions of "Dreaming"—a complex cosmology and spiritual system that maps "the rich histories of ancestral sites and tracks that locate individual identity in particular places."[47] Kathryn Weir notes that the subdued ochre tones of the landscapes in *Pioneer Dreaming* recall the magisterial watercolors of Albert Namatjira, the mid-twentieth-century Aboriginal painter who mastered the "Western" art of watercolor painting, and Ian McLean argues that Namatjira's landscapes "depict a transcendent stillness through which Namatjira claims the modernity of Arrernte spiritualism and thus the continuing presence of Dreaming."[48] Similarly, Moffatt's evocation of the "transcendent stillness" of Namatjira's landscapes in *Pioneer Dreaming*, together with the dreamscapes of *As I Lay Back on My Ancestral Land*, suggest the ongoing resonance and power of alternative personal and collective cosmologies. These cosmologies provide a direct rejoinder to the *Pioneer Dreaming* of the white settler imagination, one that is replete with images of indigenous bodies and lands in need of civilizational uplift and cultivation.

Moffatt's final series in *Spirit Landscapes* is *Night Spirits*, eight triptychs set apart from the main gallery space in a small, almost completely darkened room. The images of the Queensland outback—of desert landscape, a lone house, a telephone pole along the road, a river—are repeated and displayed in different permutations and through different monochrome filters of red, blue, green, or yellow (plate 13). What emerge are eerie nightscapes seemingly devoid of living beings, populated solely by ghostly, indeterminate white shapes, splotches, and shadows. The series seems to consciously mimic the "spirit photographs" that gained tremendous popularity in Europe in the nineteenth century; according to Elspeth Brown and Thy Phu, spirit photographs were meant to capture the so-called "ectoplasm" believed to be the

"materialized phenomena for the world beyond the senses. Photographs were the medium for translating or making visible, indeed material, that which would otherwise be invisible."[49] Kathryn Weir writes of the process by which Moffatt created these images: "Moffatt drove alone at night along isolated roads in outback Queensland. She would stop the car and slowly and deliberately set up the camera, while the small hairs rose on the back of her neck and a tingle of fear sharpened her senses. The resulting intense, luminous images show strange traces populating the night, suggesting some lingering plasma residue of untold lives."[50] Moffatt here turns to the sensorial—the feeling of fear and the bodily and mental transformations it causes—as a way to capture and render visible the specters of past violences. These violences continue to haunt the present and cannot be apprehended simply through conventional technologies of representation that seek to capture "evidence" that is visible, quantifiable, and measurable. These apparently deserted landscapes are in fact teeming with the bodies of the dispossessed that can only be sensed and felt in and through the body: Moffatt's body and, by extension, the body of the viewer, who is in turn pulled into the state of trepidation that initially gave rise to these images. Spectrality is, in fact, a recurrent theme in Tracey Moffatt's work; as Gerry Turcotte notes, through Australian government policies such as *terra nullius* and child removal laws, "Aboriginal people were made ghostly . . . turned into insubstantial spectres haunting their own land, a process that was reinforced in wider government policy, in historical record-keeping, in map-making, and . . . in literary figurations."[51] Moffatt's work responds to this "imperial legacy of spectralizing Indigeneity"[52] not only by conjuring forth the ghosts that colonial violence produces, but by insisting on their materiality, as they act on, and interact with, bodies and landscapes in the present.

Moffatt's work makes evident how the aesthetic practices of queer diaspora are precisely that: a practice and a doing, a reading strategy and a viewing tactic, that allow us to see and to sense differently. *Spirit Landscapes* quite literally enacts a queer-sighted vision that allows us to see the ghosts that live among us, that continue to shape our daily and nightly existence whether we are conscious of their presence or not. "Queerness," in Moffatt's work, also names a positioning outside of white settler normativity, even as it is a way of imagining alternative futures and possibilities, modes of dwelling and making home, despite brutal histories of dispossession, displacement, and regulation. In claiming Moffatt's work as an important instance of the aesthetic practices of queer diaspora, I do not wish to engage in a colonizing move that simply absorbs articulations of indigeneity under the sign of diaspora. Rather, I hope

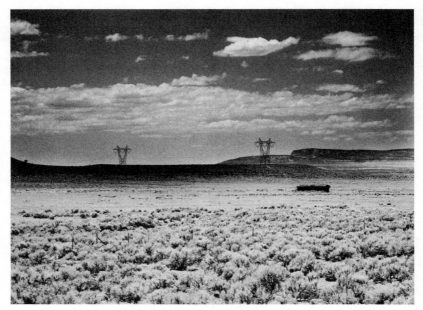

FIGURE 3.2 Seher Shah, *Open Lines*, from *Hinterland Structures* (2011), courtesy of the artist and Green Art Gallery.

to have illuminated the complex interaction and interrelation between the diasporic and the indigenous that her work maps out: the ways in which indigeneity is routed through diaspora, just as diaspora is rooted in indigeneity. Moffatt's work thereby enacts a queer method that foregrounds the intertwined nature of these apparently discrete and oppositional concepts.

DWELLING IN DISPLACEMENT:
ON THE ROAD WITH SEHER SHAH

If Tracey Moffatt encounters the specters of colonial violence along the backroads of rural Queensland, Australia, the Pakistani-born artist Seher Shah encounters them along the highways and byways of the American West. Shah's work allows us to further theorize the queerness of diasporic dwelling and displacement, and the shared space between the diasporic and the indigenous these histories of housing and unhousing engender. Shah was initially trained as an architect before turning to drawing, sculpture, and photography. I focus in particular on her 2011 work *Hinterland Structures*, a series of lightboxes of postcard-size photographs that Shah took of the American West and

Southwest, where barren desert landscapes are interrupted by "strangely alien man-made structures," as her gallery statement puts it.[53] In placing Tracey Moffatt's work alongside that of Seher Shah, I suggest the uses of a comparative framework that makes evident the resonances between the spatial practices of different imperial and settler colonial projects, all of which seek to segregate and regulate variously racialized and colonized populations. But this juxtaposition of the work of Moffatt and Shah also makes apparent how such populations imaginatively respond to and contest these various forms of racial and colonial violence by finding ways to viably dwell in the context of displacement and dispossession.

Hinterland Structures was part of Shah's 2011 solo exhibition in New York City entitled *Object Anxiety*, which included two large-scale works. The first, *The Mirror Spectacle* (2010), is a black-and-white digital giclée print, measuring almost five by ten feet, that takes as its starting point the official photographic archive of the 1903 Delhi Durbar, the grandiose coronation ceremony for King Edward VII meant to underscore the incontrovertible power and authority of British colonial rule in India. Shah describes the piece as follows: "I reconstructed the semicircle of the amphitheater [where the ceremony was held] through layers of drawing and digital processes. By intentionally flattening out the perspective, I employed a drawing method that created an alternative view of historical event and removed the hierarchy involved in the photographic image."[54] In Shah's imaginative deconstruction of this colonial "spectacle of force" (as Shah names an earlier work in this series), the ghostly white photographic negatives of colonial monuments are overlaid and interspersed with Shah's own intricate, exquisitely detailed drawings of buildings and figures, some of which suggest the contours and ornamentation of Islamic architecture.

The second large-scale work in *Object Anxiety*, entitled *Object Relic (Unité d'Habitation)* (2011), deconstructs iconic modernist architect Le Corbusier's famed housing project Unité d'habitation (which roughly translates as "Living Unit"), completed in 1952 on the outskirts of Marseille, France. Le Corbusier's building—originally meant to house those displaced and rendered homeless by World War II—is cited as a prime example of the early Brutalist architectural style that he initiated and promoted, with its characteristic use of "raw concrete," straight lines, stocky pilotis, voluminous dimensions, and utter lack of ornamentation. The Swiss photographer René Burri, one of the main visual documentarians of the architect's life and work, published a series of photographs detailing everyday life within the famed structure.

FIGURE 3.3 Delhi Durbar, 1911.

FIGURE 3.4 Seher Shah, *The Mirror Spectacle* (2010), courtesy of the artist and Green Art Gallery.

One 1959 photograph, taken of the interior of a Unité apartment, depicts a prototypical nuclear family (mother, father, two children) sitting down to dinner; the gaze of the camera is firmly centered on the figure of the father, who appears a paragon of masculine respectability in a crisp white shirt and black tie, as he deliberately cuts into his dinner. His gestures are mimicked by his equally properly dressed daughter, her face partially visible in profile, who sits opposite him and also attends to her dinner in the same methodical fashion. The faces of the other family members are wholly obscured: the mother has her back to the camera as she tends to the needs of the other child, who is almost fully hidden by her mother's body. The interior of the apartment itself, with its lack of clutter and clean minimalist lines, both enables and is an extension of the structure and order of the family unit. The photograph is telling in that it depicts an idealized vision of the hygienic domesticity that Le Corbusier's designs were meant to foster. The photograph makes clear how the architect's housing structures—as "machine[s] for living in," as he famously dubbed them in 1923—interpellate a very particular social order; Le Corbusier imagined precisely this heteropatriarchal nuclear family as the ideal inhabitant of his housing unit, which epitomized his vision of a forward-looking, utopian modernity.

Shah's radical reimagining of the Unité evokes the massive scale of the original structure in a six-by-eight-foot graphite and gouache black-and-white drawing that reduces the building to its most elemental forms; as one critic puts it, "It is a trademark of Shah's work in general to reiterate urban structures such as buildings, amphitheaters, and monuments in their most minimal forms—squares, rectangles, triangles, crosses, and lines."[55] Shah proceeds to flatten out the original structure's imposing height and mass, creating a grid-like effect out of these "minimal forms" that is interrupted by finely rendered curving, swooping lines, and cloudlike streams that also evoke wind and water. The entire drawing is dominated by a massive, solid black trapezoidal shape that cuts through its center and effaces what lies beneath. These two large-scale works occupied the main room of the gallery when they were shown as part of the 2011 *Object Anxiety* show, while *Hinterland Structures* was housed in a small room off the main space and initially seems utterly distinct, both formally and thematically, from the large-scale drawings. But in fact all three works—*The Mirror Spectacle, Object Relic (Unité d'Habitation)*, and *Hinterland Structures*—evince Shah's interest in exploring and exploding the hierarchies and power dynamics inherent in the relation of built structures to landscape and the way they organize spaces and bodies.

FIGURE 3.5 Le Corbusier's
Unité d'habitation,
Marseille, France.

FIGURE 3.6 René Burri, interior of a Unité d'habitation apartment, 1959.

FIGURE 3.7 Seher Shah, *Object Relic (Unité d'Habitation)* (2011), courtesy of the artist and Green Art Gallery.

The unexpected juxtaposition of multiple times and spaces in the *Object Anxiety* show — colonial India in 1903, postwar France in 1952, and the U.S. West and Southwest in 2011 — is characteristic of much of Shah's work. In an astute assessment of an earlier iteration of *The Mirror Spectacle* (Shah's 2009 *Geometric Landscapes and the Spectacle of Force*), Bakirathi Mani comments that Shah "provocatively alters nationalist frameworks.... [She binds] together memories of the British Empire in South Asia with the domestic expansion of empire in the United States." As such, Mani argues, Shah's work "demands a different historical perspective on South Asian diasporic visual culture, a narrative that is necessarily triangulated among the legacy of British colonialism, decolonization movements on the subcontinent, and the emergence of the U.S. as a global power."[56]

Similarly, the monumentality and iconicity of the built structures in both *The Mirror Spectacle* and *Object Relic (Unité d'Habitation)* speak to the utopian visions of European colonial states (Britain and France) in their desire to organize, contain, segregate, and discipline bodies and populations both at home and abroad. But at a 2012 conference at Cornell University, Shah spoke of how she understood *Object Relic (Unité d'Habitation)* to also allude to failed utopian modernist projects in the U.S., in particular the infamous

Pruitt-Igoe public housing project in St. Louis, Missouri. Designated as racially segregated housing from its inception, Pruitt-Igoe was built in 1956 and torn down in the mid-1970s; the image of its demolition in 1972 was broadcast nationwide and became an iconic emblem of both "urban blight" and of modernism's failure.[57] Shah's evocation of Pruitt-Igoe during her discussion of *Object Relic (Unité d'Habitation)* is significant: while there is no explicit reference to Pruitt-Igoe in *Object Relic (Unité d'Habitation)* itself, Le Corbusier's modernist utopian vision and Brutalist style, of which his Unité d'habitation project is paradigmatic, directly influenced Yamasaki's vision for Pruitt-Igoe as well as countless other high-rise, high-density public housing projects throughout the world, often with disastrous results. In the 2011 documentary *The Pruitt-Igoe Myth* (dir. Chad Freidrichs), the former inhabitants of Pruitt-Igoe, who are overwhelmingly African American, speak poignantly of the stringent government regulations that ordered their daily lives and domestic space. Certainly their lives could not be further from the idealized heteropatriarchal domesticity envisioned in the 1959 René Burri photograph of Le Corbusier's Unité; the former Pruitt-Igoe inhabitants instead attest to the welfare regulations that did not allow men to reside in the apartments, thereby producing and reproducing precisely the "pathological" family structure of black female-headed households decried by the infamous Moynihan Report in 1965. The spectacular failure of Pruitt-Igoe starkly reveals state-sanctioned ideologies of sexual respectability that are deeply classed, gendered, and racialized. These ideologies provide the state with a measuring stick of what constitutes worthy and deserving inhabitants of public housing, and speak volumes about the state's investment in shoring up patriarchal heteronormativity even as it makes the conditions for achieving such normativity impossible for racialized communities. *Object Relic (Unité d'Habitation)* can thereby be seen as a necessary corollary to Tracey Moffatt's *Picturesque Cherbourg*: if Moffatt's work reveals the spatial practices of settler colonial power in its management of indigenous bodies and lands, *Object Relic (Unité d'Habitation)* gestures to the ways in which these utopian built environments are central to the state's biopolitical regulation and surveillance of racialized populations. The production of these populations as perverse and deviant provides further justification for their continued regulation. *Object Relic (Unité d'Habitation)* conjures forth multiple geographies and time periods as it jumps scale—from the monument to the domestic space to the body itself—in order to reveal the mutually constitutive nature of these disparate locations.

FIGURE 3.8 Still from *The Pruitt-Igoe Myth* (dir. Chad Freidrichs, 2011).

Hinterland Structures more explicitly and quite radically shifts our scale of vision to document the resolutely antimonumental and the noniconic: these are photographs taken by Shah on a meandering road trip across California that passed through Utah and Arizona, as she turned her lens on what seem to be temporary, everyday structures built not of concrete and marble but of wooden planks, plastic, corrugated metal. The resulting images of churches, sheds, trailers, and houses are presented in small scale, in the form and size of a postcard, itself a genre that is temporary, intimate, informal; Shah has said, in fact, that she initially did not intend these images for exhibition at all. However, a closer look at *Hinterland Structures* reveals that it too references the histories and continuing processes of colonial expansion, as well as state power and authority, that are referenced by *The Mirror Spectacle* and *Object Relic (Unité d'Habitation)*. While the images deflate and demonumentalize the archetypal structures of colonial and state power, they also suggest alternative modes of archiving and remembering these converging historical violences. What is particularly striking about Shah's "postcards" is that her "hinterland structures" are placed in landscapes that, like Tracey Moffatt's nightscapes, are seemingly utterly devoid of living beings: there are no bodies, human or otherwise, to be found in the frame. María Josefina Saldaña-Portillo notes that "Anglo-American colonization required not only the dispossession of indigenous peoples

(and mestizo Mexicans) for the expansion of the U.S., but also the banishment of the figure of the Indian from the national imagination."[58] Shah's postcards, in their depiction of the desert landscapes of California and the U.S. Southwest as absent of living beings, may initially seem to reiterate the dominant representation of the region in the U.S. popular imagination as "a barren landscape of radical loneliness,"[59] as Saldaña-Portillo terms it, one that simply reinforces this "displacement of the Indian from the American landscape."[60]

I would argue that the seemingly empty landscapes of Shah's postcards serve not to reinforce a settler colonial logic of elimination, but, as with Moffatt's work, to lay bare this logic and to call attention to past and continuing processes of displacement and dispossession. Interspersed among other images of apparently unremarkable "hinterland structures," such as a corrugated iron church and a trailer home that interrupt the flat, nondescript desert landscapes, is one photograph entitled simply "Observation Tower": here, a wood and metal structure resembling a prison guard tower stands starkly against a dramatic backdrop of snowcapped mountains and a cloud-slashed sky.

Shah's photograph is eerily similar in its framing and composition to the iconic clandestine 1943 image of the very same structure—the "watch tower" at Manzanar, the World War II–era internment camp in California—taken by the interned Japanese American photographer Toyo Miyatake close to seventy years earlier. Manzanar was long a site of forced relocations and dispossessions even prior to World War II, as the Owens Valley Paiute, the area's original inhabitants, were forcibly driven from their land and "relocated" south to Fort Tejon in 1863. Recent scholarship has mapped the discursive and material connections between Native containment and displacement and that of Japanese Americans during and after World War II.[61]

Shah's postcards directly reference these braided histories of colonial dispossession, segregation, and state violence that lie at the heart of U.S. liberal democracy: included with "Observation Tower" are two images, both of which were taken at the entrance to Utah's Monument Valley on Navajo reservation land. The first, entitled "Native Trailer," depicts a white trailer with Native insignia and a sign reading "artwork for sale"; the bleak desert landscape that surrounds it is interrupted only by electrical poles in the background and a construction cone in the foreground. The second image, a rendering of the photograph of Geronimo that greets visitors to Monument Valley, is named "Stripped," a title that gestures to the violence of colonial dispossession; in "Stripped," the ghostly stars and stripes of an American flag solidify into thick black bars that entrap and dissect Geronimo's body.

FIGURE 3.9 Seher Shah, "Observation Tower," from *Hinterland Structures* (2011), courtesy of the artist and Green Art Gallery.

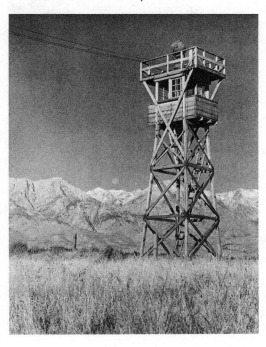

FIGURE 3.10 Toyo Miyatake, *Watch Tower* (1943).

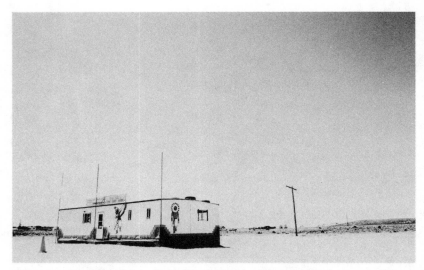

FIGURE 3.11 Seher Shah, "Native Trailer," from *Hinterland Structures* (2011), courtesy of the artist and Green Art Gallery.

FIGURE 3.12 Seher Shah, "Stripped," from *Hinterland Structures* (2011), courtesy of the artist and Green Art Gallery.

Hinterland Structures, like Tracey Moffatt's *Spirit Landscapes*, suggests the ways in which dispossessed populations construct modes of dwelling that render inhabitable seemingly uninhabitable locations in the aftermath of past and continuing processes of dispossession. From *The Mirror Spectacle* to *Object Relic (Unité D'Habitation)* to *Hinterland Structures*, Shah maps out how various forms of state power function spatially, through the gendered, sexual, and racial regulation of bodies and landscapes. *Hinterland Structures* thus also acts as an alternative archive that records everyday forms of dwelling in displacement. These images demand that we dwell in landscapes that are far from comfortable or comforting, but instead afford us a vision that allows us to see the intimacies of apparently discrete historical processes.

FORCED CONTAINMENT/FORCED MOBILITY: ALLAN DESOUZA'S *WORLD SERIES*

The palimpsestic and proximate nature of multiple histories of dwelling, displacement, and dispossession also animate the work of San Francisco–based artist Allan deSouza. DeSouza was born in Kenya to Goan Indian parents, and his photographic installation *World Series* (2012) can be read as an intertext to the work of Moffatt and Shah. The installation drew its initial inspiration from African American painter Jacob Lawrence's monumental series of sixty panel paintings known as the *Migration Series*, a "connective narrative,"[62] as Lawrence himself put it, which documents the Great Migration of African Americans from the rural U.S. South to the industrial urban centers of the North in the interwar period. Historian Stephanie Smallwood notes that the Great Migration was characterized as "the second emancipation," and that "this lexicon of serial repetition suggests that the passage of time marks not the steady, linear progression from slavery to freedom, but rather the crisis and (dis)orientation of being stuck in the time and place of slavery."[63] At first glance, Lawrence's masterwork—completed in 1941—seems to present a straightforward narrative of leaving a South riven by racist violence and deep poverty to journey to a North that is the site of vibrant black culture, albeit with its own forms of segregation and injustice. While the work initially appears to adhere to a teleological grid of departure and arrival, it in fact precludes any easy sense of the North as a space of liberation and freedom; "arrival" is ambivalent at best. A central thematic thread throughout the series is that of housing and unhousing, of being forced to leave a home space made

uninhabitable by poverty, discrimination, and racist violence only to face another form of unhousing in the North: materially, in the form of crowded, unsanitary housing conditions, but also in the broader sense of living in a space of chronic precarity, where one's bodily and psychic integrity is constantly under siege. Indeed the penultimate panel of the series is double-edged: it depicts urban Black folk lined up in front of a voting booth and is captioned, "In the North they had the freedom to vote." The panel can be read as the triumphant culmination of the migration narrative, in that African Americans finally inhabit the rights of full citizenship. But in the context of the variegated, brutal forms of black dispossession and unhousing in both the North and the South depicted in the preceding panels, it also gestures to the inadequacy of definitions of freedom that rest solely on gaining formal equality before the law. Particularly in light of the 2013 Supreme Court decision dismantling the 1965 Voting Rights Act, this penultimate panel suggests a cyclical vision of history, of being stuck and disoriented in the time of slavery, that is at odds with the vision of history consecrated by the dominant nationalist imagination of the U.S. liberal egalitarian nation-state. As Smallwood writes, "Time need not march forward in lockstep unison with freedom's steady expansion, as the liberal progressive narrative promises. . . . Rather, the temporality of black freedom is such that time always threatens to carry the unfreedoms of the past forward into the present."[64] We can, in other words, read Lawrence's work in two ways: as a profound indictment of the temporality presumed by "the liberal progressive narrative," as Smallwood terms it, and its vision of democratic equality, but also as a testament to the creativity and imagination of black migrants as they insist on making home in violently inhospitable landscapes.

DeSouza's work—which takes as its touchstone Lawrence's epic narrative of black migration and the alternative temporality of freedom that it suggests—is comprised of a series of forty photographs rather than the sixty paintings of Lawrence's series. Writing through his alter ego, a Berlin-based critic named Dr. Moi Tsien, deSouza's artist's statement describes *World Series* as follows:

> deSouza's photographs invoke history to track contemporary pathways through the signage of metaphorical, transcultural, political and psycho-geographic encounters. The paths taken may refer to deSouza's own history—and we can indeed read elements of deSouza's known biography; or these encounters suggest a fictional protagonist who moves through them, much like in a novel, storyboard or film; or the encounters

FIGURE 3.13 Jacob Lawrence, from *Migration Series* (1941).

are themselves protagonists, and are largely understood through narratives suggested both within each photograph and through their accumulation and sequencing. Whether the tales of a tourist, a migrant, exile, returnee or one who inhabits many locations and psyches, it is precisely through combining fictional strategies with the truth-telling claims of photography . . . that we are led to multivalent, counter-readings of history.[65]

DeSouza's reading of his own work astutely foregrounds the different viewing positions available through the photographs (of tourist, migrant, exile, or returnee, as he puts it), as well as the way in which the work plays on the photograph's indexical nature, its promise of immediacy and unmediated access to the "real." While all of deSouza's photographs are carefully composed and some digitally altered, they have the casual, autobiographical feel of postcards or snapshots taken by the artist himself as he moves through different landscapes; in fact, the installation is accompanied by a printed set of postcards, made from the images, inscribed with postcard-style text written by various artist and critic friends of deSouza.

The postcard as a genre has both temporal and spatial valences: it is the most mundane form of memorialization of places, people, events, or objects, and is meant to be read quickly and then either discarded, or perhaps stuck on

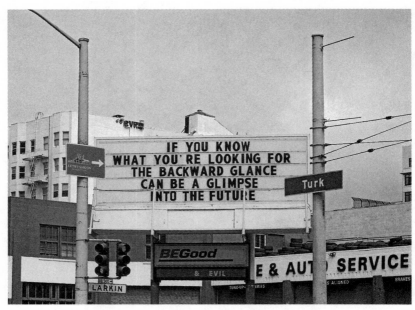

FIGURE 3.14 Allan deSouza, "Future," from *World Series* (2012), courtesy of the artist.

a fridge with a magnet, instantiating a brief moment of connection between the sender and the recipient, between "here" and "there." While postcards typically portray the iconic or the picturesque through a tourist gaze, deSouza's postcards, like Shah's postcard-size images of "hinterland structures," memorialize the everyday and the unremarkable. If the recurring motif in Jacob Lawrence's *Migration Series* is the train, that symbol of modernist progress as well as violence,[66] in deSouza's *World Series* it is the airplane and airport that emerge as the most potent sites both of global movement and border-crossing, of surveillance and restriction. As with deSouza's earlier 2008 photography installation *UFO*,[67] which I discuss in the following chapter, many of the images in *World Series* are taken from the interior of a commercial plane, and document the resolutely antiscenic: the workers and signage on the tarmac, a slice of an airplane wing, a portion of a plane parked at the gate. DeSouza's view of ice cubes through the bottom of a plastic cup, or the shards of ice on the airplane window, or the rows of heads of his fellow passengers, function to render unfamiliar the most sterile and systematized of interior landscapes. This denaturalization, as in Moffatt's *Picturesque Cherbourg* and in Shah's depiction of mundane "hinterland structures," reveals the ominous threat of

FIGURE 3.15 Allan deSouza, "Point," from *World Series* (2012), courtesy of the artist.

FIGURE 3.16 Allan deSouza, "Revolve," from *World Series* (2012), courtesy of the artist.

state power that lurks just beneath the bland, seemingly innocuous surfaces of these spaces.

Airplanes and airports are of course some of the most heavily surveilled sites in the world, and one central thematic animating *World Series* is that of threat, safety, and security; more specifically, the series asks whose safety and whose security is at stake when some bodies are allowed to cross borders, while others are seen as threats to be contained, removed, or expunged. While Jacob Lawrence's work documents the new forms of violence, segregation, and dispossession that rural black migrants encounter as they struggle to dwell in the apparently "free" North in the first half of the twentieth century, deSouza's series documents the contemporary forms of segregation that corral and discipline various bodies of color in Europe and North America. The postcards, replete with images of locked gates, closed doorways, and no-entry signs, make visible the everyday forms of violence experienced by racialized and colonized populations. Simultaneously, the postcards document the myriad ways in which these populations contest such forms of dispossession as they reterritorialize and lay claim to public space.

Alongside images of and from airports and airplanes are those of bridges, subways, and freeways: all transitional spaces of liminality, movement, and crossing, and necessarily fraught sites of contest around national and communal belonging and unbelonging. Although these structures are built to transport objects and people from here to there, deSouza's series immediately disorients a narrative of fixed departures and arrivals. The opening images, for instance, shuffle the temporal and linear logic of progression that structures the architecture of the airport, or, for that matter, of the freeway or the subway. The first image, entitled "Future," is of a film theater marquee on Turk Street in San Francisco's Tenderloin district that reads, "If you know what you're looking for the backward glance can be a glimpse into the future." It is followed by "Point," where workers on the airport tarmac all face an apparent future, pointed toward by a sharply etched shadow that cuts across the tarmac, while one sole worker gestures backwards. In the next image, "Revolve," revolving doors to the airport entrance are decorated with planes that circle endlessly. The entire series ends with an image entitled "Sign Out," where a nonfunctional subway platform suggests more broadly the nonfunctionality of this progress narrative of departure and arrival.

Rather than the straight and narrow path of history presumed by a dominant nationalist, liberal progressive narrative, then, deSouza's series envisions a cyclical, revolving, layering, and looping of history, of multiple times and

FIGURE 3.17 Allan deSouza, "Sign Out," from *World Series* (2012), courtesy of the artist.

spaces.[68] This is particularly clear in an image of an airplane flight map, aptly entitled "Location." "Location," apparently taken by the artist midflight, captures the location of the plane as it traverses the U.S. Midwest, specifically Indiana; the simulated wing covers the letter "a" of "Indiana" on the map, transforming the word to "Indian." The signifier "Indian" in this context is an ambivalent one, that can reference either American Indians or those who claim/are claimed by the nation of India. DeSouza's postcard keeps these two meanings in productive tension. The image resonates, for instance, with Ali's poem "In Search of Evanescence," discussed in the previous chapter, by enacting a queer diasporic vision that conjures forth a palimpsestic landscape, where "India" emerges in the most unexpected places, off the highways and byways that crosscut the American Midwest. The simulated airplane map heightens a sense of disorientation even as it promises orientation; the task, then, as deSouza, Moffatt, and Shah seem to suggest, is to learn to dwell in this state of suspension and disorientation. But deSouza's image also obliquely references the erasure of indigenous mappings of territory and space by the U.S. nation-state. As Jodi Byrd notes, viewing the continental U.S. through the frame of indigenous critical theory "means imagining an entirely different

FIGURE 3.18 Allan deSouza, "Location," from *World Series* (2012), courtesy of the artist.

map and understanding of territory and space: a map constituted by over 565 sovereign indigenous nations, with their own borders and boundaries that transgress what has been naturalized as contiguous territory divided into 48 states."[69] DeSouza's transformation of "Indiana" to "Indian" in effect exposes this alternative spatial mapping and its violent occlusion by a hegemonic nationalist vision. As such, in its suturing together of different forms of "Indianness," deSouza's image renders intimate the ongoing processes of Native dispossession, dispersal, and relocation, with those of South Asian diasporic dislocation engendered by more recent global flows.

A number of deSouza's images suggest the ways in which the continuing, violent dispossession of Native populations shadows the forms of containment, disciplining, and segregation of immigrants and communities of color. Two particularly striking images in the series make the slippage between "Indian" (as in Native) and "Indian" (as in South Asian diasporic migrant) explicit: one is entitled simply "Indians" and the other "No Stopping." "Indians" is an image taken from a ferry as it docks at Alcatraz Island, the former military prison in the San Francisco Bay, now a national park, that was the site of a nineteen-month occupation by Native activists from November 1969

to June 1971. Alcatraz has a complicated past, enmeshed in the long history of U.S. imperial and military expansion, conquest, and incarceration. While I can only gesture to these intersecting histories here, it is important to do so in order to understand the play between the diasporic and the indigenous that deSouza's work enacts. Built with convict labor, Alcatraz Island housed a U.S. military prison from 1850–1934, and subsequently became a federal penitentiary until it was closed in 1963. During the Spanish American War it held both military and civilian prisoners, and a significant number of those incarcerated in the late nineteenth and early twentieth centuries were Native. In one particularly infamous instance, in 1895, nineteen Hopi men from northern Arizona were incarcerated at Alcatraz due to their resistance to forced relocation and the coercive, assimilative education policies of the federal government; they were released only after pledging to "cease interference with the plans of the government for the civilization and education of its Indian wards."[70] Some seventy-five years later, after its widely reported occupation by Native activists, Alcatraz became a potent symbol of Native resistance in North America and sparked various other Native "occupations" throughout the U.S.

During the 1969 occupation, the sign that initially greeted visitors to the island and marked it as U.S. government property was transformed into a poignant statement of Native repossession and pan-Indian solidarity: the occupiers changed the sign so that it read "United Indian Property," rather than "United States Penitentiary," and added the phrases "Indians Welcome" and "Indian Land" above and below it. In deSouza's 2012 image, the words "Indians Welcome" are still faintly visible, but, significantly, the phrase "Indian Land" is all but obscured by the ferry boat's flagpole bearing the U.S. flag, while the phrase "United States Penitentiary" has clearly reasserted itself. Given the government's forcible ejection of the occupiers from the island in 1971, and the mind-boggling increase in the number of prisons and prisoners in the U.S. since then, deSouza's image could be read as a sober testament to the undiminished imperial ambitions of a carceral nation-state that remains impervious to any challenges to its power. However, in capturing the faded but still visible evidence of the occupation, deSouza's postcard also speaks to the ways in which the subterranean memory of this apparently "failed" movement continues to resonate. As Jack Halberstam writes, "Failure is the map of political paths not taken, though it does not chart a completely separate land; failure's byways are all the spaces in between the superhighways of capital."[71] The 1969 occupation that sought to repossess Native land and institute its

FIGURE 3.19 Alcatraz
Island, San Francisco Bay,
California, 1969.

own form of governance existed not outside of or apart from the dominant as much as it emerged from within its crevices and interstices, both literally and figuratively. In fact, occupiers used the very infrastructure of the penitentiary (the kitchen, the meeting areas, etc.) to strategize and plan their movement, wresting a sense of "freedom" and possibility from the most unfree of spaces. This, then, is precisely what deSouza's image memorializes: it functions as evidence not only of ongoing state power and violence, but also of those "failed" movements that still hold the potential to animate visions of other possibilities of social and political arrangements—in short, of what "freedom" can look and feel like.

"Indians" was presumably taken by deSouza himself, from the ferry that bore his own brown body to Alcatraz, that site of both Native resistance and incarceration. The title of the image thus hails into the present both the memory *and* continued presence of alternatives to the here and now, while also staging an intimate encounter between the distinct racial and historical formations that fall under the sign of "Indian" in the project of U.S. empire.

FIGURE 3.20 Allan deSouza, "Indians," from *World Series* (2012), courtesy of the artist.

Again, this is not to deny the ways in which non-Native diasporic and ra-
cialized communities have long been conscripted into the project of settler
colonialism.[72] Nevertheless, we can read deSouza's image as instantiating a di-
alogic relation between "Indians" (as Native) and "Indians" (as postcolonial
diasporic migrants from South Asia) that makes visible the ongoing carceral
logic of the U.S. nation-state that seeks to contain, segregate, and discipline
differently racialized and colonized populations. This carceral logic of the
settler colonial state, and deSouza's framing of space and landscape as replete
with the sedimented histories of multiple violences, are particularly apparent
in the image "No Stopping" (plate 14).

This image, which, according to deSouza, was taken in Arizona somewhere
between Tucson and the Mexico border, depicts an empty freeway cutting
through apparently barren desert landscape; it takes its title from the traffic
sign by the side of the road that reads, "No Stopping: Inmates Working." The
continuous line of asphalt and the injunction against stopping insists upon
a unidirectional flow from here to there, from past to present to future. The
sign also traffics in the logic of threat and security, whereby an "innocent" and
potentially at-risk motorist is interpellated over and against the threatening

bodies of those laboring at the side of the road. In an instantiation of Chandan Reddy's formulation of legitimate versus arbitrary violence, the "legitimate" violence of the state is here projected onto the absent, potentially threatening bodies of the displaced and the incarcerated.[73] As in Tracey Moffatt's *Night Spirits* or Seher Shah's *Hinterland Structures*, in the apparent emptiness of the landscape the absent presence of missing bodies is inescapable. But "No Stopping" also references the *enforced* transience and estrangement that has marked the history of South Asian migrants in North America in the first half of the twentieth century. As historian Nayan Shah's research compellingly documents, these working-class, predominantly male migrants created forms of "stranger intimacy"—bonds of homosocial, homoerotic, cross-class, and cross-racial sociality—despite and in opposition to state-sanctioned estrangements.[74] DeSouza's image allows us to see how the carceral logic of the settler colonial state undergirds this containment and forced mobility of variously racialized Asian populations, the ongoing colonization of Native lands, and the staggering growth of the prison industrial complex in the U.S. and its criminalization of predominantly black and brown bodies.

Thus, deSouza, as well as Tracey Moffatt and Seher Shah, refuse the injunction not to stop. Instead they return, pause, linger, and remain suspended along the backroads and byways that afford a vista of the braided relations of contest *and* comingling between differently racialized and colonized populations and the contradictory, heterogeneous and overlapping histories these relations engender. Placing the work of Moffatt, Shah, and deSouza in the same frame demands that we trace the lines of connection between various sites of biopolitical regulation: the Aboriginal settlement, the imperial amphitheater, the low-income housing project, the Native reservation, the internment camp, the prison. These architectures of state power span projects of European empire in South Asia and white settler colonialism in the U.S. and Australia, and tether the histories of indigenous and non-Native racialized and diasporic populations to each other. The queer diasporic vision of Moffatt, Shah, and deSouza allow heterotopic landscapes to come into view.[75] These landscapes suggest a mode of dwelling in displacement that rejects the consolations offered by fantasies of return to lost homelands, and is attuned to both the dissonances and convergences of myriad histories and modes of dispossession. In this way, the aesthetic practices of queer diaspora produce alternative cartographies that map brave new worlds of relationality and intimacy across multiple times and spaces.

Archive, Affect, and the Everyday

This chapter explores the interface of archive, affect, and the everyday in the aesthetic practices of queer diaspora. I focus in particular on the photography of Allan deSouza; the ongoing collaborative multimedia/installation project *Index of the Disappeared*, by the artists Chitra Ganesh and Mariam Ghani; and the work of the Lebanese visual artist Akram Zaatari. Queer diasporic affect, in their work and the aesthetic practices of queer diaspora in general, becomes the portal through which history, memory, and the process of archiving itself are reworked, in order to both critique the ongoing legacies of slavery, colonialism, war and occupation, and contemporary forms of racialization, as well as to imagine alternative forms of affiliation and collectivity. The materiality of the everyday—the small, the antimonumental, the inconsequential—is closely linked to this project of excavating the past: it is precisely through what Kathleen Stewart terms "ordinary affects," which saturate the everyday, that this grappling with the past occurs.[1] This chapter is centrally concerned with how the aesthetic practices of queer diaspora are in fact *archival* practices; as we have seen in the preceding chapters, these archival aesthetic practices mobilize the affective register to make apparent the everyday intimacies of bodies and landscapes, histories and temporalities.

My point of entry into a discussion of the archival dimension of the aesthetic practices of queer diaspora, and the centrality of everyday affects to this dimension, is Saidiya Hartman's much-praised memoir *Lose Your Mother: A Journey along the Atlantic Slave Trade*.[2] Hartman's text, which traces her journey along a slave route in Ghana, is a powerful reckoning with slavery's aftermath, its wiping out of individual and collective histories and genealogies. Situating Hartman's memoir as an important intertext to the work of deSouza, Ganesh/Ghani, and Zaatari, as I do here, runs the risk of flattening out the distinctions between the various diasporic roots of, and routes traveled by, differently racialized populations. Hartman is an African American literary scholar and a descendant of slaves whose own familial genealogy fades into obscurity after three generations; her relation to Ghana and to the postcolonial Africans from all parts of the continent she encounters there is marked by an irreducible sense of her own strangeness and estrangement. DeSouza, on the other hand, as I mentioned in the last chapter, grew up in postcolonial Kenya, a descendant of Goan Indian immigrants who arrived in British-ruled East Africa in the 1930s to work on the railroads initially built by Indian indentured laborers in the late nineteenth century. He migrated with his family to London, then as an adult moved to Los Angeles and San Francisco; his parents settled in Portugal, "one step closer to their colonial histories."[3] DeSouza comments on the spatial and temporal dislocations engendered by these various movements as he recalls being viciously beaten in a racist attack in London: "Perhaps I was too often in the wrong place, but if your family history and childhood experience are routed through three different colonies and their colonial powers—Goa under the Portuguese, India under the British, and Kenya, again British—then being in the wrong place and at the wrong time too easily becomes habitual."[4]

At first glance, Chitra Ganesh's diasporic trajectory appears more straightforward than deSouza's. Ganesh, as I mentioned in chapter 2, was born and bred in Brooklyn, and is the daughter of South Indian immigrants from Calcutta who settled in New York City in the early 1970s. Her parents were already cosmopolitan migrant subjects before entering the U.S., in that they belonged to the community of Tamil Brahmins who had become an established presence in Calcutta since the 1920s; their background thus speaks to the displacements and movements that happen within the nation itself, prior to the experience of transnational migration. While Ganesh's parents were part of the influx of mainly professional South Asians that entered the U.S. as a result of the 1965 Hart-Celler Act, they did not follow the typical trajectory of South

Asian middle-class migrants. Her mother was a schoolteacher, her father a bank clerk, and their circle of acquaintances encompassed other lower-middle-class South Asians who worked as mechanics, grocery store owners, and house-wives.[5] Significantly, Ganesh's parents chose to remain in the multiracial urban environment of Brooklyn rather than escaping to the suburbs "as part of [the narrative of] desi immigrant upward social mobility," as Ganesh puts it.[6]

The multimedia artist Mariam Ghani, Ganesh's collaborator since 2004 on the project *Index of the Disappeared*, was born in New York City in 1978 to an Afghan father and Lebanese mother. Ghani's father, a noted economist before becoming president of Afghanistan in 2014, was in effect exiled from Afghanistan in the late 1970s; Ghani herself visited Afghanistan for the first time in 2002, when she was in her mid-twenties. In an essay on the genesis of her web-based art project *Kabul: Reconstructions*, which documents the phys-ical reconstruction of Kabul from 2002 to 2004, Ghani writes eloquently about the complex realignment of her identity that took place in the wake of 9/11: she was "like many other Afghan-Americans suddenly forced onto intimate terms with an identity that had formerly seemed remote and inac-cessible."[7] Ghani notes that the process of creating *Kabul: Reconstructions* allowed her to forge a diasporic relation to Afghanistan, and Kabul in partic-ular, as an Afghan American who had to consciously reconstruct her relation to this space as home.

Finally, Lebanese visual artist Akram Zaatari did his graduate studies in the U.S. but has primarily been based in Beirut, Lebanon, throughout his ca-reer. Perhaps somewhat surprisingly, I apply the concept of diaspora to his work to signal the displacement and dispersal that occur within the space of the nation itself, when one is subject to the vagaries of war and occupation that precipitate the constant shifting of borders. As I mentioned in the in-troduction, Zaatari's work is especially concerned with the region of south Lebanon (under Israeli occupation for almost two decades) and the town of Saida, where he grew up, and its particular positioning as "other" within the Lebanese national imagination. As in the work of Ligy Pullappally, David Kalal, Sheba Chhachhi, Agha Shahid Ali, Chitra Ganesh, Aurora Guerrero, and Tracey Moffatt, discussed in previous chapters, Zaatari's emphasis on the region makes clear the frailty and mutability of national boundaries and the comparatively greater importance of subnational spaces (such as "the south") in producing a sense of collectivity and in excavating the past.

I refer to the biographical details of these artists because their work en-gages with their personal and collective histories either obliquely or directly,

and because I want to emphasize the very different diasporic trajectories that inform them. Certainly the traumas and space/time disjunctures precipitated by slavery are distinct from those of war and occupation, indentureship, and postcolonial displacement; each of these historical phenomena engender their own affective ties, traps, and possibilities. At the same time, situating these formations as utterly incommensurate rather than as co-constitutive ignores, as I discussed in the previous chapter, their unexpected intimacies and congruences. Despite their obvious differences, we can discern a particular aesthetic sensibility that circulates through and across these works—a queer diasporic aesthetic—that allows us to place them in the same frame. Identifying this aesthetic sensibility as such demands a productive reframing of the parameters of both diaspora and queerness. While I am aware that I run the risk of stretching these categories to such an extent that they are rendered meaningless, what I hope to do instead is make clear the resonances between texts that may not otherwise be apparent. By considering the work of deSouza, Ganesh/Ghani, and Zaatari in tandem with Hartman's memoir, I seek to illuminate both the intimacies and divergences of different diasporic histories as they engender specific forms of affect and temporality.

In the last chapters of Hartman's memoir, she journeys north, to "the heartland of slavery," and experiences "a moment of fleeting intimacy" with a young Ghanaian man who is a descendant of slaves himself.[8] This intimacy, she writes, "was not a matter of blood or kinship, but of affiliation. We were the children of slaves. We were the children of commoners."[9] This notion of affiliation, defined outside a logic of blood,[10] resonates with theories of kinship articulated by queer studies scholars who have sought to map the bonds of relationality between subjects and communities without recourse to claims of biological reproduction and patrilineal genealogy. I would argue that it may be useful to read Hartman's memoir as a queer text and a work of queer theory, as it offers queer studies a model of non-blood-based affiliation routed in and through difference, in an awareness of the difficulties and traps of identification, rather than in a fantasy of sameness, wholeness, or completeness. The queerness of the text resides in its refusal of origins, its insistence on the impossibility of tracing lineage and accessing the past through bloodlines, genealogy, or conventional historiography. The model of racialized subjectivity that Hartman sets forth is one that is always already queer, in the sense that it is marked by nonreproductive futurity, the failure of generation, and the desires and losses associated with normative genealogies of belonging. Queerness here does not so much bravely or heroically refuse the normative, the way

it appears to in some narratives of queer subjectivity,[11] as much as it names the impossibility of normativity for racialized subjects marked by histories of violent dispossession. As we have seen throughout this book, for such subjects a recourse to the comforting fictions of belonging are always out of reach. A queer reframing of *Lose Your Mother* brings to the fore those moments in the text that in fact reframe our understanding of "queerness" itself—moments that might otherwise be obscured if the text is read solely as a narrative of racial trauma and melancholia. Read through a queer lens, the text articulates a model of queer affiliation that may indeed be fleeting, may not coalesce into an easily intelligible or quantifiable form of political coalition; nevertheless, it produces moments of affective relationality that open the door to new ways of conceptualizing the self and others. Hartman's memoir does not address the presence or histories of non-Black Africans in postcolonial Ghana, nor does it comment on the relation between African Americans and other racialized diasporic communities in the U.S. However, we can use the model of affiliation that a queer reading of the text gives us to map the intimacies of seemingly disparate diasporic trajectories. In this current historical context, where South Asian, Middle Eastern, and African American populations in the U.S. have been quite explicitly positioned over and against one another, it seems particularly urgent to create modes of analysis that account for these braided and overlapping diasporic histories.

It is precisely an excavation of the "fleeting intimacies" of cross-racial affiliation that fuels the recent renewed interest in the pan–Third Worldist movements of the mid-twentieth century, such as the Bandung Conference of 1955 and the Non-Aligned Movement of the 1960s. Vijay Prashad's reconsideration of the legacies of such Afro-Asian solidarity movements speaks powerfully to the desire on the part of contemporary scholars and activists of color to trace a genealogy of shared resistance to first-world hegemony that works through and across racial and geographic difference.[12] In an essay tellingly titled "Bandung Is Done: Passages in Afro-Asian Epistemology," Prashad recognizes that in a moment when "the bold pronouncements [of the Bandung era] for a radical reconfiguration of the international political economy has vanished . . . these excavations of AfroAsian solidarity might be nostalgic, anachronistic or even aesthetic."[13] Indeed, generations of feminist and, more recently, queer scholars have long critiqued such pan–Third Worldist projects for their exclusions and hierarchies, both in their cultural nationalist and state nationalist forms. In keeping with these critiques, both Hartman's text as well as the queer visual art that I discuss here can be seen as enacting

a queer critique of the Bandung moment and its promises of liberation and transnational solidarity. Yet in its engagement with the pitfalls and dangers of both dominant and anticolonial nationalist projects, such work also suggests that the memory of these ephemeral, apparently failed movements, marked as out of time and out of place, may still have a powerfully transformative effect on the present. Bandung may indeed be done as an explicit political platform, but other modes of political relationality can be gleaned if we produce alternative understandings of what constitutes the political. The texts that I discuss here and throughout the book demand that we rethink those perhaps anachronous cultural forms, practices, and affective relations (such as nostalgia) that may be dismissed as "merely" personal, apolitical, trivial, or transitory. I thereby hope to contribute to a collective project that attends to the ties that have bound differentially racialized populations to one another, and that may ultimately provide the conditions of possibility for conjoined futures.

"THE RUPTURE WAS THE STORY": SAIDIYA HARTMAN'S *LOSE YOUR MOTHER*

An exquisite meditation on diasporic loss and longing, *Lose Your Mother* is not a triumphal return to origins; the diasporic sensibility that emerges from the text is marked by the impossibility of return as well as, for the most part, commonality or affiliation. Throughout much of Hartman's narrative, there is an unbridgeable distance between her and those she encounters in Ghana. "The rupture was the story," she writes, not the hope of re-creating lineage and familial genealogy. The affect of diaspora, in Hartman's text, is that of irredeemable loss, failure, defeat, alienation, and disappointment; it is these forms of negative affect that saturate the text, and where Hartman herself as narrator resides. Speaking of the numerous African American tourists who travel to Ghana to view slavery's ruins, she writes, "Did the rich ones suffer from nostalgia? Did I? Was longing or melancholy what defined the tribe of the Middle Passage?"[14] "The rich ones" here refers to the African Americans who travel to Africa in search of a sense of belonging, propelled by a fantasy of commonality and shared identification that is always and inevitably a failed project of recognition and recuperation. Hartman quickly finds that in the grim economic realities of postcolonial Ghana, the Pan-Africanist embrace of the diaspora which characterized the anticolonial liberation era (encapsulated in the slogan "Africa for Africans abroad and at home") is indeed ancient his-

tory, almost as remote from the daily lives of postcolonial Ghanaians as the memory of slavery. She writes, "Pan-Africanism had yielded to the dashed hopes of neocolonialism and postcolonialism and African socialism . . . had been ambushed by the West and bankrupted by African dictators and kleptocrats, all of whom had made a travesty of independence."[15] Hartman, like those African American expatriates who settled in Ghana in the hopes of being part of the new nation, finds herself to be "just another stranger."[16]

Svetlana Boym helpfully distinguishes between two forms of nostalgia: "utopian (reconstructive and totalizing) and ironic (inconclusive and fragmentary)."[17] She writes:

> The former stresses the first root of the word, *nostos* (home), and puts the emphasis on the return to that mythical place on the island of Utopia where the greater patria has to be rebuilt . . . Ironic nostalgia puts emphasis on *algia*, longing, and acknowledges the displacement of the mythical place without trying to rebuild it. . . . If the utopian nostalgic sees exile . . . as a definite falling from grace, the ironic one accepts (if not enjoys) the paradoxes of permanent exile.[18]

Anthropologist C. Nadia Seremetakis's meditation on the role of the senses in history and memory-making further nuances Boym's distinction between ironic and utopian nostalgia. Juxtaposing the English word "nostalgia" to the Greek *nostalghia*, she notes:

> In English the word nostalgia (in Greek *nostalghia*) implies trivializing romantic sentimentality. [*Nostalghia*] . . . evokes the sensory dimension of memory in exile and estrangement. . . . In this sense *nostalghia* is linked to the personal consequences of historicizing sensory experience which is conceived as a painful bodily and emotional journey. *Nostalghia* thus is far from trivializing romantic sentimentality. This reduction of the term confines the past and removes it from any transactional and material relation to the present; the past becomes an isolatable and consumable unit of time. Nostalgia, in the American sense, freezes the past in such a manner as to preclude it from any capacity for social transformation in the present, preventing the present from establishing a dynamic perceptual relationship to its history. Whereas the Greek etymology evokes the transformative impact of the past as unreconciled historical experience.[19]

Unlike the nostalgia of those who seek and believe in a fantasy of return, we can understand the nostalgia with which Hartman is afflicted as ironic in

Boym's sense of the term. For Hartman the mother is always lost, and, as she puts it, "routes are as close to the mother country as [she] would come."[20] Similarly, Hartman enacts precisely the dynamic, dialogic, and transformational relation to the past that the Greek word *nostalghia* implies. Her journey seeks not to recover a fixed, whole subjectivity prior to the rupture of the middle passage, but rather to enter into slavery's archive—the material documents and the physical ruins of slave holds and dungeons—in order to search "for the traces of the destroyed."[21] Her engagement with the material archive, however, yields nothing but greater historical blankness. In one particularly haunting scene, Hartman stands in one of the slave dungeons; the floor is made up, hideously, of the "compressed remains of captives—feces, blood and exfoliated skin." Hartman concludes, "I came to this fort searching for ancestors, but in truth only base matter awaited me. . . . Waste is the remnant of all the lives that are outside of history."[22] This is all that slavery's material archive offers her: "blood, shit, and dirt."[23] This passage speaks powerfully to the failure of the archive to "raise the dead," as Sharon Holland phrases it, to restore to Hartman any sense of their humanity.[24] As Hartman writes, "In the dungeon, there were remains but no stories that could resurrect the dead except the stories I invented."[25]

In a sense it is waste, the excess that exists outside of official narratives of memory, that unites Hartman's memoir to the work of Allan deSouza, even as they respond to its challenge in different ways. Again, by juxtaposing Hartman and deSouza, I do not mean to suggest that different historical processes (of slavery, colonialism, indentureship, nationalism, migration) have the same material or discursive effects in the production of bodies, psyches, and subjectivities. While the work of Hartman and deSouza make clear that the losses that attend the legacies of slavery are distinct from those of colonialism or postcolonial nationalism, it is nevertheless worth putting these different experiences of diasporic loss into dialogue, in order to bring to the fore the common ground that they do in fact share. Ultimately, both Hartman's text and deSouza's artwork reckon with the place of the individual within history; they suggest that it is through a narrative of the self in relation to an opaque past, a stubborn present, and an uncertain future that one confronts the limits and gaps of the material archive. Hartman's longing to "reach through time and touch the prisoners" yields only the abjected material of destroyed bodies; this waste seems to speak of nothing but destruction, amnesia, and annihilation. Yet this waste, and the historical blankness that it connotes, is what propels Hartman toward the genre of memoir, into the realm of the

imagination, into creating what she finds missing from the material archive: the voices, sensations, and emotions of the slaves themselves. Similarly, for deSouza (as I will discuss), it is precisely bodily waste and excess, the detritus of the everyday, that allows him to call into a diasporic present a postcolonial African past. This inhabiting of multiple times and places, and the double vision it affords him, is, in fact, what marks deSouza as a queer diasporic postcolonial subject. He writes, "Born into a colony, and later living in the colonial mother country, I saw myself outside history since it never seemed to be of my making or made by anyone that seemed to resemble me. I experienced time not as a linear sequence but as fragmented, a compression of lost pasts and disputed presents . . . in attempts to invent possible futures."[26] For Hartman, the "compressed remains of captives" speaks to her failed attempt to conjure forth the dead through the evidence available to her within slavery's material archive. Yet for both Hartman and deSouza, bodily detritus is ultimately generative; waste speaks to history, even if that history has to be imagined. Waste allows for a reckoning with the past while being marked by the present, in order to—as deSouza says—invent possible futures.

THE FAILURE OF THE ARCHIVE: ALLAN DESOUZA'S *THE LOST PICTURES*

DeSouza's 2004 photographic series *The Lost Pictures*, created in the aftermath of his mother's death, grapples with similar questions of historical memory, genealogy, and diasporic loss and longing that haunt Hartman's text. In deSouza's photoworks, the queer diasporic body itself becomes an archive of multiple displacements and colonial histories. *The Lost Pictures* is composed of digitally manipulated prints made from slides taken by the father of deSouza and his siblings during his childhood in postindependence Kenya. After making the slides into prints, deSouza allowed them to be overlaid with the detritus of daily life as he left them in the intimate spaces of his Los Angeles apartment: the bathroom floor, the kitchen counter, next to the sink and the shower stall. In their final version, the past, in the form of the original slide images, is rendered ghostly, fading into white, barely visible, while the diasporic present asserts itself through the detritus of the artist's own body: semen, blood, hair, food, sloughed-off skin. As in Hartman's text, the personal and the autobiographical function as modes of theorizing the archive and the relation of diasporic subjects to an elusive past. Situating deSouza's photoworks in relation to Hartman's memoir allows us to reflect on the limits

and uses of these two different genres in the project of excavating the past and reimagining the present and future. DeSouza's work is a profound meditation on visuality, specifically on the genre of photography itself: the contradiction between its promise of rendering a transparent reality, and its inevitable opacities and occlusions. In his essay "My Mother, My Sight," which accompanies the catalog for *The Lost Pictures*, deSouza beautifully details the deterioration of his own vision as he is diagnosed with cataracts at the age of thirty-eight. DeSouza writes of obsessively taking photographs of the minutiae of his childhood sites/sights in Nairobi to show his mother, who lies dying of cancer in a hospital in Portugal; the photographs are an attempt to "see *for*" his mother—who is also losing her sight—and to heal her own "dis-ease of dislocation."[27] The visual functions as the primary arena through which his identification with his mother is solidified, yet he is always aware of the failure of the photograph to capture what he terms an "inner vision—that complex amalgam of memory, imagination and projection."[28] As his own sight falters and transforms, he finds himself relying more on what he terms this "internal vision" than the "externally visual" captured by photography. Echoing the poetry of Agha Shahid Ali in his recognition of the gap between memory and representation, deSouza reflects on the notion of the photograph as evidence of the past "as it really was":

> I remember photographs even as other memories fail. It is the photograph
> —and my enduring faith in its veracity—that I have held onto as proof.
> And for many years I have had the proof, the many photographs taken
> by my father, the tangible evidence of our life in Kenya. . . . And yet the
> recent return of memories in such physical, bodily ways has accumulated
> and layered meaning beyond the simply visual. As a result, my faith in the
> photograph as ultimate repository of memory is, if not shattered, at least
> shaken. Now, when I look at the two-dimensionality of photographs, I
> wonder how much else is lost along with that third dimension. Or perhaps
> I'm merely re-experiencing my earlier disenchantment: the failure of the
> photograph to match the vividness I have ascribed to it within my memory
> and imagination.[29]

If Hartman turns to memoir and her own imagination in responding to the gaps of the official archive, deSouza turns to the materiality of his own body, to the tactile and the affective, in order to conjure into the present precisely that which is lost within the two-dimensionality of the photograph. *The Lost Pictures* that deSouza produces from his father's originals are indeed pictures

of what is lost within an official archive of both familial and national forma-tion; they are deSouza's attempt to mediate, and perhaps close the distance between, an "internal vision" and the external, apparently indexical and fixed image of the past exemplified by the original photographs. DeSouza's trans-formation of the original images can also be read as a rejection of "looking (seeing) like his father" and, instead, an embrace of "looking (seeing) like his mother": as such, deSouza repudiates a narrative of patrilineal oedipality that subtends many conventional framings of both nationalist and diasporic subjectivity.[30] The practice of looking that deSouza enacts in *The Lost Pic-tures* resonates with what Christopher Pinney terms "looking past"—a phrase Pinney uses to describe a reading practice through which subaltern subjects challenge dominant visual representation, and photography in particular.[31] He writes,

> "Looking past" suggests a complexity of perspectival positions or a multi-plicity of layers that endow photographs with an enormously greater com-plexity than that which they are usually credited. The photograph ceases to be a univocal, flat, and uncontestable indexical trace of what was, and becomes instead a complexly textured artifact (concealing many differ-ent depths) inviting the viewer to assume many possible different stand-points—both spatial and temporal—in respect to it.[32]

As with Hartman's memoir, deSouza's refashioned images "look (to the) past" not with utopian nostalgia (in Boym's sense of the term) but rather with *nos-talghia*, as Seremetakis understands it, enacting a palimpsestic, dialectical re-lation between past and present. DeSouza in effect "looks past" the past, to foreground the contradictions of postcolonial nationalism and the complici-ties of the heteronormative family form within this project.

Many of the final images in *The Lost Pictures* are deliberately opaque, and appear to be almost completely bleached out, or veiled by fog. The human figures are barely distinguishable, existing as simply darker or lighter blotches against blurred backgrounds mottled by white watermarks, delicate black squiggles, stains, and shards. As with Chitra Ganesh's family photographs in *13 Photos*, deSouza's images frustrate the viewer's "will to see"; however long and hard a viewer gazes at them, the fog refuses to lift and the figures remain ghostly, indistinct, ungraspable, and unknowable. In his essay, deSouza speaks of the fear with which his mother, as she dies, feels a "fog" descending on her; he understands this "fog" as "an internal blindness," which obscures her "inner vision."[33] In rendering the images so impenetrable, deSouza invites us as view-

ers into a shared identification with his mother—we too look (and see) like her—and thus into the site of memory's failure (plate 15).

That deSouza uses the dead matter of his own body as the artistic medium through which he obscures the original images is particularly striking. In his earlier work, such as the *Terrain* series (1999–2003), he photographs landscapes that he created out of street trash, as well as his own ear wax, fingernails, eyelashes, and hair. DeSouza's use of bodily remains powerfully engages with notions of abjection, filth, and disgust,[34] and its valence is double-edged: while the images do speak to the horror of death, obliteration, and bodily disintegration, they may also offer a way of understanding such bodily waste as potentially productive. William Cohen's formulation of filth underscores the ways in which "contradictory ideas—about filth as both polluting and valuable—can be held at once."[35] He writes:

> While filthy objects initially seem utterly repulsive and alien . . . they also paradoxically bear potential value. But are there conditions under which filth might actually provide an appealing point of identification for subjects? When people who understand themselves to be degraded, dispossessed, or abjected by a dominant order adopt and appropriate . . . what is otherwise castigated as filth, there is a possibility of revaluing filth while partially preserving its aversiveness. Not merely owning up to, but taking comfort in, one's supposed dirtiness can serve powerful purposes of self-formation and group identification. In these senses, filth is put to important use, both psychologically and politically.[36]

I quote Cohen at some length here because I find that his formulation of filth as both polluting and reusable precisely names the ambivalent meanings and effects of deSouza's use of bodily remains. In deSouza's images, filth is indeed put to use: the abjected remains of the dispossessed (signified by the dead matter of his own body) become the medium through which deSouza revisions a personal and collective relation to colonial and anticolonial nationalist pasts, and to multiple diasporic locations in the present. For instance, in "Fountain" (plate 16), the artist and his siblings stand with their backs to the viewer, facing an indeterminate, vaguely apocalyptic future. They appear to be gazing at what could be a fountain, a mushroom cloud, or some kind of ominous sun, but that is in fact a spot of blood staining the print's surface. The image is deeply unsettling: parts of the children's bodies seem to be quite literally under erasure, mottled by white, black, and brown stains, while the entire surface of the photograph is covered with a delicate filigree of black

etchings, created by the artist's hair. As such, "Fountain" is the antithesis of the optimistic, forward-looking gaze of the newly independent nation; it refuses to consolidate into a comforting narrative of what Boym would term the utopian or reconstructive nostalgia of nationalist projects.

The title of deSouza's image can be read as an oblique reference to Marcel Duchamp's infamous 1917 installation piece of the same name, in which he mounted a mass-produced urinal on a pedestal, signed it with a pseudonym, and sought to exhibit it as a work of art. Svetlana Boym finds intertextual echoes between Duchamp's and the work of contemporary Russian conceptual artist Ilya Kabakov, who re-created Soviet-era toilets for the 1992 Kassel Documenta show; she reads Kabakov's installation, like Duchamp's work, as "trespassing the boundaries between the aesthetic and everyday life."[37] I would argue that deSouza's image references Duchamp (and, by extension, Kabakov) to suggest the elevation and memorialization of precisely that which is conventionally expunged and discarded. In doing so, deSouza disturbs the boundaries between the mundane and the everyday (which falls outside of history) and the monumental and the spectacular (which constitutes official history).

DeSouza's particular mobilization of ideas of abjection and filth must be situated in relation to the specific historical moment out of which the original images emerge—the early years of Kenyan independence from British colonial rule—and the fraught location of Kenyan Indians within that nation-building project. Under British colonial rule, Indian indentured laborers were brought to East Africa in mass numbers from the 1860s to 1917, to work primarily on building the British East African Railroad, "a key element in Britain's imperial strategy during the scramble."[38] The British imperial project was dependent not only on Indian indentured labor but also on Indians making up the management and bureaucracy of the railways at all levels.[39] In Savita Nair's research on Indians in colonial Kenya, she points to the heterogeneity of the Indian population, and argues that Indians in Kenya were just as likely to be traders, merchants, and professionals as they were to be indentured labor or descendants of the indentured. East African Indians inhabited a "dubious status," situated as they were "in a precariously liminal category between colonized and colonizer."[40] This liminality meant that, as historian Thomas Metcalf notes, "Indian Africans remained vulnerable to a politics of hostility, exclusion and even, in the case of Idi Amin's Uganda, expulsion."[41]

For Hartman, the slogan "Africa for Africans abroad and at home" from the anticolonial nationalist era conjures forth the seductive promise of dias-

poric belonging in the new nation that, forty years after independence, rings hollow; it highlights her own sense of estrangement as a black diasporic subject in postcolonial Africa. For Indian Africans such as deSouza, however, this slogan from its very inception is no seduction, but an ominous sign of what is to come, for it names a collective history of expulsion, as "authentic African-ness" came to be defined in strictly racial terms. DeSouza's work necessarily speaks back to the feelings of alienation that saturate Hartman's text: I would suggest that, in her emphasis on her own strangeness, Hartman may in fact grant a fictional stability of identification to the postcolonial Africans she encounters.[42] When read through the prism of deSouza's work, it becomes clear that Hartman might be eliding the ways in which the postcolonial others that she encounters also have deeply vexed and unfixed relations to both time and place. It is precisely the ambiguity and ambivalence of racialized Indian African subjectivity that deSouza's images reference, through their deployment of notions of filth and abjection. The "borderline feelings" that his images evoke — between disgust and fascination — speak not only to the borderline positionality of the artist himself as a multiply diasporic subject but also to the status of Indian Africans as both inside and outside the national project.[43]

DeSouza's engagement with the promises and the failures of decolonization movements is particularly apparent in an image entitled "Harambee!" (plate 17). The original slide was taken by deSouza's father during Kenya's 1963 Independence Day celebrations. Here, the ghostly outlines of the artist and his siblings are seen on either side of a man dressed, oddly enough, in a gorilla costume — a representation, according to deSouza, of something "generically African [even though] there are no gorillas in Kenya!"[44] Barely visible in the background is the exterior of a parade float, draped with the black, red, and green stripes of the Kenyan flag. DeSouza's reworking of the original image comments directly on the contradictions of the anticolonial nationalist project. "Harambee," a Swahili word literally meaning "everyone working together for a common cause," was adopted as the official motto of the newly independent nation, and used by Jomo Kenyatta as a nationalist rallying cry for national unity and collective endeavor. Ironically, this term is thought to have originated with Indian indentured laborers toiling on the British East African Railroad in the nineteenth century, and is imagined to have come from their evocation of Durga, a Hindu goddess ("Hare, Ambi"), as they pulled heavy loads together. DeSouza's photograph directly confronts the legacies of overlapping systems of colonial, capitalist labor extraction upon differently racialized populations in the postcolony. The image speaks

to the fragility and fissures of this post-Independence nationalist vision of unity, given the vexed position of "the Asian African" within Black African nationalist discourse.

Finally, in the image "Tomorrow" (plate 18), we can barely make out the outlines of the artist and his brother as they obediently stand at attention, flanking what appears to be a Black African train conductor; behind them a huge billboard carries an image of a train seemingly speeding forward, " . . . for to-morrow" partially visible in bold red lettering across the top. The image of the train—a symbol of both nationalist pride and the technological prowess of the new nation—as well as the slogan "for to-morrow" promise a new beginning, a utopian future that lies just beyond the frame. As I have suggested, the train is also, ironically, a potent symbol of the British imperial project and the various systems of labor extraction upon which it depended. Thus deSouza's image lays bare the continuities between imperial and postcolonial nationalist projects in their adherence to a developmentalist narrative of progress and modernity, and in the inevitable violences upon which this modernity depends. Referring to both "Harambee!" and "Tomorrow," deSouza writes, "People often ask me if the train conductor is my father, but I'm tempted to think of both, the conductor [in "Tomorrow"] and the gorilla [in "Harambee!"] as father substitutes, as well as stand-ins for the new nation."[45] DeSouza's suggestive comment underscores the ways in which both imperial and nationalist projects invariably rest upon conventional gendered and sexual hierarchies. Savita Nair documents how, in colonial East Africa, the railway as an institution, and the railway station in particular, were key sites of contestation where assertions of racial and class power and privilege between white British, Indian, and African men were played out.[46] Similarly, in deSouza's image, the railway becomes the backdrop against which differently racialized masculinities come into contact and conflict in the moment of national liberation. In the original slides, it is the patriarchal gaze of deSouza's Indian father that orchestrates, frames, and organizes the family photograph. In this sense, *The Lost Pictures* implicitly references the centrality of the heteronormative family unit to the making of the modern nation. Yet this gaze is always under threat of its own dispossession: in "Tomorrow," the father's ownership of it is contested by the figure of the Black African train conductor who seems to claim the mantle of nationalist patriarchal authority. And, in the final images of *The Lost Pictures*, the organizing patriarchal gaze of the camera utterly loses its centrality and authority. The camera's eye is blocked, mediated, and rendered barely functional: the images do not connote scopic mastery but

rather the failure of vision, the impossibility of a transparent access to the past and to laying claim to what exists inside the frame.

The Lost Pictures "queers" Bandung in the sense that it enacts a disidentificatory relation to an early moment of postcolonial nationalism: its promises of third-world solidarity and radical social transformation are neither monumentalized nor totally rejected. Rather, the images prompt an ironically nostalgic gaze upon this project, one that brings to the fore its inherent instabilities, particularly in its management of heterogeneous racial, gendered, and sexual others within the newly decolonized nation. There is now a significant body of work in queer studies on how the postcolonial nation defines its boundaries over and against the bodies of those subjects deemed "perverse" within a nationalist imaginary. Jacqui Alexander, for instance, wrote over two decades ago of the particular sense of anger and betrayal that attends the realization that "flag independence" for the newly liberated nation simply enacts another form of radical disenfranchisement for queer and feminist subjects outside the "charmed circle" of criteria for national and communal belonging.[47] Instead of responding to unbelonging with simple resignation and a rejection of the past, deSouza's work allows us to imagine history as "a weave of possibilities," as he puts it; histories of dislocation and expulsion may in fact open new ways of imagining collectivity, beyond the horizon of decolonization and civil rights.[48]

WARM DATA: CHITRA GANESH AND MARIAM GHANI'S
INDEX OF THE DISAPPEARED

I move now from the archive of slavery, British colonialism, and anticolonial nationalism, to that of the post-9/11 surveillance state in the U.S. There are fruitful connections to be drawn here that work against the "ideologies of discreteness"—to cite Roderick Ferguson's apt phrase—that would deny the material and discursive linkages between these different sites.[49] I turn to the work of Chitra Ganesh and Mariam Ghani, who since 2004 have created an ongoing multimedia installation and web-based project entitled *Index of the Disappeared*. If Hartman grapples with the losses generated by the distant past of transatlantic slavery (which remains all too present for her in the material realities of everyday racism in the U.S.), and deSouza's *The Lost Pictures* engages with those absences engendered by the more recent past of postcolonial nationalism, Ganesh and Ghani's *Index* documents those who have been disappeared by contemporary forms of state terror in the U.S. By placing these

works in relation to one another, we can begin to unravel the intertwined diasporic histories of loss, absence, and disappearance: the ways in which black and brown bodies traverse common diasporic ground as they are both marked and rendered invisible by ongoing legacies of slavery, colonialism, and contemporary discourses of racialization.

Jonathan Flatley's notion of "antidepressive melancholia" is particularly suggestive in thinking through the connections between the work of Hartman, deSouza, and Ganesh/Ghani. Flatley understands melancholia to mean "an emotional attachment to something or someone lost," but argues that "such dwelling on loss need not produce depression. . . . In fact, some melancholias are the opposite of depressing, functioning as the very mechanism through which one may be interested in the world."[50] He continues:

> Insofar as the losses at the source of individual melancholias are seen to be generated by historical processes . . . melancholia comes to define the locus of the "psychic life of power" . . . the place where modernity touches down in our lives in the most intimate of ways. As such, melancholia forms the site in which the social origins of our emotional lives can be mapped out and from which we can see the other persons who share our losses and are subject to the same social forces.[51]

In Flatley's formulation, melancholia is not privatizing and narcissistic, but communal and relational; it opens one up to new forms of affiliation and connection on the basis of a shared sense of loss that is socially and historically produced. We can thereby understand the melancholia that suffuses the work of Hartman, deSouza, and Ganesh/Ghani—their refusal to let go of the lost object and their insistence on dwelling on that loss—to be politically productive in that it allows us to place in relation to one another these various experiences of loss and the queer world-making to which they give rise. As I have suggested throughout this chapter, the losses that adhere to black and brown bodies are not "the same," nor are they produced by the "same social forces." However, as the work of Hartman, deSouza, and Ganesh/Ghani reveal, the social forces, discourses, and institutions that uphold slavery and colonialism are intimately linked to contemporary forms of racialized incarceration and detention in the U.S. Thus, Flatley's suggestion that melancholia provides the site for new modes of relationality resonates with my own desire to map the lines of queer affiliation between different diasporic communities.

Ganesh and Ghani's *Index* emerged as a response to the disappearance of hundreds of predominantly South Asian and Arab Muslim men in the U.S.

in the wake of 9/11. The project, which has taken on various iterations since its initial installment in 2004, is described by the artists as "both a physical archive of post-9/11 disappearances and a mobile platform for public dialogue."[52] *Index* in some ways shares the spirit of one of Ghani's earlier works, *Afghanistan: A Lexicon*, cocreated with her father Ashraf Ghani as part of dOCUMENTA(13), and published as a book in 2012. An annotated dictionary or encyclopedia of sorts, somewhat like Raymond Williams's *Keywords*, *Afghanistan: A Lexicon* is highly subjective—indeed, the authors annotate the word "Lexicon" in the title itself, noting that it is "selective; associative; may include myth, speculation, and rumor as well as facts."[53] The entries range from historical figures and places, to concepts such as "loss," "vanishing," and "projection"; the *Lexicon* thus veers from the material to the abstract and blurs the boundaries between the two. Ghani's fascination with annotation, definitions, and compilations of facts that are also always fictive, mutable, affective, and subjective, continues with *Index*. On their website, Ganesh and Ghani describe the project as follows:

> As an archive, *Index of the Disappeared* foregrounds the difficult histories of immigrant, "Other" and dissenting communities in the U.S. since 9/11. Through official documents, secondary literature, and personal narratives, the Index archive traces the ways in which censorship and data blackouts are part of a discursive shift to secrecy that allows for disappearances, deportations, renditions and detentions on an unprecedented scale. The Index builds up its collection by collaborating with others actively engaged in political and legal challenges to the policies we track, and draws on radical archival, legal and activist traditions to select, group, and arrange information.[54]

In one of the later iterations of the project, created while in residence at the Asian/Pacific/American Studies Institute at NYU in 2013–2014, Ghani and Ganesh constructed what they term a "parasitic archive" which combines the materials and documents from the *Index* with the existing collection at NYU's Kevorkian Center for Near Eastern Studies. Ghani explains the notion of a parasitic archive as follows: "The idea of the parasitic archive is about what does it mean for the *Index* archive to be translated into existing libraries and collections, and what does it do for the collection to be understood within that context and within that new frame, and how can it [the *Index*] mix into that existing collection and revamp itself to it and draw resources from it and actually remould the [existing] collection to become more like the *Index* in

a way."[55] Ganesh further elaborates on the notion of a parasitic archive: "Our process, both the visual component and textual component, is not about presenting a brand new document that you've never seen before, but it's about sharing, culling, and curating documents that are already out there."[56] While Ghani here describes this particular iteration of the *Index* as parasitic, in that it absorbs, cannibalizes, and transforms the existing, "official" archive in which it is housed, Ganesh also makes clear that all iterations of the *Index* are parasitic insofar as they present material that already exists in the public domain; the *Index*'s intervention is that it "shares, culls, and curates" this material so as to produce an alternative version of history.

Central to Ganesh and Ghani's production of an alternative archive is their concept of "warm data," which, Ghani explains, stands in opposition to the "cold hard facts" elicited by official interrogations of the detainees and used to produce, discipline, and contain the "terrorist." The artists glean this "warm data" by reading heavily redacted government documents for their "accidental ruptures," for their "productive breaks and slippages, moments where language escapes from official to unofficial registers, from public to private domains, from political to poetic testimony," as Ganesh and Ghani put it in their artists' statement.[57] Ganesh, for instance, describes coming across a detainee's hand-drawn map of his pomegranate garden in the middle of an official U.S. government document detailing his interrogation and torture:[58] an "accidental rupture" that speaks to this detainee's particular psychic geography in an otherwise studiously dispassionate and deliberately dehumanizing document.

Moreover, the artists glean "warm data" not only from the interstices of official documents, but also from their own alternative forms of data collection, which are then collated into what they term a "Warm Database." To that end, the artists have posted on their website a "Warm Data Questionnaire"; they invite all those who have been "affected by detention and/or deportation" to answer questions such as the following: "Who was the first person you ever fell in love with? What is your favorite flavor, and what is the one food that if you had the choice you would never eat? Which family member are you the closest to? Describe a place you see when you close your eyes at night. Name a piece of music that is always running through your head. What is your earliest childhood memory? Which muscle do you use the most in your normal daily activities?" The artists state that their intention is to collect material or information that would be deemed "useless" in the eyes of the surveillance apparatus: precisely the information that is excised or never granted entrance in the official archive in the first place. If what is deemed as "religious fervor"

or "anti-Americanism" are the only forms of affect that the security apparatus seeks to elicit and document as "proof" of the detainee's terrorist status, the "warm data" gathered by Ganesh and Ghani instead constitute an alternative "archive of feelings," to use Ann Cvetkovich's phrase. As with the archives of queer history theorized by Cvetkovich, the "Warm Database" catalogs "emotional memory, those details of experience that are affective, sensory, often highly specific, and personal."[59] Yet the danger of any such project is that, despite the intentions of the archivists, the very act of gathering and indexing information—however arbitrary, fragmented and impressionistic this information may be—produces a body of material that may make the detained ever more available to the state's scrutinizing gaze.[60]

Nevertheless, the "warmth" of such data consists of those affective attachments—to places, people, things—that are experienced sensorially and through the body itself, and impossible to capture and quantify through conventional measurements and indices. As Nadia Seremetakis asks, "How is history experienced and thought of, on the level of the everyday? . . . Where can historicity be found? In what sensory forms and practices? And to what extent [is] the experience of and the capacity to narrate history . . . tied to the senses?"[61] Seremetakis's questions allow us to understand the *Index* as archiving the "sensory experience of history";[62] sensorial memory (smell, texture, touch, sound, heat) conjures forth those affective attachments that store individual, familial, and collective histories, and that evade or are banished from the official archive. For Ghani and Ganesh, the collection of "warm data" has the potential to reverse the process by which complex lives and subjectivities are transformed into nameless and faceless "special interest immigrants."

What I find particularly fascinating about their questionnaire is the power of the detail, the mundane, and the everyday, which work through and beyond a visual register to mobilize an affective response that conjures forth other times and places, landscapes both physical and psychic, and relationalities and affiliations deemed excessive or irrelevant within the conventions of the official archive. It is the stray detail that does not stay in place that stands against the monumentalism of state terror. This strategic use of the detail and the mundane is particularly apparent in a series of watercolor portraits by Ganesh entitled *Seeing the Disappeared* (plates 19 and 20). Here Ganesh critiques processes of memorialization by mimicking the form of the flyers of missing persons that covered public surfaces directly after the collapse of the World Trade Center. Ganesh was compelled to produce these watercolor

portraits as a response to the public silence, indifference, and invisibility that surrounded the mass detentions of immigrants, in stark contrast to the tremendous vocal and visible outpouring of public emotion that attended the deaths of those killed in the collapse. Evoking deSouza's refashioning of the family photograph in *The Lost Pictures*, Ganesh "remakes" the original photographic images of the disappeared gleaned from newspaper articles, family photos, or police mug shots into watercolor images framed by cursive text. These portraits, of those who have in various ways been disappeared by the dragnet of counterterrorist policies, tell the stories that cannot be told by the official mug shot or the newspaper account. In keeping with Ganesh's larger body of work, the portraits compel the viewer to think through the interplay and tension between text and image: the text does not "explain" the image as much as it underscores the limits and gaps of the visual field in producing the "truth" of what it purports to represent.[63] The disjointed fragments of phrases that float around the figures of the disappeared refuse to cohere into a linear narrative; instead they evoke, in Cvetkovich's words, "the idiosyncrasies of the psyche and the logic of the unconscious" that escape codification in the visual field.[64] As such, the portraits grant their subjects a much more complex, rich, and variegated psychic landscape than can be captured by the flat, indexical nature of the original photographs. Ganesh's transformation of the photograph into the watercolor image blurs the boundaries between photography and painting and thereby makes apparent the inherent instability of all forms of representation. If watercolor as a medium is notoriously unpredictable, its lines bleeding and transforming regardless of the artist's original intention, Ganesh's portraits also underscore the inherent instability of the photograph itself, despite its apparent purchase on fixity, transparency, and truth.[65]

The portraits restore to the disappeared the "warm data" that the questionnaire collects: along with the names of the disappeared and the supposed reason for their detention, the text alludes to those apparently random or useless details of lives that have lost the luxury of the mundane. One of the portraits is of Ansar Mahmood, a green card holder originally from Pakistan, arrested in October 2001 for taking a photograph of himself in front of a water tank in upstate New York. He was turned in to immigration authorities by security guards who could not believe that he was taking a tourist photo rather than being engaged in some form of terrorist activity, and then imprisoned in a detention center in Buffalo for thirty-two months before finally being deported. Below the image of Mahmood's face, taken from a family photograph, Ganesh notes in small script his name and his ostensible crime:

"Ansar Mahmood, for taking a photograph." Surrounding the image are fragments of text: "the first time he saw a body of water/or the smells and textures of his wedding day/another instance of . . . the hardest working kid I've ever seen!" These phrases, while seemingly nonsensical and incoherent, in fact grant a psychic interiority and relationality to Mahmood that the official data effaces. Ganesh and Ghani's *Index* thus uses the power of the detail and the mundane against the catastrophic disappearance of entire populations.[66] The artists here appear to heed Jack Halberstam's call for "low theory in popular places, in the small, the inconsequential, the anti-monumental, the micro, the irrelevant," in order to locate alternatives to the seemingly totalizing forces of capitalism and heteronormativity.[67] This call resonates powerfully with the turn to the minor, to the tangential and the excessive, the banal and the everyday, that is at work in the art of both deSouza and Ganesh and Ghani. In deSouza's use of the detritus of the everyday, as well as in Ganesh and Ghani's attention to the everyday of lives lost, it is precisely the antimonumental that suggests alternative ways of being in the world.

"NOT TOURIST PHOTOS": ALLAN DESOUZA'S *UFO* AND *DIVINE*

DeSouza's two photographic series from 2007–2008, *UFO* and *Divine*, refer even more directly to the transformative effects of the mundane, mining its power to connote both the innocuous and the dangerous (plates 21 and 22). In the *UFO* series, showcased in an exhibit tellingly entitled *(i don't care what you say) Those Are Not Tourist Photos*, deSouza manipulates photographs that he initially took from the interior of an airplane as he commuted between San Francisco and Los Angeles. The title of the exhibit comes from a confrontation that he had with a fellow passenger which eerily echoes the experience of Ansar Mahmood memorialized by Ganesh. This passenger, responding to deSouza's brown skin and the apparent lack of the scenic in what he was photographing, stated, "I don't care what you say, those are not tourist photos, and as an American citizen I want you to stop taking them!"[68] The encounter crystallizes the hierarchies of power and privilege that determine who is allowed a tourist gaze and who is not, and for whom is the luxury of the mundane and the everyday effaced, or seen as a threat subject to discipline and incarceration. That the fellow passenger was a young, professional African American man further complicates this scenario, and demands that we create analytical frameworks that can unpack the ways in which minoritarian claims to citizenship have been routed through and against each other, particularly since 9/11.

The photographs that constitute the series *UFO* were created by making mirror images of the unspectacular and the unremarkable, the aggressively antiscenic: the tarmac and the runway taken in that liminal space just before take-off or just after landing. The title, *UFO*, in light of deSouza's encounter with the fellow passenger, can be read as either "Unidentified Flying Object" or "Unidentified Foreign Object," and as referencing both the image and deSouza himself. Inhabiting the threat attributed to his body and his actions, deSouza transforms the mundane into a missile, a rocket, a potentially murderous object. Similarly, in the *Divine* series, deSouza's apparently nefarious aerial surveillance activity renders strange and spectacular the most featureless of landscapes, transforming them into organic and skeletal outlines of divine (female) bodies. As such they fall outside the grasp of what is readily imagined as knowable within the logic of the surveillance state. In its radical reframing of landscape photography, the *Divine* series recalls both Sheba Chhachhi's *Winged Pilgrims* and Tracey Moffatt's *As I Lay Back on My Ancestral Land*, discussed in previous chapters, where Chhachhi's and Moffatt's visions of palimpsestic landscapes gesture to other ways of being in the human and nonhuman worlds that far exceed a colonial logic and imagination. Likewise, deSouza eschews the demand that the aerial photograph function as a form of evidence or data in militarized surveillance operations, and instead reframes the landscape into precisely that which cannot be apprehended within this reductive, militarized logic. DeSouza's aerial vision, like Chhachhi's "birds-eye view," brings into focus an altered landscape that escapes intelligibility within the normative forms of knowledge production upon which the surveillance state depends.

DAMAGED NEGATIVES: AKRAM ZAATARI'S QUEER VISUAL EXCAVATIONS

I turn now to Lebanese visual artist Akram Zaatari, whose remarkable body of work from the mid-1990s to the present speaks eloquently to the questions of archive, affect, and the everyday—and the different registers of loss, absence, and disappearance—that preoccupy Hartman, deSouza, and Ganesh/Ghani. Zaatari works as both a curator and an image-maker, archivist and artist,[69] and his video and photographic works, as well as his archival and curatorial practices, have made him one of the most recognizable contemporary artists based in the Middle East to circulate in the international art world.[70] Critics and scholars generally contextualize Zaatari by situating him as part

of an important generation of artists who emerged in the 1990s out of Beirut, Lebanon,[71] and were concerned with countering the collective amnesia that characterizes Lebanon's postwar public culture.[72] Commentators also situate Zaatari within a wider network of contemporary multimedia Middle Eastern artists based in both the region and the diaspora (such as the Palestinian artist Emily Jacir and the Iraqi American artist Wafaa Bilal), all of whom grapple with questions of violence, militarism, occupation, and traumatic memory in their work.[73] While this contextualization is clearly indispensable to un-derstanding the geographical and historical specificity of Zaatari's work, I want to suggest that if we also place Zaatari alongside the work of Hartman, deSouza, and Ganesh/Ghani (who are not figures with whom Zaatari is typ-ically imagined to be in conversation), we can begin to identify a shared aes-thetic and conceptual sensibility that I have been calling the aesthetic practice of queer diaspora. This somewhat unexpected juxtaposition of artists, each of whom engages a different diasporic history, opens up the possibility of trac-ing the lines of connection between these disparate histories and formations; such a juxtaposition transforms the meanings of both diaspora and queerness in the process.[74] Queerness provides us with an alternative historical optic that allows us to see the affective intimacies between distinct and nonequiva-lent diasporic histories and formations; the aesthetic practices of queer dias-pora constitute an important site where modes of affiliation across difference become apparent.

Zaatari is cofounder of the Arab Image Foundation, which since 1997 has striven to archive photographic practices in Lebanon and throughout the sur-rounding region, and much of Zaatari's work engages with this particular his-tory of image-making and its centrality to the production of Lebanese moder-nity. As part of a generation of "post-war artists" (who came of age after the official end of the Lebanese civil war in 1990),[75] Zaatari's work approaches the ongoing legacy of war and violence in Lebanon—its imprint on the physical and psychic landscapes of people and places—through a careful recording and memorializing of the quotidian and the antimonumental.[76] His interest in documenting the mundane and the everyday as they coexist with the spec-tacularity of historical events (such as the 1982 Israeli invasion of south Leba-non) has the effect, as one critic notes, of "fragmenting the assumed narrative of a culture overcome by conflict."[77] More importantly, this minute attention to the everyday in Zaatari's work, as well as the work of the other artists dis-cussed in this chapter, brings to the fore those shadow histories, subjectivities, and desires that are occluded in dominant tellings of history. The personal

and the quotidian, as salient categories in his work, range from the everyday modes of mid-twentieth-century image-making and self-representation that he painstakingly archives and curates, to the (mostly male) erotic practices, fantasies, and desires that he documents in his video, web-based, and photographic works. As a number of critics have pointed out, the two strands of Zaatari's oeuvre—the concern with the effects of war, occupation, and militarized violence on the one hand, and with sexual and gendered desires, practices, and identities on the other—have typically been seen as discrete elements, when they may more fruitfully be viewed as co-constitutive.[78]

The imbricated nature of these two thematic strains is particularly apparent in Zaatari's ongoing curatorial and archivist project that engages the photographic output of Hashem El Madani, a studio photographer in the south Lebanese city of Saida, Zaatari's hometown. El Madani took hundreds of thousands of photographs of Saida's residents from the 1950s through the 1980s and beyond at his studio, Studio Shehrazade, which he founded in 1953. As I discussed in the introduction, in his coedited 2004 volume *Hashem El Madani: Studio Practices* Zaatari selects, prints, and arranges a selection of photographs from El Madani's vast collection of negatives, which totals over five hundred thousand images. He thereby produces what Ganesh and Ghani term a "parasitic archive," that intervenes into an existing archive by drawing from it and transforming it in the process.[79] Zaatari does not approach El Madani's photography as documentary evidence of the past "as it really was"; as Hannah Feldman and Zaatari himself comment in a coauthored essay on Zaatari's appropriation of El Madani's work: "Manipulated by the intervening hand of the artist, the photographer's archive is reorganized, rearranged, and re-sorted to communicate something of photography's economy, conventions and even conflicting relationship with the social and the political. . . . It is Zaatari who presents the re-orchestrated archive as his own artistic intervention."[80] Even though El Madani himself provides captions for most of the photographs in the volume, Zaatari understands his engagement with El Madani's oeuvre less in terms of collaboration with the photographer than as a form of excavation: "As with the paleontologist who literally unearths a fossil by smashing a stone, the artist has enriched our understanding of the fabric of everyday life in the region by unearthing, recoding and circulating these images to a broad public. At the same time, the artist can do so only because the tradition that originally framed these images has, as a consequence of time, itself disappeared."[81] But, as Mark Westmoreland comments, while the photography studio in Zaatari's work "emerges as a site of loss," threatened

by wartime destruction as well as by the passage of time and changing cultural mores, "Zaatari's engagement with the photo studio should not be mistaken as a nostalgic desire for recreating a lost form of public art, but instead as an effort to re-inhabit these sites and re-enchant their legacy within the present."[82] As with Ganesh's *13 Photos*, deSouza's *The Lost Pictures*, and Tracey Moffatt's *Spirit Landscapes*, Zaatari's reanimation of El Madani's oeuvre "looks (to the) past" to enact a dynamic dialogic relation between past and present, one that allows the photographs to speak "in two different tenses," as Feldman and Zaatari put it.

Hashem El Madani: Studio Practices is but one iteration of Zaatari's extended engagement with El Madani's prodigious photographic output: since 2004, Zaatari has assiduously explored El Madani's body of work and made it available to a broader viewing public through various video and photography installations that showcase not only El Madani's images — which Zaatari digitally reproduces — but also the minutiae of the photographer's studio and his instruments, supplemented by interviews with El Madani himself. Zaatari's very fascination with Madani's work has something of a queer edge to it;[83] one reviewer commented that Zaatari's 2013 exhibition *On Photography, People, and Modern Times*, consisting in part of "Zaatari's comprehensive photographic and video documentation of el Madani's studio equipment — ranging from pencil stubs, to retouching brushes, to cardboard boxes where he kept his negatives — [felt] overdone," and that such work "ends up simply fetishizing the equipment."[84] But it is precisely this fetishistic, "overdone" quality through which Zaatari engages El Madani's work that transforms it from a collection into a queer archive.[85] Zaatari demands that we value El Madani's images not only as social documents of a particular regional history of south Lebanon, but because of what Ann Cvetkovich terms their "felt value"; this "felt value" is evident in the way the photographs act as both a record and performance of queer affects between the subjects in the photographs as well as between these subjects and Zaatari himself.[86]

Zaatari's queer relation to the photographs is apparent in how he determines which photographs to reproduce, and how he chooses to order and arrange them. For instance, one striking series of portraits that Zaatari assembles from El Madani's disparate negatives depicts young men, some in military-style garb and with *keffiyeh* wrapped around their heads, others in the latest fashions of the day, staring proudly into the camera, with semiautomatic rifles in their hands. The images, which were taken in the late 1960s and early 1970s, appear to depict Palestinian resistance fighters, or *fedaiyin*, who

FIGURE 4.1 "Zarif, a Palestinian resistant. Studio Shehrazade, 1968–72," from *Hashem El Madani: Studio Practices*, courtesy of Akram Zaatari and Arab Image Foundation.

were at that time familiar figures in Saida, which was using south Lebanon as a base for attacks against Israeli forces. But, as El Madani explains in an interview with Zaatari, some of the men in the images were in fact simply civilians posing as militants for the purposes of the portrait; the gun may very well have been borrowed or simply a studio prop that El Madani had lent them, along with other accoutrements such as hats and scarves.[87] The photographs militate against any transparent reading of them as unmediated documentation of historical fact by speaking to the desires and aspirations of the sitters themselves, their attempts at self-fashioning, and their own investments in a fantasy of a heroic, militant masculinity. At the same time—as art historian Chad Elias notes in his insightful interview with Zaatari—these images "also lead us to consider how Zaatari's seemingly dispassionate project of archival

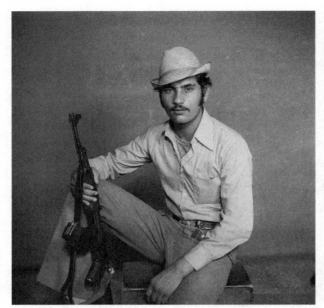

FIGURE 4.2 "Palestinian resistant. Studio Shehrazade, 1968–72," from *Hashem El Madani: Studio Practices*, courtesy of Akram Zaatari and Arab Image Foundation.

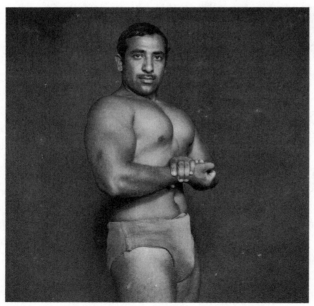

FIGURE 4.3 "Rishe. Studio Shehrazade, late 1960s," from *Hashem El Madani: Studio Practices*, courtesy of Akram Zaatari and Arab Image Foundation.

research is bound up with his own deep attraction to the subjects captured in these images." As Zaatari comments: "'I loved the Palestinian *feda'i*, my childhood mythical fighter figures, who used to give me all sorts of bullets to collect as a kid. I loved how they lived on the streets, how they slept in the fields or in vacant buildings. I loved how they smelled. I envied them for fighting for justice; I sincerely loved them.'"[88]

Zaatari's ongoing fascination with the figure of the resistance fighter (both Lebanese and Palestinian) is evident throughout much of his work, and in *Hashem El Madani: Studio Practices*, he tellingly intersperses these images of performative, militant Palestinian masculinity with others of a body builder flexing his muscles, and of a young man posing shirtless, his muscled torso inviting an admiring gaze. Such juxtapositions prompt Chad Elias to note that, for Zaatari, the archive functions "as a site of libidinal investment."[89] This, then, is how the photographs "speak in two different tenses," as Feldman and Zaatari put it: they attest to the self-making practices and desires of the original sitters, as well as to Zaatari's own queer transtemporal gaze that reanimates these images of a romanticized masculinity that exists only in fantasy, outside the realm of the present. Zaatari's affective and sensorial relation to these resuscitated representations of hyperbolic masculinity evoke Elizabeth Freeman's concept of "erotohistoriography," a term she uses to index "how queer relations exceed the present. . . . Against pain and loss, erotohistoriography posits the value of surprise, of pleasurable interruptions and momentary fulfillments from elsewhere, other times," that run counter to "the logic of development."[90] Zaatari's adult queer sensibility is indelibly marked by his childhood love and desire for the romanticized image of the Palestinian freedom fighter. These images precisely demonstrate how the two strands in Zaatari's work that critics have identified—his concern with the effects of war and violence, and his interest in sexual practices, desires, and identities—mesh most deeply. It is not so much that queer desire in his work functions "against pain and loss"; rather, queerness—as sexual practice, as relationality, as desire—is intimately bound up in the interminable cycles of pain and loss that mark Lebanon's history. Freeman asks, "How might queer practices of pleasure, specifically, the bodily enjoyments that travel under the sign of queer sex, be thought of as temporal practices, even as portals to historical thinking?"[91] For Zaatari, his desire for a particular iteration of idealized masculinity that "exceeds the present," as Freeman phrases it, has the effect of queering a specific history of anticolonial nationalist struggle in much the same way that Allan deSouza's *The Lost Pictures*, as I argued, enacts a queer critique of Bandung-era postcolonial nationalism.

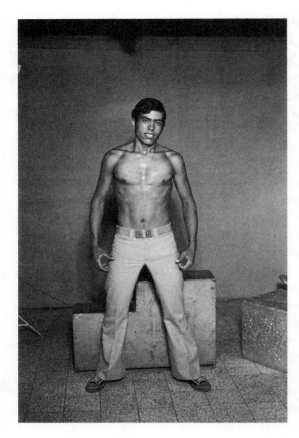

FIGURE 4.4 "Anonymous. Studio Shehrazade, 1972," from *Hashem El Madani: Studio Practices*, courtesy of Akram Zaatari and Arab Image Foundation.

Zaatari's excavation and reanimation of El Madani's portraits constitute a form of "erotohistoriography," in that they call into the present the submerged histories of homoerotic desire and queer relationality that are repudiated, and that cannot be told or neatly contained within standard developmentalist narratives of nationalist struggle. Such triumphalist narratives are typically predicated on patriarchal and heteronormative tropes that allow no room for unruly forms of love, relationality, and desire, nor for the more "disturbing and confusing"[92] stories of defeat, uncertainty, and failure that invariably shadow them.

It is precisely these other stories that counter triumphalist nationalist narratives that Zaatari attempts to capture in one of his earliest projects, the 1997 experimental video *All Is Well on the Border Front*. The video tells a different story of the Israeli occupation of south Lebanon from 1982–2000 than that which is available through what Zaatari terms the "pompous narratives

of resistance"[93] ubiquitous in Lebanese national media at the time. I want to briefly touch on this work, as it provides a useful corollary to his later engagement with El Madani's oeuvre. *All Is Well* reflects on the displacement and relocation of the occupied zone's inhabitants to the southern suburbs of Beirut, thereby transforming Beirut itself into a diasporic space. As Zaatari explains, "People displaced from their villages in south Lebanon lived mostly in the same neighborhood [in Beirut]. In order to preserve ties to their place of origin they recreated a set of social ties in a different geography. Your neighbor in the village became also your neighbor in Beirut. It was . . . a way to keep intact the social structures of their village of origin, and to assimilate more easily to an urban environment that threatened to strip them of their communal histories."[94] In a similar vein as Tracey Moffatt's reframing of diaspora through indigeneity in *Spirit Landscapes* that I discussed in chapter 3, *All Is Well* documents how war and occupation engender a peculiar kind of diasporic consciousness that emerges ostensibly within the boundaries of the nation-state, where the displaced and relocated hold strongly to idealized visions of the lost homelands they were forced to leave behind. Countering such mythologies, Zaatari reflects on the testimonies of Lebanese resistance fighters in the south in such a way that eschews the rhetoric and dogma of both the secular and religious resistance: Zaatari foregrounds the far more ambivalent, unheroic stories that these fighters tell, "the very personal defeat that they had experienced in [Israeli] detention."[95] In so doing, *All Is Well* presents the viewer with what Zaatari terms "an alternative history of the Lebanese wars from the vantage point of those excluded from its dominant representations—the prisoners, the traitors, the exiled, the coerced, the opportunistic."[96] As he states in his interview with Chad Elias, Zaatari casts his lot with the defeated: "Between defeat and ruling for eternity, I prefer defeat. . . . The left in Lebanon was progressive, diverse, democratic, too weak to rule by itself, which led indirectly to its withdrawal from the political scene—what you call defeat. Why not? Ideologies are not meant to live forever. . . . My critique of the secular resistance in Lebanon is that it was dogmatic, on all levels."[97] Zaatari's critique of the secular left in Lebanon is not that it failed to achieve political dominance, but that it embraced a certain brand of revolutionary dogma that ultimately shut down all possible spaces for alternative narratives and formations to emerge. Similar to Allan deSouza's *World Series*, Zaatari conjures the memory of this failed movement into the present in order to gesture toward the possibilities it fleetingly suggested but that remained unrealized in the past, and that may nevertheless suggest alternative pathways in the future.[98]

Zaatari's complex engagement with the historic failures of the secular left in Lebanon is crystallized in his relation to the figure of the resistance fighter. Speaking of one of the Lebanese resistance fighters who occupies a central position in *All Is Well*, Zaatari comments, "I loved him, and desired the figure of the resistance fighter that I could not claim with my middle class background and education."[99] Zaatari's affective connection to this figure of the Lebanese resistance fighter in *All Is Well* carries over to and colors his re-presentations of El Madani's portraits of (the performance of) Palestinian male militancy. If we view *All Is Well* as a kind of precursor to *Hashem El Madani: Studio Practices*, it becomes clear that Zaatari is not simply reframing this figure of hyperbolic, militant masculinity through a queer lens, nor merely celebrating it as the genesis of a queer subjectivity. Rather than naïvely idealizing earlier liberation movements, Zaatari lays bare the fault lines and ruptures of these movements, even as they are partially reworked and recuperated through a transtemporal queer gaze. Zaatari's reanimation of past liberation struggles through his evocation of the figure of the Palestinian resistance fighter, which he imbues with queer meaning, calls attention to and vigorously challenges the troubling adherence to gender and sexual normativity that exists not only within some strands of Palestinian nationalist discourse (which equate homosexuality with a traitorous allegiance to Israel and/or "the West"),[100] but within nationalist movements more broadly. Echoing Allan deSouza's reframing of Kenyan postcolonial nationalism in *The Lost Pictures*, Zaatari enacts a disidentificatory relation to this figure of the revolutionary male militant and the nationalist projects that he represents. Zaatari is interested in bringing to the surface the fissures and fault lines, the negative spaces, so to speak, of state and revolutionary nationalist movements and the gendered and sexual formations to which they give rise, even as he insists on the affective and libidinal pull that these formations continue to exert on the present.

Zaatari lays bare these negative spaces of dominant histories in a particularly disturbing pair of photographs in *Hashem El Madani: Studio Practices* that he would later name "Scratched Portraits of Mrs. Baqari," when he reprinted and enlarged them as part of his 2012 *Damaged Negatives* series. In the poignant caption that accompanies these images in *Hashem El Madani: Studio Practices*, El Madani explains that he used a pin to scratch the negatives of the portraits of a young woman that he took in 1957, in response to "her jealous husband," who was angered that she had come to Studio Shehrazade without his knowledge. The husband demanded that El Madani return the negatives to him; El Madani refused, and agreed instead to damage the neg-

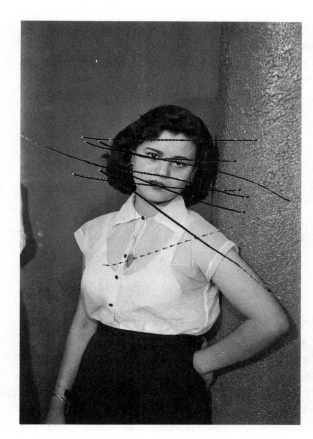

FIGURE 4.5 "Anonymous. Studio Shehrazade, 1957," from *Hashem El Madani: Studio Practices*, courtesy of Akram Zaatari and Arab Image Foundation.

atives so that they could no longer be printed or circulated. "Years later," El Madani writes, "after she burnt herself to death to escape her misery, he came back to me asking for enlargements of those photographs, or other photographs she might have taken without his permission."[101] Zaatari creates two prints from El Madani's damaged negatives: in the first, a young woman gazes soulfully at the camera as she stands against a pillar in a white blouse and black skirt, her hand on her waist; in the second, she poses with a water jug on her shoulder, playing out a picturesque scene of rural life. Both of the images are jarringly defaced by black scratches that slash across the woman's face, while leaving the rest of her body and the background relatively unscathed. The force of these images is twofold. First, when read through El Madani's explanatory text, the images are a moving testament to this woman's insistence on some degree of autonomy, self-representation, and the pleasurable

space of fantasy in the face of the everyday forms of annihilating patriarchal violence that mark the space of the domestic. Second, when viewed alongside the various images of militant masculinity in Zaatari's reconstituted archive of El Madani's photographs, the obliteration of the woman's face speaks to both the material and representational effacements enacted by standard patriarchal historical accounts, where such gendered forms of violence are cast as merely private, and not worthy of inclusion within larger nationalist or collective narratives. We can read these "Scratched Portraits of Mrs. Baqari" as precisely the "damaged negatives" that shadow Zaatari's ambivalently desiring relation to the figure of the male resistance fighter and the heroic telling of history that he represents. It is useful to turn here to Ann Stoler's strategy for reading colonial archives, which she names "developing historical negatives," and describes as the "analytic shift from the high-gloss print of history writ-large to the space of its production, the darkroom negative: from direct to refracted light, from 'figure' and 'field'—that which is more often in historic relief—to the inverse, grainy texture of 'surfaces' and their shifting 'grounds.'"[102] Stoler's evocation of texture and surfaces highlights the "fundamentally tactile"[103] nature of photography, "a site where the haptic and the optic collide."[104] The black slashes across the face of the sitter in "Scratched Portraits of Mrs. Baqari" make inescapably evident El Madani's own intervening hand as it tears into the surface of the print. In his appropriation of El Madani's archive, we can understand Zaatari to be engaged in this process of literally and figuratively "developing historical negatives," in that his reconstituted images reveal the textures and surfaces of the obverse, the surplus and the discarded, the minor and the marginal, that stand as the shadow and in the shadow of "history writ-large." By imbuing them with a sense of touch and texture, Zaatari's reclaiming of Madani's damaged negatives thereby render these shadow histories material.

It is significant that Zaatari chooses El Madani's archive as his point of entry into an excavation of these "reverse-images" of history,[105] given that El Madani is a Saida-based photographer who captures everyday life in pre-civil war south Lebanon. As Rasha Salti comments, the south has occupied a distinct place in the Lebanese national imagination since the onset of the Israeli occupation in 1982:

> The popular logic of this [national public] consensus argued that the civil war [of 1975–1990] and the occupation of the south [from 1982–2000] were two separate conflicts; the former should be concluded because the

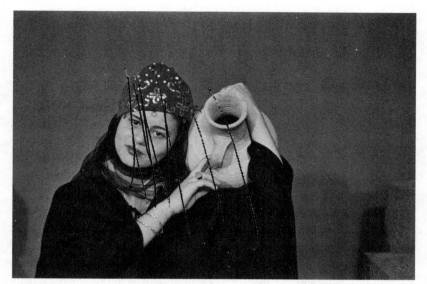

FIGURE 4.6 "Anonymous. Studio Shehrazade, 1957," from *Hashem El Madani: Studio Practices*, courtesy of Akram Zaatari and Arab Image Foundation.

country needed to be rebuilt and rehabilitated, and the "war" in the south could not drag the rest of the country into a confrontation with Israel. As long as the question of the occupied south was marginalized to near obscurity, this consensus generated and capitalized on indifference. In the public sphere, in the realms of popular culture and debate, the occupied south became a faraway geography whose physical attributes were blurred, demography silenced, and history abstracted . . . it became an "elsewhere."[106]

Zaatari's choice to unearth a history of Lebanese modernity through centralizing the pre-civil war, pre-occupation, image-making practices of this abjected region thus has the effect of suturing the south back into the Lebanese body politic instead of allowing it to remain as its "mutilated organ," as Zaatari phrases it. But Zaatari's creation of a "parasitic archive" from El Madani's collection also has the somewhat contradictory effect of outlining the contours of a specifically subnational, regional modernity that stands in contradistinction to a national one. Hearkening back to my discussion of David Kalal's remakes of Ravi Varma's paintings in chapter 1, *Hashem El Madani: Studio Practices* calls into the present the history of various forms of queerness that mark this othered space of the region, and that were perhaps

only possible within it. These submerged histories are hinted at in the many displays of what appear to be male and female homoerotic desire and relationality, as well as gender nonconformity, that Zaatari chooses to highlight from El Madani's collection. The image of "Abed, a tailor" that I discussed in the introduction is one manifestation of these subterranean regional histories, and is in fact one in a series of portraits of this figure. These photographs, as I mentioned, were taken by El Madani sometime between 1948 and 1953, and are accompanied in *Hashem El Madani: Studio Practices* by a succinct yet telling caption from El Madani: "As he was effeminate I would give him poses that I usually chose for women. He used to come often to the studio with his family and friends."[107] The series consists of five portraits; in one, Abed reclines on a pedestal, one arm propping up his head while his other hand rests on his waist, his body arranged in perfect geometric lines; a twinned image that Zaatari displays directly below depicts a young woman identified as "Abed's sister" in the very same pose, sporting a similar hairstyle. The final pair of images shows Abed with two male figures: in one, Abed casually drapes his arms over the shoulder of his more butch companion, while in the other, Abed gracefully leans into the torso of a dapper man outfitted in a suit with a flower in the lapel, his arm wrapped protectively (or proprietarily) around Abed's shoulder.[108]

What I find most remarkable about these images, and about El Madani's accompanying commentary, is just how *un*remarkable they are: El Madani's nonjudgmental, matter-of-fact explication, along with the images of Abed gazing calmly and confidently into the camera among his sister and his male companions, give a sense of an individual whose gender nonconformity is neither spectacular nor fetishized, but quite ordinary. As I suggested in the introduction, it would be reductive to take the photographs as mere reflections of a reality outside the photo studio. However, we can read them as aspirational enactments of queer dwelling and belonging: they produce Abed as a subject who is deeply embedded within a rich social world—a network of friends, lovers, and family members—and they speak to the quotidian strategies of self-representation by which queer subjects envision a sense of place and emplacement. Zaatari's resuscitation of El Madani's images some fifty years after they were initially created insists on the centrality of the memory of alternative modes of desire and embodiment, kinship and affiliation, to the project of imagining a different present. The evocation of this memory, culled from the visual archives of prewar, pre-occupation Saida, does not romanticize the past, but it does evoke other ways of being in the world: it serves as a rebuke

FIGURE 4.7 "Abed. Madani's parents' home, the studio, 1948–53," from *Hashem El Madani: Studio Practices*, courtesy of Akram Zaatari and Arab Image Foundation.

FIGURE 4.8 "Abed's sister. Madani's parents' home, the studio, 1948–53," from *Hashem El Madani: Studio Practices*, courtesy of Akram Zaatari and Arab Image Foundation.

FIGURE 4.9 "Abed. Madani's parents' home, the studio, 1948–53," from *Hashem El Madani: Studio Practices*, courtesy of Akram Zaatari and Arab Image Foundation.

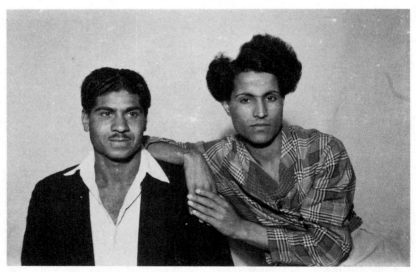

FIGURE 4.10 "Abed and a friend, Rajab Arna'out. Madani's parents' home, the studio, 1948–53," from *Hashem El Madani: Studio Practices*, courtesy of Akram Zaatari and Arab Image Foundation.

to the brutality of a here and now marked by grinding, ongoing cycles of militarized violence.

The images of "Abed, a tailor" are but one intimation of queer relationality and same-sex desire that Zaatari excavates from El Madani's archive. Another series of images in *Hashem El Madani: Studio Practices* consists of a photograph of two women locking lips as they embrace each other, and a photograph of a young man gazing sideways into the camera as he plants a kiss on the cheek of another youth, who has his arm around the man's waist and is gazing down bashfully. Yet another series of images depict what appear to be same-sex weddings with both male and female couples, where one member of the couple (whether male or female) is decked out in a white dress and bridal veil and holding a bouquet. In his interview with Zaatari, El Madani comments that, "in a conservative society such as Saida," social mores kept people from enacting heterosexual desires on camera; same-sex role playing became the practiced norm of circumventing the societal strictures against public displays of sexuality between men and women.[109] In light of El Madani's statement, one could simply take these images at face value: as documents of an adherence to extreme codes of gender and sexual normativity, where what appear to be articulations of same-sex desire are simply a mere substitute for the "real thing"—that is, heterosexuality. Undoubtedly, in each of these photographs the participants are explicitly and self-consciously performing for the camera. However, one could also read these images as suggesting how the sexual and gender "conservatism" of Saida may in fact have enabled especially playful and pleasurable forms of female and male homoeroticism and gender crossing to thrive in the interstices of heteronormativity.[110] Zaatari allows us to understand south Lebanon as a "queer region" in the sense that I discussed in chapter 1: as a space that exists as a deliberately obscured and forgotten "elsewhere" within the national imagination, and evinces its own gender and sexual logics that may trouble the apparently smooth surfaces of heteronormative nationalist ideologies. As with David Kalal's reframings of Ravi Varma, the "reverse-images" that Zaatari gleans from El Madani's archive conjure forth a queer regional imaginary within which we can discern the contours of female subjectivity, queer desire, and gender nonconformity that stand outside the confines of "history writ-large." In so doing, Zaatari summons into the present a queer world that is most certainly lost to us now, but that nevertheless suggests an alternative to the violent present and its toxic sectarian and nationalist ideologies. As an exemplary instance of the work that the aesthetic practices of queer diaspora do, Zaatari's curation of

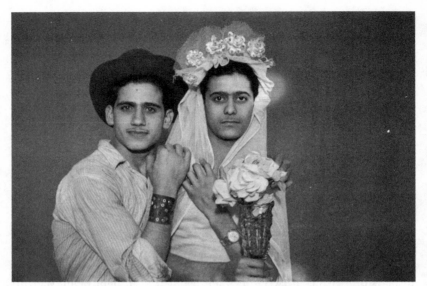

FIGURE 4.11 "Najm (left) and Asmar (right), Studio Shehrazade, 1950s," from *Hashem El Madani: Studio Practices*, courtesy of Akram Zaatari and Arab Image Foundation.

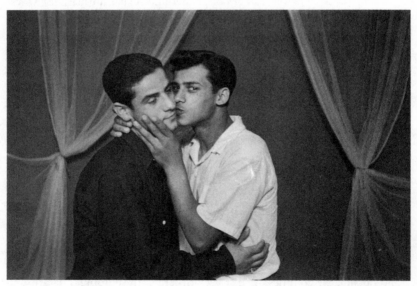

FIGURE 4.12 "Tarho and El Masri. Studio Shehrazade, 1958," from *Hashem El Madani: Studio Practices*, courtesy of Akram Zaatari and Arab Image Foundation.

El Madani's images evokes past possibilities and logics of political and so-
cial life in order to suggest other trajectories for the present.[111] Crucially, it
is through queer desire, identification, and relationality that these visions of
the past are renewed and reactivated: it is in the photographs of Abed and his
companions, of same-sex couples kissing, of the muscled torsos and inviting
gaze of the male bodybuilders and resistance fighters, that we can glimpse
other modes of existence that counter the deadening strictures of the present
moment.

While Zaatari's engagement with El Madani's work in *Hashem El Madani:
Studio Practices* explores the contours of a queer regional imaginary that
mobilizes the concept of the region in its subnational sense, Zaatari's other
work—such as his experimental documentary *This Day* (2003)—interrogates
supranational framings of the region, specifically of the geographic area known
as the Middle East. As Zaatari himself comments, "*This Day* was . . . meant to
address the production and diffusion of images in the Middle East, meaning
Lebanon, Syria, Jordan, and Palestine/Israel. So geography was in the proj-
ect from the beginning. I am particularly interested in looking at the Middle
East as an important part of the former Ottoman Empire, and as a region
that never recovered from colonial partitioning."[112] I cannot do justice to the
theoretical and formal complexities of Zaatari's documentary here, but I do
want to at least gesture toward its thematic concerns, as another example
of how the aesthetic practices of queer diaspora deploy the concept of the
region *both* in its subnational and supranational senses in order to map al-
ternative geographies. The documentary takes as its starting point a seminal
ethnographic monograph on the Bedouins, *The Bedouins and the Desert* (*El
Badou wal badiya*) by Arab scholar Jibrail Jabbur, based on his fieldwork
in the Syrian desert in the 1950s, and the photographs of people and land-
scapes by Lebanese-Armenian photographer Manoug that illustrate Jabbur's
study.[113]

Throughout the film, Zaatari highlights the construction of knowledge pro-
duction, specifically the ways in which knowledge about a particular subject
(such as "the Bedouin") is produced and circulated through the photographic
image. Placing himself within the frame, Zaatari intersperses point-of-view shots
from his jeep as he traverses empty desert terrain with those of a white-gloved
archivist handling and arranging Manoug's photographs, for instance. *This Day*
can be read, as Mark Westmoreland argues, as constituting an alternative eth-
nography of Lebanon.[114] But the work also interrogates the very construction

of the "Middle East" as a supranational region within area studies projects of knowledge production. Zaatari explains his relation to Jabbur's work as follows:

> Very often people misread my interest in Jabbur as an attempt to recover the origins of Arab culture (symbolised in the vanishing figure of the Bedouin), but this was not my intention. I was interested in Jabbur because he was the earliest example of an Arab scholar who decided to document his culture photographically. In *This Day* I set out to film the same locations and people that he photographed in the desert. The idea was not to reconstitute his itinerary but in fact to show that the conditions that defined Arab culture for Jabbur in the 1950s are no longer accessible to me.[115]

Indeed, the documentary shows the impossibility of recovery projects that fetishize fixed notions of origin, with the fossilized figure of the Bedouin as emblematic of a romanticized, disappearing indigenous past. This becomes particularly clear in Zaatari's discovery that some of Manoug's photographs of "authentic" desert life were in fact staged, and in his failed attempts to communicate with a "real" Bedouin he encounters in the Syrian desert, given that they speak different Arabic dialects. As Chad Elias comments on this moment in the film: "Eventually . . . [Zaatari] discovers that the man had wandered across to this part of Syria from Saudi Arabia before the two nations existed. This stateless subject thus comes to symbolize a time and place that stands in tension with the dominant cartographic logic of the present-day Middle East."[116]

In *This Day*, then, the older Bedouin man functions not as an embodiment of a vanishing authentic Arab culture, but as a queer figure, in the sense that he is out of time and out of place, rendered unintelligible (Zaatari literally cannot understand him) within a spatial and temporal logic that privileges colonial or nationalist cartographies. He therefore signals the persistence of what Zaatari terms "older geographies,"[117] alternative spatial sensibilities that are obscured by the regulatory mappings of successive colonial and nationalist regimes but that exist in intimate, palimpsestic proximity to them. As Zaatari notes, "My fascination with nomadism and Bedouin culture was about considering whether these pre-modern spatial practices might provide an alternative to the still prevailing logic of partitioning and cartographic containment."[118] Just as Sheba Chhachhi's 2007 installation *Winged Pilgrims* (discussed in chapter 1) challenges conventional framings of "Asia" as a region, so, too, does Zaatari's *This Day* interrogate the production of the "Middle East" within area studies and modern geopolitical cartographies.

Zaatari's queer visual excavations into the region in both its supranational and subnational senses, along with deSouza's *The Lost Pictures* and Ganesh and Ghani's *Index of the Disappeared*, call into consciousness all that is lost, devalued, and violently disappeared within dominant historiography and modes of knowledge production. Instead, they turn to the affective and the sensorial as alternative pathways toward accessing the past in order to imagine a different present. I want to end now where I began, by circling back to the final passages in Saidiya Hartman's *Lose Your Mother* that speak to a sense of queer affiliation and possibility; these passages are striking in that they mark a shift from the sense of intransigent despair that permeates much of the text, and seem to gesture to Hartman's conversion, in Jonathan Flatley's terms, of "a depressive melancholia into a way to be interested in the world."[119] Hartman writes, "At the end of the journey, I knew that Africa wasn't dead to me, nor was it just a grave. My future was entangled with it, just as it was entangled with every other place on the globe where people were struggling to live and hoping to thrive."[120] Here, Hartman articulates a capacious sense of affiliation and of her place in the world that stands in sharp contrast to the experience of irreducible strangeness that, in earlier portions of the memoir, forestalls any possibility of connection with those she encounters. This sense of affiliation is achieved, paradoxically, through a recognition and acceptance of the difference of the other, rather than through an attempt to narcissistically mirror the self in the other. As Hartman observes, "In listening for my story I had almost missed theirs. I had been waiting to hear a story with which I was already familiar. But things were different here."[121] Hartman thus leaves us with a model of affiliation through difference that I have been calling queer; such a model opens the way to placing different diasporic formations, and their attendant longings, losses, aspirations and "dreams of an elsewhere" as Hartman puts it, within a common frame.[122]

Hartman's memoir ends in Gwolu, her last stop on the slave route. She writes, "I had come to the end of my journey, so if I didn't recover any traces of the captives here, in the heartland of slavery, then it was unlikely that I would ever find any."[123] But as she watches a group of girls dancing, singing and clapping, she is told by a young man who translates the song they are singing that this, finally, is the story she has been searching for. He tells her that "the girls are singing about those taken from Gwolu and sold into slavery in the Americas. They are singing about the diaspora." Hartman concludes,

"Here it was—my song, the song of the lost tribe. I closed my eyes and I listened."[124] Ultimately, it is not the material archive of slavery, nor even the triumphal counternarratives of those who eluded slavery's grasp, that allow Hartman to finally touch the past. This intimacy with the disappeared comes, tellingly, in the form of the nonvisual, the tactile, the audible, the kinesthetic, and the antimonumental. As is apparent in the aesthetic practices of queer diaspora that I have engaged with throughout this book, it may very well be through the inconsequential and the tangential, the excessive and the abject, the defeated and the discarded, that we can divine alternative, more generative forms of knowledge and affiliation.

Crossed Eyes

Toward a Queer-Sighted Vision

Throughout this book, I have attempted to map out the triangulated relation between the conceptual categories of archive, region, and aesthetics, and to demonstrate how the aesthetic practices of queer diaspora mobilize each of these categories through an affective register. As is amply evident in Akram Zaatari's arrangement of El Madani's images, or in Chitra Ganesh's collection of discarded family photographs, queer visual aesthetic practices function as archival practices that excavate and memorialize queer modes of desire, affiliation, and embodiment obscured and deemed without value by conventional methods of recording and retrieving the past. The aesthetic practices of queer diaspora also mobilize the space of the region in crucial ways: by conjuring forth a queer regional imaginary, these practices situate the region as the locus of alternative logics of gender and sexuality that challenge the primacy of metronormative sexual and gender formations. Whether it is Ligy Pullappally's imagining of a queer rural Kerala, Aurora Guerrero's situating of queerness in that space "just west of East L.A.," or Sheba Chhachhi's and Akram Zaatari's re-visioning of "Asia" and the "Middle East" respectively, the aesthetic practices of queer diaspora reframe the region as a spatial category with the capacity to disrupt taken-for-granted geopolitical mappings, and to instead trace lines of queer affiliation across disparate locations. In so doing,

these aesthetic practices create new multiscalar cartographies that produce South-South, region-to-region, and diaspora-to-region connectivities that profoundly disturb disciplinary and area studies rubrics.

The aesthetic practices of queer diaspora thereby powerfully contest the ongoing legacies of colonial modernity. One of the violences of colonial modernity is the consigning of gendered, sexualized, and racially marked bodies to hypervisibility and/or invisibility within a hegemonic visual field. These aesthetic practices enact and produce a queer optic that allows us to apprehend the intertwined nature of the historical forces that produce this in/visibility; this queer optic, in turn, enables us to grasp the unanticipated intimacies between bodies, temporalities, and geographies that are the product of overlapping histories of racialization and diasporic dislocation, settler colonialism and empire, war and nationalism. Just as crucially, the aesthetic practices of queer diaspora document imaginative strategies of creating and dwelling in vibrant life-worlds off of metronormative gay, immigrant, and nationalist grids of progress and development.

As a closing illustration of the work that the aesthetic practices of queer diaspora do, I end *Unruly Visions* with a final act of queer curation as I juxtapose two apparently incommensurate images. The first is Allan deSouza's "Navigation Chart," part of his exhibition, *Through the Black Country*, that was on view in New York City at the Talwar Gallery in 2017. *Through the Black Country* narrates the journey of a fictional traveler, Hafeed Sidi Mubarak Mumbai, who is the fictional great-grandson of an actual nineteenth-century historical figure, Sidi Mubarak Bombay (1820–1885). Bombay was born in East Africa, on the border of modern-day Tanzania and Mozambique, captured by Arab slavers, and transported to India as a child.[1] After being emancipated, he returned to Africa and worked as a guide for British explorers.[2] Bombay's life speaks to the intertwined trajectories of African and Indian diasporic histories in the context of British imperial rule in ways that resonate with deSouza's own biography, which I discussed in the previous chapter. DeSouza imagines Bombay's fictional descendant, Sidi Mubarak Mumbai, as enacting a reversal of his ancestor's journey; deSouza creates for the fictional Mumbai a travel journal, along with maps and graphs, of London in 2016, "position[ing] modern-day England as the object of ethnographic exploration."[3] The journal mimics the sensibilities of nineteenth-century European travelers in India and Africa, with all the condescension and presumption of knowledge that characterized their encounters with difference.[4] But, as Aruna d'Souza notes in her astute analysis of the exhibition, "deSouza's intervention is not simply one of reversing the colonialist's gaze. . . . London is remade in

the image of empire; its history of colonial oppression reshapes—deforms, even—the very fabric of the city that was once the center of global political and economic power."[5] DeSouza's re-visioning of London is particularly apparent in "Navigation Chart" (plate 23), which flips the iconic London tube map upside-down. DeSouza thereby quite literally privileges the (global) South, and replaces the names of stations with those of queer, brown, and black intellectuals, artists, activists, and public figures who in fact chart deSouza's own artistic, political, emotional, and intellectual genealogy.

The names of those killed in racist, state, transphobic, and homophobic attacks are scattered throughout the grid; those of trans women of color icons such as Sylvia Rivera and Holly Woodlawn share space with the names of celebrated artists, activists, and intellectuals from the global South and its diasporas, as well as indigenous nations, ranging from Raja Ravi Varma to Cesar Chavez, C. L. R. James, and Wilma Mankiller. While to a casual observer these varied names may initially appear to be randomly selected and haphazardly placed, deSouza in fact situates them in what he calls "clusters," at strategic "intersections," so as to stage specific "interruptions": for instance, he juxtaposes a cluster of male revolutionary heroes (Che Guevara, Fidel Castro) with gender nonconforming figures such as Freddie Mercury, Prince, and Sylvester.[6] In so doing, deSouza provides another instantiation of the queer critique of militant male nationalism that we see in his earlier work, as well as in that of Akram Zaatari. As deSouza himself writes of "Navigation Chart":

I did think of it as mapping out one's (my) life, influences, aspirations, and I think responsibilities. In the sense, I think, of trying to live up to, or honoring the memory of some of the people listed. Some are particular to me, some to the generation I'm part of—going from Kenya to England, then again to the US, and drawing so much from South Asia, but from the location of England. Some references to the Black Art movement in Britain, my peers—Samena Rana, Brenda Agard (both of whom were my lovers), Donald Rodney, Maud Sulter, Rotimi Fani-Kayode—all close friends. Some are precursors to my generation—South Asian, African Caribbean artists. Alongside all the South Asian movie stars and singers were the Black American influences—that was my childhood/teens. And of course, the liberation movements of the 60s/70s, national/anti-colonial, civil rights, feminist, queer, trans. . . . I wanted to make these inseparable.[7]

Thus we can understand deSouza's "navigation chart" as a deeply personal form of "affective mapping," to borrow Jonathan Flatley's term, which in turn

borrows from Deleuze and Guattari's notion of a rhizomatic map—one that "not only gives us a view of a terrain shared with others in the present but also traces the paths, resting places, dead ends, and detours we might share with those who came before us."[8] This shared terrain with others in the present, following along the tracks of those from the past, is precisely that which deSouza's image archives and memorializes. "Navigation Chart" offers us a way to navigate through the palimpsestic temporal and geographic terrain produced by brutal, overlapping histories of slavery, racialization, settler colonialism, and empire. In this sense, deSouza's image both enacts and utilizes a queer optic, which makes apparent the unexpected convergences of different queer, diasporic, racial formations that emerge in the wake of these histories. But it also functions as a queer archive that refuses to forget those lost to myriad forms of violence; by mapping their names onto the space of the city, "Navigation Chart" forces us to reckon with these violences as part of our everyday navigation of the world. As such, deSouza's reimagined tube map encapsulates the project of this book: to map the subterranean points of crossing and collision, relationality and encounter, between bodies, histories, and temporalities that are typically submerged within standard epistemologies, and that only come into view when deploying a queer optic.

The second image with which I close this book is a portrait dating from the early 1950s: one of the photographs that Akram Zaatari selects to reprint from Hashem El Madani's vast collection of negatives documenting everyday life in south Lebanon. It is of a small boy, dressed in shorts and a white shirt, who is somewhat disheveled despite what we can imagine are his parents' best intentions, and who stands with his arm resting on a pedestal next to a vase of plastic flowers. The boy appears to be attempting to keep his eyes as still and wide open as possible, perhaps at El Madani's urging; nevertheless, he is unmistakably cross-eyed as he gazes both ahead, toward the viewer, and sideways, toward the edge of the frame, with a bewildered expression. In the caption that accompanies this image, El Madani writes: "Other photographers used to send me negatives of cross-eyed people, asking me to retouch them. I used to scratch out the emulsion where the pupil is, and draw another one right next to it."[9] In the longer 2003–2004 interview with Zaatari from which this caption is drawn, El Madani makes clear that he understands that his role as a studio photographer is to "[make] people beautiful and [provide] them with a documentation of their lives."[10] To that end, he drew on techniques used to recolor and retouch film stills, subtly transforming his clients' visages by softening a jaw line or lightening skin tone. His cross-eyed

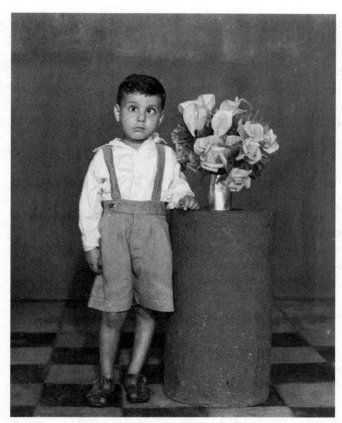

FIGURE EPI.I. "Anonymous. Madani's parents' home, the studio, 1948–53," from *Hashem El Madani: Studio Practices,* courtesy of Akram Zaatari and Arab Image Foundation.

clients provided him with a particular challenge, and he would often go to quite elaborate lengths to create images of them that he deemed acceptable. He describes, for instance, how he tried in vain to uncross the eyes of one particular client: "Once, a cross-eyed man came to my studio. No matter how I tried to make him look in different directions, his eyes would still seem crossed."[11] El Madani was finally able to create an acceptable image by having the client look at different numbers marked along the length of a wooden stick that he placed outside the camera frame: "I brought [the stick], and tried moving it from one place to another, asking him to move his eyes from one number to another until I was satisfied with one particular angle. And I took the photo."[12] While El Madani became expert at normalizing the gaze of his

cross-eyed clients, in this particular image of the boy in the white shirt, his gaze remains flagrantly uncorrected.

It seems fitting that I end with this image of uncorrected vision that veers off-tangent, as it characterizes much of the work I have discussed in these pages.[13] The dictionary defines the condition of being cross-eyed—technically termed *strabismus*, from the Greek root *strabos*, or "squinting"—as "a disorder of vision due to a deviation from normal orientation of one or both eyes so that both cannot be directed at the same object at the same time."[14] The deviant orientation of crossed eyes connotes both aberrant temporality and directionality through an attraction to multiple objects. Interestingly, Allan deSouza mentions undergoing surgery to correct strabismus in his autobiographical essay "My Mother, My Sight," which I discussed in the previous chapter. For deSouza, strabismus is particularly stigmatizing and a source of shame under the normalizing gaze of others: "People tend to assume strabismus is a sign of mental illness, or mental incapacity, especially in black or brown bodies, and they treat you accordingly. Then they won't look you in the face, because they're embarrassed."[15] The word "curation," as I noted in the introduction, stems from the Latin root meaning "to care for," but it also connotes "to heal."[16] My hope is that this book has demonstrated the possibility of queering the project of curation: a project that seeks not "to heal" in the sense of normalizing deviant vision but, on the contrary, to suggest how unruly vision can open up other ways of seeing and sensing the world unimaginable through a normative lens. In fact, deSouza comments that, following his surgery, he would play games with his still-disjunctive vision: "One favorite amusement is a variation of that old ventriloquist trick: while drinking from a cup I look directly with one eye into the cup, and with the other eye watch the room. I can then superimpose the two images so that the room looks like it's underwater. Not only do I conflate time, I can now conflate space."[17]

This conflation of time and space that deSouza describes precisely characterizes the aesthetic practices of queer diaspora: they allow for, and indeed demand, the disordered, disorderly, multifocused, unruly mode of vision that I call a queer optic. This queer optic deviates from a forward-looking directionality and instead veers toward multiple objects, spaces, and temporalities simultaneously. It provides us with a vantage point both productively disoriented and disorienting: it is from here that we can glimpse a palimpsestic landscape marked by the promiscuous intimacies of entangled histories of dispossession and containment, diaspora and dwelling. Indeed we can under-

stand the phrase "crossed eyes" to also reference the crossings and encounters of numerous "I"s: the radical relationality of multiple subjectivities that constitute and at times interrupt one another, as they traverse this disorienting terrain. In Zaatari's *Hashem El Madani: Studio Practices*, for instance, the hypermasculine freedom fighter and the effeminate tailor are not antithetical to one another in terms of representing opposite ends on a spectrum of normative masculinity[18]; rather, they are intimately connected in Zaatari's queer transtemporal imagination, and both are in turn shadowed by the haunting, defaced/effaced visage of Mrs. Baqari. Both deSouza's and Zaatari's images, along with the other aesthetic practices of queer diaspora that I have discussed throughout these pages, deploy queer desire, affect, and affiliation as conduits for excavating both the violences of the past and its forgotten possibilities. Thus, they attest to the imprint of the past on the present and provide a glimpse of alternative social orders and political imaginaries.

As deSouza's "ventriloquist trick" suggests, the temporal interventions of the aesthetic practices of queer diaspora function alongside the alternative modes of spatialization that they produce. If the conceptual categories of nation, diaspora, and the global skew gigantic,[19] these aesthetic practices grant us the bird's-eye view of Sheba Chhachhi's *Winged Pilgrims*: one that brings into focus and homes in on the regional and the particular, the small and the tangential, the mundane and the personal, the fragmentary and the discarded. Viewing the region through a queer optic allows us to place in conversation objects of analyses that would otherwise be sequestered within disciplinary or area studies rubrics. The aesthetic practices of queer diaspora point to the inadequacy of such rubrics to account for those embodiments, desires, identifications, and affiliations that fall outside scrutiny and codification within standard positivist historiographic, ethnographic, political, or sociological narratives. As such, these practices are not only archival practices, but are in and of themselves curatorial practices that direct our vision and school us how to read queerly through their selection and arrangement of objects. They demand that we—as viewers, readers, spectators, and listeners—place in the same frame apparently radically dissimilar objects, so as to become attuned to the resonances between them. In so doing, the aesthetic practices of queer diaspora suggest strategies for bringing other worlds into view that attest to our conjoined pasts, presents, and potential futures.

Notes

INTRODUCTION

1. Lebanon was a French Mandate from 1920 to 1946. It was under Syrian occupa-
tion from 1976 to 2005, and Israeli occupation first in 1978, and then again from
1982 to 2000. The Lebanese civil war took place from 1975 to 1990.
2. Le Feuvre and Zaatari, *Hashem El Madani*, 96.
3. My understanding of aesthetics and aesthetic practices follows Jacques Rancière's
formulation of "the aesthetic regime of art" as that which intervenes in "the very
distribution of the sensible that delimits the horizons of the sayable and deter-
mines the relationship between seeing, hearing, doing, making, and thinking."
See Rockhill, "Editor's Introduction," 4.
4. Feldman and Zaatari, "Mining War," 62.
5. Writing about curatorial projects that engage traumatic, often violent histories,
Erica Lerner and Cynthia E. Milton stress a "'custodial' understanding of curato-
rial practice": "The notion of curation as 'care' is meant neither prescriptively nor
timidly. Rather, we use it expansively to draw attention to the profound senses
of obligation the authors in this volume express to *deal with* the past when it
impinges painfully on the present." Lerner and Milton, "Introduction: Witnesses
to Witnessing," 4.
6. I am thinking here of the Indian artist/curator Jitish Kallat, who understands
curation "as harnessing the potential of rearrangement as a way to get at an
insight." Kallat asks, "How do you move something in the world so that its

re-positioning creates new meaning?" Kallat, D'Souza, and Manghani, "Curation as Dialogue."

7. Other scholarship on contemporary curatorial practice that has informed my own work includes Skrubbe, "Preface: Feminisms, Exhibitions, and Curatorial Spaces"; O'Neill, *The Culture of Curating and the Curating of Culture(s)*; Dēmētrakakē and Perry, *Politics in a Glass Case*; and Thea, *On Curating*. My gratitude to Deborah Willis and Nicole Fleetwood for pointing me in the right direction.

8. See, in particular, Manalansan, "The Messy Itineraries of Queerness," n.p., and "The Biyuti and Drama of Everyday Life," in *Global Divas*, 89–125; Muñoz, "Gesture, Ephemera, and Queer Feeling"; Cvetkovich, "Photographing Objects as Queer Archival Practice"; Halberstam, *The Queer Art of Failure*.

9. The U.S.-based artist Glenn Ligon describes his own curatorial method as follows: "It's more of a meander. I'm not bound by chronology or genre. It's about encounters and collisions." Hilarie M. Sheets, "How Glenn Ligon Is Using Black and Blue to Create a Dialogue," *New York Times*, June 2, 2017, https://nyti .ms/2rAuhL4.

10. For more on this "regional turn" in queer scholarship, where the region is understood in its subnational sense, see, for instance, Gopinath, "Queer Regions"; for such work that examines subnational queer regions in the U.S. in particular, see Manalansan et al., "Queering the Middle"; Herring, *Another Country*; Tongson, *Relocations*; and Rohy, *Anachronism and Its Others*.

11. Indeed, the portraits of "Abed" call to mind queer scholar Roderick A. Ferguson's lyrical autobiographical essay, "Sissies at the Picnic," where Ferguson recalls how, growing up in small town Georgia in the 1970s, the figure of the "black sissy"— the gender queer figure who may have played the piano at church or worked at the local beauty parlor—was a valued and established fixture in the community. See Ferguson, "Sissies at the Picnic."

12. My use of the term "provincialize" here borrows from Dipesh Chakravarty's influential monograph *Provincializing Europe*.

13. My work is thus part of a collective project to destabilize area studies through queer studies. Two recent iterations of this project include Arondekar and Patel, "Area Impossible," and University of Washington's "Regionalism, Sexuality, Area Studies" symposium, convened by Amanda Lock Swarr and Chandan Reddy, May 26–28, 2016.

14. As Kris Manjapra argues in his study of anticolonial nationalism in India, "Taking sideways glances towards 'lateral networks' that transgressed the colonial duality is the best way to disrupt the hemispheric myth that the globe was congenitally divided into an East and West, and that ideas were exchanged across that fault line alone." Manjapra, "Introduction," in Bose and Manjapra, *Cosmopolitan Thought Zones*, 2.

15. For queer scholarship that powerfully contests the ways in which both heteronormativity and homonormativity determine individual and collective temporalities,

see Halberstam, *In a Queer Time and Place*; Freeman, *Time Binds*; Ahmed, *Queer Phenomenology*.

16. Gopinath, *Impossible Desires*.
17. I use "visuality" to reference a "politics of vision," as Gil Z. Hochberg writes, one which attends to questions of seeing and being seen, visibility and invisibility. See Hochberg, *Visual Occupations*, 168. I also bear in mind the more specific meaning of visuality put forth by Nicholas Mirzoeff, where he juxtaposes "visuality" (which he sees as a strategy of the dominant) with the "right to look" (one that is claimed by those subject to the disciplining, classifying gaze of the plantation overseer, the colonial administrator, or the military general). Mirzoeff, *The Right to Look*, 24.
18. I use the term "colonial modernity" to broadly reference the various civilizational discourses of progress and development that have undergirded projects of U.S. and European imperial expansion and colonial domination throughout the Americas, the Middle East, Africa, Asia, and the Pacific. For important analyses of the centrality of vision and visuality to colonial modernity, see Jay and Ramaswamy, *Empires of Vision*.
19. See Mirzoeff, *The Right to Look*, and Jay and Ramaswamy, *Empires of Vision*, on the relation between visuality and empire.
20. For important work on visuality and the colonial occupation of Palestine, see Weitzman, *Hollow Land*, and Hochberg, *Visual Occupations*. For the relation between invisibility and hypervisibility in dominant representations of racialized subjects, see Thompson, *Shine*, where she draws from Ralph Ellison's *Invisible Man* to theorize the "unvisibility" of Black bodies.
21. Fellow travelers and contemporaries in queer diaspora studies include Alexander, *Pedagogies of Crossing*; Eng, *The Feeling of Kinship*; Fiol-Matta, *The Great Woman Singer*; La Fontain-Stokes, *Queer Ricans*; Lubhéid and Cantú, *Queer Migrations*; Manalansan, *Global Divas*; Muñoz, *Disidentifications*; Quiroga, *Tropics of Desire*; Rodríguez, *Queer Latinidad* and *Sexual Futures, Queer Gestures, and Other Latina Longings*; Shah, *Stranger Intimacy*; Walcott, *Queer Returns*.
22. For crucial theorizations of intimacy, see Lowe, *The Intimacies of Four Continents*, and Stoler, "Intimidations of Empire," in *Haunted by Empire*; Shah, *Stranger Intimacy*. In particular, I take Lisa Lowe's three-tiered, mutually constitutive definition of intimacy—by which she references the spatial proximity of four continents produced by colonial labor relations; European bourgeois domesticity, which is both dependent on and erases these global intimacies; and the cross-racial alliances between colonized peoples that these proximities produce—as my point of departure in situating the aesthetic practices of queer diaspora.
23. I borrow this phrase from historian Kris Manjapra, "The Impossible Intimacies of M. N. Roy."
24. See Lowe, *The Intimacies of Four Continents*, and Stoler, "Intimidations of Empire."
25. In this sense, the aesthetic practices of queer diaspora work against what Roderick A. Ferguson aptly terms "ideologies of discreteness." Ferguson, *Aberrations in Black*, 3.

26. This is what José Esteban Muñoz terms a "backward glance that enacts a future vision" of queerness, or "a forward-dawning futurity." Muñoz, *Cruising Utopia*, 4.

27. Their work thus resonates with Ann Cvetkovich's examination of queer archives as created by artists who, acting as curators, photograph and display seemingly mundane and inconsequential objects and thereby imbue them with what she terms "felt value." She writes, "When objects are animated by feelings, they may demand alternative or experimental archival practices. Artists have thus been important curators of queer archives because they have a knack not only for valuing objects that others don't but also for exhibiting them in ways that can capture both their felt value and their historical value (and make claims for felt value as historical value)." Cvetkovich, *An Archive of Feelings*, 280.

28. Queer scholarship on time, space, affect, and archives is too voluminous to list here, but key texts for my own project include Freeman, *Time Binds*; Halberstam, *In a Queer Time and Place*; Dinshaw, *How Soon Is Now?*; Muñoz, *Cruising Utopia*; Eng, *The Feeling of Kinship*; Cvetkovich, *An Archive of Feelings*; Flatley, *Affective Mapping*; Berlant, *Cruel Optimism*; Rodríguez, *Sexual Futures, Queer Gestures, and Other Latina Longings*; Shah, *Stranger Intimacy*. In addition, I have found the work on archives by both Campt, *Image Matters*, and Stoler, *Along the Archival Grain*, very generative for queer purposes, even though their work is not explicitly in conversation with queer studies.

29. There is too vast a quantity of work on the temporality of regions, diasporas, and nations to cite here, but to mention just three key texts: on the anachronism of the region, see Rohy, *Anachronism and Its Others*; on the typically "backward-looking" directionality of diaspora, see Stuart Hall's classic essay "Cultural Identity and Diaspora"; on the gendered temporality of the nation, see McClintock, *Imperial Leather*.

30. Rohy, *Anachronism and Its Others*; see also Richardson, *Black Masculinity and the U.S. South*.

31. Sara Ahmed, in reflecting on the ways in which her own work "moves between conceptual analysis and personal digression," asks, "but why call the personal a digression? Why is it that the personal so often enters writing as if we are being led astray from a proper course?" Ahmed, *Queer Phenomenology*, 22. Similarly, Valerie Rohy remarks on the equation of regionalism and digression in the context of nineteenth-century regionalist women's writing in the U.S.: "The understanding of regionalism as a digression . . . from the 'main road of development' regards local color as a swerve from the straight way to American futurity." Rohy, *Anachronism and Its Others*, 53. Rohy here points to the way in which literary evocations of the region were seen as antithetical to the teleological project of consolidating a modern, national "American" cultural identity.

32. Elspeth H. Brown and Thy Phu, following the work of Roland Barthes in *Camera Lucida*, forcefully make this point in their introduction to *Feeling Photography*.

33. Brah, *Cartographies of Diaspora*, 208.
34. Sarita Echavez See astutely critiques what she terms the "nineteenth century expansionist aesthetic" of "emptied space" which "relies on the genocidal consolidation of a continent." She writes: "A land becomes beautiful when, and because, the genocidal act of nation-building not only produces depopulated and razed 'virginal' land but also disavows the violence and materiality of that process . . . American notions of beauty, which rely on the boundlessness of nature, demand the emptying of a land of its peoples so as to produce the contiguous sweep and vast emptiness of a continent while the sexualized rhetoric of the now 'virginal' land crucially sustains the ideological purity of manifest destiny." See *The Decolonized Eye*, 64.
35. Ananya Jahanara Kabir, for instance, details how representations of Ladakh, a region of Kashmir, reiterate an idea of the region as vast, empty, primitive space. See Kabir, *Territory of Desire*.
36. As Jack Halberstam points out in relation to the photographs of empty swimming pools and bars by the queer collaborative Spanish artists Cabello/Carceller, the disappearance of the body in their images creates "space itself as queer": "These photographs . . . record the evidence of presence in the absence of the body. The emptied-out spaces demand that the viewer fill in the blanks; we may feel almost compelled to complete the picture in front of us, to give it meaning and narrative. . . . The photographers lead their viewers to the site of dispersal and then leave us there, alone, to contemplate all that has been lost and what remains to be seen." Halberstam, *The Queer Art of Failure*, 113.
37. Akram Zaatari, quoted in Westmoreland, "Akram Zaatari," 65.
38. Laidi-Hanieh, "Palestinian Landscape Photography," 118.
39. As Dana Seitler notes in her essay on queer aesthetics, "The aesthetic encounter . . . is one in which we may glimpse our relatedness in the world, where we may fantasize about our affinities and affiliations, not with the aim of producing clarity or coherence about those affiliations but by means of which their very gathering mobilizes new ways of making sense of ourselves in the world, or at the very least, acts as a counter to the forms of alienation experienced every day by non-majority subjects." Seitler, "Making Sexuality Sensible," 52.
40. In this sense, my formulation of the aesthetic practices of queer diaspora is aligned with José Esteban Muñoz's explication of the relation between queerness, futurity, and the aesthetic. He writes: "Turning to the aesthetic in the case of queerness is nothing like an escape from the social realm insofar as queer aesthetics map future social relations. Queerness is also performative because it is not simply a being but a doing for and toward the future." Muñoz, *Cruising Utopia*, 1. For more on diaspora as a practice, see Edwards, *The Practice of Diaspora*.
41. Akram Zaatari, curator's statement for *Radical Closure*, 9.
42. Berlant, *Cruel Optimism*, 3.
43. I find resonance with what Mishuana Goeman identifies as the "alternative spatial practices" evident in Native women's writing that move "beyond a settler

heteropatriarchal mapping of space." Goeman understands this literature as "not testaments to geographies that are apart from dominant constructions of space and time, but instead they are explorations of geographies that sit alongside them and engage with them at every scale." Goeman, *Mark My Words*, 15.

CHAPTER 1. QUEER REGIONS

1. Abu Dhabi is the capital of the seven emirates that make up the United Arab Emirates, which came into existence as a nation in 1971.
2. See Ross, *The Gulf*, for trenchant commentary on the politics of labor, culture, and commerce involved in the building of cultural institutions in the Gulf region, and in Abu Dhabi in particular.
3. Since 2014, Saadiyat Island in Abu Dhabi has been the site of the NYU Abu Dhabi campus, as well as the home of branches of the Guggenheim and Louvre museums; at the time of this writing, these museums were still under construction.
4. These socialities resonate with what historian Nayan Shah, in an entirely different historical context, names "stranger intimacy": the cross-class, cross-racial and cross-generational homosocial/homoerotic forms of sociality created by working-class South Asian migrant men in the North American West in the first half of the twentieth century. See Shah, *Stranger Intimacy*.
5. Gulf Labor activists note that some South Asian migrant men who arrive in Abu Dhabi as construction workers spend months solely shuttling between their work site and their labor camp without ever accessing the rest of the city. See Ross, "For Security Reasons: A Gulf Labor Report (July 2015)," in *The Gulf*, 315. While this limited mobility may preclude accessing queer spaces in the city, or interacting with other racial/national/ethnic communities, it nevertheless raises the question of what forms of homosocial/homoerotic desire and relationality emerge in the all-male labor camps themselves. Workers, after all, are not simply workers; they are also desiring subjects. Furthermore, "South Asian male migrant labor" in a space such as Abu Dhabi is a heterogeneous and variegated category, with working-class South Asian men functioning at all levels of the labor market: as construction and factory workers, certainly, but also as security guards, taxi drivers, waiters, shopkeepers, etc. The almost exclusive focus on construction and factory workers in much of the activist and media attention given to labor issues in the Gulf tends to elide this heterogeneity, and the various forms of sociality (queer and otherwise) that may emerge from it.
6. Malayalam is the state langauge of Kerala; "Malayali" refers to those who are from Kerala.
7. For more discussion of how conventional indices of scale are undone by a "queer metrics," see the introduction to Manalansan et al., "Queering the Middle."
8. Neha Vora argues that the regions of "South Asia" and the "Middle East" must be rethought, given the long history of a cosmopolitan, hybrid South Asian

presence in the Gulf that predates by several centuries the oil industry boom of the 1970s and the subsequent influx of South Asian laborers. See Vora, *Impossible Citizens*, 3.

9. See Gopinath, "Queer Regions" and "Who's Your Daddy?" For subsequent scholarship that explores queerness and region, see Manalansan et al., "Queering the Middle," and Cakirlar, "Queer/ing Regions." For scholarship in "critical regional studies" that emerges from anthropology and that specifically addresses queer sexuality in relation to Asia as a region, see Wilson, "Queering Asia"; Johnson, Jackson, and Herdt, "Critical Regionalities and the Study of Gender and Sexual Diversity in South East and East Asia"; Boellstorff, *A Coincidence of Desires*; Rofel, *Desiring China*. See also Arondekar and Patel, "Area Impossible," on the nexus of area studies and queer studies.

10. Neha Vora notes that Indians in Dubai, for instance, are subject both to UAE restrictions on citizenship and labor (in the form of the kafala system of migration sponsorship), as well as being simultaneously politically disenfranchised in India through their designation by the Indian state as "non-resident Indians." See Vora, *Impossible Citizens*, 27.

11. As one instance of the transient nature of such socialities and the spaces in which they thrive, the area in Abu Dhabi known as the Tourist Club, home to a number of queer-oriented bars and clubs frequented by working-class migrants, was summarily demolished in 2014.

12. In an important essay that critiques the heteronormative presumptions underlying much of the academic research on gender and migration, particularly with respect to Filipina migrant laborers, Martin Manalansan argues for the need to "[go] beyond a laboring gendered agent and [highlight] a desiring and pleasure-seeking migrant subject. . . . Migrants are not just displaced caretakers and mothering workers but in fact possess sexual desires and erotic practices that must be taken into consideration. These desires are not limited to migrants' search for material and social advancement but also are often pivotal reasons for the decision to migrate." Manalansan, "Queer Intersections," 243. While Manalansan here specifically critiques scholarly framings of Filipina migrant workers that invariably naturalize gender norms and elide sexuality outside of a discourse of exploitation, we can identify a corollary in the heteronormative presumptions of much of the literature on South Asian male labor in the UAE.

13. Even as I use the term "migrants" here, I am mindful of Neha Vora's important point that the categories of "migrant," "local," and "expat" generally used to describe the population of the UAE efface the existence of the long-standing Indian communities who have made the UAE (Dubai in particular) their home for generations, for well over a century. Vora also notes that these communities are variegated, comprised of middle-class, working-class, and elite Indians who often exist in intimate relation to one another as factory owners/employers and workers. See Vora, *Impossible Citizens*, 2, 66.

14. As Neha Vora notes, much of this literature "collapses migrant lives into economic terms and removes possibilities of community formation, political agency, cultural hybridity, emotional attachment, consumption, leisure activity, and other forms of belonging from South Asian experiences in the Gulf." Vora, *Impossible Citizens*, 11.

15. See Rohy, *Anachronism and Its Others*, for an extended discussion of the temporality of the region in a U.S. context.

16. Remittances, predominantly from the Gulf, have been central to Kerala's economy since the 1970s. Studies have documented how the male to female ratio within Kerala has dramatically altered given the large numbers of men who travel to the Gulf as labor. See Ramanathaiyer and Macpherson, *Social Development in Kerala*, 169–170. The complicated way in which male out-migration to the Gulf has transformed gender dynamics and kinship networks in towns and villages in Kerala is the focus of innovative research by sociologist Swethaa Ballakrishnen, "Migration and Kerala's Gender Paradox" (paper presented at Gender Studies Brown Bag, New York University, Abu Dhabi, April 16, 2017). The physical landscape of Kerala has also changed with out-migration, as foreign remittances are often used to build new housing structures in Kerala that depart from traditional forms of architecture. This is the focus of Dubai-based Indian artist Vikram Divecha's sound/video installation "Veedu" (or "House" in Malayalam), shown at the 2016 Kochi Biennial as part of the exhibition *Binary States: India-UAE*, curated by Umer Butt. Divecha documents the emergence of a contemporary architectural aesthetic in Kerala that stems from the aspirational longings of Gulf-returned Malayalis, for whom building a house in Kerala with money saved from their years of labor in the Gulf is a key marker of achievement and success; these houses are often imagined as hybrids of Arab and traditional Kerala architectural styles. The work of both Ballakrishnan and Divecha reveal how Gulf migration produces Kerala itself as "diaspora-space," to use Avtar Brah's still-useful term. See Brah, *Cartographies of Diaspora*, 16.

17. This becomes readily apparent in the many grocery stores and shopping malls, movie theaters and eateries, that are staffed by Malayalis and cater to a specifically Malayali clientele in specific neighborhoods in Gulf cities such as Abu Dhabi, Dubai, and Doha.

18. A *taravad* is the ancestral, joint household property unit of Nair families. The Nairs are a Hindu, caste-based formation that has historically comprised a large part of the landowning as well as administrative and governing elites in Kerala during both the precolonial and colonial periods. The Nairs followed a matrilineal system of social organization and property inheritance until the early twentieth century.

19. *Sancharram* was also shown at film festivals in India in 2005, and was picked up for distribution by Wolfe Releasing that year.

20. For a discussion of the *Fire* controversy, see Gopinath, *Impossible Desires*. At the time of *Fire*'s release, the Hindu Right was in firm control on both the state

and national levels; the controversy around *Fire* prompted heated debate about homosexuality, religion, and nationalism in India. At the time of *Sancharram*'s release in 2004, however, the Hindu Right had temporarily relinquished its electoral dominance on the national level.

21. David Kalal, artist statement, email communication with the author.

22. Varma's paintings visually stage the debates around gender and modernity as they played out on women's bodies in late nineteenth- and early twentieth-century Kerala. Historian J. Devika details the ways in which new norms for women's dress, bodily comportment, and education—all evident in Varma's *Malabar Girl*—were rapidly being consolidated in the production of a modern middle-class domesticity in Kerala at the time. See Devika, "The Aesthetic Woman."

23. For an investigation into the role of humor and parody in South Asian diasporic art, see Bissonauth, "Play in the Turn of the Millennium."

24. Literary scholar Riché Richardson, for instance, opens her study on black masculinity in the U.S. South by writing, "Admittedly, my background as an African American born and raised in the South has partly fueled my passion to engage in systematic critical reflection on the region"; she hastens to add, "At the same time it is necessary, of course, to unsettle logic that links southern identity to the production of scholarship on the South. . . . It is crucial to remember that a 'southernist' and a 'southerner' are very different things." Richardson, *Black Masculinity and the U.S. South*, 239n12.

25. For an extended engagement with the relation between the autobiographical and the regional, see Casemore, *The Autobiographical Demand of Place*.

26. Ann Stoler writes, in relation to the apparently marginal debates, the "distractions and deferrals" within the Dutch colonial archive, that "minor histories should not be mistaken for trivial ones. Nor are they iconic, mere microcosms of events played out elsewhere on a larger central stage. Minor history . . . marks a differential political temper and a critical space. It attends to structures of feeling and force that in 'major' history might otherwise be displaced." Stoler, *Along the Archival Grain*, 7.

27. Pullappally wrote the original film script in English; it was then translated into Malayalam and subtitled in English.

28. This phrase is used by Lyons, "Larry Brown's *Joe* and the Uses and Abuses of the 'Region' Concept," 27.

29. Lyons traces the renewed attention and purchase of the region concept in American studies, and quotes an essay by Robert Brinkmeyer, who notes that, during World War II, regionalism's "emphasis on particularism and indigenous culture appeared . . . chauvinist, regressive, and racist—for many observers regionalism was the seedbed of fascism." See Lyons, "Larry Brown's *Joe* and the Uses and Abuses of the 'Region' Concept," 96.

30. I am thinking, for instance, of the website for the Abu Dhabi chapter of the Kerala Samajam (Kerala Association, catering to Malayalis in the UAE) which

features gender-segregated group photographs of the members dressed in "traditional" Kerala clothing that is deeply caste/class-inflected.

31. Various critics have pointed to the shared ground between regionalism and nationalism in that both concepts tend to "'speak the same language' and 'foster the same desires, menacing and childish, of purity and authenticity.'" Roberto Maria Dainotto, quoted in Lyons, "Larry Brown's *Joe* and the Uses and Abuses of the 'Region' Concept," 96. At the same time, in a space such as the UAE, we can understand the fact that Indian migrants are so centrally organized around regional affiliations as a response to the sense of nonbelonging fostered by both Indian *and* Emirati nationalisms.

32. This investment in refiguring queer studies through area studies and area studies through queer studies is a collective project that has emerged in recent years. Indeed as I was nearing the completion of this book, Anjali Arondekar and Geeta Patel, in their special issue of *GLQ* entitled "Area Impossible," make the case for precisely this project as they attempt to bring queer studies to bear on area studies in a way that pushes against the Euro-American centrism of the former, and the Cold War–era investments of the latter. See Arondekar and Patel, "Area Impossible."

33. For a genealogy of the concept of region in different disciplines, see Gopinath, "Queer Regions."

34. An essay written over forty years ago, by renowned anthropologist of South Asia Bernard S. Cohn, opened with the following caution: "Regions, even the assumed enduring ones . . . are of a changing nature through time. Various kinds of circumstances can rapidly alter the boundaries and the very nature and conception of a region. . . . Regions are far from fixed, enduring things, especially if any historical perspective is taken. They are not absolutes and they are difficult, if not impossible, to define by objective criteria." Cohn, "Regions, Subjective and Objective," 113. Cohn warned against reifying the region at a time when the region was in fact being fixed within area studies scholarship in precisely the ways that he was cautioning against; he instead urged the field of South Asian studies to recognize how the region is constituted through an interplay of spatial and temporal logics. My thanks to Saloni Mathur for reminding me of Cohn's essay.

35. In their explication of what they term "regional modernities" within India, for instance, social scientists K. Sivaramakrishnan and Arun Agrawal assert, "The local is produced in systematic articulations of social, economic and cultural processes that may have a far more regional character than a resolutely independent local one or a thoroughly overdetermined global one." For these authors, the regional is a strictly relational term rather than a pregiven entity, one that is meaningfully constituted only in relation to these other scales. See Sivaramakrishnan and Agrawal, *Regional Modernities*, 12. This turn to the region is part of a collective project that is being undertaken by postcolonial scholars in order to provincialize the West through a focus on the traffic and travel within and between locations

in the global South. One exemplary instance of such scholarship is Niranjana's *Mobilizing India*. See Gopinath, "Who's Your Daddy?," for an extended engagement with Niranjana's book.

36. For instance, the adoption of the neologism "Afpak" by the Obama administration to designate Afghanistan and Pakistan as a single "theater of war" speaks to how new "regions" come into being in relation to the geopolitical interests of the U.S. and other global powers. See Gopinath, "Queer Regions," for a more detailed discussion of the use of "the region" within recent area studies scholarship. In these rearticulations of the concept, the region is a preferred term over "the local," as the the latter is often framed as a stable, transparent, and parochial entity, as opposed to the fluidity and cosmopolitanism of "the global." "The region" importantly avoids replicating this global/local binary and instead stresses the relational aspect of all notions of space and scale.

37. For just a few important instances of queer scholarship on the region in a U.S. context, see Martin Manalansan et al., eds., "Queering the Middle," special issue of *GLQ*; Tongson, *Relocations*; Rohy, *Anachronism and Its Others*; Herring, *Another Country*; Johnson, *Sweet Tea*; Howard, *Men Like That*.

38. See Valerie Rohy's insightful study of women's regionalist literature in the U.S. in the late nineteenth and early twentieth century, which unravels the intimate connections between "regionalism, retrospection, and queer desire": "Regionalist writing as a genre . . . finds itself pressed into the service of national identity yet regarded as suspect, as a literature of perversity, sterility, and anachronism. Within this contradictory logic, the backwardness of local [regional] color is essential to the nationalist project, if only as a figure for the abject—for what must be summoned into national consciousness in order to be disavowed in favor of progress, fertility, and futurity." Rohy, *Anachronism and Its Others*, 50.

39. The queerness of the region and its divergence from the linearity of national time is particularly apparent in queer studies scholar Roderick Ferguson's essay "Sissies at the Picnic," which details the logic of race, class, gender, and sexuality that characterized Ferguson's hometown of Manchester, in west central Georgia in the U.S. South in the 1970s. Ferguson remembers Manchester as queer both temporally and spatially: temporally in its blurring of past and present, its refusal to enter into the modern time of the nation; and spatially in its gender and sexual heterogeneity, emblematized most dramatically in the bodies of the black sissies, the gender queer men deemed "funny" or "odd" who were nevertheless an intrinsic and valued part of the neighborhood. Ferguson poignantly recounts the demise of the black sissy in the early 1980s, with the advent of AIDS, the rise of right-wing Christianity, and the emergence of a black bourgeoisie invested in sexual respectability, as Manchester fell in step with the nation in the name of progress and integration. Ferguson, "Sissies at the Picnic."

40. See, for instance, the important work of queer Kerala scholar T. Muraleedharan, who excavates the alternative, regionally based forms of gender and sexuality

that are elided in dominant nationalist articulations of Indian "tradition" and "culture." Echoing Ferguson's essay "Sissies at the Picnic," Muraleedharan details the ways in which the Indian nation historically attempted to manage regional difference by simultaneously recognizing and disavowing it: Kerala's entrance into the modern time of the (Indian) nation, he notes, was purchased through the effacement of gender and sexual arrangements deemed "perverse," first by the colonial British state and then by the postcolonial Indian state. Muraleedharan, "The Writing on Absent (Stone) Walls."

41. Manalansan et al., introduction to "Queering the Middle," 2.

42. This alternative mapping speaks to what Françoise Lionnet and Shu-mei Shih have termed "minor transnationalism," where "the transnational" is understood not through the connectivities between dominant metropolitan locations or through a vertical relation of oppositionality/resistance between dominant and minority cultures, but rather through minor to minor engagements that avoid the center, the dominant, and the metropole. See Lionnet and Shih, eds., *Minor Transnationalism*.

43. In a similar vein, Arondekar and Patel assert: "Instead of reproducing . . . maligned models of areas studies, we are interested here in looking for ways in which to coagulate areas in the service of a queer geopolitics by focusing on the idea of area as a postcolonial form through which epistemologies of empire and market can be critiqued." See Arondekar and Patel, "Area Impossible," 156.

44. See Muraleedharan, "Crisis in Desire," for a fascinating analysis of the shifting representations of male homoeroticism/homosociality in Malayalam cinema, as it develops along a trajectory quite distinct from that of popular Hindi cinema.

45. Mira Nair's acclaimed 2001 film *Monsoon Wedding* is set in New Delhi, as is Mehta's 1996 film *Fire*. Both films garnered much acclaim and major audiences outside of India, many of whom took the films' representations of Indian life, culture, and "tradition" at face value rather than as diasporic reimaginings of "home" space. For an extended discussion of the transnational trajectories of both films, see Gopinath, *Impossible Desires*, 93–131.

46. My use of the term "provincialize" borrows from Dipesh Chakravarty's notion of "provincializing Europe," which he uses to counter notions of European universalism by foregrounding other locations and epistemologies. See Chakravarty, *Provinicializing Europe*.

47. Nautiyal, "A High That's Going to Last for Months," 3.

48. See Deepa V. N., "Queering Kerala," 177.

49. Deepa V. N. uses the term "women-loving-women" throughout her essay in order to get away from labeling as "lesbian" those women who do not identify with this category. Nevertheless, "women-loving-women" suggests problematic assumptions around who or what constitutes "woman" in the first place. This may not be an adequate framing through which to talk about queer desire for gender nonconforming individuals, for instance. Deepa V. N., "Queering Kerala."

50. For an explication of queer diasporic reading practices, see Gopinath, *Impossible Desires*, 140.
51. Tsing, *Friction*, 9. Tsing looks specifically at what she calls the "accomplishments of the universal" in the form of the Indonesian democratic movement of the 1980s and 1990s that relied on a liberal, "universalizing rhetoric of rights and justice" even as it transformed the meaning of liberalism in the process. Tsing, *Friction*, 5.
52. Deepa V. N., "Queering Kerala," 187.
53. Tsing, *Friction*, 5.
54. One of the most trenchant and thorough-going articulations of this critique of a "global" gay subject is found in Martin Manalansan's *Global Divas*. See also Massad, *Desiring Arabs*, for a critique of what he terms "the gay international."
55. See Halberstam, *In a Queer Time and Place*, for an explication of metronormativity as the process by which rural life is imagined to be antithetical to queer existence, while the urban is positioned as its natural locus.
56. I borrow the term "Gay International" from Joseph Massad, *Desiring Arabs*.
57. I draw on María Josefina Saldaña-Portillo's use of the term "developmentalist" here to refer to the naturalization of "normative concepts of growth, progress and modernity" that underlie both dominant, meliorative models of sexual, as well as economic and political, formation. See Saldaña-Portillo, *The Revolutionary Imagination in the Americas and the Age of Development*, 6.
58. Anthropologist Ritty Lukose describes this discourse of exceptionalism, through which Kerala has gained visibility in both scholarly and popular discourses, as follows: "While this discourse [of exceptionalism] has many registers, it is noteworthy that they oscillate between the idea of Kerala as a space of exotic 'tradition,' marked as exceptional by its tropical beauty, unique matrilineal kinship patterns, and rigid caste system, and Kerala as uniquely 'modern' and revolutionary, indexed as exceptional by high levels of literacy and its communist traditions. . . . Specifically, one important thread within the construction of Kerala as exceptional is the trope of development, in which the so-called 'Kerala Model of Development' is held up as an example for other parts of the world. This literature narrates a heroic story of a progressive march from 'tradition' to 'modernity.'" Writing against this discourse of exceptionalism, Lukose's analysis rejects "standard spatial imaginaries of social scales and globalization" that would "nest the region within the nation and then within the world." Instead she suggests that we must understand how "regional histories are part of a flexible articulation between region, nation, and globe; one that does not make Kerala exceptional but points to specificities that mediate Kerala's experience of globalization." Lukose underscores here the necessity of situating regional particularities within a broader context of globalization rather than seeing such particularities as markers of Kerala's anomalous status. Lukose, *Liberalization's Children*, 24.
59. See, for instance, Parayil, *Kerala*, 2.

60. Parayil, *Kerala*, 3.

61. As Anna Tsing's work on rainforest dwellers in Indonesia makes apparent, "Even seemingly isolated cultures . . . are shaped in national and transnational dialogues"; furthermore, she argues, "global forces are themselves congeries of local/global interaction." Tsing, *Friction*, 3.

62. *Sancharram*'s evocation of seemingly "timeless" and unchanging traditions also echoes the ways in which the Malayalam "parallel cinema" movement in the 1990s fetishized the "local" and the picturesque as an anxious response to processes of globalization that had drastically reshaped Kerala culture since the 1970s. See Muraleedharan, "National Interests, Regional Concerns."

63. Ligy Pullappally, lecture at Provisions Library, Washington, DC, September 28, 2005.

64. For a detailed account of this process, see Anurima, *There Comes Papa*.

65. See Anurima, *There Comes Papa*.

66. See Anurima for a complex social history of matriliny in Kerala and its multiple implications for women's rights and empowerment. She writes, "Matrilineal families were not characterised by 'mother right' or women's power in any uncomplicated sense. Equally, the contention that matrilineal communities were merely an avuncular form of patriarchy, where the figure of the uncle replaced the husband/father, is also untenable." Anurima, *There Comes Papa*, 13.

67. As Deepa V. N. has argued, Kerala's matrilineal past points to the "historical relativity of the construction of the 'modern' family in Kerala as patrilineal, nuclear and monogamous and the variety of practices which have existed outside of this." Deepa V. N., "Queering Kerala," 195.

68. Gopinath, *Impossible Desires*, 7.

69. I paraphrase here Kathleen Stewart's evocation of an "Other America" in *A Space on the Side of the Road*.

70. Mathur, *India by Design*, 103.

71. Varma's works then "stand as masterpieces of liminality," as Christopher Pinney puts it, "positioned as they are between different audiences, both Indian nationalists and the British elite, and between secular ideals and Hindu thematics." Pinney, as quoted in Mathur, *India by Design*, 103.

72. Rohy, *Anachronism and Its Others*, 52.

73. Mathur, *India by Design*, 104.

74. Sambrani, "Apocalypse Recalled," n.p.

75. Geeta Kapur, as quoted in Mathur, *India by Design*, 103.

76. For an extended discussion of how reformist movements focused not only on the establishment of conjugal domesticity but also on the disciplining of the female body in particular, see Devika, "The Aesthetic Woman."

77. As Lukose writes, "Among a variety of caste-based movements with different and overlapping traditions of kinship and inheritance, the nuclear family ideal, founded on monogamous sexual arrangements, became the focus of reform. Each group subordinated women's roles to the production of a new kind of modern

family and its attendant domestic arrangements. Each understood this ideal as the 'liberation' of women from barbaric caste practices through the workings of a modern and progressive public." Lukose, *Liberalization's Children*, 13.

78. Anurima, *There Comes Papa*, 22.

79. Anurima, *There Comes Papa*, 1.

80. Ali and Agarwal, "A Standard Program to Classify Books/Documents according to Colon Scheme of Classification Ed. 6 Using Php Environment," 592.

81. Sambrani, "Apocalypse Recalled," n.p.

82. Sambrani, "Apocalypse Recalled," n.p.

83. As feminist critic Susie Tharu writes, Pushpamala "draws attention to the continuing presence of colonialism and its schemes in 'free' India." Tharu, "This Is Not an Inventory," 13.

84. Tejal Shah, artist statement, https://www.brooklynmuseum.org/eascfa/feminist _art_base/tejal-shah.

85. Dinshaw et al., "Theorizing Queer Temporalities," 178.

86. Anurima, "Face Value," 60.

87. Sheba Chhachhi, artist statement, http://www.bosepacia.com/exhibitions/2008 -11-13_sheba-chhachhi/press-release.

88. Nixon, *Slow Violence and the Environmentalism of the Poor*, 3.

89. In this sense, Chhachhi's *Winged Pilgrims* is the aesthetic counterpart to the scholarship of Sugata Bose, Enseng Ho, Kris Manjapra, and others who have rethought the "area" of area studies through interregional, "postnationalist" comparative and oceanic frameworks. Their work traces long histories of overlapping diasporas of traders, scholars, pilgrims, and other travelers that preexisted European colonial trade routes and continued to coexist in sometimes uneasy relation to them. See Ho, *The Graves of Tarim*; Bose, *A Hundred Horizons*; and Manjapra, introduction to Bose and Manjapra, *Cosmopolitan Thought Zones*, 3. As Bose writes in his study of the Indian Ocean arena, "Regional entities known today as the Middle East, South Asia, and Southeast Asia, which underpin the rubric of area studies in the Western academy, are relatively recent constructions that arbitrarily project certain legacies of colonial power onto the domain of knowledge in the postcolonial era." For Bose, "The world of the Indian Ocean . . . has much greater depth of economic and cultural meaning" than can be captured through conventional area studies models. Bose, *A Hundred Horizons*, 6. And, as Manjapra phrases it, "The historical gaze may rest on the interstitial and intermediate routes of connection: oceans, rivers, pilgrimage routes, borderlands and flights of imagination, in order to find a different history of continuity and change." Manjapra, "Introduction," 3.

CHAPTER 2. QUEER DISORIENTATIONS

1. My thanks to Marcia Ochoa for introducing me to "La bota loca" way back when.

2. Hutchinson, *From Quebradita to Duranguense*.

3. Jack Halberstam coins the term "metronormativity" to refer to the dominant story of gay formation as "a migration from 'country' to 'town,'" where the urban is seen as the only viable space for queer worldmaking," while the nonurban is seen as the repository of homophobic backwardness. Judith Halberstam, *In a Queer Time and Place*, 36–37. Building on Halberstam's notion of metronormativity, Scott Herring takes to task what he terms "queer metronormativity" for sidelining and indeed erasing the richness and specificity of queer lives lived beyond the bicoastal gay axis of San Francisco and New York City, materially linked by Route 80. Herring demands that we disorient our metronormative vision and focus instead on those alternative routes off the superhighway to urban queerdom that may initially appear as roads to nowhere, dead-ends, cul-de-sacs, far from Castro Street or Christopher Street; for Herring, it is these "countless other highways and byways that receive scant attention in an urbane queer topography," that are the "much needed detour[s]" leading us to those queer topographies that remain unthought and unaccounted for within a metronormative gay imaginary. Herring briefly references the transnational implications of his critique of metronormativity by ending his book with a description of a "Noche Latina" at a big gay club in a Midwestern metropolis that recalls the scene I witnessed in Oakland, California. This is a club night, he tells us, that is frequented by undocumented queer Mexican workers who drive in from the small Midwestern towns where they work and live, and who are themselves from small towns in rural Mexico. For Herring, the migrations of these queer Mexican men and women from the provinces of Mexico to the provinces of the Midwest and their brief, fleeting territorialization of "big city" gay nightlife speaks to the ways in which, for a few hours, as he puts it, "Mexican *ambiente* rusticates a few square feet of the nation." Herring, *Another Country*, 181.
4. My own use of the terms "metronormative" and "metronormativity" builds on the work of Halberstam and Herring to name the singular mode of queerness legitimized and rendered intelligible by a colonial logic that situates sexual and gender formations in the global South (as well as in subaltern, regional spaces in the global North) as the backward, prepolitical "other" to an implicitly white, urban, upper-middle-class gay subject in the global North.
5. This explication and critique of "the good life" is powerfully articulated by Lauren Berlant, who notes that adherence to such "conventional good life fantasies" are forms of what she terms "cruel optimism," desires that are in fact deeply toxic and detrimental to one's flourishing. Berlant, *Cruel Optimism*, 3.
6. Of course, for migrant workers in a space such as the UAE, there is no lure or promise of inclusion or state recognition, given the state's draconian immigration laws that keep non-UAE nationals in a state of unbelonging, sometimes for generations. My point is that despite (or especially because of) these circumstances, there exist queer world-making practices that exceed desires for inclusion or recognition on the one hand, or the mode of "bare life" often seen to characterize migrant lives on the other.

7. Here I have in mind, for instance, the growth of regional queer studies in Asia over the past decade, epitomized by the Queer Asia conference in Bangkok in 2005 and the Queer Diaspora conference in Taipei in 2010. While these conferences did indeed occur in the cosmopolitan centers of the global South, they drew together scholarship on resolutely *non*metronormative queer formations in sites such as rural Southern Taiwan and rural Indonesia; furthermore, they placed these sites, which may initially appear utterly distinct and disparate, in meaningful relation to one another even as they traversed the rubric of "Asia" writ large (from South Asia to Southeast Asia to East Asia to the Pacific Islands).

8. As Jack Halberstam writes, "We might consider getting lost over finding our way, and so we should conjure . . . an ambulatory journey through the unplanned, the unexpected, the improvised and the surprising." Judith Halberstam, *The Queer Art of Failure*, 15–16. Similarly, Sara Ahmed suggests that if we "consider heterosexuality as a compulsory orientation," then "risking departure from the straight and narrow makes new futures possible, which might involve going astray, getting lost, or even becoming queer." Ahmed, *Queer Phenomenology,* 84. And José Esteban Muñoz adds, "We can understand queerness itself as being filled with the intention to be lost. Queerness is illegible and therefore lost in relation to the straight minds' mapping of space. Queerness is lost in space or lost in relation to the space of heteronormativity. . . . To be lost . . . is to veer away from heterosexuality's path." Muñoz, *Cruising Utopia*, 72–73.

9. See, for instance, Joseph N. DeFilippis, Lisa Duggan, Kenyon Farrow, and Richard Kim, eds. "A New Queer Agenda," special issue of *The Scholar and Feminist Online.*

10. As Lisa Marie Cacho writes, "To be represented as entitled to civil rights and deserving of legal recognition, working poor African American and undocumented Latinas/os must demonstrate that they are deserving and/or in need of U.S. citizenship and its rights and privileges. For these marginalized groups, connections to heterosexual nuclear families are crucial to illustrate respectability and deservingness. . . . Impoverished African American and undocumented Latinas/os need to perform sexual normativity to construct themselves as moral agents deserving of rights, recognition, and resources." Cacho, *Social Death*, 129. Similarly, Chandan Reddy argues that the racialized immigrant family has in fact become a key site of governmentality in a neoliberal landscape. Pointing to the effects of the major immigration legislation of 1965 and 1990 that were premised on family reunification, Reddy notes: "For immigrants recruited through family reunification, patriarchal, heterosexual mandates have often become prerequisites to gaining family or welfare support In other words, federal immigration policies such as family reunification extend and institute heteronormative community structures as a requirement for accessing welfare provisions for new immigrants, by attaching those provisions to the family unit." Reddy, "Asian Diasporas, Neoliberalism, and Family," 110.

11. As political theorist Cristina Beltrán notes of the 2006 immigrant rights marches in the U.S., "a number of liberal immigrant-rights organizations emphasized immigrants' 'strong work ethic, deep religious faith, and commitment to family' as proof that noncitizens sought to join and strengthen the United States rather than subvert its identity and institutions." Beltrán, "Undocumented, Unafraid, and Unapologetic," 85.

12. Sociologist Monisha Das Gupta, for instance, argues that the antideportation group Families for Freedom (FFF) mobilizes the rhetoric of the family to actually critique the ways in which "deportation continues to be a vital mechanism through which the state organizes gender and sexual norms and deviance to tie them to national belonging." Das Gupta contends that a group like FFF rejects the binary between good vs. bad, innocent vs. criminal, deserving vs. undeserving immigrants, and instead launches a broad-based critique of the gendered and racialized mechanisms of criminalization itself. Das Gupta, *Unruly Immigrants*.

13. The DREAM Act is legislation that allows undocumented immigrants who were brought to the U.S. as children a path to citizenship. The language of the act stresses that only those who "demonstrate good moral character" are eligible for citizenship. See http://equalityarchive.com/wp-content/uploads/2015/11/DREAM-Act-Fact-Sheet.pdf.

14. Beltrán, "Undocumented, Unafraid, and Unapologetic," 81.

15. Beltrán, "Undocumented, Unafraid, and Unapologetic," 81.

16. Melissa White's reading of the UndocuQueer movement, and Salgado's portraits in particular, points to the ambivalent effects of the immigrant youth movement's embracing of a politics of visibility: "Tactics designed to reveal 'who' undocumented migrants 'really are'—or what they might become ('undocuqueer')—enact a performative contradiction in that they risk reinforcing as much as disrupting normative scripts around deserving (morally upstanding, 'accidental' migrants) and undeserving migrants (criminals, intentionally law-breaking migrants). In other words, the 'coalitional' rhetorical moves of migrant youth activism gesture toward both normative and utopian politics at once." White, "Documenting the Undocumented." For a nuanced analysis of the representational and aesthetic strategies of queer migration politics, particularly UndocuQueer activists, see also Chavez, "Coming Out as Coalitional Gesture?"

17. Sara Ahmed beautifully articulates this distinction between identity and orientation: "The concept of 'orientations' allows us to expose how life gets directed in some ways rather than others, through the very requirement that we follow what is already given to us. For a life to count as a good life, then, it must return the debt of its life by taking on the direction promised as a social good, which means imagining one's futurity in terms of reaching certain points along a life course. . . . A queer life might be one that fails to make such gestures of return." Ahmed, *Queer Phenomenology*, 21.

18. On queerness as a disruption of normative temporality, see, for instance, Halberstam, *In a Queer Time and Place*; Dinshaw, *How Soon Is Now?*; Freeman, *Time Binds*; Love, *Feeling Backward*; Muñoz, *Cruising Utopia*.

19. For an exploration of the comparative racialization of Asian American and Latinx communities, see Parikh, *An Ethics of Betrayal*.

20. Hirsch, *Family Frames*, 48.

21. Hirsch, *Family Frames*, 8.

22. Kuhn, *Family Secrets*, 8.

23. Kuhn, *Family Secrets*, 8.

24. Key texts on the political uses of affect that have informed my own work include Cvetkovitch, *An Archive of Feelings*; Eng, *The Feeling of Kinship*; Flatley, *Affective Mapping*; Berlant, *Cruel Optimism*; Rodríguez, *Sexual Futures, Queer Gestures, and Other Latina Longings*; Shah, *Stranger Intimacy*; and Cho, *Haunting the Korean Diaspora*.

25. See Stoler, *Along the Archival Grain*.

26. Stockton, *The Queer Child, or Growing Sideways in the Twentieth Century*, 13.

27. See Pinney, *Camera Indica*, 72–107.

28. As I was completing this chapter, Ganesh mentioned to me that her father finally revealed to her that he believes he took these photos not in Kashmir but in Sikkim, a northeast region of India with an equally complicated history. Sikkim, too, is a region that bears a complex relation to the Indian nation writ large, given that it has been in the crosshairs of long-standing territorial disputes between Great Britain, China, Tibet, India, and Nepal, from the colonial through the postcolonial periods. It was formally annexed by India in 1975, after having retained a semiautonomous status following Indian independence in 1947.

29. Kabir, *Territory of Desire*, 14.

30. Kabir, *Territory of Desire*, 16.

31. As Lavina Dhingra Shankar and Rajini Srikanth note, Ali often referred to himself as a "Kashmiri-American-Kashmiri." They write: "In the double hyphenation, Ali reveals that the 'American' is not the endpoint of his identity, not the destination of his being. . . . Cleverly, he suggests that America takes him back to Kashmir." Shankar and Srikanth, "South Asian American Literature," 378.

32. A notable exception to this nonengagement with queerness in Agha Shahid Ali's work is found in Arondekar and Patel, introduction to "Area Impossible," 151–171.

33. As Jacqueline Rose comments, "You can only start seeing—this was Freud's most basic insight—when you know that your vision is troubled, fallible, off-key. The only viable way of reading is not to find, but to disorient, oneself." Quoted in Stoler, *Along the Archival Grain*, 119.

34. Amitav Ghosh, personal email communication, August 5, 2011.

35. See Herring, "Queer Infrastructure," in *Another Country*, 149–180.

36. Ahmed, *Queer Phenomenology*, 79.

37. Ali quoted in interview with Rehan Ansari and Rajinderpal S. Pal, "Agha Shahid Ali," n.p.
38. However, we could also read Ali's elegiac rendering of the indigenous presence of Arizona as reiterating the settler colonial trope of situating indigeneity as always already past, as inevitably extinct. See Byrd, *The Transit of Empire*, for an elaboration of the problematic rendering of the "pastness" of indigeneity within postcolonial studies.
39. White, *Women's Cinema, World Cinema*, 204 n13.
40. White, *Women's Cinema, World Cinema*, 4–5. Like Pullappally's *Sancharram*, Guerrero's *Mosquita y Mari* circulated in both mainstream and queer film festivals in the U.S., and was then picked up by Wolfe Releasing for distribution. It also had a theatrical release in the U.S. in 2012. It was, notably, the first feature film by a Chicana director to be shown at the Sundance Film Festival. Guerrero drew on her own experience as a longtime activist and community organizer in the Bay Area to fund the film partly through a successful Kickstarter campaign. Fuchs, "Most of Us Don't Have to Put Labels on It."
41. In her study of the "queer suburban imaginaries" of Southern California, Karen Tongson notes, "racialized neighborhoods in the city [of Los Angeles] itself, like the predominantly Latino East L.A., are historically segregated from the city's discourse on 'urbanity,' and enfolded instead into what the scholar Raul Homero Villa calls a 'barrio logos.'" Tongson, *Relocations*, 171. These racialized, immigrant communities are "absorbed under the sign and sprawl of 'Los Angeles' and relegated to serving as the city's minor sites." Tongson, *Relocations*, 164.
42. Guerrero, "Aurora Guerrero on the Making of *Mosquita y Mari* and Scouring Remezcla for Music."
43. Guerrero, "Aurora Guerrero on the Making of *Mosquita y Mari* and Scouring Remezcla for Music."
44. This formulation is from Stockton, *The Queer Child*.
45. See Manalansan, "Servicing the World."
46. Nixon, *Slow Violence and the Environmentalism of the Poor*, 2.
47. Nixon, *Slow Violence and the Environmentalism of the Poor*, 2.
48. I draw here from Muñoz's understanding of queer futurity as a rejection of the "here and now" through an evocation of the "there and then." See Muñoz, *Cruising Utopia*.
49. My thanks to Jacqueline Nassy Brown for urging me to elaborate my reading of this scene along these lines.
50. See the website for Equality Archive, https://equalityarchive.com/issues/undocuqueer-movement.

CHAPTER 3. DIASPORA, INDIGENEITY, QUEER CRITIQUE

1. Sociologists Macarena Gomez-Barris and Herman Gray, following the example set by Avery Gordon's important work on ghosting, have called for what they term a "sociology of the trace" as a way to "attenuate the distance between observ-

able social worlds and those things that are not easily found through method-ologies that attempt to empirically account for social reality." It is precisely "the traces and inscriptions" of the social that fall outside "the purview of disciplinary knowledge," as they put it, that are captured by the aesthetic practices of queer diaspora. Gomez-Barris and Gray, "Toward a Sociology of the Trace," 5.

2. Lily Cho succinctly sums up the problematic nature of diaspora studies in rela-tion to indigenous studies as follows: "Not only does diaspora seem to privilege movement and mobility over rootedness, it also threatens to re-center transna-tional interests at the expense of the local." She continues, "Are diasporas colonial in their disregard for autochthony and in the forms of their settlement? Does diasporic theory and literature elide First Nations, aboriginal and indigenous concerns? . . . Are diasporas necessarily transnational in their constitution?" Cho, "Diaspora and Indigeneity," n.p. Furthermore, in his examination of what he terms "multicultural forms of settler colonialism" in Hawaii, Dean Itsuji Saranil-lio takes to task "a 'migrant's eye-view of the world', a way of seeing that is limited by an episteme that does not contend with an Indigenous history of dispossession of the very land beneath migrants' feet." Saranillio, "Why Asian Settler Colonial-ism Matters," 286.

3. As James Clifford observes: "In everyday practices of mobility and dwelling, the line separating the diasporic from the indigenous thickens; a complex borderland opens up." Clifford, "Varieties of Indigenous Experience," 198.

4. See, for instance, Graham Harvey and Charles D. Thompson, "Introduction," *Indigenous Diasporas and Dislocation*; Watson, "Diasporic Indigeneity"; Ramirez, *Native Hubs*; Smithers, *The Cherokee Diaspora*.

5. Such a suturing together of "diaspora" and "indigeneity" powerfully contests the dominant conception of indigenous identity as fixed in a particular location; this framing of indigeneity as immobile negates the material realities of the many indigenous people who forge lives and communities outside their "traditional" place. In so doing, this scholarship importantly challenges notions of "authen-tic" vs. "inauthentic" indigeneity that link authenticity to having never left a particular (often rural) land base. As Margaret Jolly notes in relation to Australia: "There is still a persisting tendency to distinguish between 'real' and the 'unreal' Aborigines, between those who are constructed as 'authentic,' living in remote areas of Australia, where they are struggling to retain attachment to country and to ancestral beliefs and practices, and those who are 'inauthentic,' who live in the cities and towns whose land was taken decades before, and who are often denigrated as 'overeducated activists' or detached urbanites without 'traditional' roots." Jolly, "Our Part of the World," 205.

6. Also critiquing the notion of authenticity as tied to the rural, Reyna Ramirez's ethnography of urban Indians in the Silicon Valley area uses the formulation of "Native hubs" to name a specifically Native articulation of diaspora. Arguing that "urban Indians ultimately maintain a rooted connection to their tribal lands

and communities even if we don't live there," Ramirez emphasizes what James Clifford aptly describes as "a rooted sense of routes" in her articulation of a "Native diasporic consciousness." She identifies this consciousness as "the subjective experience of feeling connected to tribe, to urban spaces, and to Native peoples within the diaspora, as well as other Indigenous cultural and national formations." Ramirez, *Native Hubs*, 11.

7. J. Kēhaulani Kauanui proposes as much in her exploration of the often fraught relation between "off-island Hawaiians" and those based in Hawai'i, when she argues for the need for "multiple diasporic frameworks that reckon with indigeneity, the persistence of homeland, and Hawaiian connections to other people who have their own claims to Hawai'i as home, to illuminate Hawaiians' off-island subjectivities. . . . In addition, Hawaiians who have had experiences outside of Hawai'i can and should incorporate their histories of mobility into their genealogical recitations as part of their personal heritage to reclaim those travels and movements as part of their Hawaiianess." Kauanui importantly suggests here that placing the diasporic mobilities of indigenous peoples at the center of theorizing "diaspora" as well as "indigeneity" significantly transforms our understandings of both categories. Kauanui, "Diasporic Deracination and 'Off-Island Hawaiians,'" 158.

8. As Scott Lauria Morgensen writes, "Histories of white settler colonialism and its logic of elimination in the Americas and the Pacific must theorize its coproduction with the transatlantic slave trade and the African diaspora, franchise colonialism in Asia and Africa, and global migrations of indentured labor, all of which inform the globalization of European capital and empire. This context suggests that the relationality of 'settler' to 'Native' in a white settler society has the effect of excluding non-Native people of color from the civilizational modernity that white settlers seek when they appear to eliminate Native peoples only to elide the subjugation of non-Native people of color on stolen land." Morgensen, *Spaces between Us*, 18.

9. This framework is powerfully instantiated by reading the work of Lisa Lowe and Jodi Byrd in tandem. In *The Intimacies of Four Continents*, Lowe foregrounds the figure of the transatlantic Chinese "coolie" in the British colonial archive in order to access the various historical intimacies between Europe, Africa, Asia, and the Americas that are deliberately forgotten yet constitutive of European modernity and liberal humanism. As Lowe puts it, "the particular obscurity of the transatlantic Chinese in these relations [between Europe, Africa, Asia, and the Americas] permits an entry into a range of connections, the global intimacies out of which emerged not only modern humanism but a modern racialized division of labor." Lowe argues that the figure of the "coolie" is strategically deployed and necessarily disremembered in order to secure the divide between free and unfree labor that characterizes postemancipation Euro-American thought and political economy. Lowe's excavation of the figure of the Chinese

"coolie" in the colonial archive resonates with Jodi Byrd's elaboration of the figure of the "Indian" in U.S. nationalist ideology in her book *The Transit of Empire: Indigenous Critiques of Colonialism*. If, for Lowe, the absent presence of the Chinese "coolie" illuminates the obscured intimacies of peoples, geographies, and economies in the making of Euro-American modernity, for Byrd the figure of the "Indian" is an all too visible marker of the past and continuing violences of U.S. empire. Byrd writes, "As a transit, Indianness becomes a site through which U.S. empire orients and replicates itself by transforming those to be colonized into 'Indians' through continual reiterations of pioneer logics, whether in the Pacific, the Caribbean, or the Middle East." Byrd, *The Transit of Empire*, xiii. As Byrd notes, Native dispossession is not a thing of the past but is in fact the central logic of U.S. empire; it is a continuing process of colonization reiterated across various racialized populations and geographic spaces both within and far beyond the territorial boundaries of the U.S. nation-state. Reading the work of Byrd in relation to Lowe makes evident how the figures of the "coolie" and the "Indian" function together in past and continuing projects of U.S. and British colonialism. See Lowe, *The Intimacies of Four Continents*, 192, and Byrd, *The Transit of Empire*, xiii.

10. As Vanita Reddy asks, "Is queer diaspora a useful framework for de-naturalizing settler colonialism? . . . Might understanding Native populations as diasporic reveal the way in which the nation-as-homeland has been naturalized within theories of diaspora?" Vanita Reddy, "Que(e)rying Alliances."

11. Andrea Smith, "Queer Theory and Native Studies," 42.

12. Andrea Smith, "Queer Theory and Native Studies," 56.

13. Andrea Smith, "Queer Theory and Native Studies," 61.

14. Byrd, *The Transit of Empire*, 37. See also Saldaña Portillo's *Indian Given* for work that powerfully brings together indigenous studies, American studies, and post-colonial studies scholarship.

15. Chandan Reddy argues that the state's putative "protection" of the individual from violence deemed arbitrary, anachronistic, and private is in fact dependent on the deployment of so-called "legitimate" violence that the state wields, and that it bestows on itself alone as a kind of ethical responsibility. As he writes, "Indeed what we find by the late twentieth century, in ways that repeat the onset of the twentieth century, is a braiding so thorough of the repressive and ideological state apparatuses within the institutional sites, occasions and acts that ensure racial inclusion that it is nearly impossible to demarcate their boundaries." Reddy, *Freedom with Violence*, 223.

16. One could argue that the election of Donald Trump in 2016 heralded a shift away from the "liberal egalitarian nation-state" toward an authoritarian state that relies more on draconian forms of regulation. However, I would argue that one model does not supersede the other; rather, they function in tandem.

17. See Nayan Shah, *Stranger Intimacy*.

18. Roderick Ferguson and Grace Hong warn against a mode of comparative race scholarship that "simply parallels instances of historical similarity across racial groups in the United States." Instead, the authors seek to imagine "alternative modes of coalition beyond prior models of racial and ethnic solidarity based on a notion of homogeneity or similarity." Ferguson and Hong, introduction to *Strange Affinities*, 1.

19. Indigenous studies scholars have powerfully argued that this rendering effaces the fact that Native populations have a colonial rather than minoritarian relation to the U.S. nation-state, and that non-Native diasporic and racialized communities have been complicit with settler colonialism. See, for instance, Deloria, "American Indians, American Studies, and the ASA."

20. As Saranillio puts it, such a framing would "situate . . . these different histories in complex unity—not flattening difference and assuming they are always in solidarity, or falling into the pitfalls of difference and framing these groups as always in opposition." Saranillio, "Why Asian Settler Colonialism Matters," 282.

21. Various scholars have turned to the language of "affinity," "encounter," and "conversation" to characterize the nonequivalent relation between indigeneity and non-Native racialized formations. See, in particular, Ferguson and Hong, *Strange Affinities*; Morgensen, *Spaces between Us*; Byrd, *The Transit of Empire*.

22. This is precisely what Roderick Ferguson and Grace Hong refer to as the "strange affinities" that bind different communities of color together. See Ferguson and Hong, *Strange Affinities*.

23. Robertson, "The Spectre at the Window."

24. Smith, "Queer Theory and Native Studies," 53.

25. I am indebted here to Stuart Hall's famous formulation of identity not as an essence but as a positioning. See Hall, "Cultural Identity and Diaspora."

26. Muñoz, *Cruising Utopia*, 7.

27. See "Tracey Moffatt," *Deadly Vibe* 84 (February 2004), http://www.deadlyvibe .com.au/2007/11/tracey-moffatt.

28. McLean, "Aboriginal Modernism in Central Australia," 76.

29. Kathryn Weir, "Tracey Moffatt: Spirit Landscapes," Tyler Rollins Fine Art, 2013.

30. "Tracey Moffatt."

31. "Tracey Moffatt."

32. "Tracey Moffatt."

33. Cerwonka, *Native to the Nation*, 62.

34. Cerwonka, *Native to the Nation*, 62.

35. Cerwonka, *Native to the Nation*, 66.

36. Jacobs, *White Mother to a Dark Nation*, 248.

37. For a detailed study of the formation of Cherbourg, see Blake, *A Dumping Ground*.

38. Blake, *A Dumping Ground*, 130.

39. Kathryn Weir, gallery statement displayed in Tracey Moffatt's *Spirit Landscapes* exhibit, Tyler Rollins Fine Art, New York City, 2013.

40. Hall, "Cultural Identity and Diaspora," 235.
41. As James Clifford notes, the embrace of fluidity and the distrust of "nativism" on the part of diaspora studies scholars "can make all deeply rooted attachments seem illegitimate, bad essentialism. Genuinely complex indigenous histories which involve mobility as well as staying put, and that have always been based on transformative, potentially expansive interactions, become invisible." Clifford, *Returns*, 71.
42. It may be illuminating to reference here the work of Ana Mendieta, the Cuban diasporic feminist artist whose controversial "earth-body sculptures" of the 1970s raised similar questions, as Julia Bryan-Wilson notes, about "essentialism and fraught 'innate' correspondences made between female bodies and nature." Bryan-Wilson argues that while Mendieta's work has been hotly debated among scholars who seek to situate her within either an essentialist or antiessentialist camp (or both), Mendieta understood herself as part of a critical genealogy of "Third World feminism," which "had concerns quite distinct from the 'essentialism' and 'anti-essentialism' debate." Bryan-Wilson, "Against the Body," 34. Similarly, José Esteban Muñoz argues in relation to Mendieta's work that "if we displace the predictable good dog/bad dog argumentation around concepts like essentialism we might see . . . something other than a conservative or even reactionary appeal to heritage or common memory. It may indeed be a matter of building a cosmology that responds cogently to precarious histories of singular and multiple dispossessions that may seem different at first glance, like the histories of violence against women and the imperial subjection of Caribbean people." Muñoz, "Vitalism's After-Burn," 195. I thank Leon Hilton for reminding me to return to Muñoz's essay.
43. I draw this observation from Julia Bryan-Wilson's astute reading of Ana Mendieta's *Siluetas* series. Moffatt's work is akin to Mendieta's in that, as Bryan-Wilson observes about the latter, "Just as there is no such thing as 'the earth' or 'the goddess,' there is no such thing as 'the body' in Mendieta's work; she goes against 'the body,' to reassert the existence of, and interdependence between, many bodies." Bryan-Wilson, "Against the Body," 36.
44. Muñoz, *Cruising Utopia*, 7, 11.
45. See Jacobs, *White Mother to a Dark Race*.
46. Robertson, "The Spectre at the Window," n.p.
47. McLean, "Aboriginal Modernism in Central Australia," 75.
48. McLean, "Aboriginal Modernism in Central Australia," 92. "Arrernte" refers to the Aboriginal people in central Australia who are the original custodians of this land.
49. Elspeth Brown and Thy Phu, "Introduction," in Brown and Phu, eds., *Feeling Photography*, 15.
50. Weir, gallery statement.
51. Turcotte, "Spectrality in Indigenous Women's Cinema," 10.

52. Turcotte, "Spectrality in Indigenous Women's Cinema," 8.

53. Scaramouche, *Object Anxiety*, press release, 2011, http://www.sehershah.net/
Press-Release-2.

54. Adams, "Seher Shah's Constructed Landscapes," 10.

55. Susan Scafati Shahan, "Seher Shah: Constructed Landscapes at AMOA/
Arthouse," http://glasstire.com/2013/06/19/seher-shah-constructed-landscapes
-at-amoaarthouse.

56. Mani, "Archives of Empire," 131.

57. As Shah pointed out at the Cornell conference, the Japanese American architect
of Pruitt-Igoe, Minoru Yamasaki, was also the lead architect for the World Trade
Center, both projects that have become best known for their spectacular destruc-
tion and failure. Seher Shah, artist presentation, Symposium: Lines of Control,
Cornell University, Ithaca, New York, March 4, 2012.

58. Saldaña-Portillo, "'No Country for Old Mexicans,'" 67.

59. Saldaña-Portillo, "'No Country for Old Mexicans,'" 76.

60. Saldaña-Portillo, "'No Country for Old Mexicans,'" 67.

61. Fugikawa, "Domestic Containment." See also Stewart, *Placing Memory*. As of
this writing, Karen J. Leong is undertaking an oral history that attends to the re-
lation between Native communities and Japanese Americans interned in Arizona
during World War II. See Leong and Carpio, "Carceral Subjugations."

62. Jacob Lawrence, as quoted in Lemke, "Diaspora Aesthetics," 129.

63. Smallwood, "Freedom."

64. Smallwood, "Freedom."

65. Allan deSouza, *(Untitled, 02)*, http://allandesouza.com/index.php?/
photoworks/2011-the-world-series.

66. A number of Lawrence's panels display a deeply ambivalent relation to the image
of the train: it is at once a symbol of movement and mobility as well as of new
forms of immobility and stasis, in the form of indebtedness and brutal labor
conditions. Panel #5, for instance, depicts a train speeding through a blue-black
night, and is captioned as follows: "Migrants were advanced passage on the rail-
roads, paid for by northern industry. Northern industry was to be repaid by the
migrants out of their future wages."

67. See Gopinath, "Archive, Affect, and the Everyday," for an analysis of deSouza's
earlier work.

68. See Smallwood, "Freedom," for an astute historicization of the notion of "free-
dom" presumed by what she terms the U.S. liberal progressive narrative of history.

69. Byrd, *The Transit of Empire*, xii.

70. "The Post on Alcatraces," https://www.nps.gov/alca/learn/historyculture/the
-post-on-alcatraces.htm. For a detailed history of the Alcatraz occupation, see
Paul Chaat Smith, *Like a Hurricane*.

71. As Halberstam writes, "The history of alternative political formations is impor-
tant because it contests social relations as given and allows us to access traditions

of political action that, while not necessarily successful in the sense of becoming dominant, do offer models of contestation, rupture and discontinuity for the political present. These histories also identify potent avenues of failure, failures that we might build upon in order to counter the logics of success that have emerged from the triumphs of global capitalism." Halberstam, *The Queer Art of Failure*, 19.

72. As Ferguson and Hong put it, "Particular populations are rendered vulnerable to processes of death and devaluation over and against other populations, in ways that palimpsestically register older modalities of racialized death but also exceed them." Ferguson and Hong, *Strange Affinities*, 5. Similarly, Byrd reminds us that "U.S. colonialism and imperialism domestically and abroad often coerces struggles for social justice for queers, racial minorities and immigrants into complicity with settler colonialism." Byrd, *The Transit of Empire*, xv.

73. See Reddy, *Freedom with Violence*.

74. See Shah, *Stranger Intimacy*.

75. I am thinking here of Hong and Ferguson's mobilization of Michel Foucault's notion of heterotopias as "spatial imaginaries that mark epistemological or discursive failure, disjuncture, or dissonance," as opposed to the consolation, order and stability offered by utopias. Ferguson and Hong, *Strange Affinities*, 5.

CHAPTER 4. ARCHIVE, AFFECT, AND THE EVERYDAY

1. Stewart, *Ordinary Affects*.

2. Hartman, *Lose Your Mother*.

3. Allan deSouza, "My Mother, My Sight," n.p.

4. DeSouza, "My Mother, My Sight," n.p.

5. Chitra Ganesh, interview by the author, 2009.

6. Chitra Ganesh, interview by the author, 2009.

7. Mariam Ghani, "Diasporic Networks and the Collaborative Construction of Identities in Kabul: Reconstructions," March 2004, http://www.kabul-reconstructions .net/mariam/texts/KRNetworkedIdentity.pdf.

8. Hartman, *Lose Your Mother*, 204.

9. Hartman, *Lose Your Mother*, 204.

10. As Micol Seigel puts it, Hartman's notion of affiliation "offers an active form of identification that can recognize difference, conflict, and change over time, an alternative to the 'emptiness and irrelevance of an "African identity" in making sense of the Atlantic slave trade." Seigel, "Saidiya Hartman's *Lose Your Mother* and Marcus Rediker's *The Slave Ship*," n.p.

11. For a critique of "queer heroism," see Judith Halberstam, "Sex, Failure and the Anti-Heroic Queer," paper presented at the "Rethinking Sex" Conference, University of Pennsylvania, March 5, 2009.

12. Prashad, "Bandung Is Done," xi–xxiii.

13. Prashad, "Bandung Is Done," xiv.

14. Hartman, *Lose Your Mother*, 106.

15. Hartman, *Lose Your Mother*, 45.
16. Hartman, *Lose Your Mother*, 45.
17. Boym, *Common Places*, 284.
18. Boym, *Common Places*, 284.
19. Seremetakis, *The Senses Still*, 4. My thanks to Ann Cvetkovich for pointing me to Seremetakis's work.
20. Hartman, *Lose Your Mother*, 17.
21. Hartman, *Lose Your Mother*, 17.
22. Hartman, *Lose Your Mother*, 115.
23. Hartman, *Lose Your Mother*, 119.
24. Holland, *Raising the Dead*.
25. Hartman, *Lose Your Mother*, 116.
26. DeSouza, "My Mother, My Sight," n.p.
27. DeSouza, "My Mother, My Sight," n.p.
28. DeSouza, "My Mother, My Sight," n.p.
29. DeSouza, "My Mother, My Sight," n.p.
30. For a queer feminist critique of the oedipality of diasporic narratives, see my chapter "Surviving Naipaul: Housing Masculinity in *A House for Mr. Biswas, Surviving Sabu* and *East Is East*," in *Impossible Desires*, 63–92.
31. Pinney, "Introduction: 'How the Other Half . . . ,'" 4.
32. Pinney, "Introduction: 'How the Other Half . . . ,'" 4–5.
33. DeSouza, "My Mother, My Sight," n.p. Eve Oishi argues, in her astute reading of *The Lost Pictures*, that "the internal terrain of memory itself is externalized and made strange, reenacting the 'fog' of his mother's 'internal visuality.'" Oishi, "Painting with an Eraser," n.p.
34. As Oishi writes: "These images link the very process of art and representation with the notion of the abject, defined by Julia Kristeva as the horror of the impure and the improper figured as the body turned inside out. . . . While the abject embodies the limits of human understanding, the inevitability of death, its presence also provides a reassurance against death's encroachment on the body: These bodily fluids, this defilement, this shit are what life withstands, hardly and with difficulty, on the part of death." Oishi, "Painting with an Eraser," n.p.
35. Cohen, "Introduction: Locating Filth," xiii.
36. Cohen, "Introduction: Locating Filth," x–xi.
37. Boym, *Common Places*, 511. My thanks to Martin Manalansan for pointing out to me this reference to Duchamp's work.
38. Metcalf, *Imperial Connections*, 188.
39. Metcalf, *Imperial Connections*.
40. Nair, "Shops and Stations," 85.
41. Metcalf, *Imperial Connections*, 220.
42. As Michael Ralph comments, "It seems, paradoxically, evidence of too strong a romance with the violent dehumanization of enslavement to suggest 'towns

vanished from sight and banished from memory' are all any African American 'can ever hope to claim' (9). What of the historical understandings African people developed beyond the rigid criteria of verifiable proof (cf. Brown 2003), the meaningful ties they manage to forge despite "the slipperiness and elusiveness of slavery's archive" (Hartman 2007, 17)? Whose ancestral connection, after all, is indubitably real?" Ralph, "'Crimes of History,'" 218n48. Ralph suggests here that Hartman's overwhelming sense of loss and failure as the primary affective responses to the "violent dehumanization of enslavement" has the inadvertent effect of privileging conventional notions of "evidence" and obscuring other existing, possible modes of relationality between individuals and communities.

43. Cohen, "Introduction," xiii.

44. Personal email communication with Allan deSouza, 2008.

45. Personal email communication with Allan deSouza, 2008.

46. While Nair does not specifically engage with the gendered dimensions of the racialization, it is clear that she is documenting a contest around different notions of racialized masculinity within the space of the railway station. See Nair, "Shops and Stations."

47. See Alexander, "Not Just (Any) Body Can Be a Citizen." I borrow the term "charmed circle" from Gayle Rubin's groundbreaking 1984 essay "Thinking Sex: Notes Towards a Radical Theory of Sexuality."

48. DeSouza, "My Mother, My Sight," n.p.

49. Ferguson, *Aberrations in Black*, 3.

50. Flatley, *Affective Mapping*, 1.

51. Flatley, *Affective Mapping*, 3.

52. Chitra Ganesh and Mariam Ghani, artists' statement, displayed in *Index of the Disappeared* exhibit, Asian/Pacific/American Institute Artists in Residence at New York University, New York City, 2013–2014.

53. Ghani and Ghani, *Afghanistan*.

54. See Ghani's website, www.kabul-reconstruction.net/disappeared.

55. Chitra Ganesh and Mariam Ghani, artist talk presented at the Hagop Kevorkian Center April 19, 2014.

56. Ganesh and Ghani, artist talk.

57. Chitra Ganesh and Mariam Ghani, artists' statement, *Index of the Disappeared*.

58. Ganesh, artist talk, Hagop Kevorkian Center for Near Eastern Studies, New York University, New York, NY, April 19, 2014.

59. Cvetkovich, *An Archive of Feelings*, 242.

60. The tensions and contradictions inherent in the project of creating alternative archives are suggested by Ronak Kapadia in his analysis of the *Index* as well as other "artivist" responses to the post-9/11 detentions. Kapadia argues that the attention these projects give to the visual inadvertently "replicates the link between vision and information central to the super-panopticon." In relation to the *Index*, he notes that, despite the artists' stated intent to "*see* the disappeared,"

the "warm data" collected by the questionnaire actually move beyond the visual by "evok[ing] heat, intensity vibration, feeling, tactility, energy and affect." See Kapadia, *Insurgent Aesthetics*.

61. Seremetakis, *The Senses Still*, 3.

62. Seremetakis, *The Senses Still*, 3.

63. Ganesh has long been interested in the form of the graphic novel. In her best-known early work, Ganesh reworks the genre of the Hindu mythological comic book, known as the *Amar Chitra Katha*, by creating a dissonance between text and image and thereby transforming tales of sexual and gender conformity into queer, feminist fables of unruly female bodies and desires. For a more detailed reading of Ganesh's earlier work, see Gopinath, "Chitra Ganesh's Queer Re-Visions."

64. Cvetkovich, *An Archive of Feelings*, 241.

65. This is what Christopher Pinney names "the volatility of the [photographic] image." He notes, "The photographer can never fully control the resulting photograph, and it is that lack of control and the resulting excess that permits recoding, 'resurfacing,' and 'looking past.'" Pinney, "Introduction," 7.

66. Svetlana Boym's insights on the everyday are useful in reading Ganesh and Ghani's use of the detail here. Boym writes, "We only become aware of [the everyday] when we miss it in times of war or disaster, or when it manifests itself in excess during spells of boredom. . . . The everyday is anticatastrophic, an antidote to the historical narrative of death, disaster and apocalypse." Boym, *Common Places*, 7.

67. Halberstam, *The Queer Art of Failure*, 21.

68. Moi Tsien, press release for the exhibit *(i don't care what you say) Those Are Not Tourist Photos*, Talwar Gallery, New York City, January 11–March 29, 2008.

69. Zaatari very consciously grapples with what he terms the "pigeonholing practices of the international art market" as he "migrat[es] between the rigid poles of the art world by blurring production, curating, and education." Feldman and Zaatari, "Mining War," 67.

70. Kaelen Wilson-Goldie notes that many postwar Lebanese artists such as Zaatari "come to be feted by the international art world to the extent that their work is better known abroad than at home. . . . That the work these artists produce has a stronger presence internationally than locally, despite the fact that it is deeply entrenched in issues that are arguably more relevant and specific to Lebanon than anywhere else, is nothing short of paradoxical." See Wilson-Goldie, "Contemporary Art Practices in Post-War Lebanon," 85.

71. Zaatari is included, for instance, in the 2006 exhibition and book *Out of Beirut* (ed. Suzanne Cotter), which groups together a generation of artists who are all engaged in different ways with mapping postwar Beirut and its traumatic history.

72. Demos, *The Migrant Image*, 182.

73. Many of the Lebanese artists who are exhibited and written about internationally as representing "the Middle East" or "the Arab world" reject these terms and

work to disrupt and interrogate their essentialist and Orientalist underpinnings. See, for instance, Wright, "Territories of Difference." Zaatari's video homage to El Madani, and El Madani's images themselves, were most recently exhibited in the group show *Here and Elsewhere*, billed as showcasing "contemporary art from and about the Arab world," at the New Museum, New York City, July 16– September 28, 2014.

74. I find historian Kris Manjapra's notion of "entanglement" useful in theorizing how these disparate diasporic trajectories may be fruitfully viewed in the same frame. He writes, "I refer to 'entanglements' here as the *sites* in which two or more rationalities, two or more voices, agents or worldviews enter a direct, or even indirect interdependence, whereby the actions of one agent have an effect on the other even without either agent's choice. . . . The question . . . is not where to find entanglements . . . but rather, now can we methodologically *see* the entanglements that connect distant societies in the archive?" He continues, "An optic that exposes 'strangeness' and entanglement as it emerges in global history is of great importance, especially as it challenges the dominant historical optic, which envisions the convergence of the whole modern world around North Atlantic and European norms." Manjapra carefully details the evidence in the historical record that richly documents such entanglements—the personal, political, and intellectual affinities—between German and Indian activists and intellectuals from the late 1800s–1945. Manjapra, "Transnational Approaches to Global History."

75. Mark Westmoreland notes that the notion of "postwar" art is "misguided, if not meaningless" in relation to Lebanon, given the ongoing violence in the country and the region: "Instead, these artists working in the era since the official end of the civil war give intimate perspectives on life under conditions of political uncertainty or what artist Tony Chakar refers to as 'catastrophic time and space.'" See Westmoreland, "You Cannot Partition Emotion," 31. Christine Tohme also comments, "There is no 'postwar' in Lebanon, only pauses." Quoted in Demos, *The Migrant Image*, 178.

76. As Suzanne Cotter notes, "The inscription of the personal in relation to 'events,' by way of the photographic document and the archive, is one of the most compelling and consistently interrogated forms used by artists coming out of Beirut." Cotter, "Beirut Unbound," 31.

77. Shama Khanna, "Akram Zaatari's *On Photography, People, and Modern Times*," *art-agenda*, January 17, 2014, http://www.art-agenda.com/reviews/akram -zaatari%E2%80%99s-%E2%80%9Con-photography-people-and-modern -times%E2%80%9D.

78. See, for instance, Chad Elias's interview with Zaatari, where Elias states, "For the most part, Zaatari's research on this topic [of sex and sexuality] has been neatly separated from his work on war. By contrast, this interview serves to suggest that these two strands of his practice might be mutually imbricated." See Elias, "The Libidinal Archive." Similarly, Mark Westmoreland writes: "Rather than splitting

Akram Zaatari's work into two streams that correlate to traumatic traces and erotic exploits, it may be worthwhile to consider the way different facets of his work express the theme of desire." See Westmoreland, "You Cannot Partition Emotion," 37.

79. While *Hashem El Madani: Studio Practices* takes the form of a book, with Madani's photographs captioned by Madani himself and preceded by an interview between Zaatari and Madani, Zaatari has presented his engagement with Madani's oeuvre in different forms over the years, such as through installations and video documentation.

80. Feldman and Zaatari, "Mining War," 62–63.

81. Feldman and Zaatari, "Mining War," 64.

82. Westmoreland, "You Cannot Partition Emotion," 41.

83. As Ann Cvetkovich suggests, "To love the wrong kinds of objects is to be queer (as is perhaps an overattachment to objects in the first place), and the impulse to collect them or turn collections into archives is often motivated by a desire to create the alternative histories and genealogies of queer lives. . . . Queers share with the fetishist a zeal for material objects and for the materiality of the archive." Cvetkovich, "Photographing Objects as Queer Archival Practice," 275.

84. Khanna, "Akram Zaatari's *On Photography, People, and Modern Times*," n.p.

85. My understanding of "queer archives," and of queer archives as affective archives, is indebted to Ann Cvetkovich's influential formulation in *An Archive of Feelings*.

86. Cvetkovich, "Photographing Objects as Queer Archival Practice," 280.

87. Zaatari, "Interview with Hashem El Madani," 15.

88. Elias, "The Libidinal Archive."

89. As Elias astutely notes, "The display of hyperbolic masculinity is here made open to a queer gaze. Indeed, Zaatari makes it difficult to disentangle the desiring eye of the camera from his own scopophilic attachment to these figures of hypermasculinity." Elias, "The Libidinal Archive."

90. Freeman, "Time Binds, or, Erotohistoriography," 55.

91. Freeman, "Time Binds, or, Erotohistoriography," 55.

92. Elias, "The Libidinal Archive," n.p.

93. Elias, "The Libidinal Archive," n.p.

94. Elias, "The Libidinal Archive," n.p.

95. Elias, "The Libidinal Archive," n.p.

96. Feldman and Zaatari, "Mining War," 61.

97. Elias, "The Libidinal Archive," n.p.

98. As such, Zaatari's comments here resonate powerfully with Jack Halberstam's notion of failure as a particularly queer art, in the sense that it charts "a map of political paths not taken" that can nevertheless "offer models of contestation, rupture and discontinuity for the political present." Halberstam, *The Queer Art of Failure*, 19.

99. Elias, "The Libidinal Archive," n.p.

100. Queer Palestinian activists Ghaith Hilal and Haneen Maikey argue that this equation of homosexuality and national betrayal/collaboration in Palestinian civil society has a complicated provenance, and must be seen in the context of Israel's policy of "pinkwashing." The term "pinkwashing" refers to the Israeli state's assertion of its embrace of gay rights as a marker of its respect for human rights and its distance from its apparently illiberal neighbors, while effacing the violence of its settler colonial project. Hilal and Maikey further argue that the roots of the image of "the Palestinian homosexual" as traitor and collaborator in Palestinian society can also be traced to the Israeli policy of blackmailing and coercing gay Palestinians into working with Israeli authorities during the First Intifada. See Hilal and Maikey, "Dismantling the Image of the Palestinian Homosexual," paper presented at Palestine Solidarity Symposium, World Congress for Middle Eastern Studies (WOCMES), Ankara, Turkey, August 18, 2014.

101. As quoted in Le Feuvre and Zaatari, *Hashem El Madani*, 80.

102. Stoler, *Along the Archival Grain*, 108.

103. Brown and Phu, introduction to *Feeling Photography*, 13.

104. Brown and Phu, introduction, 21.

105. Stoler defines "historical negatives" as "reverse-images" that "trace disturbances in the colonial order of things, whose shadows trace the lineaments of potential dissent and current distress." Stoler, *Along the Archival Grain*, 108.

106. Salti, "The Unbearable Weightlessness of Indifference," 15.

107. Le Feuvre and Zaatari, *Hashem El Madani*, 96. In his 2015 film *Twenty Eight Nights and a Poem*, an offscreen voice (presumably Zaatari's) asks El Madani why he photographed "Ahmad el Abed, a Tailor" in poses usually reserved for women. El Madani replies, "That's because he himself was between a man and a woman. Before that I had shot his sisters. He came in and asked to be photographed like them. He considered himself in the same category as women. Psychologically." El Madani's response indicates his absolute commitment to creating portraits that spoke to his subjects' own desires for self-representation. This same lack of judgment and his fidelity to his subjects' self-making desires is apparent later in the film, when El Madani recalls photographing a young, recently divorced woman who wanted to be photographed nude, an anomaly at the time.

108. In a subsequent, 2007 iteration of the project, Zaatari identifies the first man as Abed's brother, and the second as "his friend Rajab Arna'out." See David Hodge, "Akram Zaatari: Ahmad el Abed, and His Friend Rajab Arna'out. Madani's Parents' Home, The Studio, Saida, Lebanon, 1948–53. Hasham el Madani 2007," Tate Modern, London, November 2014, http://www.tate.org.uk/art/artworks/zaatari-ahmad-el-abed-and-his-friend-rajab-arnaout-madanis-parents-home-the-studio-saida-p79487.

109. Akram Zaatari, "Interview with Hashem El Madani," *Hashem El Madani*, 14.

110. For an extended discussion of this slippage between homoeroticism and homosociality, see Gopinath, *Impossible Desires*.

111. Such a move is similar to that which Demos identifies in the work of the U.K.-based arts duo the Otolith Group, which seeks to mobilize what the group terms "past potential futures"; as Demos writes, the group "coaxes the sleeping vitality of former political engagements into present realization, refusing to let them simply fade away, insisting that they not *not* be." The Otolith Group's investment in "past potential futures" is an insistence, Demos argues, that "progressive history is far from dead but rather remains unfulfilled, awaiting to be reanimated at some future time." Demos, *The Migrant Image*, 60.

112. Elias, "The Libidinal Archive," n.p.

113. Jabbur, *The Bedouins and the Desert*.

114. See Westmoreland, "Making Sense," for a cogent analysis of Akram Zaatari's *This Day* in the context of the experimental visual practices of post-war Lebanese artists.

115. Elias, "The Libidinal Archive."

116. Elias, "The Libidinal Archive."

117. Elias, "The Libidinal Archive."

118. Elias, "The Libidinal Archive."

119. Flatley, *Affective Mapping*, 2.

120. Hartman, *Lose Your Mother*, 233.

121. Hartman, *Lose Your Mother*, 233.

122. Hartman, *Lose Your Mother*, 234.

123. Hartman, *Lose Your Mother*, 232.

124. Hartman, *Lose Your Mother*, 235.

EPILOGUE

1. "Sidi Mubarak Bombay," Royal Geographic Society, http://www.unlockingthe archives.rgs.org/resources/documents/Sidi%20Mubarak%20Bombay%204.pdf. Bombay is also the subject of deSouza's earlier, 2009 text work, *Lies of the Land*, in which he explores in detail Bombay's peregrinations as the guide for a number of European expeditions in Africa in the late nineteenth century.

2. Aruna d'Souza, "Allan deSouza and Alia Syed," *4 Columns*, March 17, 2017, http://4columns.org/d-souza-aruna/allan-desouza-and-alia-syed.

3. Press release for Allan deSouza's *Through the Black Country* exhibit and Alia Syed's *On a Wing on a Prayer* exhibit, Talwar Gallery, New York City, January 13–April 8, 2017, http://talwargallery.com/allanalia-pr.

4. The fictional journal that makes up the wall text of the exhibit specifically mimics Henry Stanley's expedition journals, published in 1878 as *Through the Dark Continent, or, The Sources of the Nile around the Great Lakes of Equatorial Africa and Down the Livingstone River to the Atlantic Ocean*. Bombay was one of Stanley's guides. Personal email correspondence with Allan deSouza, May 6, 2017.

5. Press release for Allan deSouza's *Through the Black Country* exhibit and Alia Syed's *On a Wing on a Prayer* exhibit.

6. Personal email correspondence with Allan deSouza, March 23, 2017.
7. Personal email correspondence with Allan deSouza, May 6, 2017.
8. Flatley, *Affective Mapping*, 7.
9. Zaatari, *Hashem El Madani*, 58.
10. Zaatari, *Hashem El Madani*, 16
11. Zaatari, *Hashem El Madani*, 16.
12. Zaatari, *Hashem El Madani*, 16.
13. I am indebted to the rich body of work at the intersection of queer and disability studies. Key texts include McRuer, *Crip Theory*; Clare, *Exile and Pride*; Chen, *Animacies*; Puar, *The Right to Maim*.
14. S.v. "strabismus," *Random House Dictionary of the English Language*, 2nd ed.
15. Personal email correspondence with Allan deSouza, May 6, 2017. For an examination of the ethics of staring and staring back, looking and looking away, see Garland-Thomson, *Staring*.
16. S.v. "curation," *Merriam-Webster Dictionary*, https://www.merriam-webster.com/dictionary/curation, accessed December 21, 2017.
17. DeSouza, "My Mother, My Sight," n.p.
18. My thanks to Paul Amar for urging me to make this connection.
19. My thanks to Kandice Chuh for this phrasing.

Bibliography

Adams, Rachel. "Seher Shah's Constructed Landscapes." *Texas Architect* 7/8 (2013): 10.

Agrawal, Arun, and K. Sivaramakrishnan, eds. *Regional Modernities: The Cultural Politics of Development in India*. Oxford: Oxford University Press, 2003.

Ahmed, Sara. *Queer Phenomenology: Orientations, Objects, Others*. Durham, NC: Duke University Press, 2006.

Alexander, M. Jacqui. "Not Just (Any) Body Can Be a Citizen: The Politics of Law, Sexuality and Postcoloniality in Trinidad and Tobago and the Bahamas." *Feminist Review* 48 (1994): 5–23.

Alexander, M. Jacqui. *Pedagogies of Crossing: Meditations on Feminism, Sexual Politics, Memory, and the Sacred*. Durham, NC: Duke University Press, 2005.

Ali, Saiyed Faieem, and Umesh Kumar Agarwal. "A Standard Program to Classify Books/Documents according to Colon Scheme of Classification Ed. 6 Using Php Environment." *Indian Journal of Applied Research* 6, no. 4 (April 2016): 592–593.

Ansari, Rehan, and Rajinderpal S. Pal. "Agha Shahid Ali: Calligraphy of Coils." *Himal Southasian: A Review Magazine of Politics and Culture* (1988): n.p. http://old.himalmag.com/component/content/article/2385—agha-shahid-ali-calligraphy-of-coils.html.

Anurima, G. "Face Value: Ravi Varma's Portraiture and the Project of Colonial Modernity." *Indian Economic Social History Review* 40, no. 57 (2003): 57–79.

Anurima, G. *There Comes Papa: Colonialism and the Transformation of Matriliny in Kerala, Malabar c. 1850–1940*. New Delhi: Orient Longman, 2003.

Arondekar, Anjali, and Geeta Patel, eds. "Area Impossible: The Geopolitics of Queer Studies." Special issue, *GLQ: A Journal of Lesbian and Gay Studies* 22, no. 2 (2016).

Ballakrishnen, Swethaa. "Migration and Kerala's Gender Paradox." Paper presented at Gender Studies Brown Bag, New York University, Abu Dhabi, April 16, 2017.

Barthes, Roland. *Camera Lucida: Reflections on Photography*. Translated by Richard Howard. New York: Hill and Wang, 1980.

Beltrán, Cristina. "Undocumented, Unafraid, and Unapologetic: DREAM Activists, Immigrant Politics, and the Queering of Democracy." In *From Voice to Influence: Youth, New Media, and Political Participation*, edited by Danielle Allen and Jennifer Light, 80–104. Chicago: University of Chicago Press, 2015.

Berlant, Lauren. *Cruel Optimism*. Durham, NC: Duke University Press, 2011.

Bissonauth, Natasha. "Play in the Turn of the Millennium: Reframing South Asian Diasporic Art (1980–Present)." PhD diss., Cornell University, 2017.

Blake, Thom. *A Dumping Ground: A History of the Cherbourg Settlement*. St. Lucia: University of Queensland Press, 2001.

Boellstorff, Thom. *A Coincidence of Desires: Anthropology, Queer Studies, Indonesia*. Durham, NC: Duke University Press, 2007.

Bose, Sugata. *A Hundred Horizons: The Indian Ocean in the Age of Global Empire*. Cambridge, MA: Harvard University Press, 2006.

Boym, Svetlana. *Common Places: Mythologies and Everyday Life in Russia*. Cambridge, MA: Harvard University Press, 1994.

Boym, Svetlana. "On Diasporic Intimacy: Ilya Kabakov's Installations and Immigrant Homes." *Critical Inquiry* 24, no. 2 (1998): 498–524.

Brah, Avtar. *Cartographies of Diaspora: Contesting Identities*. New York: Routledge, 1996.

Brown, Elspeth H., and Thy Phu. Introduction to *Feeling Photography*, edited by Elspeth H. Brown and Thy Phu, 1–25. Durham, NC: Duke University Press, 2014.

Bryan-Wilson, Julia. "Against the Body: Interpreting Ana Mendieta." In *Ana Mendieta: Traces*, edited by Stephanie Rosenthal, 26–38. London: Hayward, 2013.

Byrd, Jodi. *The Transit of Empire: Indigenous Critiques of Colonialism*. Minneapolis: University of Minnesota Press, 2011.

Cacho, Lisa Marie. *Social Death: Racialized Rightlessness and the Criminalization of the Unprotected*. New York: New York University Press, 2012.

Cakirlar, Cuneyt, ed. "Queer/ing Regions." Special issue of *Gender, Place, and Culture: A Journal of Feminist Geography* 23, no. 11 (February 2016).

Campt, Tina M. *Image Matters: Archive, Photography, and the African Diaspora in Europe*. Durham, NC: Duke University Press, 2012.

Casemore, Brian. *The Autobiographical Demand of Place: Curriculum Inquiry in the American South*. New York: Peter Lang, 2008.

Cerwonka, Allaine. *Native to the Nation: Disciplining Landscapes and Bodies in Australia*. Minneapolis: University of Minnesota Press, 2004.

Chakravarty, Dipesh. *Provincializing Europe: Postcolonial Thought and Historical Difference*. Princeton, NJ: Princeton University Press, 2000.

Chavez, Karma. "Coming Out as Coalitional Gesture?" In *Queer Migration Politics: Activist Rhetoric and Coalitional Possibilities*, 79–112. Urbana: University of Illinois Press, 2013.

Chen, Mel Y. *Animacies: Biopolitics, Racial Mattering, and Queer Affect*. Durham, NC: Duke University Press, 2012.

Cho, Grace M. *Haunting the Korean Diaspora: Shame, Secrecy, and the Forgotten War*. Minneapolis: University of Minnesota Press, 2008.

Cho, Lily. "Diaspora and Indigeneity." Paper presented at the Association for Commonwealth Literature and Language Studies, Visva-Bharati, Santiniketan. February 3–5, 2006.

Clare, Eli. *Exile and Pride: Disability, Queerness, and Liberation*. Durham, NC: Duke University Press, 1999.

Clifford, James. *Returns: Becoming Indigenous in the Twenty-First Century*. Cambridge, MA: Harvard University Press, 2013.

Clifford, James. "Varieties of Indigenous Experience: Diasporas, Homelands, Sovereignties." In *Indigenous Experience Today*, edited by Marisol de la Cadena and Orin Starn, 197–224. Oxford: Berg, 2007.

Cohen, William. "Introduction: Locating Filth." In *Filth: Disgust, Dirt and Modern Life*, edited by William Cohen and Ryan Johnson, vii–xxxvii. Minneapolis: University of Minnesota Press, 2005.

Cohn, Bernard S. "Regions, Subjective and Objective." In *An Anthropologist among the Historians and Other Essays*, 100–135. New York: Oxford University Press, 1987.

Cotter, Suzanne. "Beirut Unbound." In *Out of Beirut*, edited by Suzanne Cotter, 25–34. Oxford: Modern Oxford Art, 2006.

Cvetkovich, Ann. *An Archive of Feelings: Trauma, Sexuality, and Lesbian Public Cultures*. Durham, NC: Duke University Press, 2003.

Cvetkovich, Ann. "Photographing Objects as Queer Archival Practice." In *Feeling Photography*, edited by Elspeth H. Brown and Thy Phu, 273–296. Durham, NC: Duke University Press, 2014.

Das Gupta, Monisha. *Unruly Immigrants: Rights, Activism, and Transnational South Asian Politics in the United States*. Durham, NC: Duke University Press, 2006.

Deepa V. N. "Queering Kerala: Reflections on Sahayatrika." In *Because I Have a Voice: The Politics of Alternative Sexualities in India*, edited by Arvind Narrain and Gautam Bhan, 175–196. New Delhi: Yoda Press, 2005.

DeFilippis, Joseph N., Lisa Duggan, Kenyon Farrow, and Richard Kim, eds. "A New Queer Agenda." Special issue of *The Scholar and Feminist Online* 10, nos. 1–2 (2011–2012), sfonline.barnard.edu/a-new-queer-agenda.

Deloria, Philip Joseph. "American Indians, American Studies, and the ASA." *American Quarterly* 55, no. 4 (December 2003): 669–680.

Dēmētrakakē, Angela, and Lara Perry, eds. *Politics in a Glass Case: Feminism, Exhibition Cultures and Curatorial Transgressions*. Liverpool: Liverpool University Press, 2013.

Demos, T. J. *The Migrant Image: The Art and Politics of Documentary during Global Crisis.* Durham, NC: Duke University Press, 2013.

DeSouza, Allan. "My Mother, My Sight." In *Allan deSouza: A Decade of Photoworks, 1998–2008,* n.p. New York: Talwar Gallery, 2008.

Devika, J. "The Aesthetic Woman: Re-forming Female Bodies and Minds in Early Twentieth Century Keralam." *Modern Asian Studies* 39, no. 2 (2005): 461–487.

Dinshaw, Carolyn. *How Soon Is Now? Medieval Texts, Amateur Readers, and the Queerness of Time.* Durham, NC: Duke University Press, 2012.

Dinshaw, Carolyn, Lee Edelman, Roderick A. Ferguson, and Carla Freccero. "Theorizing Queer Temporalities: A Roundtable Discussion." *GLQ: A Journal of Gay and Lesbian Studies* 13, nos. 2–3 (2007): 177–195.

Edwards, Brent. *The Practice of Diaspora: Literature, Translation, and the Rise of Black Internationalism.* Cambridge, MA: Harvard University Press, 2003.

Elias, Chad. "The Libidinal Archive: A Conversation with Akram Zaatari." *The Tate Papers* 19 (March 12, 2013), http://www.tate.org.uk/research/publications/tate-papers/libidinal-archive-conversation-akram-zaatari.

Eng, David L. *The Feeling of Kinship: Queer Liberalism and the Racialization of Intimacy.* Durham, NC: Duke University Press, 2010.

Feldman, Hannah, and Akram Zaatari. "Mining War: Fragments from a Conversation Already Passed." *Art Journal* 66, no. 2 (2014): 48–67.

Ferguson, Roderick A. *Aberrations in Black: Towards a Queer of Color Critique.* Minneapolis: University of Minnesota Press, 2003.

Ferguson, Roderick A. "Sissies at the Picnic: The Subjugated History of Black Rural Queer." In *Feminist Waves, Feminist Generations: Life Stories from the Academy,* edited by Hokulani Aikau, Karla Erickson, and Jennifer Pierce, 188–196. Minneapolis: University of Minnesota Press, 2007.

Ferguson, Roderick A., and Grace Kyungwon Hong. Introduction to *Strange Affinities: The Gender and Sexual Politics of Comparative Racialization,* edited by Roderick A. Ferguson and Grace Kyungwon Hong, 1–23. Minneapolis: University of Minnesota Press, 2011.

Fiol-Matta, Licia. *The Great Woman Singer: Gender and Voice in Puerto Rican Music.* Durham, NC: Duke University Press, 2017.

Flatley, Jonathan. *Affective Mapping: Melancholia and the Politics of Modernism.* Cambridge, MA: Harvard University Press, 2008.

Freeman, Elizabeth. "Time Binds, or, Erotohistoriography." *Social Text* 84–85, nos. 3–4 (2005): 57–68.

Freeman, Elizabeth. *Time Binds: Queer Temporalities, Queer Histories.* New York: New York University Press, 2010.

Fuchs, Ellise. "Most of Us Don't Have to Put Labels on It: An Interview with Aurora Guerrero." *Popmatters,* December 5, 2012. http://www.popmatters.com/feature/164954-interview-with-aurora-guerrero.

Fugikawa, Laura. "Domestic Containment: Japanese Americans, Native Americans and the Cultural Politics of Relocation." PhD diss., University of Southern California, 2011.

Garland-Thomson, Rosemarie. *Staring: How We Look*. Oxford: Oxford University Press, 2009.

Ghani, Mariam, and Ashraf Ghani. *Afghanistan: A Lexicon*. Ostfildern: Hatje Cantz Verlag, 2011.

Goeman, Mishuana. *Mark My Words: Native Women Mapping Our Nations*. Minneapolis: University of Minnesota Press, 2013.

Gomez-Barris, Macarena, and Herman Gray. "Toward a Sociology of the Trace." In *Toward a Sociology of the Trace*, edited by Macarena Gomez-Barris and Herman Gray, 1–14. Minneapolis: University of Minnesota Press, 2010.

Gopinath, Gayatri. "Archive, Affect, and the Everyday: Queer Diasporic Re-Visions." In *Political Emotions: New Agendas in Communications*, edited by Janet Steiger, Ann Cvetkovich, and Ann Reynolds, 165–192. New York: Taylor and Francis, 2010.

Gopinath, Gayatri. "Chitra Ganesh's Queer Re-Visions." *GLQ* 15, no. 13 (2009): 469–480.

Gopinath, Gayatri. *Impossible Desires: Queer Diasporas and South Asian Public Cultures*. Durham, NC: Duke University Press, 2005.

Gopinath, Gayatri. "Queer Regions: Locating Lesbians in *Sancharram*." In *A Companion to Lesbian, Gay, Bisexual, Transgender, and Queer Studies*, edited by George E. Haggerty and Molly McGarry, 341–354. Oxford: Blackwell, 2008.

Gopinath, Gayatri. "Who's Your Daddy? Queer Diasporic Reframings of the Region." In *The Sun Never Sets: South Asian Migrants in an Age of U.S. Power*, edited by Vivek Bald, Miabi Chatterji, Sujani Reddy, and Manu Vimalassery, 274–300. New York: New York University Press, 2013.

Guerrero, Aurora. "Aurora Guerrero on the Making of *Mosquita y Mari* and Scouring Remezcla for Music." By Vanessa Erazo. *Remezcla*, August 1, 2012. http://remezcla .com/film/aurora-guerrero-mosquita-y-mari-interview.

Hajratwala, Minal. "Intimate History: Reweaving Diasporic Narratives." *Cultural Dynamics* 19, nos. 2–3 (2007): 301–307.

Halberstam, Judith. *In a Queer Time and Place: Transgender Bodies, Subcultural Lives*. New York: New York University Press, 2005.

Halberstam, Judith. *The Queer Art of Failure*. Durham, NC: Duke University Press, 2011.

Hall, Stuart. "Cultural Identity and Diaspora." In *Identity: Community, Culture, Difference*, edited by Jonathan Rutherford, 222–237. London: Lawrence and Wishart, 1990.

Hartman, Saidiya. *Lose Your Mother: A Journey along the Atlantic Slave Route*. New York: Farrar, Straus and Giroux, 2007.

Harvey, Graham, and Charles D. Thompson Jr. Introduction to *Indigenous Diasporas and Dislocation*, edited by Graham Harvey and Charles D. Thompson Jr., 1–12. London: Routledge, 2016.

Herring, Scott. *Another Country: Queer Anti-Urbanism*. New York: New York University Press, 2010.

Hirsch, Marianne. *Family Frames: Photography, Narrative, and Postmemory*. Cambridge, MA: Harvard University Press, 1997.

Ho, Enseng. *The Graves of Tarim: Genealogy and Mobility across the Indian Ocean*. Berkeley: University of California Press, 2006.

Hochberg, Gil Z. *Visual Occupations: Violence and Visibility in a Conflict Zone*. Durham, NC: Duke University Press, 2015.

Holland, Sharon. *Raising the Dead: Readings of Death and (Black) Subjectivity*. Durham, NC: Duke University Press, 2002.

Howard, John. *Men Like That: A Southern Queer History*. Chicago: University of Chicago Press, 1999.

Hutchinson, Sydney. *From Quebradita to Duranguense: Dance in Mexican American Youth Culture*. Tucson: University of Arizona Press, 2007.

Jabbur, Jibrail S. *The Bedouins and the Desert: Aspects of Nomadic Life in the Arab East*. Edited by Suhayl J. Jabbur and Lawrence I. Conrad. Translated by Lawrence I. Conrad. Albany: SUNY Press, 1995.

Jacobs, Margaret D. *White Mother to a Dark Nation: Settler Colonialism, Maternalism, and the Removal of Indigenous Children in the American West and Australia, 1880–1940*. Lincoln: University of Nebraska Press, 2009.

Jay, Martin, and Sumathi Ramaswamy, eds. *Empires of Vision: A Reader*. Durham, NC: Duke University Press, 2012.

Johnson, E. Patrick. *Sweet Tea: Black Gay Men of the South*. Chapel Hill: University of North Carolina Press, 2008.

Johnson, Mark, Peter Jackson, and Gilbert Herdt. "Critical Regionalities and the Study of Gender and Sexual Diversity in South East and East Asia." *Culture, Health, and Sexuality* 2, no. 4 (2000): 361–375.

Jolly, Margaret. "Our Part of the World: Indigenous and Diasporic Differences and Feminist Anthropology in America and the Antipodes." *Communal/Plural* 7, no. 2 (1999): 195–212.

Kabir, Ananya Jahanara. *Territory of Desire: Representing the Valley of Kashmir*. Minneapolis: University of Minnesota Press, 2009.

Kallat, Jitish, Robert E. D'Souza, and Sunil Manghani. "Curation as Dialogue: Jitish Kallat in Conversation." In *India's Biennale Effect: A Politics of Contemporary Art*, edited by Robert E. D'Souza and Sunil Manghani, 132–159. New York: Routledge, 2017.

Kapadia, Ronak. *Insurgent Aesthetics: Race, Security, and the Sensorial Life of Empire*. Durham, NC: Duke University Press, forthcoming.

Kauanui, J. Kēhaulani. "Diasporic Deracination and 'Off-Island Hawaiians.'" *Contemporary Pacific* 19, no. 1 (2007): 137–160.

Kuhn, Annette. *Family Secrets: Acts of Memory and Imagination*. London: Verso Books, 2002.

La Fontain-Stokes, Lawrence M. *Queer Ricans: Cultures and Sexualities in the Diaspora*. Minneapolis: University of Minnesota Press, 2009.

Laidi-Hanieh, Adila. "Palestinian Landscape Photography: Dissonant Paradigm and Challenge to Visual Control." *Contemporary Practices* 5 (2009): 118–123.

Le Feuvre, Lisa, and Akram Zaatari, eds. *Hashem El Madani: Studio Practices*. Beirut: Arab Image Foundation, 2004.

Lemke, Sieglinde. "Diaspora Aesthetics: Exploring the African Diaspora in the Works of Aaron Douglas, Jacob Lawrence, and Jean-Michel Basquiat." In *Exiles, Diasporas, and Strangers*, edited by Kobena Mercer, 122–145. Cambridge, MA: MIT Press, 2008.

Leong, Karen J. and Myla Vicenti Carpio. "Carceral Subjugations: Gila River Indian Community and Incarceration of Japanese Americans on Its Lands." *Amerasia Journal* 42, no. 1 (2016): 103–120.

Lerner, Erica, and Cynthia E. Milton. "Introduction: Witnesses to Witnessing." In *Curating Difficult Knowledge: Violent Pasts in Public Places*, edited by Erica Lerner, Cynthia E. Milton, and Monica Eileen Patterson, 1–19. New York: Palgrave Macmillan, 2011.

Lewis, Rachel, and Nancy A. Naples, eds. "Queer Migration, Asylum, and Displacement." Special issue of *Sexualities* 18, no. 7 (2014).

Lionnet, Francoise, and Shu-mei Shih, eds. *Minor Transnationalism*. Durham, NC: Duke University Press, 2005.

Love, Heather. *Feeling Backward: Loss and the Politics of Queer History*. Cambridge, MA: Harvard University Press, 2009.

Lowe, Lisa. "The Intimacies of Four Continents." In *Haunted by Empire: Geographies of Intimacy in North American History*, edited by Ann Laura Stoler, 191–212. Durham, NC: Duke University Press, 2006.

Lowe, Lisa. *The Intimacies of Four Continents*. Durham, NC: Duke University Press, 2015.

Lubhéid, Eithne, and Lionel Cantú Jr., eds. *Queer Migrations: Sexuality, U.S. Citizenship, and Border Crossings*. Minneapolis: University of Minnesota Press, 2005.

Lukose, Ritty. *Liberalization's Children: Gender, Youth, and Consumer Citizenship in India*. Durham, NC: Duke University Press, 2010.

Lyons, Paul. "Larry Brown's *Joe* and the Uses and Abuses of the 'Region' Concept." In *South to a New Place*, edited by Sharon Monteith and Suzanne Jones, 96–118. Baton Rouge: Louisiana State University Press, 2002.

Manalansan, Martin F., IV. *Global Divas: Filipino Gay Men in New York City*. Durham, NC: Duke University Press, 2003.

Manalansan, Martin F., IV. "The Messy Itineraries of Queerness." Theorizing the Contemporary, *Cultural Anthropology* website, July 21, 2015. https://culanth.org/fieldsights/705-the-messy-itineraries-of-queerness.

Manalansan, Martin F., IV. "Queer Intersections: Sexuality and Gender in Migration Studies." *International Migration Review* 40, no. 1 (February 2006): 224–249.

Manalansan, Martin F., IV. "Servicing the World: Flexible Filipinos and the Unsecured Life." In *Political Emotions: New Agendas in Communications*, edited by Janet Steiger, Ann Cvetkovich, and Ann Reynolds, 215–228. New York: Taylor and Francis, 2011.

Manalansan, Martin F., IV, Chantal Nadeau, Richard T. Rodriguez, and Siobhan B. Somerville, eds. "Queering the Middle: Race, Region, and a Queer Midwest." Special issue, *GLQ: A Journal of Lesbian and Gay Studies* 20, nos. 1–2 (2014).

Mani, Bakirathi. "Archives of Empire: Seher Shah's *Geometric Landscapes and the Spectacle of Force*." *Social Text* 29, no. 3 (Fall 2011): 127–138.

Manjapra, Kris. "The Impossible Intimacies of M. N. Roy." *Postcolonial Studies* 16, no. 2 (2013): 170–171.

Manjapra, Kris. Introduction to *Cosmopolitan Thought Zones: South Asia and the Global Circulation of Ideas*, edited by Sujata Bose and Kris Manjapra, 1–19. New York: Palgrave Macmillan, 2010.

Manjapra, Kris. "Transnational Approaches to Global History: A View from the Study of German-Indian Entanglement." *German History* 32, no. 2 (2014): 288–289.

Massad, Joseph. *Desiring Arabs*. Chicago: University of Chicago Press, 2007.

Mathur, Saloni. *India by Design: Colonial History and Cultural Display*. Berkeley: University of California Press, 2007.

McClintock, Anne. *Imperial Leather: Race, Gender, and Sexuality in the Colonial Contest*. New York: Routledge, 1995.

McLean, Ian. "Aboriginal Modernism in Central Australia." In *Exiles, Diasporas, and Strangers*, edited by Kobena Mercer, 72–95. Cambridge, MA: MIT Press, 2008.

McRuer, Robert. *Crip Theory: Cultural Signs of Queerness and Disability*. New York: New York University Press, 2006.

Metcalf, Thomas. *Imperial Connections: India in the Indian Ocean Arena*. Berkeley: University of California Press, 2007.

Mirzoeff, Nicholas. *The Right to Look: A Counterhistory of Visuality*. Durham, NC: Duke University Press, 2011.

Morgensen, Scott Lauria. *Spaces between Us: Queer Settler Colonialism and Indigenous Decolonization*. Minneapolis: University of Minnesota Press, 2011.

Mosquita y Mari. Directed by Aurora Guerrero. New Almaden, CA: Wolfe Video. DVD. 2013.

Muñoz, José Esteban. *Cruising Utopia: The There and Then of Queer Futurity*. New York: New York University Press, 2009.

Muñoz, José Esteban. *Disidentifications: Queers of Color and the Performance of Politics*. Minneapolis: University of Press, 1999.

Muñoz, José Esteban. "Gesture, Ephemera, and Queer Feeling: Approaching Kevin Aviance." In *Dancing Desires: Choreographing Sexualities On and Off Stage*, edited by Jane Desmond. Madison: University of Wisconsin Press, 2001.

Muñoz, José Esteban. "Vitalism's After-Burn: The Sense of Ana Mendieta." *Women and Performance: A Journal of Feminist Theory* 21, no. 2 (2011): 191–198.

Muraleedharan, T. "Crisis in Desire: A Queer Reading of Cinema and Desire in Kerala." In *Because I Have a Voice: Queer Politics in India*, edited by Arvind Narrain and Gautam Bhan, 70–87. New Delhi: Yoda Press, 2005.

Muraleedharan, T. "National Interests, Regional Concerns: Historicising Malayalam Cinema." *Deep Focus: A Film Quarterly* (January–May 2005): 85–93.

Muraleedharan, T. "The Writing on Absent (Stone) Walls: Pleasurable Intimacies in Southern India." *Thamyris* 5, no. 1 (Spring 1998): 41–57.

Nair, Savita. "Shops and Stations: Rethinking Power and Privilege in British/Indian East Africa." In *India in Africa, Africa in India: Indian Ocean Cosmopolitanisms*, edited by John Hawley, 77–94. Bloomington: Indiana University Press, 2008.

Nautiyal, Kanak. "A High That's Going to Last for Months." *Times of India*, March 10, 2005.

Niranjana, Tejaswini. *Mobilizing India: Women, Music and Migration between India and Trinidad*. Durham, NC: Duke University Press, 2009.

Nixon, Rob. *Slow Violence and the Environmentalism of the Poor*. Cambridge, MA: Harvard University Press, 2011.

Oishi, Eve. "Painting with an Eraser." In *Allan deSouza: A Decade of Photoworks, 1998–2008*, n.p. New York: Talwar Gallery, 2008.

O'Neill, Paul. *The Culture of Curating and the Curating of Culture(s)*. Cambridge, MA: MIT Press, 2012.

Parayil, Govindan, ed. *Kerala: The Development Experience: Reflections on Sustainability and Replication*. London: Zed Books, 2000.

Parikh, Crystal. *An Ethics of Betrayal: The Politics of Otherness in Emergent U.S. Literatures and Cultures*. New York: Fordham University Press, 2009.

Pinney, Christopher. *Camera Indica: The Social Life of Indian Photographs*. Chicago: University of Chicago Press, 1998.

Pinney, Christopher. "Introduction: 'How the Other Half . . .'" In *Photography's Other History*, edited by Christopher Pinney and Nicolas Peterson, 1–15. Durham, NC: Duke University Press, 2003.

Prashad, Vijay. "Bandung Is Done: Passages in AfroAsian Epistemology." Foreword to *AfroAsian Encounters: Culture, History, Politics*, edited by Heike Rafael Hernandez and Shannon Steen, xi–xxxiii. New York: New York University Press, 2006.

Puar, Jasbir K. *The Right to Maim: Debility, Capacity, Disability*. Durham, NC: Duke University Press, 2017.

Quiroga, José A. *Tropics of Desire: Interventions from Queer Latino America*. New York: New York University Press, 2000.

Ralph, Michael. "'Crimes of History': Senegalese Soccer and the Forensics of Slavery." *Souls* 9, no. 3 (2007): 193–222.

Ramanathaiyer, Sundara, and Stewart Macpherson, eds. *Social Development in Kerala: Illusion or Reality?* Aldershot, UK: Ashgate, 2000.

Ramirez, Reyna. *Native Hubs: Culture, Community, and Belonging in Silicon Valley and Beyond*. Durham, NC: Duke University Press, 2007.

Reddy, Chandan. "Asian Diasporas, Neoliberalism, and Family: Reviewing the Case for Homosexual Asylum in the Context of Family Rights." *Social Text* 84–85, vol. 23, no. 3–4 (Fall–Winter 2005): 101–119.

Reddy, Chandan. *Freedom with Violence: Race, Sexuality, and the U.S. State*. Durham, NC: Duke University Press, 2013.

Reddy, Vanita. "Que(e)rying Alliances: Sovereignty, 'Nation,' and South Asian American Diasporic Critique." Paper presented at the Critical Ethnic Studies Conference, University of California, Riverside, March 10, 2011.

"Regionalism, Sexuality, Area Studies" Symposium. Convened by Amanda Lock Swarr and Chandan Reddy, University of Washington, Seattle, May 26–28, 2016.

Richardson, Riché. *Black Masculinity and the U.S. South: From Uncle Tom to Gangsta*. Athens: University of Georgia Press, 2007.

Robertson, Kate. "The Spectre at the Window: Tracey Moffatt's *beDevil* (1993)." *Senses of Cinema* 83 (July 2017), http://sensesofcinema.com/2017/pioneering-australian-women/spectre-window-tracey-moffatts-bedevil-1993.

Rockhill, Gabriel. "Editor's Introduction: Jacques Rancière's Politics of Perception." In Jacques Rancière, *The Politics of Aesthetics*. London: Bloomsbury, 2004.

Rodríguez, Juana María. *Queer Latinidad: Identity Practices, Discursive Spaces*. New York: New York University Press, 2003.

Rodríguez, Juana María. *Sexual Futures, Queer Gestures, and Other Latina Longings*. New York: New York University Press, 2014.

Rofel, Lisa. *Desiring China: Experiments in Neoliberalism, Sexuality, and Public Culture*. Durham, NC: Duke University Press, 2007.

Rohy, Valerie. *Anachronism and Its Others: Sexuality, Race, Temporality*. Albany: SUNY Press, 2009.

Ross, Andrew, ed. *The Gulf: High Culture/Hard Labor*. New York: OR Books, 2015.

Rubin, Gayle. "Thinking Sex: Notes towards a Radical Theory of Sexuality." In *Culture, Society, and Sexuality: A Reader*, edited by Richard Parker and Peter Aggleton, 143–178. London: UCL Press, 1999.

Saldaña Portillo, María Josefina. *Indian Given: Racial Geographies across Mexico and the United States*. Durham, NC: Duke University Press, 2016.

Saldaña Portillo, María Josefina. "'No Country for Old Mexicans': The Collisions of Empires on the Texas Frontier." *Interventions: International Journal of Postcolonial Studies* 13, no. 1 (2011): 67–84.

Saldaña Portillo, María Josefina. *The Revolutionary Imagination in the Americas and the Age of Development*. Durham, NC: Duke University Press, 2003.

Salti, Rasha. "The Unbearable Weightlessness of Indifference." In *The Earth of Endless Secrets*, edited by Akram Zaatari and Karl Bassil, 12–31. Frankfurt: Portikus, 2009.

Sambrani, Chaitanya. "Apocalypse Recalled: The Historical Discourse of Nalini Malani." In *Nalini Malani: Stories Retold*, n.p. New York: Bose Pacia Gallery, 2004.

Sancharram. Directed by Ligy J. Pullappally. 2004. New Almaden, CA: Wolfe Video, 2006. DVD.

Saranillio, Dean Itsuji. "Why Asian Settler Colonialism Matters: A Thought Piece on Critiques, Debates, and Indigenous Difference." *Settler Colonial Studies* 3, nos. 3–4 (2013): 286.

See, Sarita Echavez. *The Decolonized Eye: Filipino American Art and Performance.* Minneapolis: University of Minnesota Press, 2009.

Seigel, Micol. "Saidiya Hartman's *Lose Your Mother* and Marcus Rediker's *The Slave Ship.*" *e-misferica* 5, no. 2 (2008), http://hemisphericinstitute.org/hemi/en/e-misferica-52/seigel.

Seitler, Dana. "Making Sexuality Sensible: Tammy Rae Carland's and Catherine Opie's Queer Aesthetic Forms." In *Feeling Photography*, edited by Elspeth H. Brown and Thy Phu, 47–70. Durham, NC: Duke University Press, 2014.

Seremetakis, C. Nadia. *The Senses Still: Perception and Memory as Material Culture in Modernity.* Chicago: University of Chicago Press, 1996.

Shah, Nayan. *Stranger Intimacy: Contesting Race, Sexuality and the Law in the American West.* Berkeley: University of California Press, 2012.

Shah, Seher. Artist presentation. Symposium, "Lines of Control," Cornell University, Ithaca, NY, March 4, 2012.

Shah, Tejal. Artist statement. Elizabeth A. Sackler Center for Feminist Art. Brooklyn Museum. https://www.brooklynmuseum.org/eascfa/feminist_art_base/tejal-shah.

Shahan, Susan Scafati. "Seher Shah: Constructed Landscapes at AMOA/Arthouse." *Glasstire: Texas Visual Art.* June 19, 2013. http://glasstire.com/2013/06/19/seher-shah-constructed-landscapes-at-amoaarthouse.

Shankar, Lavina Dhingra, and Rajini Srikanth. "South Asian American Literature: 'Off the Turnpike' of Asian America." In *Postcolonial Theory and the United States: Race, Ethnicty, and Literature*, edited by Amritjit Singh and Peter Schmidt, 370–387. Jackson: University Press of Mississippi, 2000.

Skrubbe, Jessica Sjöholm. "Preface: Feminisms, Exhibitions, and Curatorial Spaces." In *Curating Differently: Feminisms, Exhibitions, and Curatorial Spaces*, edited by Jessica Sjöholm Skrubbe, xi–xviii. Newcastle upon Tyne: Cambridge Scholars, 2016.

Smallwood, Stephanie. "Freedom." In *Keywords for American Cultural Studies*, 2nd ed., edited by Bruce Burgett and Glenn Hedler, 111–114. New York: New York University Press, 2014.

Smith, Andrea. "Queer Theory and Native Studies: The Heteronormativity of Settler Colonialism." *GLQ* 16, nos. 1–2 (2010): 42–68.

Smith, Paul Chaat. *Like a Hurricane: The Indian Movement from Alcatraz to Wounded Knee.* New York: New Press, 1997.

Smithers, Gregory. *The Cherokee Diaspora: An Indigenous History of Migration, Resettlement and Identity.* New Haven, CT: Yale University Press, 2015.

Stewart, Kathleen. *Ordinary Affects.* Durham, NC: Duke University Press, 2007.

Stewart, Kathleen. *A Space on the Side of the Road: The Cultural Poetics in an "Other" America.* Princeton, NJ: Princeton University Press, 1996.

Stewart, Todd. *Placing Memory: A Photographic Exploration of Japanese American Internment.* Norman: University of Oklahoma Press, 2008.

Stockton, Kathryn Bond. *The Queer Child, or Growing Sideways in the Twentieth Century.* Durham, NC: Duke University Press, 2009.

Stoler, Ann Laura. *Along the Archival Grain: Epistemic Anxieties and Colonial Common Sense*. Princeton, NJ: Princeton University Press, 2010.

Stoler, Ann Laura. "Intimidations of Empire." In *Haunted by Empire: Geographies of Intimacy in North American History*, edited by Ann Laura Stoler, 1–22. Durham, NC: Duke University Press, 2006.

Tharu, Susie. "This Is Not an Inventory: Norms and Performance in Everyday Femininity." In *Native Women of South India: Manners and Customs*, edited by Pushpamala N. and Clare Arni. Bangalore: India Foundation for the Arts, 2004.

Thea, Carolee. *On Curating: Interviews with Ten International Curators*. New York: Distributed Art Publishers, 2009.

Thompson, Krista. *Shine: The Visual Economy of Light in African Diasporic Aesthetic Practice*. Durham, NC: Duke University Press, 2016.

Tongson, Karen. *Relocations: Queer Suburban Imaginaries*. New York: New York University Press, 2011.

Tsing, Anna Lowenhaupt. *Friction: An Ethnography of Global Connection*. Princeton, NJ: Princeton University Press, 2005.

Turcotte, Gerry. "Spectrality in Indigenous Women's Cinema: Tracey Moffatt and Beck Cole." *Journal of Commonwealth Literature* 43, no. 1 (2008): 7–21.

Vora, Neha. *Impossible Citizens: Dubai's Indian Diaspora*. Durham, NC: Duke University Press, 2013.

Walcott, Rinaldo. *Queer Returns: Essays on Multiculturalism, Diaspora, and Black Studies*. London: Insomniac Press, 2016.

Watson, Mark. "Diasporic Indigeneity: Place and the Articulation of Ainu Identity in Tokyo, Japan." *Environment and Planning* 42, no. 2 (2010): 268–284.

Weitzman, Eyal. *Hollow Land: The Architecture of Occupation*. New York: Verso Books, 2012.

Westmoreland, Mark R. "Akram Zaatari: Against Photography, A Conversation with Mark Westmoreland." *Aperture* 210 (2013): 60–65.

Westmoreland, Mark R. "Making Sense: Affective Research in Postwar Lebanese Art." *Critical Arts* 27, no. 6 (2013): 717–736.

Westmoreland, Mark R. "You Cannot Partition Emotion: Akram Zaatari's Creative Motivations." In *Akram Zaatari: The Uneasy Subject*, edited by Juan Vicente Aliaga and Akram Zaatari, 25–51. León: MUSAC, 2011.

White, Melissa. "Documenting the Undocumented: Toward a Queer Politics of No Borders." In Rachel Lewis and Nancy A. Naples, eds., "Queer Migration, Asylum, and Displacement," special issue, *Sexualities* 18, no. 7 (2014): 976–997.

White, Patricia. *Women's Cinema, World Cinema*. Durham, NC: Duke University Press, 2015.

Wilson, Ara. "Queering Asia." *Intersections: Gender, History, and Culture in the Asian Context*, no. 14 (November 2006), http://intersections.anu.edu.au/issue14/wilson.html.

Wilson-Goldie, Kaelen. "Contemporary Art Practices in Post-War Lebanon: An Introduction." In *Out of Beirut*, edited by Suzanne Cotter, 81–89. Oxford: Modern Art Oxford, 2006.

Wright, Stephen. "Territories of Difference: Excerpts from an Email Exchange between Tony Chakar, Bilal Khbeiz and Walid Sadek." In *Out of Beirut*, edited by Suzanne Cotter, 58–64. Oxford: Modern Art Oxford, 2006.

Zaatari, Akram. Curator's statement for *Radical Closure*. Curated by Akram Zaatari. Chicago: Video Data Bank, 2007.

Zaatari, Akram. "Interview with Hashem El Madani." In *Hashem El Madani: Studio Practices*, edited by Lisa Le Feuvre and Akram Zaatari, 11–17. Beirut: Arab Image Foundation, 2004.

Index

Divecha, Vikram: "Veedu," 184n16
dOCUMENTA(13), 142
Doha, 184n17
domesticity, 8, 25, 44, 46, 50, 66, 69, 83, 97,
 107–108, 158, 185n22, 190n76, 190n77
DREAM Act, 63, 78, 194n13
Duchamp, Marcel, 137, 204n37
Durga, 138
dwelling, 4, 15–16, 26, 61–62, 67, 72–74, 88–89,
 92, 99, 101–103, 113, 118–119, 124, 141, 170,
 174, 197n3

economics (academic discipline), 28, 34
Edward VII, King (Britain), 103
Elias, Chad, 151, 153, 155, 166, 207n78, 208n89
El Mandani, Hashem, 1
entanglement, 167, 174, 207n74
erotohistoriography, 153–154
essentialism, 26, 98, 201n41, 201n42, 206n73
Ethiopia: Harare, 55
ethnography, 41, 47, 89, 165, 170, 175, 197n6
Europe, 6, 8, 13, 22, 34, 41, 55, 57, 93, 97–98, 100,
 118, 170, 179n22, 188n46, 207n74; colonial-
 ism, 6, 56, 88, 90, 92, 107, 179n18, 191n89,
 198nn8–9, 210n1. See also individual countries
 and regions
exceptionalism: Kerala, 34–35, 50, 189n58
exile, 16, 72, 74, 94, 115, 127, 131, 155

Families for Freedom (FFF), 194n12
Fani-Kayode, Rotimi, 171
fedaiyin, 150–154
Feldman, Hannah, 149–150, 153
felt value, 150, 180n27
femininity, 34, 38, 42
feminism, 6, 31, 36, 38, 46–50, 93, 129, 140, 171,
 191n83, 201n42, 206n63; lesbian, 35; liberal,
 33; transnational, 32–33, 77
Ferguson, Rod, 140, 179n25, 200n18, 200n22,
 203n72, 203n75; "Sissies at the Picnic," 178n11,
 187n39, 187n40
film, 12, 21–25, 27, 30–40, 76–78, 100,
 184nn19–20, 190n62, 196n40; Australian,
 99, 100; documentary, 5, 17, 108, 165–166;
 feminist, 31, 76–77; Hindi, 24, 31, 39, 188n44;
 Malayalam, 24, 31, 188n44; parallel cinema
 movement, 190n62; movie theaters, 184n17;
 women's cinema, world cinema, 76–77. See
 also Hollywood; women's cinema, world
 cinema

film festivals, 4, 23–24, 77, 184n19, 196n40. See
 also individual festivals
First Intifada, 209n100
First Nations peoples, 197n2
flag independence, 140
Flatley, Jonathan, 141, 167, 171
Fleetwood, Nicole, 178n7
Fort Tejon, 110
forward-dawning futurity, 94
Foucault, Michel, 69, 203n75
France, 88; colonialism, 107, 177n1; French
 colonialism, 177n1; Marseille, 103, **106**
freedom with violence, 91
Freeman, Elizabeth, 153
Freidrichs, Chad: *The Pruitt-Igoe Myth*, 108–**109**
Freud, Sigmund, 195n33

Ganesh, Chitra, 8–9, 12–13, 17, 21, 65, 76, 83–85,
 92, 147–149, 169, 195n28, 206n63, 206n66;
 13 Photos, 11, 15, 66–73, 77–79, 95, 135, 150,
 plates 3–7; *Index of the Disappeared*, 125–128,
 140–146, 167, **plates 19–20**
Ganges River, 76
gay international, 189n54, 189n56. See also global
 gayness
gender, 11, 21, 24, 42–44, 47–50, 108, 113, 149,
 156, 158, 163, 185n22, 185n29, 185n30, 194n12,
 205n46; colonialism and, 7–8, 14–15, 84,
 93, 97, 100, 139–140, 170, 187n40, 192n4;
 genderqueerness/nonconformity, 1, 3, 5, 20,
 32–33, 160, 169, 171, 178n11, 187n39, 188n49,
 206n63; labor and, 183n9, 183n12, 184n16;
 region and, 27–39, 46, 52. See also femininity;
 masculinity; matriliny; patriarchy
genocide, 76, 181n34
geography (academic discipline), 28
Georgia, 178n11; Manchester, 187n39
Germany, 207n74; Berlin, 114
Geronimo, 110
Ghana, 126, 128–131. See also Gwolu
Ghani, Ashraf, 142
Ghani, Mariam, 9, 12–13, 21, 147–149, 206n66;
 Afghanistan: A Lexicon, 142; *Index of the
 Disappeared*, 125–128, 140–146, 167, **plates
 19–20**; *Kabul: Reconstructions*, 127
Ghosh, Amitav: "The Ghat of the Only World," 74
ghosts, 47, 68–69, 100–101, 103, 110, 133, 135,
 138, 196n1
global art market, 4, 93, 206n69
global gayness, 33, 36, 60. See also gay international

globalization, 22, 30, 35, 56, 78, 189n58, 190n62, 198n8

global North, 6, 34, 192n4

global South, 34, 55, 171, 186n35, 192n4, 193n7

GLQ: Area Impossible special issue, 186n32; Queering the Middle special issue, 29

Goa, 113, 126

Goeman, Mishuana, 181n43

Gomez-Barris, Macarena, 196n1

"good life," 17, 60, 74, 76, 83, 192n5, 194n17

Gopinath, Gayatri: *Impossible Desires*, 6, 23

Gordon, Avery, 196n1

Gray, Herman, 196n1

Great Britain, 40, 95, 190n71; colonialism, 41–43, 47–48, 53, 55, 67, 72, 87–88, 96, 103, 107, 126, 133, 136–140, 170–171, 187n40, 195n28, 198n9. *See also* Lake District; London

Great Migration, 113

Greek (language), 131–132, 174

growing sideways, 69

Guattari, Félix, 172

Guerrero, Aurora, 127, 169; *Mosquita y Mari*, 12, 17, 65, 76–85, 196n40

Guevara, Che, 171

Guggenheim Abu Dhabi, 182n3

Gujarat, 26, 47

Gujarat massacre, 47

Gulf Labor Coalition, 19

Gwolu, 167

Halberstam, Jack, 121, 146, 181n36, 189n55, 192n3, 193n8, 202n71, 208n98

Hall, Stuart, 98, 200n25

Hart Cellar Immigration Act, 66, 126

Hartman, Saidiya: *Lose Your Mother*, 11–13, 126, 128–135, 137–138, 140–141, 147–148, 167–168, 203n10, 204n42

Hawai'i, 197n2, 198n7

Herring, Scott, 75, 192n3

heteronormativity, 6, 14, 21, 32, 39, 50, 52, 58, 61–65, 67, 69, 71, 83–84, 92, 108, 135, 139, 146, 154, 163, 183n12, 193n8

heterosexuality, 34, 70, 75, 163, 193n8

heterotopias, 124, 203n75

Hilal, Ghaith, 209n100

Himalayas, 73; Hindu Kush range, 75; Karakoram range, 75

Hindi (language), 24, 31, 39, 188n44

Hinduism, 22, 24, 30, 38–40, 42, 47, 49, 52, 56, 75, 138, 184n18, 184n20, 190n71, 206n63

Hindu Right, 39, 184n20

Hirsch, Marianne, 67

historical negatives, 158, 209n105

Ho, Enseng, 191n89

Hochberg, Gil Z., 179n17

Holland, Sharon, 131

Hollywood, 99

home-as-region, 74

homoeroticism, 25, 36, 38, 57, 60, 72, 76–77, 92, 124, 154, 160, 163, 182n4, 188n44

homonormativity, 6, 16, 60–62, 64–66, 75, 84, 90

homosexuality, 19, 72, 74, 184n20, 209n100

homosociality, 21, 36, 38, 57, 60, 76–77, 124, 182n4, 188n44

Hong, Grace, 200n18, 200n22, 203n72, 203n75

Hopi, 121

Human Rights Watch, 19

ideologies of discreteness, 140, 179n25

imperialism, 7, 18, 32, 40, 90, 103, 172, 188n43, 201n42; Australian, 8, 88; British, 107, 137, 139, 170–171; European, 198n8; Ottoman, 165; U.S., 15, 56–57, 78, 88, 121–124, 179n18, 198n9, 203n72. *See also* colonialism

India, 23, 35, 39, 60, 66, 68–69, 75, 84, 87, 103, 107, 113, 170, 186n35, 191n83, 195n28; artists, 9, 25–26, 40–55, 177n6, 184n16; film industry, 24, 31–32, 36, 184n19, 184n20; Indian diaspora, 27, 119–120, 123, 126, 137–139, 183n10, 188n45; Indian nationalism, 22, 27, 31, 40–50, 67, 70–72, 178n14, 184n20, 187n40, 190n71; relationship to Kashmir, 15, 70. *See also* Brand India; Calcutta; Delhi; Goa; Gujarat; Kashmir; Kerala; Kochi; Malabar; New Delhi; Sikkim; Tiruvitamkoor

India Day Parade (New York), 27

Indiana, 119–120

Indian Africans, 137–138

Indian (Native) / Indian (South Asian), 120–123

Indian Ocean, 20, 56, 191n89

indigeneity, 8, 40, 53, 166, 171, 185n29, 196n38, 200n21; relationship to diaspora, 13–14, 16, 87–124, 155, 196n1, 197nn2–3, 197nn5–6, 198nn7–9, 199n10, 200n19, 201n41

indigenous peoples. *See* Aboriginal peoples; Arrernte people; First Nations peoples; Hopi; Native Americans; Native Hawaiians; Navajo; Owens Valley Paiute

indigenous studies, 14, 87–91, 93, 197n2, 199n14, 200n19

Indonesia, 189n51, 190n61, 193n7
invisibility, 6–7, 64, 101, 141, 145, 170, 179n17, 201n41
Iraqi Americans, 148
Ireland, 26, 94
Islam, 22, 45, 52, 56, 103. *See also* Muslims
Israel, 156, 165; occupation of Lebanon, 3, 127, 148, 151, 154–155, 158–159, 177n1; occupation of Palestine, 209n100

Jabbur, Jibrail: *The Bedouins and the Desert (El Badou wal badiya)*, 165–166
Jacir, Emily, 148
Jacobs, Margaret, 100
James, C. L. R., 171
Japanese American internment, 110, 202n61
Jolly, Margaret, 197n5
Jordan, 165
Judaism, 22

Kabakov, Ilya, 137
Kabir, Ananya Jayanara, 70, 181n35
Kalal, David Dasharat, 9–10, 12, 17, 21–22, 39–40, 49–50, 55, 57–58, 127, 159, 163; *Kalalabad*, 24–28; *Lady with Garland*, **51**; *Not Gonna*, 44–46; *Who's Your Daddy?*, 52–**53**
Kallat, Jitish, 177n6
Kapadia, Ronak, 205n60
Kapur, Geeta, 40
Kashmir, 15, 70–74, 85, 195n28; Ladakh, 181n35
Kassel Documenta show, 137
Kauanui, J. Kēhaulani, 198n7
Kenya, 9, 87, 113, 126, 133, 137–138, 156, 171; Indian laborers in, 137; Nairobi, 134
Kenyan Independence Day, 138
Kenyatta, Jomo, 138
Kerala, 19–26, 28, 30–33, 39–42, 51–53, 56–57, 169, 182n6, 184n16, 184n18, 185n22, 185n30, 187n40, 190n62, 190n66; Kerala model of development, 34–35, 189n58; matriliny, 36–38, 43–44, 50, 54–55, 189n58, 190nn66–67; Ottapalam, 23
Kerala Samajam, 185n30
Kevorkian Center for Near Eastern Studies, 142
Kickstarter, 196n40
Kochi, 22
Kristeva, Julia, 204n34
Kuhn, Annette, 67

labor, 79, 121, 179n22, 182n2; gendered, 97, 183n9, 183n12, 184n16; racialized migrant, 8,

19–22, 90, 126, 137–139, 182n5, 182n8, 183n12, 183nn10–13, 184n14, 184nn16–17, 198nn8–9, 202n66
Lake District, 96
lateral networks, 178n14
Latinx people, 12, 59–60, 65–66, 77–79, 192n3, 193n10. *See also* Chicanx people; Mexican Americans
Lawrence, Jacob, 118; *Migration Series*, 113–116
Lebanon, 13, 125, 147, 150, 153, 156, 165, 172, 206n70, 206n73; Beirut, 1, 127, 148, 155, 206n71, 207n76; civil war, 148, 158, 159, 177n1, 207n75; Israeli occupation of, 3, 127, 148, 151, 154–155, 158–159, 177n1; Saida, 1, 3, 127, 149, 151, 158, 160, 163; Syrian occupation of, 177n1
Le Corbusier: Unité d'habitation, 103, 105–109, 113
Lehrer, Erica, 4
Leong, Karen J., 202n61
Lerner, Erica, 177n5
Library of Congress classification system, 45
Ligon, Glenn, 178n9
Lionnet, Françoise, 188n42
London, 1, 126, 170–171
Long Beach, CA, 63
looking past, 135, 206n65
Los Angeles, CA, 59, 126, 133, 146; Huntington Park, 77–81, 84; "just west of East L.A.," 77–78, 84, 169, 196n41
Louvre Abu Dhabi, 182n3
Lowe, Lisa, 8, 170n22, 179n22, 198n9
low theory, 146
Lukose, Ritty, 189n58, 190n77
Lyons, Paul, 185n29

Madras Marrumakkathayam Act, 38
Mahmood, Ansar, 145–146
Maikey, Haneen, 209n100
Malabar, 22, 25, 44, 185n22
Malabar Marriage Bill, 36–38, 54
Malani, Nalini, 49; *Re-thinking Raja Ravi Varma*, 46–47; *Unity in Diversity*, 47
Malayalam (language), 19, 23–24, 31, 182n6, 184n16, 185n27, 188n44, 190n62
Malayali (people), 22, 182n6, 184n16, 185n30
Manalansan, Martin, 80, 183n12, 189n54, 204n37
Manjapra, Kris, 178n14, 179n23, 191n89, 207n74
Mankiller, Wilma, 171
Manoug, 165–166
Manzanar internment camp, 110

Out of Beirut, 206n71
Owens Valley Paiute, 110

Pacific Islands, 193n7
paintings, 9, 12, 25, 40–**54**, 100, 113, **113**–114, 145, 159, 185n22; picturesque style, 96. *See also individual works*
Pakistan, 70, 72, 87, 102, 145, 187n36. *See also* Afpak; Kashmir
Palat, R. M., 54–55
Palat House, 23–24
Palestine, 148, 150–153, 156, 165, 209n100
Pan-Africanism, 130–131
pan–Third Worldist movements, 129–130. *See also* Afro-Asian solidarity movements; Bandung Conference; Non-Aligned Movement
Patel, Geeta, 186n32, 188n43
patriarchy, 38, 43–45, 139, 154, 158, 190n66, 193n10; heteropatriarchy, 20, 63, 69, 90, 97, 105, 108, 181n43
patriliny, 6, 36, 43–44, 46, 52–53, 55, 128, 135, 190n67
Pennsylvania, 72
performance, 3, 7, 16, 18, 59, 62, 68, 150, 156, 163, 193n10
performativity, 44, 53, 153, 181n40, 194n16
Persian Gulf, 22
Philippines, 183n12
photography, 1, 12, 36, 40, 47–49, 55, 63, 87, 104, 108, 125, 180n27, 181n36, 185n30, 195n28, 206n65, 207n76; family, 8–9, 11, 15, 66–69, 79, 135, 139, 145, 169; honeymoon, 15, 67–68; landscape, 15, 70–73, 77, 93–103, 109–113; multimedia, 133–140, 145–147; spirit, 100–101; studio, 3, 18, 79, 82, 147–166, 172–175, 208n79, 209n107; urban, 113–124. *See also individual works*
Phu, Thy, 100, 180n32
pinkwashing, 209n100
Pinney, Christopher, 135, 190n71, 206n65
poetry, 12, 30, 33, 72–76, 119, 209n107
political science, 28–29, 34
Portugal, 126, 134
postcolonialism, 4, 6, 9, 33, 36, 38, 40, 44, 68, 70, 84, 87–90, 123, 126, 128–131, 133, 135, 138, 186n35, 187n40, 191n89; postcolonial nationalism, 8, 67, 72, 132, 135, 140, 153, 156
postcolonial studies, 33, 90, 186n35, 196n38
Prashad, Vijay, 129
Prince, 171

provincialization, 6, 31, 178n12, 186n35, 188n46
Pruitt-Igoe public housing project (St. Louis), 107–109, 202n57
Pullappally, Liga, 127; *Sancharram*, 12, 21–25, 27, 30–39, 76–78, 184nn19–20, 190n62, 196n40
Pushpamala N., 46, 49, 52, 191n83; *Native Women of South India: Manners and Customs*, 47–**48**

quebradita, 59
queer archives, 5, 9–11, 21, 44, 66–69, 125–126, 147–166, 172, 175, 180n27, 208n83, 208n85
Queer Asia conference (2005), 193n7
queer cartography, 5–6, 18, 85, 124, 170
queer critique, 57, 63–65, 67, 87–124, 130, 153, 171
queer curatorial practice, 3–4, 9, 11, 18, 149, 163, 170, 174–175, 180n27
queer diaspora, 5–28, 32, 44, 50–52, 55–73, 76, 84, 87–93, 99, 101, 119, 124–126, 128, 148, 163–165, 167–170, 174–175, 179n22, 179n25, 181n40, 193n7, 196n1, 199n10
Queer Diaspora Conference (2010), 193n7
queer genealogy, 69, 83–84
queerness, definition, 14, 20, 61
queer regional imaginary, 5–6, 26, 57, 163, 165, 169
queer socialities, 19–20, 44, 58
queer studies, 4–5, 14–15, 20, 28, 30, 33, 38, 75, 87, 128–129, 140n13, 178n15, 180n28, 183n9, 186n32, 187nn39–40, 193n7; regional turn in, 178n10
queer suburban imaginaries, 196n41
queer utopian memory, 84
queer world-making, 20, 60, 64, 141, 192n3, 192n6
quotidian, 5

race, 4, 7, 11, 14, 29, 187n39, 205n46; colonialism and, 15, 17–18, 91–92, 97, 103, 116, 122–125, 138–141, 170, 172, 198n9, 200nn19–22, 203n72; comparative race studies, 200n18; cross-racial solidarities, 124, 129–130, 179n22, 182nn4–5, 200n22; diaspora and, 16, 28, 61–62, 126–130; migration and, 62–69, 78–79, 84, 88, 193n10, 194n12; racialized labor, 8, 182n5, 198n9; segregation, 95–96, 103, 108, 110, 113, 118, 120, 123, 196n41
racism, 113–114, 126, 140, 171, 185n29
Ralph, Michael, 204n42
Ramirez, Reyna, 197n6
Rana, Samena, 171
Rancière, Jacques, 177n2
Ranganathan, S. R., 45
Reddy, Chandan, 91, 124, 193n10, 199n15